BOLLINGEN SERIES

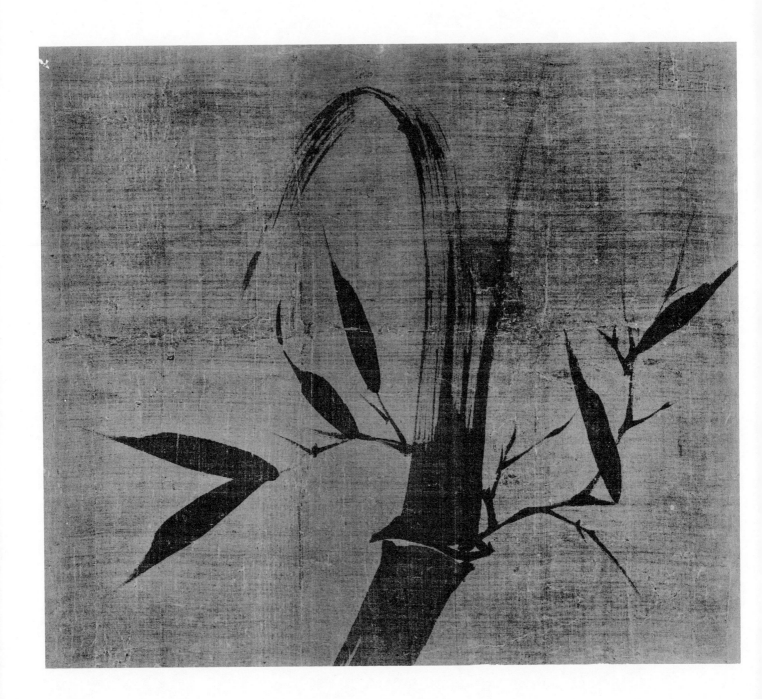

The Mustard Seed Garden Manual of Painting

Chieh Tzŭ Yüan Hua Chuan, 1679-1701

A facsimile of the 1887–1888 Shanghai edition
with the text translated from the Chinese
and edited by

MAI-MAI SZE

 BOLLINGEN SERIES · PRINCETON UNIVERSITY PRESS

LCC 77–312
ISBN 0–691–01819–7 (paperback edition)
ISBN 0–691–09940–5 (hardcover edition)

First Princeton Paperback printing, 1977
Second printing, 1978

Publisher's Note

THE MUSTARD SEED GARDEN MANUAL OF PAINTING was originally part of a larger work, *The Tao of Painting*, first published in Bollingen Series in 1956 in a two-volume edition. The first volume consisted of an essay by Mai-mai Sze on the *tao*, or "way," of Chinese painting; the second volume reproduced the Manual of Painting and provided the first English translation of the text. In 1963 a second edition was issued in one volume. Both editions are now out of print.

The present book consists of the original second volume, the Manual of Painting, in its entirety. Miss Sze's study of *The Way of Chinese Painting* is preserved in a book of that title published by Vintage Books.

The frontispiece, "Bamboo," reproduces an ink painting on silk by an unknown artist, probably of the fourteenth century. The original is in the Museum of Fine Arts, Boston.

The title page of the first edition of the *Chieh Tzŭ Yüan Hua Chuan* (Part I, 1679) is reproduced following page 2 by courtesy of the Nelson Gallery of Art and Atkins Museum, Kansas City, Missouri.

Contents

Traditional Chronology

B.C.

c. 3000–2205	Era of the legendary Five Emperors and Three Kings (and the Yang Shao culture in Honan; the P'an Shan and Ma Chia Yao cultures in Kansu; the black pottery culture in Shantung, Honan, and Anhui)
2205–1766	Hsia Dynasty
1766–1122	Shang-Yin Dynasty
1122–255	Chou Dynasty
255–207	Ch'in Dynasty
207–A.D. 220	Han Dynasty

A.D.

220–264	Three Kingdoms	
	Wei	220–265
	Wu	222–265
	Shu Han	221–264
265–420	Chin (Tsin) Dynasty	

265–589	Six Dynasties	
	Wu	265–280
	Eastern Chin	317–420
	Sung	420–479
	Southern Ch'i	479–501
	Liang	502–556
	Ch'ên	557–589
589–618	Sui Dynasty	
618–906	T'ang Dynasty	
907–959	Five Dynasties	
	Later Liang	907–922
	Later T'ang	923–934
	Later Chin	936–946
	Later Han	947–951
	Later Chou	951–959
960–1280	Sung Dynasty	
	Northern Sung	960–1126
	Southern Sung	1127–1280
1260–1368	Yüan Dynasty	
1368–1644	Ming Dynasty	
1644–1911	Ch'ing Dynasty	
	K'ang Hsi	1662–1722
	Ch'ien Lung	1736–1795
1912–	Republic	

Introduction

IN NANKING during the last quarter of the XVII century, three painters, who were also brothers, prepared the illustrations and text of a work that subsequently became the most widely used handbook of painting in China, the *Chieh Tzŭ Yüan Hua Chuan* or Mustard Seed Garden Manual of Painting. The complete work consists of thirteen "books" arranged in three parts. Part I, on landscape, appeared in 1679, and constitutes the first edition of the *Chieh Tzŭ Yüan.* It contains five books: one on general principles and standards, with historical notes and a section on colors; *Book of Trees; Book of Rocks; Book of Jên-wu ("People and Things")*; and a book of additional plates of examples of landscape painting. In 1701 the publisher reissued Part I along with Parts II and III, which together make up the first *complete* edition. Part II contains four books: *Book of the Orchid; Book of the Bamboo; Book of the Plum;* and *Book of the Chrysanthemum;* and Part III, four books: *Book of Grasses, Insects, and Flowering Plants; Book of Feathers-and-Fur and Flowering Plants;* and two books of additional examples. In 1818, a short work on figures appeared, purporting to be the last part of the *Chieh Tzŭ Yüan;* it is still occasionally treated as Part IV of the Manual, although it was not part of the original work nor in any way connected with its publisher and authors.

The Mustard Seed Garden Manual of Painting received its title from the name of a small property and house in Nanking, the home of the publisher of the work. What seems a most appropriate

title for a Manual was in fact a mere coincidence; the Manual contains no statement relating its title to the Buddhist parable of the mustard seed. Li Yü (1611–80), an essayist and playwright, who wrote the foreword to the first (1679) edition, apparently acquired the piece of property in question, near the South Gate in Nanking, only a few years before the Manual was compiled and published; he built the house and bookstore on it, and called the place the "Chieh Tzŭ Yüan": "Mustard Seed Garden." In notes preserved among his works, Li Yü wrote: "This is my Chin-ling [Nanking] villa. It occupies only a hillock, hence the name 'Mustard Seed' to designate its smallness. When visitors who come and go notice that the place has hills and dales, they remark that it brings to mind the saying "Mount Sumeru is contained in a grain of mustard seed.' " [1]

Li Yü has sometimes been credited with being the author of the *Chieh Tzŭ Yüan*. The prefaces and comments in the work make it clear, however, that he contributed only the foreword to Part I. His son-in-law, Shên Hsin-yu, who seems to have been in charge of the Chieh Tzŭ Yüan and who made the arrangements for the Manual, may be described as the publisher. Shên also wrote some introductory remarks and a section of additional notes on color which was placed at the end of the original edition. The authors—or more strictly, the editors—who also prepared the hundreds of pages of illustrations, were the three brothers surnamed Wang. Wang Kai (*tzŭ* An-chieh) was the general editor of the whole work and the sole author of Part I, for which he also prepared the illustrations, a task that took three years; in the work he used the pseudonym Lu Ch'ai, Master of the Ch'ing Tsai T'ang, the name either of the home and studio of the Wangs or of a fictitious headquarters. His brothers, Wang Shih (*tzŭ* Mi-ts'ao) and Wang Nieh (*tzŭ* Ssŭ-chih), are known to have specialized in bird and flower painting, and presumably for this reason helped in the preparation of Parts II and III. According to the publisher's notes in the first complete (1701) edition, Wang Shih was responsible mainly for compiling Parts II and III, Wang Kai being consulted on final decisions. Wang Shih and Wang Nieh, the publisher's notes say, were assisted by two other painters: Wang Chih (*tzŭ* Yün-an) and Chu Shêng (*tzŭ* Hsi-an), who helped to prepare the plates respectively of flowers and of orchid and bamboo. The Wangs were natives of Hsiu-shui, in Chekiang Province. They seem to have been particu-

1. Hummel, *Eminent Chinese of Ch'ing Period*, pp. 495–97, in remarks on Li Yü's life and works, makes brief reference to the *Chieh Tzŭ Yüan*. Another side of Li Yü is mentioned by Waley (introduction to a translation of the *Chin P'ing Mei*): "He lived from about 1620 to 1690. Li Yü is considered by the Chinese to be a very disreputable person. One of his plays deals with sapphism, another with sodomy, and a third (the *Na Ho T'ien*) contains a lampoon on the personal appearance of the head of the K'ung family, 65th descendant of Confucius. . . ."

larly well equipped to produce a handbook such as the *Chieh Tzŭ Yüan,* for while they were not great painters, they knew the background and discipline of Chinese painting and could give the material clear and orderly arrangement.

Except for the first book, consisting entirely of text, the original Manual was composed of framed full pages, which measured within the frames about five by eight inches, on which were printed instructions and explanations varying in length from a phrase to several sentences, together with illustrations. Parts II and III contained extra prefatory notes and other brief comments praising the Manual and restating some of the information given in the text of each book. Later editions included still other prefatory remarks, in the nature of testimonials, that add nothing at all substantial to the body of the Manual.

The popularity of the *Chieh Tzŭ Yüan* is attested by the number of its editions—more than twenty—and of its lithographic reprints, which have been innumerable.[2] In scholarly circles, however, the work was for many decades largely ignored, since it was regarded as a guide for beginners in painting. Recognition came slowly, and in recent years the Manual has been hailed by authorities as a uniquely important work. Just how important it is, and in what way, is worth considering. Age does not necessarily make it valuable, nor does its thoroughness in setting forth the basic steps of Chinese painting assure it uniqueness and importance as a Manual.

The few specimens of the first edition still in existence each contain several hundred pages, many in color, copied from paintings and printed from wood blocks.[3] Their quality and the large number of them in a single work place them among the very finest collections of early block printing with color. Estimates of the Manual have tended to emphasize this aspect, obscuring to

2. A. K'ai-ming Ch'iu, "The *Chieh Tzŭ Yüan Hua Chuan*," pp. 55–69, discusses the first three editions, with reproductions of the title pages and the end of the Li Yü preface, and gives information about later editions, translations, and the location of copies of early editions. The following specimens of the principal editions of the *Chieh Tzŭ Yüan* are in American collections:

K'ang Hsi editions: 1679 (Part I): Nelson Gallery of Art and Atkins Museum (Kansas City, Mo.), Harvard-Yenching Institute, Rhode Island School of Design (Providence); 1701 (Part II): Nelson Gallery of Art and Atkins Museum, Columbia University; 1701 (Part III): Nelson Gallery of Art and Atkins Museum.

Ch'ien Lung edition, 1782 (Parts I–III): Art Institute of Chicago, Harvard-Yenching Institute, Library of Congress, Princeton University; Part II only: Museum of Fine Arts (Boston); Part III only: Columbia University.

Chia Ch'ing edition, 1800 (Parts I–III): Museum of Fine Arts (Boston), Harvard-Yenching Institute, Library of Congress, Metropolitan Museum of Art (New York), Philadelphia Museum of Art.

Shanghai (first lithographic) edition, 1887–88: University of California (Berkeley), Columbia University, Harvard-Yenching Institute, Library of Congress.

Japanese wood-block edition (with complete translation into Japanese based on the K'ang Hsi and Ch'ien Lung editions), 1936–37: University of California (Berkeley), Harvard-Yenching Institute.

3. Besides the plates of the few copies of early editions in the libraries, 16 facsimiles of wood-block-printed pages have been beautifully reproduced in Jan Tschichold, ed., *Chinese Color-Prints from the Painting Manual of the Mustard Seed Garden* (Basel and London, 1952).

some extent the main value of the examples in demonstrating brushstrokes and the use of color in painting. It is, of course, difficult to attempt to judge by their present faded tints how helpful the illustrations might actually have been in instructing a beginner in painting or in aiding others who consulted them; [4] for us today, lovely as they are as block prints, they are hardly adequate as illustrations of the handling of color and tones and the rendering of line in painting. As to their value in demonstrating brushstrokes, the effect of stiffness that necessarily results from carved wood blocks makes them unsatisfactory as examples of strokes made by the soft Chinese brush. Later editions reproduced by a lithographic process, with only black-and-white plates, though they fail to show the full range of ink tones of the living brushstroke, offer better examples of the brushstroke forms and give a better idea of the vitality of brushwork, which has always been the primary factor in Chinese painting. There is therefore a considerable difference between the interest of a connoisseur of prints or a bibliophile in the *Chieh Tzŭ Yüan* and that of a painter or anyone else interested in the technique of Chinese painting; from the point of view of the latter, the discrepancies inevitable in the wood-block reproduction of brushstrokes deprive the Manual of an essential element. Nevertheless, the examples are indispensable in illustrating the summary of the basic steps and the technical discipline. They help not only to clarify the text, but also to enunciate the principles and standards of the *tao* of painting and to demonstrate how the traditions were handed down from period to period.

The amount of space apportioned to the text of the Manual, compared to that given to the illustrations, is relatively little, yet it is surprising how much the text manages to cover. This may be attributed partly to the faculty of the Chinese language for implying a great deal in a phrase and even in a character, and partly to the fact that the authors of the text assumed a reader's familiarity with the Chinese tradition. The contents of the Manual and the whole attitude toward painting embodied in it are based on ideas and beliefs long a part of this tradition of thought, usage, and ritual conduct. Indeed, many passages are quoted directly from basic works of earlier periods. As in all Chinese writings, references to Confucian, Taoist, and Buddhist classics are scattered throughout, and the artist-authors naturally also draw amply on the records of painting: sections such as the beginning of the *Book of the Bamboo* and the *Book of the Plum* are condensed paraphrases from such well-known works as the *Chu P'u* (Treatise on the Bamboo) and

4. A preface to the 1887–88 edition already remarked: "It is not easy to find a perfect copy."

the *Mei P'u* (Treatise on the Plum Tree). Other material borrowed by the Manual ranges from Hsieh Ho's work of the beginning of the VI century to the opinions of Ming critics. It should be explained that it is an accepted practice in Chinese writing and compilations to incorporate phrases, sentences, and long passages without necessarily identifying sources, for such borrowings are considered to be in the service of tradition—serving to transmit it and in transmitting to sustain and strengthen it. In instances when a borrowed passage is identified, it is for the specific purpose of emphasizing its authority. An attempt has been made to note such borrowing of passages in the Manual when the sources are significant to the material under discussion, but it has been impossible to identify every phrase taken from the records of the past.

The *Chieh Tzŭ Yüan* bears an interesting relation to the period in which it appeared, for its publication was significant in marking a stage in Chinese painting. Among the effects of the fall of the Ming dynasty, which was Chinese, in the middle of the XVII century, and the rise of the Manchu (and foreign) Ch'ing dynasty was the intensification among scholars and the intelligentsia of the collection and rearrangement of the records and works of earlier periods—partly, perhaps, in a futile attempt to recapture the glory of the past. Although the *Chieh Tzŭ Yüan* had a relatively minor place among the many notable encyclopedias and other compilations of the period, it was no less a symptom of its times. The great creative periods of Chinese painting, the pre-T'ang and T'ang-Sung, were past; the academic spirit of the Ming period had had its day, and, with the exception of a few individual painters, the ebb of creative powers was increasingly evident. From one point of view, the *Chieh Tzŭ Yüan* might be described as an attempt to set down everything that, in effect, could not be reduced to rules and formulas. On the other hand, it achieves a summing up that represents a reaffirmation of the standards established in the great periods of painting; and in detailing the principles and basic steps of technique it transmits the main features of the *tao* of painting. There has been no other work similar in scope, contents, and arrangement. It probably could not have appeared at any other time and is of value today for just this reason. It offers a perspective on the heights of Chinese painting from a point in time soon after the periods of greatest creative activity, and it sums up the permanent and durable aspects. For our purpose this point of vantage is especially valuable. There are advantages also in approaching Chinese painting through the stages of apprenticeship.

*

A second edition of the entire Manual was published in 1782, during the reign of the Emperor Ch'ien Lung. Printed from newly cut wood blocks, it reproduced without significant alterations the contents of the original K'ang Hsi edition. A third edition appeared in 1800, during the Chia Ch'ing era. The first edition printed by a lithographic process, at Shanghai in 1887–88, is discussed below.

No complete translation of the *Chieh Tzŭ Yüan* into a Western language has been published:[5] complete, that is, in the sense of containing, besides the main contents consisting of the text and pictures of instructions, all of the several hundred pages of extra examples and the numerous complimentary remarks. For practical purposes it is doubtful that such a translation would be either necessary or feasible. A French translation (based on the 1887 edition) was made by Raphael Petrucci: *Kiai-Tseu-Yuan Houa Tchouan, Les Enseignements de la Peinture du Jardin Grand comme un Grain de Moutarde: Encyclopédie de la Peinture Chinoise,* published in a limited edition of five hundred and fifty copies, in 1918, by the Librairie Renouard, Paris. It contains all the pages of illustrated instructions with their text (the illustrations being reduced in size by half or more, and presented as scattered text figures) and a small selection from the pages of additional examples; it omits all the various prefaces and comments, but, in the translator's preface, sums up the essential information they contain about the preparation of the Manual. A few works in English and in German on Chinese painting have included brief excerpts from the Manual and some of the illustrations. When such excerpts consist of the translation and discussion of the Six Canons and other main principles, they have probably been based on the statements of them in the larger collections of writings rather than those in the *Chieh Tzŭ Yüan.*

The copy of the Manual used in this translation bears the imprint of the Ch'ien Ch'ing T'ang bookstore and publishing house in Shanghai, which owned the manuscript of the 1887–88 edition, considered to be the earliest edition printed by a lithographic process. This edition—cited in the present work as the Shanghai or 1887 edition—and its reprints have been the best copies of the Manual available in China in recent years, and thus may be presumed to have been the most widely used in our times. Owing to the relative lateness of this edition, in the course of this translation the contents were compared and checked throughout with the complete Japanese translation, entitled *Zenyaku Kaishi-en Gaden,* by Kosugi Hōan and Kōda Rentarō (Atorie-

5. There have been a number of Japanese translations.

sha, Tokyo, 1935–36), which reproduced the illustrations and the Chinese text of the original K'ang Hsi (1679–1701) and Ch'ien Lung (1782) editions. This represents the most nearly accurate version of the original text readily available; furthermore, punctuation was added to its text, which helps to elucidate certain difficult passages. In the present translation, errors in the Shanghai text made in the course of the preparation of new editions have been noted and a few phrases that were omitted have been inserted. Considering the many editions published since those of 1679–1701, the mistakes and omissions are few and minor. The occasional changes that were made in the text and illustrations are also indicated in the footnotes; some were actually improvements, such as, on p. 483, below, the example of the narcissus, for which the later edition gives at the head of the stem a cluster of flowers and the original but a single flower.

<p style="text-align:center">*</p>

The present translation contains the full text and all the illustrated pages of instructions. It excludes the minor prefatory remarks and comments, and all of the pages, some four hundred, of additional examples. The main prefaces are given fully, including a preface written for the 1887–88 edition, which, although not essential to the contents of the Manual, supplies a brief summary of the records of Chinese painting among which the *Chieh Tzŭ Yüan* has its place. In the Chinese editions, the tables of contents of the various books of the Manual appear at the beginning of each book. These contain slips and omissions, however, and in the present translation they are replaced by a detailed general summary of contents, beginning on page 589. In both the summary and the translation, omitted contents—certain prefatory remarks, comments, and additional examples—are described in brackets. The extra examples varied in the different editions, the later editions containing many more, all in black and white. For the reasons explained above, these plates are unsatisfactory as examples of brushwork and do not adequately represent finished works of Chinese painting.

The first step in translating the Manual was a literal first draft, character by character, in the hope that the meaning would not stray far from the original. However, as anyone who has

translated Chinese into English knows, there often are instances when the literal rendering of a Chinese sentence presents in English only a meaningless string of words, and there also are Chinese phrases that defy translation. At such times, translation must become interpretation. Indeed, that perhaps is all it can be most of the time.

A word should be said in explanation of the handling of Chinese names. By custom an individual could take, besides his *ming* (personal or given name), one or more extra names, such as a *tzŭ* (courtesy name) and *hao* (literary names). There was no limit. While the custom is picturesque, it can cause confusion. Many painters are referred to in the Manual by one or another of their various names or, sometimes, by a part of one of their names. In the translation, they are identified by adding in parentheses the rest of the name or the name by which the painter was best known. This seems the simplest way of preserving the tone of respectful familiarity implied in the authors' use of a part of a name, a nickname, or a descriptive title. Care has been taken to keep intact such nuances, for the tone of the Manual varies from the deliberately formal, befitting a teacher, to the conversational and often quite intimate.

Parentheses are used also for brief explanatory material: Chinese transliterations, or else the translations of Chinese terms when these are themselves introduced into the text; material supplied more or less tentatively to fill out particularly elliptical constructions; and, as explained in footnotes, certain passages of text omitted in the Shanghai edition and supplied from the earlier editions. A scheme of numbering the examples composing each book has been introduced for convenience of reference, and some of the books have been given their popular shortened titles for the same reason. Each "book" of the present translation actually was a separately bound booklet in the Chinese edition. The sequence of pages, of course, has been converted in the translation to the Western order, with the exception of pairs of facing pages that compose a single subject or presentation—for example, *Rocks* 28–29 through 32–33 and *Orchid* 1–2 through 17–18—the integrity of which has been preserved. Western order has been applied, unless otherwise noted, in translating the text accompanying the illustrations. In general, each element of the translation is placed opposite the part of the illustration it describes rather than the Chinese text it translates. The choice of larger type for certain headings is a more or less arbitrary device of translation, since the Chinese does not distinguish headings by size but, if at all, by position.

The pages of the Manual within the frames are slightly reduced. The frame itself

has been conventionalized for better appearance; in the Chinese editions, the three outer sides of the frame are slightly heavier than the inner side. The side margins of the Chinese editions contain, as is customary, the book title as a vertical running heading; this detail is omitted from the reproduction, though it is given in effect in the translation.

*

It may be observed that, like everything else written by Chinese painters and critics on the subject of painting, virtually the entire contents of the Manual are aimed at developing the painter's spiritual resources (*ch'i*) in order to express the Spirit (*Ch'i*), the Breath of the *Tao*. The authors of the Manual made no attempt, however, to formulate a definition of *Ch'i*. Like the Chinese philosophers, from whom the concept and the term were taken, they examined, discussed, and revered the idea. As an aspect of the *Tao, Ch'i* was recognized as something essentially undefinable, something perceptible only when man's *ch'i* was exercised together with his intellectual faculties. Nevertheless, the constant references to the *Ch'i* are not merely rhapsodic; they are statements of a firm conviction of the existence of the *Ch'i*, the Breath or Vitalizing Force of the *Tao*, which was the belief underlying the whole of Chinese life in the order and harmony of nature, or, according to the familiar phrase, "the harmony of Heaven and Earth."

The Mustard Seed Garden
Manual of Painting

Chieh Tzŭ Yüan Hua Chuan, 1679-1701

Title Page (11 in. × 6 in.; frame 8.25 in. × 5.25 in.) of the first edition (Part I, 1679). Courtesy of the Nelson Gallery of Art and Atkins Museum, Kansas City, Mo.

CENTER:

Chieh Tzŭ Yüan Hua Chuan (Mustard Seed Garden Painting Manual)

RIGHT:

Hsiu-shui (village in Chia-hsing district of Chekiang) *Wang An-chieh mu ku* (copying old styles)

LEFT:

Pên-hsiang (local) *ts'ang* (gather) *pan* (blocks)

TOP (right to left):

Li Li-wêng (Li Yü) *hsien-shêng* (Master) *lun ting* (explanatory remarks)

SEAL (lower right):

Ku su (Soochow) *Shu Yeh T'ang* (name of bookstore) *Chao shih* (Chao family) *fa* (issue) *tui* (for sale)

Mustard Seed Garden Manual of Painting, by Wang An-chieh of Hsiu-shui, with examples copied from old paintings. Printed from blocks of local wood. Foreword by Li Li-wêng. Published by the Chao family of Soochow and on sale at their bookstore, the Shu Yeh T'ang.

李笠翁先生論定

繡水王安節摹古

芥子園畫傳

本衙藏板

Preface to the Shanghai (1887–88) Edition[1]

THE *Chieh Tzǔ Yüan Hua Chuan* was compiled by old Master Wang An-chieh, of Hsiu-shui. Li Li-wêng, of Hu-shang, wrote a preface to it and had it published. It took three years to prepare the book for publication. The draftsmanship and block engraving in it were excellent. The work has become very popular, sweeping like a wind over the country, and almost everybody who paints (*tan ch'ing chia,* people in the art of red-and-green or blue) owns a copy. As the book was first published in the eighteenth year of K'ang Hsi (1679), over two hundred years ago, the original edition is out of print and it is impossible to obtain a copy. There have been many reprints, but few have been free of inaccuracies. A tiny mistake can make a world of difference in meaning, and it is not easy to find a perfect copy.

Ch'ao Tzǔ-yü, of Yüan-hu, a pupil of old Master Chang Tzǔ-hsiang, often used to discuss the *Chieh Tzǔ Yüan Hua Chuan* with his teacher, and together they began to re-edit the old master's fine copy with a view to publication. Unfortunately, the old master died before they could complete the task, but his grandsons, I-ch'ing and Mou-ts'ai, undertook to carry through the project and had new illustrations made on stone (i.e., lithographic plates) for the book.

1. By the time this preface was written, the Manual had appeared in many editions and reprints; the 1887–88 (Shanghai) edition was the first reproduced by lithography. It is interesting to read of the reception of the Manual during the first two hundred years of its existence. The main reason for including this preface in full, however, is its brief summary of the most important essays and compilations, which gives an idea of the voluminous records of Chinese painting and also of the unique place of the *Chieh Tzǔ Yüan* among them. Two companion prefaces, at the beginning of Parts II and III, in the nature of testimonials, are omitted in this translation, since today they add nothing of importance to the Manual itself.

This preface was actually bound in Book 1, but it is presented here because in content it is prefatory to the entire Manual.

Wang Sung-t'ang, owner of the Little Pavilion, has requested me through Mr. Ch'ao to write a preface to the present edition. As a layman, what can I write in the way of a preface? Yet the request is an honor I cannot decline, so I write this preface based on information I have gathered and on my own observations.

When were such records of painting first compiled? So far as I know, the earliest record about artists and their works was the *Ku Hua P'in Lu* (Record of the Classification of Painters), by Hsieh Ho (*c.* 500), of the Southern Ch'i period. He classified twenty-seven painters since the time of Lu T'an-wei, placing them in six categories. It was in this work that the famous Six Canons were set down for the first time.

A continuation of Hsieh Ho's book was composed by Ch'ên Yao-tsui (*c.* 550), entitled *Hsü Hua P'in* (Further Classification of Painters). Twenty painters were discussed in the sixteen chapters of this book. In method it differed from Hsieh Ho's by confining itself to a record of the various periods, with little comment on individual painters.

Next comes the *Chên Kuan Kung Ssŭ Hua Shih* (Record of the Public and Private Collections of the Emperor Chên Kuan), by P'ei Hsiao-yüan, of the T'ang period. This work actually dealt with the collection of paintings of the Sui dynasty (589–618) up to the work of Yang Ch'i-tan of that period. In other words, the book was a record of the collection of paintings of the Sui dynasty that were in existence in the reign of the T'ang emperor Chên Kuan. It consisted of a list of titles of paintings together with the names of the artists and notations as to whether they were included in the *Liang T'ai Ch'ing Mu* (Record of Liang Dynasty Collection). For those who wish to study the famous paintings of the pre-Sui period, there is nothing more authoritative or older than this book.

Chang Yen-yüan compiled (*c.* 845) the *Li Tai Ming Hua Chi* (Notes on Famous Painters of all the Dynasties), the first three chapters of which were devoted to the theories of painting and the other thirteen to biographical sketches of famous painters, including excerpts from their writings and anecdotes about their lives. This book was so profusely documented that it was much more than a review. It is, in fact, a valuable book of reference.

Next came the *T'ang Ch'ao Ming Hua Lu* (T'ang Dynasty Collection of Famous Painters), compiled by Chu Ching-yüan (*c.* 1000), of the T'ang period. In this book, painters were classified as *shên* (divine), *miao* (wonderful), *nêng* (able), and *i* (spontaneous). The first three classes

were further divided; the *i* category, however, was not. Ching-yüan was the first critic to introduce the *i* classification.

The *Hua Shan Shui Lu* (Essay on Landscape Painting), which included the *Pi Fa Chi* (Notes on Brushstroke Methods), is said to have been written by Ching Hao, of the T'ang period. Its inferior style makes dry reading, and it may be that the work was composed by someone who used the author's name. Since it is old and has had a wide circulation, however, the work has survived to the present day.

The *Wu Tai Ming Hua Pu I* (Record of the Five Dynasties Collection of Famous Paintings) was compiled by Liu Tao-ch'un, of the Sung period, and was a supplement to Hu Sung-hsien's *Liang Ch'ao Ming Hua Lu* (Liang Dynasty Collection of Famous Paintings). The former and its companion work, the *Sung Ch'ao Ming Hua P'ing* (Record of the Sung Dynasty Collection of Famous Paintings), are considered two of the greatest compilations. The *Sung Ch'ao Ming Hua P'ing* was divided into six parts: *jên-wu* (figures and things), *shan shui lin* (mountain, water, and forest scenes), *ch'u shou* (animals, domestic and wild), *hua liu ling mao* (flowers, willows, birds, and animals), *kuei shên* (devils and gods), and *wu mu* (houses and structures). The paintings were classified according to the *San P'in* (Three Classes), *shên, miao,* and *nêng;* this marked the first classification of ancient paintings into the Three Classes.

Then there was the *I Chou Ming Hua Lu* (I Chou Record of Famous Painters, published in 1005), compiled by Huang Hsiu-fu, of the Sung period. The work dealt with fifty-eight painters of Shu (Ssŭchuan) from the period of Ch'ien Yüan, of the T'ang dynasty, to that of Ch'ien Tê, of the Sung dynasty. As in Chu Ching-yüan's book, the painters were classified as *i, shên, miao,* and *nêng.* There was the slight difference of placing the *i* class ahead of the others.

Following Chang Yen-yüan's *Li Tai Ming Hua Chi* was Kuo Jo-hsü's *T'u Hua Chien Wên Lu* (Record of Things Seen and Heard about Painting). This book (composed during 1078–85) covered the period from the beginning of the Five Dynasties to the seventh year of Hsi Ning (1074). It was divided into four parts: stories, skill in representation, forgotten anecdotes rediscovered, and contemporary painting. The discussion showed a wide knowledge of the theories of painting. Ma Tuan-lin, in his *Wên Hsien T'ung K'ao* (Essay in General Review of Painting), spoke of it as the most authoritative work on calligraphy and painting.

Lin Ch'üan Kao Chih (The Supreme Effects of Forests and Streams) by Kuo Hsi (*c.*

1020–90), of the Sung period, contained the *Shan Shui Hsün* (Comments on Landscape), the *Hua I* (Meaning of Painting), the *Hua Chüeh* (Secrets of Painting), and the *Hua T'i* (Titles for Paintings). His son, Kuo Ssŭ, supplied footnotes and additional material on Kuo Hsi's life and works, including an account of Kuo Hsi's strange adventure in a temple.

Li Chai (XI century) compiled the *Tê Yü Chai Hua P'in* (Tê Yü Chai Review of Painting), and Mi (Fei) Yüan-chang (last half of XI century) wrote the *Hua Shih* (History of Painting).

The *Hsüan Ho Shu P'u* (Catalogue of the Hsüan Ho Palace Collection of Paintings) does not give the name of its author. It is divided into ten parts, listing 231 painters and 6,396 paintings. According to experts, these lists were prepared by Mi Fei, and they may therefore be considered authoritative. The whole book is an important record of pictorial art.

Apart from the above works, two others are worth examining: the *Hua Chih* (Painting Records), by Têng Ch'un, of the Sung period, and the *Hua Ch'ien* (Appreciation of Painting), by T'ang Hu, of the Yüan dynasty.

In the present dynasty, besides the *Shih Chu Pao Chi* (Shih Chu's Treasured Album), such books as *T'u Hua Lu* (Records of Studies of Paintings), by Chou Liang-kung, Wang Yu-hsien's *Hui Shih Pei K'ao* (Reference Book on Painting), Li Tai-hung's *Nan Sung Yüan Hua Lu* (Records of Southern Sung Paintings), and Tsou I-kuei's *Hsiao Shan Hua P'u* (Remarks on Painting) are concerned with new theories of painting and should be read by all students of painting.

The *Chieh Tzŭ Yüan Hua Chuan* offers examples of the methods of various schools together with instructions on brushwork. Furthermore, it has been enlarged by the addition of examples taken from the works of famous painters of Shanghai.[2] Even a beginner, if he studied this book, would have no difficulty in eventually finding his own way. The book is a valuable contribution to the art of painting.

There is an old saying that those who are skilled in painting will live long because life created through the sweep of the brush can strengthen life itself, both being of the *ch'i*. But to create life one must comprehend the *li* (principle) of life; without that knowledge and understanding, it is impossible for the *ch'i* to rise. This book clearly is dedicated to encouraging an understanding of *li* so that people may achieve *jên* (Goodness) and longevity. The author's *jên* is substantial. Mr. Chao's paintings surpass the works of Ching (Hao) and Kuan (T'ung). His knowledge and grasp

2. Omitted from the present edition.

of technique show in his painting and writing. Although not a close friend of his, I am able to judge what manner of man he is by his work. My deepest admiration also goes to I-ch'ing and Mou-ts'ai for having carried out their family project so wonderfully. I am sure that, once this (new edition of the) book is published, the work and its creators will enjoy everlasting fame.

Notes composed in the Month of the Yellow Flowers (ninth month of the lunar calendar, when chrysanthemums bloom) in the Ting Hai cycle, the thirteenth year of the reign of Kuang Hsü (1887), by Ho Yung, tzŭ Han Shih-shêng and Kuei-shêng, of Shan-yin and Kao-ch'ang (in Chekiang), at the southern window of the studio called Kao Wu Hsiao Yin (Little Retreat in an Eminent Corridor) in Shanghai. Respectfully transcribed by Su Yü-hsün, tzŭ Chien-ch'u, of Chiang-yin (in Kiangsu).

PART I

The Fundamentals of Painting

Book of Trees

Book of Rocks

Book of Jên-wu

[A Book of Additional Examples]

Preface to the First (1679) Edition[1]

PEOPLE nowadays enjoy looking at landscape paintings as much as at the scenery itself. Panels of screens offer countless vistas, and scrolls and albums spread before us a variety of scenes—distant hills and plains, blue-green mountain peaks, and murmuring brooks. At one moment a landscape may appear overcast with mist and clouds, at another the view emerges clear and fair. Or one may find oneself by a spring of pure flowing water, ready to set out over hills and ravines, free to roam without having to wax one's sandals or take up a bamboo staff.[2]

It is one thing, however, to look at pleasant pictures painted by other people and another matter entirely to paint such pictures. Appreciating the works of others, one is essentially a spectator receiving impressions; whereas, in painting pictures, the conception originates and rises from the deepest recesses of the heart. There is this significant difference in the approach to landscape painting.

All my life I have loved landscape painting, but it has been the pleasure of looking at other people's work, for I myself cannot paint. In the past, when I used to travel, I often met painters,

1. Written by Li Yü. The first edition comprised only Part I, the section primarily on landscape. Parts II and III appeared in 1701, after Li Yü's death.

This preface was actually bound in Book 1, having been especially written as the introduction, but it is presented here because in content it is prefatory to Part I.

2. In this respect, Li Yü's sentiments were typical of the intelligentsia of the Ch'ing period in imitation of the attitudes of the Ming literati, who in turn had conventionalized the views of the Sung gentlemen-painters. In contrast to this view—that landscape paintings are a means of enjoying scenery and wandering in remote places without setting foot outdoors—were such opinions as the Sung master Kuo Hsi's. In his *Essay on Landscape Painting,* he allowed that such pictures might serve sometimes as substitutes when an official could not take time from duties to enjoy scenes away from the city, but he strongly disapproved of withdrawing from life to rusticate, either actually or through paintings. While it was quite honorable for sages to seek seclusion, he observed, for most men it was "contrary to what was right . . . and egotistical to leave society and retire to a mountain."

men who had followed in the footsteps of Mo-chieh [3] and Ch'ang-k'ang,[4] who kindly let me discuss with them the *Tao* in painting. When, however, I began to ask questions, they would knit their brows and declare: "It is easy to appreciate the idea of *Tao* but quite another matter to give it form." [5]

I have been ill now for the past year and unable to travel, being confined to sitting or lying in my room, shut off from all other activities. Fortunately I have paintings and so can unroll whole landscapes on my table. They are here before me even while I eat or sleep. I enjoy this kind of wandering while at rest. It has prompted me to write on one of these scrolls: "Many walled cities under my roof and many landscapes before my eyes." In my solitude, I have regretted not having the knowledge and ability to write about this branch of the Seven Manifestations.

This thought was in my mind one day when I was talking with my son-in-law, Yin-po,[6] and I said to him: "Painting is an ancient art. How is it that there are excellent treatises on the painting of figures, birds, animals, flowers, and plants, yet the most important category, landscape, seems to have been neglected? Do you suppose that most of us can only enjoy looking at landscape paintings?—that, while we may understand the idea of *Tao* in painting, it is really impossible for us to be more definite about it? Is it true, do you suppose, that landscape painters through the centuries have purposely guarded this secret among themselves?"

Thereupon, Yin-po brought out an album. "This has been in our family for many generations," he said.

At the sight of the album my curiosity was aroused. On examining it carefully, I found that it contained copious examples of the methods of individual masters of various schools of (landscape) painting. I particularly noted the comments and their calligraphic style, for they seemed to bear the touch of Ch'ang-hêng,[7] of our family. At the end of the album were two seals, inscribed "Li Family Collection" and "Liu-fang," which confirmed my impression that the album was compiled by Ch'ang-hêng.

3. Wang Wei (*c.* 698–759), traditionally one of the greatest of Chinese landscape painters, also a poet and expert calligrapher; credited as the founder of the Southern School. He was a devout Buddhist, and his *tzŭ*, Mo-chieh or Mo-ch'i, was taken from Wei Mo-ch'i, Chinese name of Vimalakirti, the Indian Buddhist teacher.

4. Ku K'ai-chih, *tzŭ* Ch'ang-k'ang (*c.* 344–406), another great master revered by tradition, famous through anecdotes about his eccentricities as well as his works. Hsieh Ho commented that "his fame surpassed his real merit." The masterpiece *Admonitions of the Palace Instructress*, in

the British Museum, is attributed to him, and has preserved his design and style.

5. The great merit attributed to the ancients, and representing the ideal, was their ability to convey the idea (*i*) while rendering form (*hsing*).

6. Shên Hsin-yu, joint owner of the Mustard Seed Garden and publisher of the Manual.

7. Li Liu-fang, *tzŭ* Ch'ang-hêng, also known as T'an Yüan (1575–1629), painter, writer, and calligrapher. Several of his works still exist: e.g., an album of his paintings in the Boston Museum of Fine Arts.

Since the album was a record of a private collection, the material and its arrangement were not suitable for a manual of painting. Just then, however, Yin-po brought out another album, and he smilingly explained: "When I was living at the Mustard Seed Garden in Nanking, I commissioned Wang An-chieh to rearrange, enlarge, and edit the whole work, an arduous task. Finally, after three years, he completed the work."

Eagerly I took up the album and examined it. I could not help applauding the whole and each of its parts, stopping here and there to sigh with admiration. The plan of the book included the original forty-three pages, to which had been added detailed instructions on the painting of trees and branches, including methods of dotting leaves and of drawing mountain ranges, peaks, rivers, and waterfalls, as well as banks, slopes, rocks, bridges, paths, palaces, houses, boats, and carts. Wang An-chieh, in moments of leisure, had copied out the whole work, enlarging and rearranging it to a total of one hundred and thirty-three pages. He included examples of the styles of many of the masters and of every important school of painting. Furthermore, to aid the beginner, he added forty pages of text on brushwork and the handling of ink tones, composition, and perspective. Following the instructions in this book, one could eventually paint a picture of what hitherto had been locked in one's imagination—could produce results, as it were, with a few twists of the wrist. Would it not be a pity to hide this wonderful book from the world? I have been most anxious to see it published so that generation after generation of those who love to look at landscapes may also learn to appreciate landscape painting and, moreover, may not only read the Manual but also try to paint. For, as the saying goes, thus may ten thousand miles be illustrated in a foot, and one may wander in a landscape while actually at rest and never have to go any distance.

Written on the third day after the summer solstice in the Chi Wei cycle, the eighteenth year of the reign of K'ang Hsi (1679), by Li-wêng (Fisherman of the Lake) [8] *Li Yü at Ts'êng Yüan in Wu-shan.*

8. Li Yü also used the name Li-wêng. On the seal at the end of his foreword to the first edition, the full form was inscribed: "Hu-shang (West Lake at Hangchou) Li-wêng (old man with bamboo hat; poetically, a fisherman)." The year the Manual appeared, Li Yü had already moved to Hangchou, his foreword being written at Ts'êng Yüan, a small property he had acquired through the help of friends.

芥子園畫傳

序文　畫學　淺說

目錄　設色　各法

The Fundamentals of Painting

The five large characters give the Manual title: "Chieh Tzǔ Yüan Hua Chuan." The next four characters: two at right, "Preface"; at left, "Table of Contents." The two pairs of characters next below at right, "Discussion of the Fundamentals of Painting"; the two at left, "Approach to Color and Methods of Preparing Colors."

The characters are reproduced here slightly larger than in the original. Written in *k'ai shu* (regular or model style), they appear on a label, approximately 1.6 × 6.9 in., at the upper left of the paper cover of the first edition of 1679 (Part I). Another label on the original cover, listing the contents of the other four books of Part I, is **not** shown here.

The label on the foregoing page is reproduced by courtesy of the Nelson Gallery of Art and Atkins Museum, Kansas City, Mo.

Ch'ing Tsai T'ang[1]
Discussion of the Fundamentals of Painting

L U CH'AI says:

Among those who study painting, some strive for an elaborate effect and others prefer the simple. Neither complexity in itself nor simplicity is enough.

Some aim to be deft, others to be laboriously careful. Neither dexterity nor conscientiousness is enough.

Some set great value on method, while others pride themselves on dispensing with method. To be without method is deplorable, but to depend entirely on method is worse.

You must learn first to observe the rules faithfully; afterwards, modify them according to your intelligence and capacity. The end of all method is to seem to have no method.

Among the masters, it was a different matter. Ku (K'ai-chih) Ch'ang-k'ang applied his colors sprinkling and splashing, and the grass and flowers seemed to grow at the movement of his hand. Han Kan,[2] whose picture *The Yellow Horse* was unique, used to pray before he painted, and his

1. Name of the studio of Lu Ch'ai (Wang Kai, *tzŭ* An-chieh).

2. VIII-century T'ang master. Though he painted other subjects, he was famed for his pictures of horses. *The Yellow Horse Sent as Tribute from Khotan* was frequently mentioned in the records. The reference to Han Kan praying before he painted suggests the habit of meditation practiced by many painters. The character *ch'ing* (to pray) is composed of *yen* (to speak), a drawing of words issuing from the mouth, and *ch'ing* (green), made up of *shêng* (to produce, to grow; life) over *tan* (red), forming a vivid pictographic description of the process of growing as "burning with life." Thus "to pray" might be rendered as "asking for the fire of life"; among Taoists and Zen Buddhists, it is the emptying of the mind and heart in the practice of meditation in order to be filled with and to reflect the *Tao*, moreover to become identified with the *Tao* in the object painted. As recorded in a comment by Su Tung-p'o, when Han Kan, of whom we are speaking, painted a horse "he became a horse." The common use of *ch'ing*, as in "please (pray) be seated," carries over a ritual manner into what now is mere politeness.

brush was inspired. At a later stage, therefore, one may choose either to proceed methodically or to paint seemingly without method.

First, however, you must work hard. Bury the brush again and again in the ink and grind the inkstone to dust. Take ten days to paint a stream and five to paint a rock. Then, later, you may try to paint the landscape at Chialing. Li Ssŭ-hsün took months to paint it; Wu Tao-tzŭ did it in one evening.[3] Thus, at a later stage, one may proceed slowly and carefully or one may rely on dexterity.

First, however, learn to hold in your thoughts the Five Peaks. Do not concentrate on the whole ox. Study ten thousand volumes and walk ten thousand miles. Clear the barriers set by Tung and Chü, and pass straightway into the mansions of Ku and Chêng. Follow Ni Yün-lin painting in the style of Yu Ch'êng: when he painted, mountains soared and springs flowed, waters ran clear and forests spread vast and lonely. Be like Kuo Shu-hsien, who with one stroke of the brush released a kite on a hundred-foot string, who painted with equal facility the large and the small—towers and many-storied buildings as easily as the hair of oxen and the thread of a silkworm. Thus, at a later stage, an elaborate effect is acceptable and a simple one is equally acceptable.[4]

3. Wu Tao-tzŭ (c. 700–760), traditionally assigned the first place among all the Chinese masters as the only one who achieved the standards set forth in the Six Canons; the records repeatedly spoke of his bold and free brushwork on temple frescoes, particularly of his Buddhist figures, which have not survived but are known through copies and stone engravings.

Li Ssŭ-hsün (c. 651–715), the most prominent landscape painter of his period, named by later critics as the founder of the Northern School. He painted landscapes in the blue-and-green style, sometimes with outlining in gold, a technique that in its precision and detail was similar to that of miniature painting.

The legendary story here referred to illustrates so well the contrast between the two different methods and manners of painting that, although the dates prove that the story could not have been true, it has been faithfully handed down through centuries: Emperor Ming Huang was said to have commissioned the two masters each to paint a picture of the Chialing River, in Ssŭchuan; Wu finished his in one day, while Li took several months, and both were admirable.

4. This paragraph sets the focus of achievement for the student of painting:

"The Five Peaks" refers to the Five Sacred Mountains and the beliefs and concepts embodied in the Five Points, discussed in Vol. 1, Ch. I; and, by implication, the harmony of the Tao within the whole universe, represented by the four cardinal points and the Center; and, by analogy, harmony in man himself through self-cultivation and following the Tao.

"The whole ox" alludes to the story in the Chuang Tzŭ about Prince Hui's cook, who, because he had devoted himself to the Tao, developed his skill as a butcher into an art; when he first started cutting up bullocks, he saw "the whole ox," but he learned through Tao to use his mind properly and to work according to his knowledge of the construction of the animal, therefore he achieved results in perfect harmony. (Giles, Chuang Tzŭ, pp. 33 ff.) These first two references pertain to the spirit and inner resources, which Lu Ch'ai follows up with a much-quoted phrase about the necessity for a painter to broaden his horizons by study and experience, including wide and keen observation, eventually to find in enrichment of the spirit the secret of the rhythm of nature.

Tung Yüan and Chü-jan were early Sung, x-century, masters of landscape and the Southern School style. Ku K'ai-chih has already been mentioned, and Chêng Fa-shih of the Sui period was famed for his paintings of festivals and processions. Ni Yün-lin (Ni, recluse of the Clouds and Forests), the name most often used of Ni Tsan, tzŭ Yüan-chên, was one of the Great Masters of the Yüan period and is mentioned often in the Manual. Ni was prolific, and sometimes painted in the style of Yu Ch'êng, which was the official name of Wang Wei, the great T'ang master. Kuo Shu-hsien (x century) was more often referred to by his other name, Kuo Chung-shu; an eccentric with great versatility in painting, he is best known for his architectural compositions. He was the painter who copied the famous Wang Wei scroll of his home in Shensi, Wang Ch'uan, from which engravings and other copies were made that give us information about Wang Wei's style and skill in design.

If you aim to dispense with method, learn method. If you aim at facility, work hard. If you aim for simplicity, master complexity.

Finally, there are the Six Canons, the Six Essentials, the Six Qualities, the Three Faults, and the Twelve Things To Avoid. How can one disregard them?

<p style="text-align:center">*</p>

Notes on Eighteen Basic Principles, Standards, and Rules

The Six Canons (*Lu Fa*) [5]

In the Southern Ch'i period (479–501), Hsieh Ho said:

Circulation of the *Ch'i* (Breath, Spirit, Vital Force of Heaven) produces movement of life.[6]

Brush creates structure.

According to the object draw its form.

According to the nature of the object apply color.

Organize composition with the elements in their proper places.

In copying, seek to pass on the essence of the master's brush and methods.

(Lu Ch'ai, citing one school of thought, adds:)

All but the First Canon can be learned and practiced to the point of true accomplishment.

5. See *The Way of Chinese Painting* for a discussion of the original six-character forms of the Canons and the four-character forms which have been in use since the IX century. They appear in the Manual in these four-character forms, quoted in the style of Hsieh Ho's *Ku Hua P'in Lu* (Record of the Classification of Painters), published *c.* 500, although probably taken directly from a work such as Chang Yen-yüan's *Li Tai Ming Hua Chi* (Notes on Famous Painters of All the Dynasties). Lu Ch'ai's comment at the end of this section aligns him with the painters and critics who believed, as Hsia Wên-yen of the XIV century wrote, that possessing *ch'i* or being attuned to the *Ch'i* was an aspect of the soul, something one was born with, "one can not know how, yet it is there"; whereas others, such as the Ming critic Tung Ch'i-ch'ang, believed *ch'i* could be cultivated, since in painting it was primarily the results produced by the scholar's brush.

6. Translations of this First Principle of Chinese painting vary to some extent, but intuitively they are in agreement, as may be seen in the following interpretations. "Spirit-Resonance, which means vitality" (Acker). "Rhythmic Vitality or spiritual rhythm expressed in the movement of life" (Binyon). "The harmonizing movement of life-breath" (Contag). "Operation or revolution, or concord or reverberation, of the spirit in life movement" (Coomaraswamy). "The fusion of the rhythm of the spirit with the movement of living things" (Cranmer-Byng). "The Conception should possess harmony and vitality" (Ferguson). "Rhythmic Vitality" (Giles). "Spiritual Element, Life's Motion" (Hirth). "Spiritual expression and life movement" (Jenyns). "A picture should be inspired and possess life in itself" (March). "The life-movement of the Spirit through the rhythm of things" (Okakura). "La consonance de l'Esprit engendre le mouvement (de la vie)" (Petrucci). "Spirit-resonance life-movement" (Rowley). "Spirit Resonance (or Vibration of Vitality) and Life Movement" (Sirén). "Animation through spirit consonance" (Soper). "Spiritual tone and life movement" (Taki). "Spiritual expression or life quality in a picture" (Tomita). While quoting the Canon in Chinese, Suzuki makes no attempt to translate it but comments: "Whatever this may mean, it is the lively presence of a certain spiritual atmosphere . . ."

(As for the ability to make manifest aspects of the) *Ch'i* in its constant revolving and mutation, one has to be born with that gift.

The Six Essentials (*Lu Yao*) and the Six Qualities (*Lu Ch'ang*) [7]

In the Sung period, Liu Tao-ch'un said:

First Essential: Action of the *Ch'i* and powerful brushwork go together.

Second Essential: Basic design should be according to tradition.

Third Essential: Originality should not disregard the *li* (the principles or essence) of things.

Fourth Essential: Color (if used) should enrich.

Fifth Essential: The brush should be handled with *tzǔ jan* (spontaneity).

Sixth Essential: Learn from the masters but avoid their faults.

First Quality: To display brushstroke power with good brushwork control.

Second Quality: To possess sturdy simplicity with refinement of true talent.

Third Quality: To possess delicacy of skill with vigor of execution.

Fourth Quality: To exhibit originality, even to the point of eccentricity, without violating the *li* of things.

Fifth Quality: In rendering space by leaving the silk or paper untouched, to be able nevertheless to convey nuances of tone.

Sixth Quality: On the flatness of the picture plane, to achieve depth and space.

The Three Faults (*San Ping*) [8]

In the Sung period, Kuo Jo-hsü said:

The Three Faults all are connected with the handling of the brush.

7. Quoted from an early XI-century work of biographies of painters of the Five Dynasties and Northern Sung periods, attributed to Liu Tao-ch'un, critic and art historian; reprinted in the *Wang Shih Hua Yüan* and in other major compilations. The two sets of standards as modifications of the Six Canons are discussed in Vol. 1, Ch. II.

8. Quoted from the early XI-century treatise by Kuo, one of the most influential works of the Sung period; the Chinese text and translation with useful notes in Soper, *Kuo Jo-hsü's Experiences in Painting*. Ching Hao's list of faults in painting (tr. in Sirén, *A History of Early Chinese Painting*, I, p. 124) is divided into those that pertain to form or shape and those that do not. The first includes flowers and trees out of season, figures larger than buildings, trees higher than mountains, and bridges not resting on banks (similar to points in the Twelve Things To Avoid); the second pair of faults Ching Hao described as absence of spirit and lack of harmony.

The first is described as "boardlike" (*p'an*), referring to the stiffness of a weak wrist and a sluggish brush. Shapes of objects become flat and thin, lacking in solidity.

The second is described as "carving" (*k'o*), referring to the labored movement of the brush caused by hesitation. Heart and hand are not in accord. In drawing, the brush is awkward.

The third is described as "knotted" (*chieh*), referring to the knotted effect when the brush seems to be tied, or in some way hindered from moving freely, and lacks pliancy.

The Twelve Things To Avoid (*Shih Êrh Chi*) [9]

In the Yüan period, Jao Tzŭ-jan said:

The first thing to avoid is a crowded, ill-arranged composition.

The second, far and near not clearly distinguished.

The third, mountains without *Ch'i,* the pulse of life. [10]

The fourth, water with no indication of its source.

The fifth, scenes lacking any places made inaccessible by nature. [11]

The sixth, paths with no indication of beginning and end.

The seventh, stones and rocks with one face. [12]

The eighth, trees with less than four main branches.

9. Quotation condensed from a XIII-century work by Jao Tzŭ-jan; main portions of the essay have been translated in Sirén, *The Chinese on the Art of Painting,* pp. 115–18.

10. Lit., "mountains lacking *ch'i* in their veins and arteries," referring not only to the need for pictorial vitality created by composition and drawing but to the idea of infusing the mountains with a quality of spirit, particularly since mountains were symbols of life, of the *Yang* (of Heaven and the Spirit). This Third Thing To Avoid pairs with the Fourth, about water, the element regarded as a source of life and associated with the *Yin.* Mountains and water are not only the main structural elements in a landscape painting, but as symbols of the *Yin* and *Yang* they are structural ideas, hence the significance of the term *shan shui* (mountain-water) for landscape pictures. The First and Second Things To Avoid are concerned with composition. They imply attention to an inner rhythm perceptible through a well-composed painting; this is a concept of rhythm that heightens the tensions of the design, of the far and near, of what pertains to background and foreground and to the higher and lower parts of the picture, and the corresponding tensions in such details as the direction of tree branches and of footpaths; each by analogy is related to the idea of the movement and rhythm of the *Tao* and the eternal complementary action of the *Yin* and *Yang.*

11. The Fifth and Sixth Things are concerned with the natural and logical: landscapes where no human being has wandered naturally have places inaccessible and, in some instances, dangerous; on the other hand, where man has ventured, paths are a sign of his presence and should naturally lead somewhere.

12. At the beginning of the *Book of Trees,* Lu Ch'ai mentions the principle applied to rocks and also to trees: A rock has three faces, referring to the third dimension and technical skill in rendering it and, symbolically, to the One (the rock, mountain, Heaven, *Yang,* or the *Tao,* depending on the angle of interpretation) manifest through the Three, the concept discussed in Vol. 1, Chs. I and II. A tree has four main branches and is represented as having solidity, roundness, and unity; it is also a universal symbol of the One—the Tree of Life, its roots deep in Earth, its crown reaching to Heaven, its branches and leaves extending in all four directions.

The ninth, figures unnaturally distorted.[13]

The tenth, buildings and pavilions inappropriately placed.

The eleventh, atmospheric effects of mist and clearness neglected.[14]

The twelfth, color applied without method.

The Three Classes (*San P'in*) [15]

Hsia Wên-yen said:

Ch'i yün shêng tung (circulation of the *Ch'i* produces the movement of life) is a principle of Heaven. When it is operating through the painter, the effect in his picture is beyond definition, and the painter may be said to belong in the *shên* (divine) class.

When brushwork is of a high order, colors appropriate, and expression clear and harmonious, the painter may be placed in the *miao* (marvelous and profound) class.

When form is realized and the rules have been applied, the painter is of the *nêng* (able and accomplished) class.

Lu Ch'ai adds:

This is a summary of the classifications. However, Chu Ching-chên (*tzŭ* Ching-yüan), of the T'ang period, put above these three classes another, the *i* (impetuous and extraordinary). Huang Hsiu-fu also placed this class ahead of both the *shên* and the *miao*. This order was based on the classification made by Chang Yen-yüan, who said: "If a picture misses *tzŭ jan* (spontaneity and complete naturalness), it falls into the *shên* class. If it misses being in the *miao* class, it ranks among works conscientiously executed."

13. The Ninth and Tenth Things emphasize fitness based on naturalness, contributing to the harmony of the parts and the whole of a painting and, as in the preceding Things, symbolically, to the harmony of Heaven and Earth or the order and pattern of nature that is the *Tao*. Figures not only should be undistorted but should be shown in action, their position and mood in tune with the rest of the painting and thus with the order of nature. Characteristically, figures are usually solitary and contemplative, enjoying the scene around them; their places and attitudes are used to direct attention to and center the focus on the mountain, waterfall, or tree. They are never represented in conflict with nature but always in a mood of reverence or ritual appreciation of nature; man's constructions, whether houses, pavilions, bridges, waterwheels, or boats, never overshadow other elements in the picture but contribute to its main theme, usually some aspect of nature rather than of human activity.

14. Lit., "lack of harmony among waves of clouds and waves of water." See below, p. 218.

15. A traditional classification taken from standards established for calligraphy, which Lu Ch'ai chose to paraphrase from the mid-XIV-century compilation by the critic Hsia Wên-yen, whose work was largely a reiteration of earlier writings on painting. Three prominent versions are mentioned in Lu Ch'ai's comments.

Chang's remarks are certainly odd. When a picture attains the *shên* or *miao* classifications, surely that is the end of the matter, for how can it fail to have *tzŭ jan,* the quality of spontaneity and naturalness? The *i* class should certainly be placed apart from the Three Classes. But how can one discuss the relative merits of the *miao* and *nêng* classes without taking into account ability and conscientious effort? One can get so deeply involved in detail that there is no true criticism, merely flattery. Moreover, painters and pictures would be falsely classified. I, for one, will have none of it!

The division of the schools [16]

The division in Buddhism into Northern and Southern Schools began in the T'ang period. A similar division in painting also took place in the T'ang period. The painters representing these two schools did not, however, come respectively from the north and the south; it was not a geographical classification.

The Northern School was founded by Li Ssŭ-hsün and his son. Their style was followed and carried on by Chao Kan, Chao Po-chü, and (Chao) Po-su in the Sung period, and later by Ma Yüan and Hsia (Kuei) Yen-chih.

The Southern School began with Wang (Wei) Mo-chieh, who used light washes and inaugurated the method of *kou chê* (broken outline).[17] This style was used and carried on by Chang Tsao, Ching Hao, Kuan T'ung, Kuo Chung-shu, Tung Yüan, Chü-jan, and the Mi's, father and son, down to the Four Great Masters of the Yüan period.[18]

16. A classification developed in the XVI century by the critic Tung Ch'i-ch'ang and his followers, presumably based on two different styles of painting: the tight detailed manner filled in with color of the Northern School and the free brushstroke manner in ink of the Southern School. Tung and his followers tended to class painters they favored in the latter group; to add weight to their views they cited the historical division, about 684, of Chinese Zen Buddhism into Northern and Southern Schools. Actually, painters worked in both styles and no rigid division existed. Examples of the styles of various masters mentioned appear later in the Manual.

17. Wang Wei was credited with starting the method of light washes, here described as *hsüan tan* (tranquil or faint washes) and also called *hsüan jan* (lit., wash-dye), with modeling by brushstrokes (*ts'un*) that "breaks up the outline" (*kou chê*), breaking through the flatness and pro-

ducing depth. This may be the explanation of the term *p'o mo,* usually translated "broken ink" and signifying a method, associated with Wang Wei, that retains the outline with wash and *ts'un* modeling, as contrasted to the other *p'o mo* (splash or sling ink) method, which gradually dispensed with outline and is primarily a wash style; the two *p'o mo* methods were sometimes combined, as, for instance, in the effective blob technique (*chi mo,* piled-up ink) of Mi Fei. The wash-and-free-brushwork style was carried to an extraordinary degree of perfection by Mu Ch'i and other Zen painters, being a wonderful vehicle for their ideal of swift, dexterous brushwork capturing the moment of inspiration and Sudden Enlightenment.

18. The Four Yüan Masters: Chao Mêng-fu, Wu Chên, Huang Kung-wang, Wang Mêng. In some lists (e.g., Tung Ch'i-ch'ang), Ni Yün-lin (Ni Tsan) was named instead of Chao. Subsequently, the classification was enlarged to six masters with the addition of Ni and Kao K'o-kung.

The situation in painting was similar to that in Buddhism after the time of the Sixth Patriarch (Hui-nêng, 637–713), when the Ma-chu and Yun-mên (branches of the Southern School of Zen Buddhism flourished and the Northern School declined).

Men of quality [19]

Since ancient times, according to the records, there have been men of renown who were distinguished patrons of the art of painting. No generation has lacked such individuals. One is curious not only about the pictures they collected but also about the men themselves; in fact, their pictures make one wonder what sort of men they were.

During the Han period, there were Chang Hêng and Ts'ai Yung; in the Wei period, Yang Hsiu. At the time of the Three Kingdoms there was Chu-ko Liang; he collected pictures done in the Southern School manner, which brought about such great changes. In the Chin period, there were Chi K'ang, Wang Hsi-chih, and Wang I, all writers, all painters of the *i* (impetuous and extraordinary) class, and all officials. After them came Wang Hsieh-chih and Wên Ch'iao. In the Sung period, there was Yüan Kung, who owned the famous landscape painting entitled *Chiang Huai*. During the Southern Ch'i dynasty, there was Hsieh Hui-lien, and in the Liang period, T'ao Hung-ching, who received the picture *Landscape with Inn and Two Oxen* as a gift from Emperor Wu Chêng. In the T'ang period, there was Lu Hung, who owned the picture *The Grass Hut*, and in the Sung period there were Ssŭ-ma Kuang, Chu Hsi, and Su Shih. That's all!

19. Traditionally great names of officials, scholars, and other eminent men who were also connoisseurs and gentlemen-painters, mentioned here in the same spirit as that in which they are frequently listed in order to invoke their presence. To identify them:

Chang Hêng: II century, official, mathematician, astronomer, writer, and poet; constructed a seismograph.

Ts'ai Yung: II century, official, historian, and musician.

Yang Hsiu: official, painter, and secretary of the famous Ts'ao Ts'ao, hero of the romance *The Three Kingdoms,* who put Yang to death c. 220.

Chu-ko Liang: 181–234, statesman, politician, general, and author of the military treatise *Hsin Shu.*

Chi K'ang: III century, scholar, philosopher, alchemist, poet, and musician.

Wang Hsi-chih: 321–79, scholar, traditionally the foremost calligrapher of China.

Wang I: IV century, figure and animal painter.

Wang Hsien-chih: son of Wang Hsi-chih, also a celebrated calligrapher.

Wên Ch'iao: IV century, general of Chin dynasty.

Yüan Kung: (?) Tung Yu (*tzŭ* Yen-yüan), early XII century, writer and art historian.

Hsieh Hui-lien: (?) Hsieh Ho, of the Southern Ch'i period.

T'ao Hung-ching: 451–536, scholar, physician, and compiler of Taoist works.

Lu Hung: VIII century, scholar and landscape painter.

Ssŭ-ma Kuang: XI century, scholar, eminent official, and famous historian.

Chu Hsi: XII century, scholar, pre-eminent among Neo-Confucianist philosophers and interpreters of Confucian teachings.

Su Shih: *hao* Tung-p'o, XI century, famous scholar, poet, calligrapher, and official; the surpassing example of the gentleman-painter.

Great masters [20]

After T'ang times, there were Ching, Kuan, Tung, and Chü, who all worked during the Sung period, though in different dynasties, and were equally renowned. They were the Four Great Masters of that period. After them came Li T'ang, Liu Sung-nien, Ma Yüan, and Hsia Kuei.

Chao Mêng-fu, Wu Chên, Huang Kung-wang, and Wang Mêng were the Four Great Masters of both the Southern School and the Yüan period.

Kao Yen-ching, Ni Yüan-chen (Yün-lin), and Fang Hu were of the *i* class and also were Great Masters.

In naming these Great Masters, it is not necessary to classify them, although degrees of excellence and differences in style existed; for instance, Li T'ang worked in the manner of (Li) Ssŭ-hsün, (Huang) Kung-wang painted in the manner of Tung Yüan, and (Kao) Yen-ching painted in the Southern Sung one-wash style. (Wu) Chên, of the Yüan period, topped all of the others of his time. The high standard set by these Great Masters is difficult to attain. It is not easy today to name their heirs.

Important changes [21]

In figure (*jên wu*) painting, an important change took place between the period of Ku (K'ai-chih), Lu (Tan-wei), Chan (Tzŭ-ch'ien) and Chêng (Fa-shih) and that of (Chang) Sêng-yu and Tao-yüan (Wu Tao-tzŭ).

20. The great names of Chinese painting since T'ang times were repeatedly mentioned in the records, thereby enlivening the tradition by their presence. The Four Masters named first were usually identified, as here, by only their surnames: they were Ching Hao, Kuan T'ung, Tung Yüan (*hao* Pei-yüan), and Chü-jan. Examples illustrating their styles are given in the Manual. Kao Yen-ching was also known as K'o-kung and Fang-shan, and worked in the style invented by Mi Fei. Fang-hu or Fang Ts'ung-i, according to the records, was a minor painter of the Yüan period and hardly merited being classed with Kao and Ni.

21. Taken from the Ming records, which in turn were based on earlier compilations such as Chang Yen-yüan's *Li Tai Ming Hua Chi*. As far as can be gathered from the records, the change in figure painting between the IV century, when Ku K'ai-chih was active, and the VIII century, in the middle of the T'ang period, when Wu Tao-tzŭ produced his masterpieces of Buddhist figures and other religious subjects, referred to the achievement of greater plasticity in the rendering of figures and objects, evident in modeling and freer brushwork, and, in the case of Wu Tao-tzŭ, to masterly handling of line, called "wavy," which conveyed an extraordinary vitality and movement, ascribed to his free spirit and displayed in his portraits and in his figures of Buddhist, Taoist, and miscellaneous divinities, devils, dragons, and other creatures.

The changes in landscape painting are more difficult to trace after the first important "change" between the Northern School and the style of the other painters named here, some of whom followed Wang Wei and his light-wash style

In landscape painting, an important change took place with the work of the Li's (Li Ssŭ-hsün and his son, Chao-tao). Another change came with Ching (Hao), Kuan (T'ung), Tung (Yüan), and Chü(-jan). Yet another change came with Li Ch'êng and Fan K'uan. Liu (Sung-nien), Li (Kung-lin), Ma (Yüan), and Hsia (Kuei) brought about another change, and Ta-chih (Huang Kung-wang) and Huang-ho (Wang Mêng) yet another.

Lu Ch'ai adds:

Chao (Mêng-fu) Tzŭ-ang belonged in the period of the Yüan dynasty, but his work followed closely the Sung masters. Shên (Chou) Chi-nan lived in the Ming period, but he definitely painted in the Yüan manner. Wang Ch'ia, of the T'ang period, as if he foresaw the coming of Mi Fei and his son, Yu-jên, inaugurated the method of *p'o mo* (splash ink),[22] the broad full strokes without outline, of the Southern Sung style. Wang (Wei) Mo-chieh, anticipating Wang Mêng, discovered the method of *hsüan tan* (light washes).

Some invent and some follow. Whether those who come first fear that those who come after them will not have the capacity to make the changes, and so make the changes themselves; or whether those who come after fear that those who in turn follow them will not be able to preserve the tradition and so fix it themselves, those who made the changes had the audacity and they also had the knowledge.

A general list of the brushstrokes used for modeling (*ts'un*) [23]

He who is learning to paint must first learn to still his heart, thus to clarify his understanding and increase his wisdom. He should then begin to study the basic brushstroke technique of one school.

but many of whom worked in several styles including the Northern. As Lu Ch'ai points out in his comment, Wang Wei foreshadowed Wang Mêng, as indeed he did all the painters listed here except the Li's, whose most characteristic work was in the precise, detailed, and decorative manner of outline filled in with blue and green, with touches of red and white, and occasionally the outline in gold. The changes referred to might be generally described as the gradual rise and eventual pre-eminence of the school of the gentlemen-painters and the scholarly, poetical, impressionist manner that culminated in the work of the Southern Sung painters. An important change, noted by Lu Ch'ai only

in passing, was the Mi Fei style, which, with its layer upon layer of rounded dotting and strokes, represented a greater change in technique than anything else mentioned.

22. This method described varying degrees of free brushwork, an extreme being reached by Wang Hsia, who was said to have dipped his fingers and hair into the ink and applied them as well as a brush. (See above, p. 23, n. 17, on the two *p'o mo* methods.)

23. Established forms of *ts'un* (brushstrokes for modeling, often translated "wrinkles") are demonstrated later among the pages of examples.

He should be sure that he is learning what he set out to learn, and that heart and hand are in accord. After this, he may try miscellaneous brushstrokes of other schools and use them as he pleases. He will then be at the stage when he himself may set up the matrix in the furnace and, as it were, cast in all kinds of brushstrokes, of whatever schools and in whatever proportion he chooses. He himself may become a master and the founder of a school. At this later stage, it is good to forget the classifications and to create one's own combinations of brushstrokes. At the beginning, however, the various brushstrokes should not be mixed.

Here, briefly, is a general list of brushstrokes used for modeling:

P'i ma ts'un: brushstrokes like spread-out hemp fibers

Luan ma ts'un: brushstrokes like entangled hemp fibers

Chih ma ts'un: brushstrokes like sesame seeds

Ta fu p'i ts'un: brushstrokes like big ax cuts

Hsiao fu p'i ts'un: brushstrokes like small ax cuts

Yün t'ou ts'un: brushstrokes like cloud heads or thunderheads

Yü tien ts'un: brushstrokes like raindrops

T'an wo ts'un: brushstrokes like an eddy or whirlpool

Ho yeh ts'un: brushstrokes like the veins of a lotus leaf

Fan t'ou ts'un: brushstrokes like lumps of alum

K'u lou ts'un: brushstrokes like skull bones

Kuei p'i ts'un: brushstrokes like the wrinkles on a devil's face

Chieh so ts'un: brushstrokes like raveled rope

Luan ch'ai ts'un: brushstrokes like brushwood

Niu mao ts'un: brushstrokes like hair of cattle

Ma ya ts'un: brushstrokes like horses' teeth

There also are combinations: *p'i ma ts'un* (spread-out-hemp-fiber strokes) with *yü tien* (dotting strokes like raindrops), and *ho yeh* (veins-of-lotus-leaf strokes) with *fu p'i* (ax-cut strokes).

As to which brushstroke styles were invented by which painter, or which painter took them from another, I have noted this information in the books (*Trees* and *Rocks*) on landscape painting.

Explanation of terms

Applying the brush with light ink, around and around, stroke over stroke, is called *wua* (revolving); using the tip of the brush obliquely is called *ts'un* (brushstrokes for modeling or "wrinkles").

(Applying) three or four light ink washes is termed *hsüan* (wash). An ink wash soaking the whole painting is called *hua* (cleansing).

Holding the brush upright for horizontal or vertical strokes is called *tsu* (grasping); holding the brush upright and using the pointed tip is called *cho* (pulling up).

Applying the tip of the brush is called *tien* (dotting). This is used in painting *jên-wu* (figures and objects), and also for mosses and leaves. Outlining with the brush is called *hua* (drawing or outlining). This term, for instance, is used for the drawing of buildings and towers, also for the drawing of pine and fir needles.

Applying light washes on the natural color of the silk of a picture, to indicate mists without traces of brushstrokes, is called *jan* (painting or applying a wash). Traces of the brush showing in the painting of clouds or rippling water is called *tzŭ* (saturating). In painting waterfalls, drawing on the natural color of the silk with dry brush and light ink is called *fên* (dividing or distinguishing).

Using light ink to indicate crevices and hollows on mountains and fissures of tree trunks in order to render their character and essence (*ch'i*) is called *ch'ên* (lining or reinforcing).

The *Shuo Wên* said that to paint or to draw (*hua*) is to indicate a boundary or to outline forms in the same manner as a fence around a field marks its boundaries. The *Shih Ming* said that paintings may also hang; and, by means of colors, forms and images may therefore be hung.[24]

Technically, pointed mountains are called *fêng* (sharp peaks), flat are called *ting* (topped), round are called *luan* (rounded). A row of mountains connected one with another is called *ling*

24. A condensation of a similar passage included in many of the compilations; Chang Yen-yüan, writing in the T'ang era on the origin of painting, quoted definitions from early dictionaries as follows: "*Kuang Ya* (of the Wei period) says: 'Painting is to produce likeness.' *Êrh Ya* (of the Chou period) says: 'Painting is to represent forms.' *Shuo Wên* (of the Han period) says: 'Painting is to draw boundaries . . .' *Shih Ming* (of the Han period) says: 'Painting is to represent objects by laying on colors.'" (*Li Tai Ming Hua Chi*, Sec. I, Ch. I, "Origin and Development of Painting," tr. in Sirén, *Chinese on the Art of Painting*, Appendix III.)

(range). When there are caves, one speaks of *hsiu* (caverns). A steep mountainside is called *yai* (precipice); such inclines are also called *yen* (cliff).

Passes among mountains are called *ku* (gorges). Passes between mountains are called *yü* (valleys). If in the valleys or ravines there is water, it is called *ch'i* (creek). When the water presses through between two mountains, it is called *chien* (torrent). A pool near the base of a mountain is called *lai* (shallows). A leveling of the terrain on a mountainside is called *fan* (slope), a rugged rock emerging from water is called a *chi* (ledge). A mountain or hill surrounded by water is called a *tao* (island).

Such are the terms most frequently used in discussing landscape painting.

Use of the brush

The ancients used the expression *yu pi yu mo* (to have brush, to have ink). Many people do not grasp the significance of the meaning of the two terms *pi* (brush) and *mo* (ink). How can there be painting without brush and without ink?

To know how to outline peaks of a mountain range but not know the strokes for modeling (*ts'un*) is described as *wu pi* (not having brush). To know the strokes but not know how to handle ink tones or indicate the nuances distinguishing near from far, clouds from reflections, light from shadow, is *wu mo* (not having ink).

Wang Ssŭ-shan (of the Yüan period) said: "He who has command of his brush should not allow the brush to control him."

The rule which states that a rock has three faces is concerned with the skill of rendering the rock, a matter involving both brush and ink.

In general, the following brushes are used in painting:

Hsieh chao pi: crab-claw brush, large and small sizes

Hua jan pi: brush for painting flowers

Lan yü chu pi: brush for painting orchids and bamboo

Brushes used for writing:

T'u hao pi: rabbit's hair brush

Hu ying pi: Hunan sheep's hair brush

Yang hao pi: sheep's hair brush

Hsüeh ngo pi: snow-goose brush, made of sheep's hair

Liu t'iao pi: willow-twig brush, made of sheep's hair

Some painters depend on the point of the brush, others on its fullness and flatness. It is a matter of habit. Each has his preference; everyone does not have to hold a brush the same way.

Lu Ch'ai adds:

(Ni) Yün-lin followed the style of Kuan T'ung. He did not, however, use his brush only in the manner called *chêng fêng* (upright and pointed); if anything, his style was even more elegant and rich. Kuan T'ung's handling of the brush was certainly *chêng fêng.*[25]

Li (Kung-lin) Po-shih's calligraphy was superb. Shan Ku (Huang T'ing-chien) said of him that his writing was the key to his painting. It is thus that writing reveals itself in painting.

Ch'ien Shu-pao daily visited Wên T'ai-shih to watch him holding his brush and writing; his own manner of painting benefited greatly.

Hsia (Chung-chao) Ch'ang was a good friend of Ch'ên Ssǔ-ch'u and Wang (Fu) Mêng-tuan. When they met to practice calligraphy, they studied the *ts'ao* (grass) style. From this, (Hsia) perfected his painting of bamboo. Literary and intellectual training greatly aid the use and control of the brush, adding to its power.

Duke Ou-yang (Hsiu) Wên-chung used a pointed brush and dry ink. He wrote characters square and open, elegant and strong. Looking at his painting was like looking at his clear bright eyes and full cheeks. Each stroke had poise.

Hsü (Wei) Wên-ch'ang, after he had drunk deeply, took an old worn-out brush and painted a beautiful woman leaning against a *t'ung* tree. Then with his brush he tinted her cheeks, and the result was wonderful. In contrast, real rouge and powder seemed dirty! The result was due to the fact that his brush was miraculous. When one can use a brush to such a degree of excellence, it might be said that one held a palmful of pearls and that the spirit had soared beyond this world. There is no difference in the brushwork of calligraphy and painting; both use the same approach.

25. Brush held and used in vertical position, mostly for outlining though also for some modeling and dotting; opposite of *pien fêng,* use of the brush held slanting for strokes and dotting.

The poets of the Southern Chou period called the various styles of writing by the names of the brushes.

Shên Yu's biography stated: "Hsieh Yüan-hui excelled at composing poems, and Jên Yen-shêng excelled at painting."

Sou Chien-wu said: "When poetry reaches the heights, the brush soars with it."

Tu Mu-chih said: "Oh, the poetry of Tu (Fu) and the writing of Han (Yü)! Looking at them when one is sad is like asking Ma Ku [26] to scratch your back!"

All this discussion is about the brush. It is used to write characters, to write poems, to write essays. One must scratch the ancients, then scratch oneself. If with this brush one composes poems and essays, and writes characters, and people look at the result and feel no ache, no itch, nothing at all, one might as well break one's arm. What use is it?

Use of ink

Li Ch'êng used ink sparingly, as if it were gold. Wang Hsia splashed it liberally in the manner called *p'o mo* (splash ink). Those who study painting should keep in mind the four words *hsi mo p'o mo* (spare ink, splash ink). If they do, they will be well on the way to understanding the Six Canons and the Three Classes.

Lu Ch'ai adds:

In general, old ink is good only for painting on old paper and for copying old paintings, for when the gloss has gone the life is ended. Liu Pu and Wei Yeh are both good examples of those who used old ink and old paper. On new silk, gold-leaf paper, or fans, old ink is not as good as new ink, which has brilliance and life. Not that old ink is no good: it simply does not go well with new paper or new silk. New paper and new silk will not easily absorb old ink. The combination is like putting the robes of the ancients on the newly promoted and the newly rich. Or it is like covering a gourd and trying to smell its contents: how could one possibly smell it? That is why I say: Reserve old ink for painting on old paper, new ink for new paper or gold-leaf paper. Above all, paint with confidence and ease, and do not spare the ink.

26. A female Immortal of Taoist legends. The scratching mentioned here and in the next paragraph was descriptive of pleasure, heightened moreover by the idea of its being done by a sorceress.

Brushwork and color washes (*hsüan jan*)

In drawing rocks, begin with light ink, so that corrections can easily be made; step by step, more ink can be applied.

Tung Yüan drew many small rocks at the foot of slopes, gradually building up the structure of a lofty mountain. He began by indicating the outline and *ts'un* (brushstrokes for modeling); then, with light ink, he drew in the crevices and hollows. At that stage, color may be used; it should be applied dark and deep in painting rocks. Tung Yüan's brushstrokes in drawing small mountains and rocks were the kind called *fan t'ou ts'un* (brushstrokes like lumps of alum).

Where clouds and mists gather among mountains, washes should be soft and light. Where the ground is sandy, a light ink should be used in sweeping brushstrokes, and breaks in the ground and rocks should be indicated in the manner called *p'o mo* (broken ink).

In painting mountains in summer, just before rain, the brush should be soaking wet and applied freely in a light wash. In modeling the mountains and rocks, use a touch of *lo ch'ing* (snail green) in *fan t'ou* brushstrokes; additional accenting with the same color will bring out an effect of moisture, and the picture will exude freshness. In painting rocks, either snail green or rattan yellow (*t'êng huang*) mixed with ink will also add a deliciously fresh quality.

In painting winter scenes, use the ground of the paper or silk as part of the snow and add light touches of white at the summit of the mountains. Then, with heavier touches of white, dot in moss (*tien t'ai*).

In painting trees, do not use dark or heavy ink. Draw the tree trunks, boughs, and branches without foliage, and the result will be a forest in winter. A light ink wash over the trees will create forests of spring.

In painting mountains, use both light and dark tones. Shadows of clouds will pass over the mountains: where there are shadows there are dark tones, where there are no shadows there will be light and color and brightness. The ink tones should accurately render these differences, and the picture will then express beautifully the rhythm and harmony of clouds and brightness, sun and shadows.

Snow scenes are very often done in a banal manner. But I have seen a snow scene by Li

(Ch'êng) Ying-ch'iu in which peaks, forests, and houses were all drawn with light ink and the surface of the silk was used plain for the water, sky, and empty spaces, with only touches of white, and it was an extraordinary picture.

In beginning a picture of distant mountains, it is advisable to use a stick of charcoal to place them and establish their forms; then, using green mixed with ink, stroke by stroke, pick out the mountains. The first wash for the mountains should be laid with light ink, the next darker, the third even darker. For the most distant mountains, wrapped in dense clouds, the color is further deepened (i.e., with more ink than color).

In drawing the beams and structure of bridges and houses, draw in lightly with ink and then strengthen the outline. With color or ink, if it is not applied moist and in repeated washes, the tones will be too light and thin.

Wang (Mêng) Shu-ming used little color in his paintings, only umber (*chê shih*) lightly in a wash on pine trunks and in outlining some angles of rocks; the effect was wonderful.

Placing the sky and earth

When planning a picture, first, before picking up the brush, estimate the proportions of sky and earth. What is meant by the sky and the earth? The top half of a panel of one *chih* (eight inches) and a half is the space for the sky, the lower is for the earth. In the middle space, the scenery of the landscape is organized.

I have seen beginners clutch a brush and scribble over the whole panel. To watch such a procedure hurts the eyes. Immediately one feels that the whole meaning (*i*) is blocked. How can work done in this manner be taken seriously?

Lu Ch'ai adds:

Hsü (Wei) Wên-ch'ang, in his discussion of landscape painting, admired scenes of lofty mountains, deep precipices, great waterfalls, huge rocks, and old pines, peopled by hermits or other colorful figures. He liked paintings in which ink had been used freely yet with control, in which mists and vapor filled the picture so that their "emptiness" pervaded the whole sky and their occupying the space that was earth made the earth a void. These words may seem contradic-

tory, but Wên-ch'ang was a free soul. All the elements in his compositions served to emphasize the emptiness; that is, the works were filled with the spirit. As his words, one after the other, expressed his thoughts, so from the space between and behind them their meaning emerged.

Guarding against evil influences [27]

Chêng Tien-hsien, Chang Fu-yang, Chung Ch'in-li, Chiang San-sung, Chang P'ing-shan, Wang Hai-yün, and Wu Hsiao-hsien all spoke of the paintings of T'u Ch'ih-shui and said they contained evil influences. One must never let the influence of evil demons gain control of the brush point.

Avoiding the banal

In painting, it is better to be inexperienced (young in *ch'i*) than stupid. It is better to be audacious than commonplace. If the brush is hesitant, it cannot be lively; if commonplace, it most likely will produce only banalities. If one aims to avoid the banal, there is no other way but to study more assiduously both books and scrolls and so to encourage the spirit (*ch'i*) to rise, for when the vulgar and the commonplace dominate, the *ch'i* subsides. The beginner should be hopeful and careful to encourage the *ch'i* to rise.

*

Notes on the Preparation of Colors (and Other Materials of Painting)

Approach to color

Lu Ch'ai says:

 The sky has tinted clouds, glistening like brocade; that is the key to the color of the sky. The earth brings forth grass and trees, all contributing ornamental touches; that is the key to the color of the earth. People have eyes and eyebrows, lips and teeth, clearly defined accents of black, red,

27. The names and the works were no doubt familiar to Lu Ch'ai's contemporaries but, unfortunately, are lost to a reader of today.

and white on specific parts of the face; that is the key to the color of human beings. The phoenix spreads its tail, the cock rears his crest, the tiger and leopard proudly display their stripes, and the pheasant preens its beautiful form; such is the key to the color of these creatures.

Ssŭ-ma Tzŭ-ch'ang, quoting from the *Shang Shu,* the *Tso Chuan,* and the *Kuo Ts'ê,* took "color" from these ancient repositories and completed his own *Historical Records (Shih Chi).*[28] This might be described as the "color" of scholars.

Official Chang I[29] was a great talker and enjoyed argument; he was capable of declaring black white and white black. Itinerant and braggart, he had a mouth that encompassed oceans and seas, and his tongue wagged as he boasted of seeing the curved roofs of mythical cities. Everything he wished people to believe he exaggerated. This might be called the "color" of windbags.

Finally, it should concern those who seek "color" in writing and speaking that words and sentences have not only form but also sound.

Ah! Considering the vastness of the heavens and the earth, looking around at people and things, reading polished essays, listening to brave utterances, all these go together and make a whole and colorful world. How can color be said to apply only to painting? Even those who live good and pure lives are part of this world; they are like the landscapes in light ink by Ni Yün-lin at which the ignorant laugh and poke fun.[30] Today so many people live in limited and colorless worlds. How may they be offered a fuller life and contentment? Pictures are one means, so let us speak of painting.

After grinding red to powder and softening white, one may produce fine figure paintings; using light green and light yellow, one may create beautiful landscapes. In them, clouds like bands of white silk, sky rose-tinted, peaks dotted blue and green, trees mantled in bright green, red flowers clustered at the mouths of valleys, convey the fact that it is late spring. When yellow

28. Ssŭ-ma Ch'ien, *tzŭ* Tzŭ-ch'ang (*c.* 145–86 B.C.), son of the Grand Annalist, Ssŭ-ma T'an, whom he succeeded and with whom he wrote the great *Shih Chi.* The *Shang Shu* was the *Shu Ching* (Book of History), the *Tso Chuan* a collection of commentaries on events in the State of Lu contained in the *Ch'un Ch'iu* (Spring and Autumn Annals) from 722–484 B.C., and the *Kuo Ts'ê* (Records of the Kingdoms) probably referred to the *Kuo Yü* (Discourses of the Kingdoms), accounts of events in other states besides Lu, complementary to the *Tso Chuan.*

29. Died *c.* 310 B.C. A follower of Wang Hsü who ad-

vocated brazen opportunism in politics.

30. Ascetics and such people might seem to the ignorant to lead colorless lives, as those who do not know about painting cannot appreciate the "color" in ink tones and brushstrokes of Ni's pictures. Ni was much respected for "purity" in his work and in his character; for instance, Wang Yüan-chi, of the Ch'ing period, wrote of him that he was not "stained by a grain of dust" and was most congenial in his ease and quietness, refined and dignified, and that these qualities of character enabled him in his paintings to transcend all rules and common methods.

leaves drop in front of the cart, one knows that it is late autumn. In one's heart one must be thoroughly acquainted with the *ch'i* of the four seasons [31]—and not only in the heart, for that knowledge must flow to the finger tips to guide the creation of the work. How the Five Colors can brighten men's eyes!

It is said that Wang Wei painted most of his landscapes in the blue-and-green style.[32] Li Kung-lin [33] painted figures and objects in ink monochrome. In the beginning, there were no variations in light and dark tones of colors. Tung Yüan was said to have been the first to handle color in that way, and the method was perfected by Huang Kung-wang. It is said that the figures in their pictures were dressed in the costumes of Wu.[34] This kind of painting was carried on by Wên (Pi) and Shên (Chou) and was much admired.

Huang Kung-wang used brushstrokes for modeling (*ts'un*) in painting the picture *The Rocky Face of the Yü Mountains;* for color he used umber (*chê shih*) very skillfully, applying it lightly; in some places he used it in outlining and organizing the composition.

Wang Mêng often used umber mixed with rattan yellow (*t'êng huang*) in his landscapes, lightly dotting in grass on mountaintops. He used umber for accenting. Sometimes he used no color at all, except to touch up faces with umber or to model the bark of pine or fir with strokes of it.

31. Not only literally the atmosphere and aspects of the four seasons but also both their *ch'i* (spirit, essence) and their *li* (principle), implying numerous analogies concerned with the rhythm and cycle of the seasons as part of the eternal mutations of the *Tao* and, microcosmically, of the life of each thing in nature, man being only one among many. Also implied is the theory of the Five Elements, which is applied to the seasons. (See Vol. 1, Ch. III.)

32. This may be somewhat confusing, since Wang Wei's name was most often associated with the wash style, whereas the blue-and-green method was that of Li Ssŭ-hsün and the Northern School. Many of the copies of Wang Wei's works used color, and they may have led to such statements as Lu Ch'ai's. While Wang Wei used color occasionally, it may be assumed from the many testimonials of those who saw his pictures, from statements in the records, from the essays attributed to him in which ink was given first place in painting, and from the evidence of his deeply religious character, that the ink wash with its subtleties of tone and free brushwork was for him the most congenial means of expression. He was, moreover, known to have loved snow scenes, which are most effective with minimum of color, or in ink monochrome, and he was famed for such pictures. Although the essays are believed to be products of a later period, they are worth reading for their connection with Wang Wei and their information about his attitudes and methods, which influenced painters after him; tr. in Sirén, *History of Early Chinese Painting,* I, pp. 88–91, and Sakanishi, *The Spirit of the Brush,* pp. 69–75.

33. Equally well known by his other names, *tzǔ* Li Po-shih, *hao* Li Lung-mien; XI century, scholar, archaeologist, calligrapher, and painter; a good example of a characteristic type of Chinese painter in that he devoted himself to study of the T'ang and pre-T'ang masters and particularly their works of religious subjects, most of his pictures being copies and paintings done in the style of these painters. Lu Ch'ai's reference alludes perhaps to his use of the *pai miao* (outlining without color) method in rendering some pictures in which color was used, although he also worked in the wash style and in color. Li was noted for his wide knowledge and variety of styles of painting, and it was said of him that he learned the good points of his predecessors, blended them in his own works, and "rose above the common level." (See below, p. 179.)

34. "Costumes of Wu" might be either those of the Wu period (III century) or those worn by the people in the area known as Wu (Kiangsu).

Mineral blue (*shih ch'ing*) [35]

In figure painting, this color may be used quite thick and dark; in landscape, it should be used light and clear. The best kind of mineral blue is called *mei hua p'ien* (plum petal), because its shape resembles a petal of the plum blossom.

Take the mineral blue and put it in a bowl; [36] add a little water, drop by drop, and crush it into a fine mixture. Do not grind too hard or there will be too much powder (*ch'ing fên*); therefore make as little of it as possible. Immediately after grinding, pour the mixture into a porcelain bowl; add a little more clear water and stir. Let this stand a while and powder of a very light blue tone will rise to the surface. Skim off this top layer. This blue is called *yu tzŭ* (oily residue) and is used for painting garments in pictures. The layer of color underneath, the middle layer in the bowl, is a good blue for painting blue-and-green landscapes (*ch'ing lu shan shui*). The layer of color at the bottom of the bowl is of a very dark tone. Use it for dotting between leaves and on the back of paintings.

There are these three shades of mineral blue: first blue (*t'ou ch'ing*), second blue (*êrh ch'ing*), and third blue (*san ch'ing*). [37]

Generally, both mineral blue and mineral green are used for painting on the face of the picture; however, sometimes they are also used on the back, giving the painting a wonderful richness.

There is one kind of mineral blue that is difficult to grind. If a little earwax is flicked into the bowl, the color can then quite easily be ground to the consistency of mud. This trick can also be used with ink that has grains in it. The secret was revealed in the *Yen Hsi Yu Shih* (Writings on Secret Matters Collected at a Mountain Retreat). [38]

35. Azurite. See Uyemura, "Studies on the Ancient Pigments in Japan," *Eastern Art*, III, p. 48, and examples of colors.

36. *Ju po*, a priest's earthenware alms bowl, small and shallow.

37. Approximately Peking, Watteau, and Beryl blues, according to examples in Maerz and Paul, *A Dictionary of Color* (2nd edn., 1950).

38. A compilation of stories and essays on painting and literature and philosophical notes, published in the late Ming period and attributed to Ch'ên Chi-ju (see Hummel, *Eminent Chinese of the Ch'ing Period*, I, p. 83). As to Lu Ch'ai's tip, it is interesting that the *New York Times*, Sept. 17, 1953, gave an account of a paper read at the annual congress of the International College of Surgeons on "the first scientific investigations on the nature and purpose of earwax," describing three years of extensive effort to determine the chemical constituency of cerumen (earwax).

Mineral green (*shih lu*) [39]

To prepare mineral green, proceed as with mineral blue. This green is, however, very hard, and may need first to be broken up with a hammer. Then it can be put into a bowl and ground very fine.

There is a kind called *hsia mo pei* (toad's back), and it is the best. It should be ground and dissolved in water.

Mineral green also has three shades: first green (*t'ou lu*), second green (*êrh lu*), and third green (*san lu*). All three are used in the same ways as the three blues.

Glue should be mixed with both the blue and the green, though not until just before the colors are to be used. Begin by putting some clear glue and water in a clean saucer or bowl. Add a little water and put over a low fire; slowly it will dissolve. Let it boil a little while, and then skim the glue from the surface. No glue should be left in the blue or the green, because it would ruin the colors. To skim off the glue, use a little boiling water with the glue and color. Place the saucer itself in some boiling water, which must be shallow so as not to overflow into the saucer. Let the water boil a little while. The glue will rise to the rim. In skimming off the top layer of water, the glue also will be removed. This is the way to remove the glue.

When glue has not been completely removed, the blue and green will lack brilliance. When the colors are to be used again, fresh glue should be added in the manner described.

Vermilion (*chu sha*) [40]

The best vermilion is the kind called *chien t'ou* (arrowhead), the next best are the kinds called *fu yung k'uai* (hibiscus section) and *p'i sha* (cinnabar grains).

39. Prepared from malachite. The three shades are approximately emerald, serpentine, and a pale Chantilly green. Chang Yen-yüan, of the T'ang period, wrote that in old paintings first blue and first green were not used.
40. In ancient times, the terms *tan sha* (cinnabar) and *chu sha* (vermilion) were both used for vermilion. Both were mercuric sulphide, the former from the natural ore cinnabar either directly or by a simple refining process, and the latter generally by the direct combination of mercury and sulphur. (Li, *The Chemical Arts of Old China*, p. 53.) *Chu sha* was mentioned as a medicine in the *Pên Ts'ao* (Materia Medica) and was named in alchemical works as a principal ingredient of the elixir. *Chin tan* (elixir), *tan sha*, and *chu sha* were, in fact, all mercuric sulphide under different names.

To prepare vermilion: Put a little in a bowl and grind it to fine powder. Mix in a little clear glue. Add a little boiling water and pour into another bowl. Stir. In a little while skim off the top layer, which will be an orange color called *chu piao* (red banner), used in the painting of men's garments. The layer of color underneath is very fine and is the best vermilion. Skim this off and put it aside for the painting of red leaves, terraces, pagodas, and temples. The bottom layer is very deep vermilion. It is used in figure painting but never in landscape.

Deep vermilion (*yin chu*) [41]

If you do not have any *chu sha* vermilion, a good substitute is *yin chu*. Use the kind called *piao chu* or *chu piao* (red banner), which has a touch of yellow in it. It should be dissolved in water before use. This color should never be used in painting the lotus. Painters today add a little white to this vermilion, but one should not do this.

Coral red (*san hu mo*) [42]

In T'ang paintings, a kind of red was used that has lasted without fading. The color is as bright today as when it was applied. It is called coral red. It was used at the Hsüan Ho Palace for the imperial seals. Although it is a color that is seldom used, one should know about it.

Cock yellow (*hsiung huang*) [43]

The best kind of this yellow is that called *chi kuan huang* (coxcomb yellow). It is prepared in the same way as *chu sha* vermilion. It is used in painting yellow leaves and people's clothing. It should

41. The first and lighter layer of vermilion, derived from cinnabar, is called *chu piao,* the red like Satsuma orange; the heavier and lower layer, *chu sha. Yin chu* (deep vermilion) is the equivalent of Goya red or currant (Maerz and Paul, *Dictionary,* Pl. 3, L. 10).

42. The remark about seals suggests that coral red may have been *yin sê* (stamp ink), which was prepared by mixing vermilion with oil—sesame, castor, rapeseed, or tea-seed. According to Li (*Chemical Arts,* pp. 137–40), when the mixture was for seals, it was used to soak a pad of leaves of the *Artemisia moxa,* which was then pounded to a spongy consistency. Coral powder, crushed pearl, gold leaf, and mica were added to produce the best grade, also drugs, nutmeg, ginger, or cinnamon.

43. An orange, perhaps the "masculine yellow" of the alchemical works, derived from orpiment (arsenic sulphide), which was also taken for health and longevity. According to Li (*Chemical Arts,* p. 26), the *Pao Pʻu Tzŭ* prescribed for longevity orpiment "as red as a cock's comb, shining and containing no impurities," pounded into powder, mixed with the gall bladder of a cow, and roasted as dry as earth.

39

never be used on gold-leaf paper. If used on gold-leaf, the paper will in a few months look burned and the color vile.

Mineral yellow (*shih huang*) [44]

This color is not often used in landscape painting, although the ancients occasionally used a little of it. The *Ni Ku Lu* [45] states: "To prepare mineral yellow, put a little water in a bowl and cover with a piece of old matting. Place the bowl on a charcoal fire until the water simmers. Wait until the yellow is as red as the fire, then take it out and place it covered on the ground. When it has cooled, it is ready for grinding and preparing for use."

Mineral yellow is used in painting the bark of pine trees and in tinting autumn leaves.

Liquid gold (*ju chin*) [46]

First, put a little glue and water in a saucer. Then take the gold-leaf between thumb and index finger. Cut your fingernails before doing this. Dip the gold in the glue, speck by speck, using the index finger to stir the mixture smooth and until the gold begins to dry. Transfer it to another saucer. Add a little clear water, drop by drop, and gently stir. When the gold begins to dry, add more water drop by drop. Repeat this procedure several times until the gold has been ground extremely fine. Do not use too much glue or the gold will rise to the surface, and then it is not possible to reduce it to extreme fineness. Tap it gently while it is still wet, and if it is sticky, wait a bit. Wash your finger and the saucer. Put the mixture in another saucer and place on a low fire. In a little while the gold will sink. Pour off the black water that covers the gold at the bottom. Dry the gold in the saucer in the sun.

Just before using the gold, add a little clear glue and water and stir well. Do not put in too much glue, or the gold will turn black. Another method is to use the pulp of the *fei tsao hê* (soap

44. Sunflower yellow, from orpiment, in ancient times often classed as gold. A source of this pigment might have been the *shih chung huang tzǔ* (egg-yellow stone). Chikashige (*Alchemy and Other Chemical Achievements of the Ancient Orient,* p. 32) describes this as a kind of rock found in the mountains and near water, oozing a thick yellow liquid that was drunk by Taoist alchemists.

45. "Notes on Ancient (Household) Arts for Maidservants"; attributed to Ch'ên Chi-ju, of the late Ming period, published in the same series as the *Yen Hsi Yu Shih* (see p. 37).

46. Lit., "milk gold."

bean).[47] Take out the white pulp from the pod and boil it to make glue. This glue is lighter and clearer than ordinary glue.

Preparing white (*fu fên*)

The ancients used white made by pulverizing oyster or clam shells. Their method was to heat the shells over a fire and then grind them into fine powder, which, mixed with water, was used as white paint.

Nowadays, in the four prefectures of Min (Fukien), this white powder from crushed shells is still used as a substitute for lime in whitewash. The ideas of the ancients still have meaning.

Painters today use lead white (*ch'ien fên*).[48] Preparation of this kind of white begins with rubbing the lead powder with the finger, dipping it into clear glue in a saucer, and continuing to rub until the white is dry. It must then again be dipped in glue, and the process repeated ten times. When the glue and powder have been thoroughly blended, it is then pinched into a flat cake, which is put aside in a saucer to dry in the sun. Just before using this white, it should be boiled in water and a few drops of glue added. Skim off and use the top layer; the lower layer is of no use. The powder should be ground with the finger, because lead dissolves easily at the human touch.

Preparing red (*t'iao chih*)

There is a saying that rattan yellow (*t'êng huang*) should never touch the mouth. Neither should you touch rouge red (*yen chih*),[49] for it can stain indelibly; in fact, if you do not use vinegar to remove the stain, it will not come off at all.

The kind of this red to use for painting is Fukien red. Take a little of it and soak in boiling water. Use two brushholders the way dyers use their two sticks to dip and wring the cloth. Any fine grains should be strained off. Place the red in lukewarm water and bring to a boil; boil until the water is absorbed; it is then ready for use.

47. Or *tsao chüeh* (*Gleditschia sinensis*), a long, thin string bean used in soapmaking.
48. Also called *hu fên*. Chang Yen-yüan mentioned "the wonderful white lead from Shu (Ssŭchuan)."
49. A red derived from several kinds of flowers, plants, and berries, among them the *hung hua* (safflower), yielding a brilliant pink red, carthamin, used as a drug as well as a color in dyeing and in painting; the flowers and berries of the *kêng hua* (*Sophora japonica*); and the flowers and leaves of the vine *yen chih hua* (*Mirabilis jalapa*).

Rattan yellow (*t'êng huang*) [50]

In explanatory notes on the *Pên Ts'ao,*[51] Kuo I-kung records that on the mountains of the State of Ngo (Hupeh), people used to gather the pollen of the *hai t'êng* vine that dropped on the rocks. They called it *sha huang* (sand yellow). When it was picked from the plant, it was called *la huang* (wax yellow). Nowadays we confuse these colors with *t'ung miao* (copper) and *shê shih* (snake-venom yellow); this is incorrect.

Chou Ta-kuan stated in the *La Chi* (Records of the Winter Sacrifice) that yellow was from the sap of trees and that there was a custom among foreigners of cutting into a tree so that the sap ran out and was gathered the following year. This statement differs from that of Kuo, who was also writing about grasses, trees, flowers, and their juices.

Although this yellow is not literally the venom of snakes, its taste is sour and it is poisonous. If it touches the teeth, they will drop out. If one licks it, the tongue will become numb. Therefore be careful not to let it touch the mouth.

The kind of rattan yellow to use is that which is the same tint as a brushholder, for which reason it is called *pi kuan huang* (brush-tube yellow). It is the best.

The ancients used rattan yellow mixed with a little ink in painting trees. A little of it in the painting of small branches adds a touch of freshness.

Indigo (*tien hua*) [52]

The kind from Fukien is the best. Today many people say that the kind from the district of T'ang (in Shantung) is also good; it has not, however, rotted in the earth, and so contains less lime and is completely different from the blues of other regions.

In selecting indigo, choose the quality that is very light in weight and in which red specks ap-

50. A gamboge from the *t'êng* (rattan) vine.
51. The first four characters, *Pên Ts'ao Shih Ming,* may refer to explanatory notes on the *Pên Ts'ao* or to two works: the *Pên Ts'ao Ching* (Materia Medica), published at the end of the Han period and revised and enlarged in the Ming period under the title *Pên Ts'ao Kang Mu,* a work still consulted by old-style Chinese doctors; and the *Shih Ming,* an encyclopedia of the Han period.
52. The instructions deal with indigo already prepared in the form of cakes of color. The process of extracting the indigo from the plant is complicated. Various species of plants yield the color of this oldest and most extensively used dyestuff—*Isatis tinctoria, Polygonum tinctorium,* etc. The stems and leaves of the plant are put in a vat or jar, covered with water, and compressed; in the fermentation that occurs, a greenish-yellow liquid is separated, and lime is added. The mixture is well stirred for several hours, in the course of which the soluble, colorless indigo white is aerated and oxidized. The insoluble blue indigo is precipitated, and, after settling, the liquid is drained off. The color is then washed, filtered, and finally pressed into cakes. (Li, *Chemical Arts,* p. 141.)

pear in the blue. It should be sifted through a piece of fine silk to separate the bits of grass from it. Then with a teaspoon add water drop by drop. Pour into a bowl, and with a mallet crush the mixture smooth. When the mixture is dry again, add more water. Then grind again. Ordinarily the refining of four ounces of indigo is a whole day's work, in order to bring out the full brilliance of the color.

Before adding glue and water, wash a pestle and bowl. Put the contents into a large bowl. Drain off the top layer and put it aside. The color at the bottom of the bowl will be dull and black; this should be thrown out. Take the part that was skimmed off the top and put it in the hot sun. Drying it in one day's sun is exactly right; if it is allowed to stay till the next day, the glue will be too old. Generally, one may prepare colors in any of the four seasons, but with indigo it is better to wait for the hottest time of the summer (san fu).

In painting, indigo is used a great deal, for it is a beautiful color.

Grass or vegetation green (ts'ao lu)

Six parts of indigo mixed with four parts of rattan yellow produce old green (lao lu). Three parts of indigo with seven parts of rattan yellow produce young or fresh green (nun lu).

Umber (chê shih) [53]

Choose an umber that is hard and of a beautiful hue. These are the two points to keep in mind in picking the best. There are kinds that are hard as iron, others as soft as mud; they are not all desirable.

Use a small earthen bowl in which to grind the color, with a little water, to the consistency of mud. Then add a lot of clear glue and water and stir well. Skim off the upper layer for use. Drain off the bottom layer, which is coarse and dull in color, and throw it out.

Yellow ocher (chê huang)

Use rattan yellow mixed with umber for the painting of the greenish yellow leaves of autumn trees. These are, of course, different from the fresh leaves of spring, which are light yellow. This color should also be used on mountain slopes and for paths through the grass in autumn landscapes.

53. From limonite, a kind of iron oxide. See Uyemura, "Studies on the Ancient Pigments," p. 56 and Pl. XXXII.

Old red (*lao hung*)

Chu sha vermilion should be used in painting the fresh and brilliant leaves of the maple or the coldly beautiful leaves of the tallow tree.

Old red should be used in painting the backs of the leaves of the persimmon and chestnut. To mix old red, use deep vermilion (*yin chu*) and umber (*chê shih*).

Gray-green (*ts'ang lu*)

In the first frost, when the green of the leaves begins to turn yellow, they appear to be of a pale somber tone. To obtain this tone, mix grass green (*ts'ao lu*) with umber (*chê shih*). Use this also in the painting of mountain slopes and paths at the beginning of autumn.

Blending ink with colors

In painting forests in sunlight and shadow, the clefts and angles of rocks on mountains, and the tones of shadows in hollows, ink should be blended with the colors. Gradations of tone will then be clear, and there will be distinctions in depth and dimension. Ink should be added to colors, moreover, to enrich the venerable air of trees and rocks. There should be in the atmosphere of the painting an element of the mysterious, a dark and fertile dignity hovering over hillock and pool. The vermilions, however, should be applied lightly and pure, never mixed with ink.

*

I (Lu Ch'ai) have now described the most important groups of colors, and I add this note about umber (*chê shih*) and indigo (*tien hua*). Having observed that landscape painters use these colors constantly, I consider their relationship as complementary as that of a host and a guest (*pin chu*).[54]

54. Various relationships are used to illustrate the placing of trees, rocks, etc., such as those of old and young, parent and children, etc.; here the two colors most often used are put into the host-guest relation, a reciprocal and ritual relationship based ultimately on the idea of the *Yin* and *Yang*.

Cinnabar (*tan sha*) and black (*shih tai*) [55] are like those guests, eminent in their high hats and wide belts, formal in their bows and murmured courtesies accompanied by the most correct shade of a smile. How could they not be given the places of honor? As in an army the vanguard, in tiger skins, leads the march while the Feathers and Fans (generals and strategists) bring up the rear, so cinnabar and black are my choice as vanguard! They are the symbols of pure virtue. "That which is not pure diminishes. That which is pure daily increases." [56] Umber and indigo also belong to the pure group. In their emptiness (purity) is the fullness of their hue. This is art and progress in the *Tao*.

Silks

Up to the beginning of the T'ang dynasty, pictures were painted on unsized silk (*shêng chüan*). And until the time of Chou Fang and Han Kan,[57] silk was prepared by immersion in boiling water. Powder (*fên*) was added, and the silk beaten until it was like a silver board. Figures and objects painted on it had a wonderful brilliance.

Nowadays, people in search of T'ang paintings try to date the pictures by the silk. When they see that the weave is coarse, they say that the picture is not a T'ang painting. This is not necessarily so. The pictures of Chang Sêng-yu and Yen Li-pên that still exist are painted on rough silk. The paintings of the Southern T'ang period were all done on coarsely woven silk (*ts'u chüan*). The silk of the paintings of Hsü Hsi was sometimes like linen or cotton.

In the Sung period, there was a silk called *Yüan chüan* (Academy silk), woven for the painters of the Imperial Academy, which was of a clear fine texture. There also was the silk called *tu so chüan* (single-shuttle silk), with a texture as fine as paper, which was woven sometimes into pieces as long as seven or eight feet. Silk of the Yüan period was similar to that of the Sung period. The Yüan period also had a finely woven and clear silk called *Mi chi chüan,* which was woven by, and therefore named for, the Mi family in Wei-tang,[58] which also happens to be my home district. Chao (Mêng-fu) Tzŭ-ngo and Shêng (Mou) Tzŭ-chao used this silk a great deal.

55. Mineral black; *tai* is a term used for blackening eyebrows, also used with *ch'ing* (blue) to describe a dark purple. As used here, it probably refers to ink. The significance of red and black as *Yang* and *Yin* and the importance of cinnabar are discussed in Vol. 1, Ch. III.

56. A version of a favorite Taoist saying, as in the *Tao Tê Ching.*
57. Last part of VIII century.
58. Ancient name of Chia-hsing, in Chekiang.

The silk used in the inner courts of the Ming palaces was very fine; it was considered equal in quality to the Sung silks. The silks of ancient pictures are the color of light ink and have a fragrance of antiquity that is delicious (*k'o ai,* lovable). When there are rips, they make a form like the mouth of a carp. There are usually three or four broken threads, which are never broken in a straight line; if they are straight or split, the silk is faked.

Applying alum (in sizing)

The silk woven in Sung-chiang [59] is the kind to use. It should be chosen not by weight but by texture, which should be extremely fine, like paper, and with no rough threads. It should be fixed on a frame at three sides, top, left, and right. If the sides seem to be fastened too tightly, they should be moistened by beating with a wet stick, or else it will be impossible to remove the silk. On the back of the frame, behind the silk, insert little sticks of bamboo to hold it firm and tighten the frame by crisscrossing a fine cord on the bamboo pegs. Do not tie dead knots that cannot be untied. After applying the alum, stretch the silk flat and straight so that there are no hollows. Now tighten the knots. If the silk is seven or eight feet long, it will be necessary to insert in the middle of the frame a stick for further support. When the silk has been fixed to the frame, wait until it is completely dry before applying the alum. If the edges are not thoroughly dry, the silk will come off. When applying the alum, do not touch the glued edges with the brush or the silk will become detached. Even when the edges are dry, do not touch with the brush. In the summer, when the humidity is high, the silk will sometimes come off. Alum should then be applied lightly along the edges. If the silk should come off, take some small bamboo spikes, those called *ya ting* (mouse teeth), and nail the silk to the frame.

Preparation of alum and steps in applying it: In the summer months, use seven *ch'ien* [60] of glue to three *ch'ien* of alum. During the winter months, to one *liang* of glue use three *ch'ien* of alum. The glue should be bright, clear, and odorless. Nowadays, flour is added to Canton glue (*Kuang chiao*), a faked mixture that should not be used.

The alum should first be put to soak in cold water until it dissolves. It should not be put into

59. In modern Kiangsu.
60. 1 *ch'ien* = $\frac{1}{10}$ Chinese ounce (*liang,* = a little more than an ounce avoirdupois).

hot glue or the alum will cook. In applying the glue and alum to the silk, there are three steps. The first coat should be light. The second should consist of several layers of light coats. And the third coat should be very thin indeed. If the glue should be too heavy, the result will be disastrous; the color will become dull and the picture will crack. Neither should the alum be too heavy. If it is applied too thickly, it will raise a white streak on the silk that will be rough for the brush; moreover, colors on it will lose their brilliance.

In painting *ch'ing lu shan shui* (blue-and-green landscapes) in which a good deal of color is used, a solution of alum and water may be applied lightly on the finished picture to protect the colors. Moreover, when the picture is mounted, the colors will not crumble and shed. When there is color backing the picture, it may be protected in the same manner.

When the alum is being applied to the silk, the frame should be standing upright. A flat brush should be used, applied from left to right, each brushstroke following the other evenly and closely so that there is no space between and the surface is smooth. The horizontal brushstroke should be even so as not to leave traces like one sees on the walls of houses where rain has seeped in. If the alum has been applied with care, it will be clean as snow, clear as the purest river; and even if the silk is not used for a picture, it in itself is a joy to behold. When painting on it, should the silk be slightly rough, moisten it with water, slap it flatly against a stone, then fix the silk on the frame and apply alum.

Papers

The Sung paper named after the Ch'êng Hsin T'ang,[61] the bamboo-pulp papers,[62] the kind called *chiu k'u p'i* (old-treasure-house roll), and the paper made in the ancient state of Ch'u (Hupeh) are all good and may be used as one pleases.

Others are the bamboo-pulp paper known as *ching mien kuang* (mirror smooth), several coarse yet thin papers from Kao-li (Korea),[63] and a Yunnan paper called *ya chin chien* (polished-gold paper). There is a paper made today that is gray and of a heavy quality but contains too

61. "Paper from the Pure Heart Hall." According to Ferguson (*Outlines of Chinese Art*, p. 165), this kind of paper originated in the Five Dynasties period, having been invented by Li Hou-chu of Later T'ang (923–34); it is fine, thin, smooth, of yellowish tint, and reputed to be the best paper ever made in China.

62. *Hsüan chih*, white, fine paper, still used, both sized and unsized.

63. *Kao-li chien chih*, a Korean silk-cocoon paper. Names of some other papers are given in Vol. 1, Ch. III.

much lime. It is not satisfactory for paintings of orchids or bamboos, in which the brushstrokes are few and swift.

Dotting moss (*tien t'ai*)

The ancients seldom used in their paintings the method known as "dotting moss." When it came into use, it often was with the purpose of covering up negligence and disorder in brushwork. If there had been no negligence or disorder, why should there have been need to distract the eye? Thus there developed a dependence on dotting moss and also on color.

One should paint moss às Shu-ming (Wang Mêng) painted dry moss and as Chung-kuei (Wu Chên) painted tufts of moss, which was with unusual care.

Inscriptions

Before the Yüan period, inscriptions were seldom included on paintings; they were occasionally hidden in the brushwork of rocks for fear the calligraphic style would not be perfect and so might spoil the picture. This was customary up to the time of Ni Yün-lin, whose calligraphic style had great subtlety in poems and comments. He sometimes wrote both a poem and a comment on a painting. The inscriptions written by Wên (Chêng-ming) Hêng-shan were clear and straight. The brushwork of Shên (Hao) Shih-t'ien had ease and naturalness. The poems of Hsü (Wei) Wên-ch'ang had originality. The commentaries of Ch'ên (Shun) Po-yang were excellent. Each time one looks at their works, there is no doubt the inscriptions add a great deal of interest.

Some of today's crude artisans should learn to hide their signed inscriptions or should follow the custom of tomb inscriptions, which were never signed!

Firing dishes

All dishes used in preparing colors should be put in water that has been used in washing rice and then placed over a slow fire until the water is boiling. After this, spread raw ginger juice and mashed soybeans over the bottom of the dishes. Again place them over a slow fire and bake. Then they are guaranteed not to crack.

Purifying white

In paintings, the areas where white is used often darken. Chew the heart of a bitter apricot seed, and with the juice wash these spots once or twice.The dark spots will then disappear.

Wiping gold leaf

Gold-leaf paper and fans generally have oil on them so that it is difficult to paint on their surfaces. Take a piece of woolen cloth and wipe the surface, and the paper should then take ink. Sometimes it is necessary to sprinkle a little powder over the surface before wiping, but in doing this some of the powder is bound to remain on the gold paper. Some people use red-lead powder (*ch'ih shih chih*) to remove the oil. In the long run, none of these ways are as good as just using a piece of woolen cloth.

Use of alum for wiping gold leaf

The gold on gold-leaf paper will come off, and this makes painting on it difficult. The oil makes the surface slippery, and the glue is likely to peel. It is really impossible to paint on this kind of surface. However, by brushing a little alum water over it, the surface will take paint easily. Moreover, when one has finished painting on good gold-leaf paper, a light wash of alum water should be applied over the whole painting. Then there will be no need to worry about cracking or peeling when the picture is mounted.

*

At one time, I (Lu Ch'ai) was a pupil of Master Liang Hsia. While compiling a history of contemporary painters, he deigned to consult such an ignorant person as me. Together we discussed the subject. Later, I myself ventured to write a manual of painting. From the Chin (IV century) and T'ang periods up to now, there have been many biographies of individual painters and accounts of groups. Friends have described this work of mine on painting as comprehensive, likening its extensiveness to an ocean. I now await its publication.

I have purposely written this book as simply as possible, for the beginner. I have not, however, stinted brush or words to encourage him. The work is offered to those who are studying painting and also to those who may not know anything about painting. A friend has spoken of this book as a model manual for beginners, at which, however, I hasten to cover his mouth!

Written on the ninth day of the ninth month in the Chi Wei cycle (eighteenth year of K'ang Hsi: 1679), while a woodchopping guest [64] *at Hsin T'ing (New Pavilion).*

64. Lu Ch'ai here describes himself as *k'ê ch'iao* (guest woodcutter or woodchopping guest), perhaps in the spirit in which Li Yü used the name Li-wêng (Fisherman of the Lake), according to the literary man's romantic notion of being humble, useful, and at the same time picturesque.

Book of Trees

to the work of the soft Chinese brush, which drew as it painted. *Fa* (model, method), in the sense of *dharma* (law), is discussed in Vol. 1, Ch. II.

2. *Ssŭ ch'i* (four main branches) is analogous to the *ssŭ chih* (four limbs) of man and the four directions or cardinal points, and involves the general symbolism of trees: the Tree of Life and the various "trees" of knowledge, races, family, religions, etc. Stated morally, as in *Mencius,* II, A, 6: "Men have these four potentialities [the Confucian qualities of *jên, i, li,* and *chih*—Goodness, Uprightness, Fitness or Propriety, and Knowledge in the sense of Wisdom] just as they have their four limbs. . . . Encourage their full development, by which love and co-operation will spread among all within the four seas. . . ."

3. The text of this first example, summed up in the opening sentence, illustrates the double intent evident throughout the Manual: on the one hand, the instructions, technically sound, are enough for some; on the other hand, a deeper significance and an inner power, and thus greater brushstroke vitality, are to be gained through understanding the underlying meaning. Technically,

one must know how to draw trees in composing a landscape painting. One should, however, also know how to depict trees symbolizing the One or *Tao* reaching out and made manifest within the four corners of the earth.

4. Lit., "attention to investigate the principle of the *Yin* and *Yang*." This refers to skill in drawing; and also—as indicated in the last part of the sentence, about some branches pushing forward (*yang*) and others giving place (*yin*) to them—it posits the underlying principle of the action and balance of the two primal forces. Thus the ritual pattern is applied to branches.

5. *Ching ying* (organize composition), from the Fifth Canon. See p. 19.

6. The expression *mien mien yu yen, t'ou t'ou shih tao* (face-face-have-eyes, head-head-is-way) sums up what is natural and therefore logical; as translated in Giles' *Dictionary,* "put your whole mind into what you do and you will not go far wrong." Here, in painting trees, when one knows how to lay out the main structure, the rest will follow and fit in properly. Symbolically, when one is clear about the Four Directions, one's course is set and everything else will fall into place.

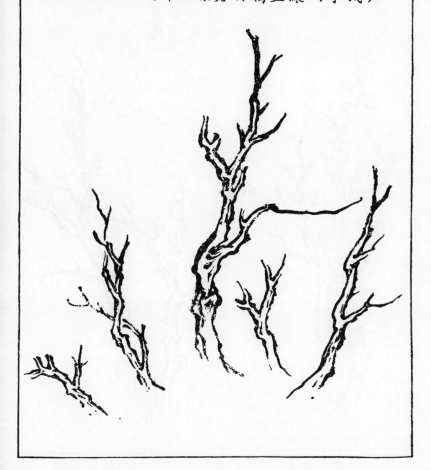

畫樹起手四歧法

畫山水必先畫樹樹必
先幹幹立加點則成茷
林增枝則爲枯樹下手
數筆最難務審陰陽向
背左右顧盼當爭當讓
或繁處增或問而益
簡故古人作畫千巖萬
壑不難一揮而就獨於
看家本樹大費經營若
作文者先立間架間架
既立潤色何難當熟四
岐後觀諸法四岐者即
畫家所謂石分三面樹
分四枝也然不曰面而
曰岐者以見此法參伍
變幻直若路之分岐熟
之則四岐之中面面有
眼四岐之外頭頭是道
千頭萬緒皆由此出

1

Method of painting [1] a tree beginning with the four main branches [2]

To paint landscapes, one should first know how to draw trees.[3] To draw trees, one should be able first to draw the trunk and main branches, then to dot the foliage, and eventually to depict a luxuriant forest.

After drawing the basic structure of trunk and main branches, add the smaller branches, establishing the form of the tree bare of foliage. The brush-strokes laying out the tree are the most difficult.

Mark well the way the branches dispose themselves, the *yin* and *yang* of them,[4] which are in front and which in the back, which are on the left and which on the right; mark well the tensions created by some branches pushing forward while others seem to withdraw. In the places where, in nature, there are many branches, add more and elaborate; where few, simplify. That is how the ancients painted their landscapes of a thousand crags and ten thousand gullies; it actually is not difficult to do in one sitting. In looking at these works, however, observe in particular how the structure and setting of the trees have been rendered, and how they contribute to the expression of the whole composition.[5] As in composing an essay, first make the outline of what is to be said. When that is done, what difficulty can there be in giving it color? It is essential, therefore, to know how to lay out the four main branches of a tree. After that, one may proceed to look into other methods and styles.

Painters call this fundamental step *shih fên san mien* (establishing the three faces of a rock), although here, in discussing trees, we speak of the four branches and, instead of faces, of paths or directions. To follow this rule one has to use imagination.

As branches fork out from the trunk, so a road branches off into other roads and paths. When one knows the way (the Four Directions), the main route is clear and its landmarks familiar, no matter how many byroads and paths. Put your whole mind into what you are doing and you will be on the right path.[6] The thousands of rules and ten thousand details all are based on this fundamental principle.

1. *Hua fa* (method of painting): *hua* originally meant scratching or incising on stone or wood; it was later applied

(continued at left)

Method of painting the trunks and main branches of two trees [1]

There are two ways of painting two trees together. Draw a large tree and add a small one; this is called *fu lao* (carrying the old on the back). Draw a small tree and add a large one; this is called *hsieh yu* (leading the young by the hand).

Old trees should show a grave dignity and an air of compassion. Young trees should appear modest and retiring. They should stand together gazing at each other. [2]

Two trees crossing each other.

Two trees together yet separate.

1. Instead of *shu* (tree) or the symbolical *Ssŭ Chih* (Four Directions), here *chu* is used, specifying the trunk and branches bare of foliage.

2. The pairs of trees are described in ritual terms: first, in the relationship of old and young; then old trees in an attitude *p'o so*—grave and ceremonial, as in a ritual dance, and exhibiting the Buddha-quality of compassion (*p'o* is also commonly used in the transliteration of "Buddha"); and finally, smaller, young trees, charming in a modest and retiring manner, the appropriate attitude of the young at ceremonies and in conduct generally.

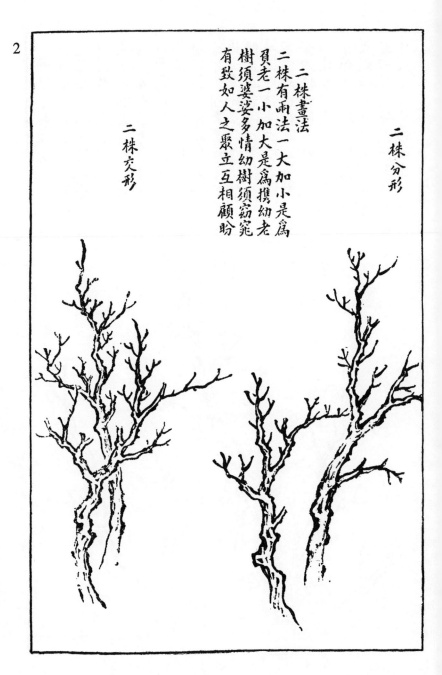

3

雖屬雁行最忌根頂俱齊
狀如束薪必須左右互讓
穿插自然

三株畫法

大小二株法

Method of painting the trunks and main branches of three trees

Although trees may be in a row, like swallows in flight, avoid making them the same height, with tops and roots at the same levels. That would look like a bundle of firewood. They should be painted so as to seem to yield place to one another and to stand together naturally (*tzŭ-jan*).

Method of painting the trunks and main branches of a large and a small tree

4

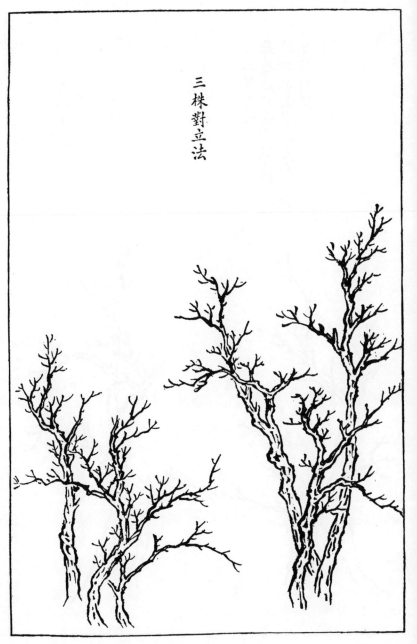

三株對立法

Methods of composing groups of three trees

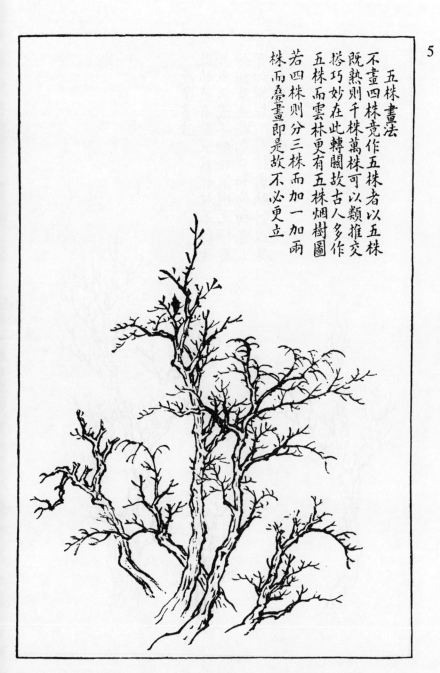

五株畫法

不畫四株竟作五株者以五株
既熟則千株萬株可以類推交
搭巧妙在此轉關故古人多作
五株而雲林更有五株烟樹圖
若四株則分三株而加一加兩
株而疊畫即是故不必更立

5

Method of painting the trunks and main branches of five trees

It is not necessary to speak of painting four trees; if one knows how to paint five trees, any number can be rendered. The key is skill in joining and crossing the branches. The ancients painted trees mostly in groups of five. (Ni) Yün-lin painted a picture entitled *Five Trees in a Mist*.

In painting four trees, compose a group of three trees and add another, or draw two pairs of trees. No need to go further into this.

6

鹿角畫法
此法最有致宜寫秋林不雜他
幹或以濃墨加於眾樹之頂有
如鷄羣之鶴也○如作初春上
可加嫩綠小點作霜林則以硃
曁赭雜點紅葉

Lu chüeh (stag horn) brushstroke

This is a brushstroke that is frequently used, and it offers much leeway. In painting trees in autumn, do not place too many kinds of trees together. Use a thick dark ink at the top of a tree, and it will stand out in the group like a crane among cocks.[1] If the picture is of trees in early spring, add touches of a fresh green. If the trees in a painting are to be frost-bitten, use small touches of vermilion (*chu sha*) and umber (*chê shih*) to dot the leaves red.[2]

1. A literary allusion often used of eminent persons.
2. The action of frost literally burning or consuming the leaves and the tips of branches.

7

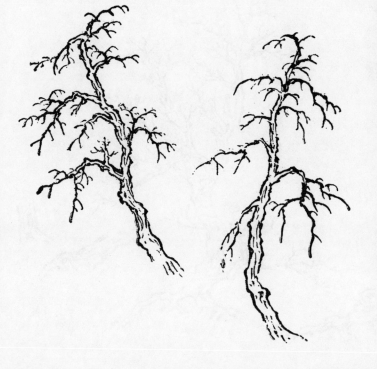

蟹爪畫法

必須鋒鋩畢露如畫家所謂懸
鍼者是也可配荷葉皴以筆法皆
主犀利也○蘸墨畫之再以淡
墨暈染便成煙林寫向寒山四
圍墨暈遂為珠樹

Hsieh chao (crab claw) brushstroke

The sharp points (*fêng mang*) in this brushstroke
should be very clearly made. Painters also call this
the *hsüan chên* (dropping needles) stroke. It may be
combined with the *ho yeh ts'un* (brushstrokes for
modeling like lotus-leaf veins). Both kinds should be
made with the sharp point of the brush.

If dry ink and a light ink wash are used in painting
the trees, the effect will be that of a forest in mist.
Trees painted in this manner, with the ink applied in
strokes round and round, should be used on moun-
tains in winter. The tree should be the *chu* tree.[1]

1. *Chloranthus inconspicua,* a tree with red berries and a
fragrant leaf that is sometimes used to scent tea.

Method of painting exposed roots

When trees are growing on mountains that have thick undergrowth, their roots are usually hidden. When they are growing among rocks, or are washed by springs, or are clinging to steep cliffs, the roots of old trees are exposed. They are like hermits, the Immortals of legends, withdrawn from the world, whose purity shows in their appearance, lean and gnarled with age, their bones and tendons protruding. Such trees are marvelous.

In painting a group of trees, it is good to vary the pattern by drawing one or two with roots exposed. These should be knotted and gnarled. All the roots should not be shown or they will look like the teeth of a saw, not a pleasant sight.

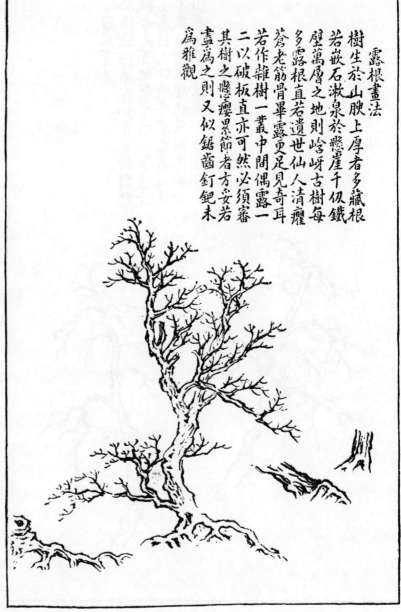

9

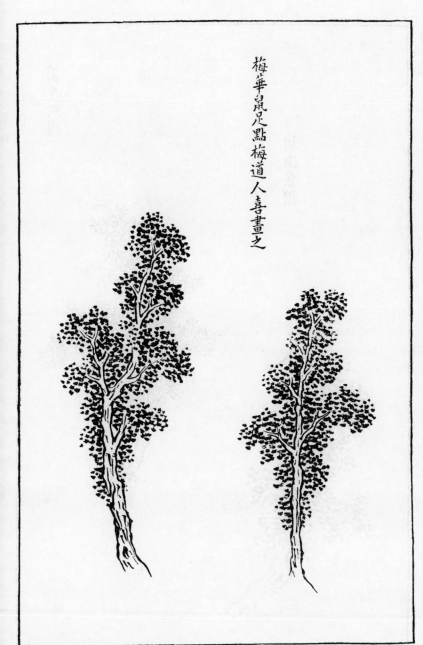

梅華鼠足點梅道人喜畫之

(Dotting foliage)

Dotting like mouse tracks (*shu tsu tien*) in the form of a plum blossom,[1] a method Mei(-hua) Tao-jên (Wu Chên) liked to use.

1. *Mei hua* (plum blossom), a term for dots in groups of five, like the petals of a plum flower. Wu Chên (1280–1354), Monk of the Plum Flower, was a master of the Yüan period, noted for calligraphic brushwork; he excelled in painting bamboos.

(More examples of dotting foliage)

10

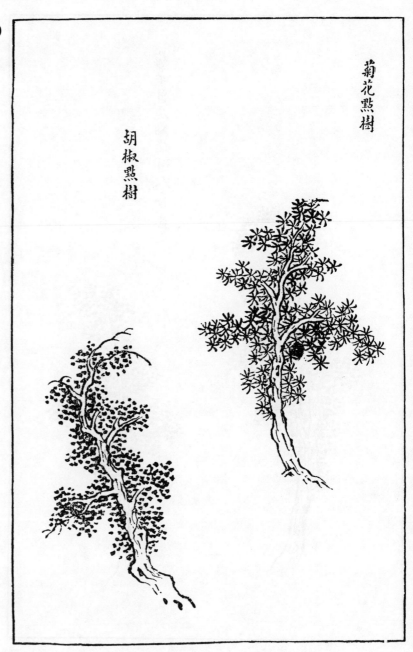

A tree with foliage dotted in the form of a chrysanthemum.

A tree with foliage dotted like a sprinkling of pepper.

11

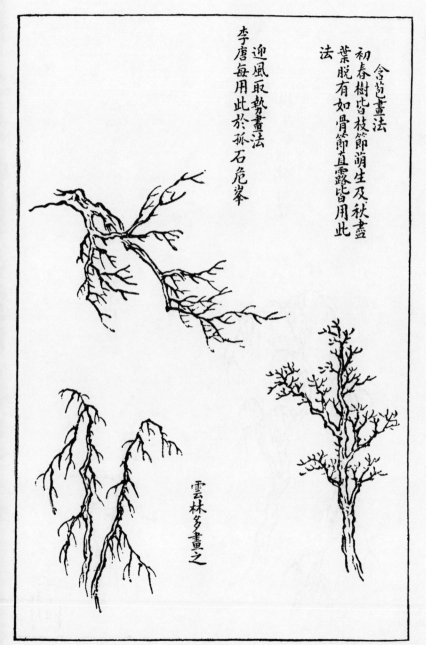

含苞畫法

初春樹皆枝節萌生及秋畫
葉脫有如骨節直露皆用此
法

迎風取勢畫法
李唐每用此於孤石危峯

雲林多畫之

Method of painting a bough in the wind

Li T'ang often worked in this manner when painting trees growing among lonely rocks and on dangerous cliffs.

Method of painting trees in bud

At the beginning of spring, the branches of trees bear buds. In autumn they shed their leaves, and the whole skeleton of the tree seems to be exposed. For both seasons, the method shown here may be used.

Left:

(Ni) Yün-lin often painted this way.

12

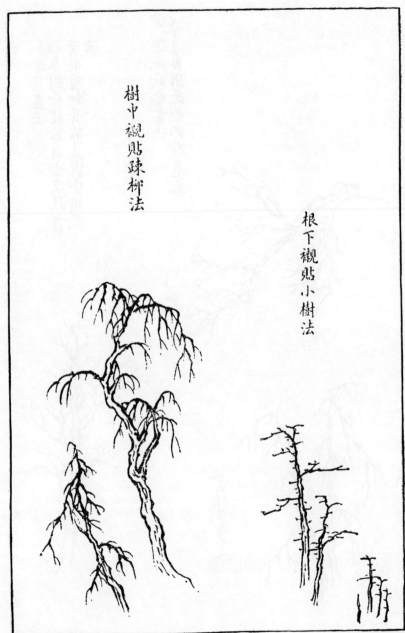

樹中視貼疎柳法

根下視貼小樹法

Method of adding strokes on willow branches.

Small trees that may be added where needed.

点葉法

點葉勾葉不
復分明其葉不
用其圈點其樹
用某圈者以
前後各樹中以
俱載有古人
點法點法雖
不同然隨筆
所至於無意
中相似者亦
復不少當神
而明之不可
死守成法

小混點

胡椒點

介字點

鼠足點

梅花點

个字點

松葉點

垂藤點

菊花點

13 Methods of dotting leaves [1]

There is not much difference between dotting leaves and drawing them. All painters do not use the same dotting methods nor the same style of brushstrokes in rings (ch'üan). On these pages the examples of brushstrokes for leaves show various dotting methods of the ancients. The way in which each painter used them naturally varied, but in actually wielding the brush for these strokes, one will find many similarities among them. One should become familiar with the various brushstroke styles, but one should avoid the deadening effects of merely copying the methods of the ancients.

Dotting like small eddies.

Dotting like a sprinkling of pepper.

Dotting in the form of 介 (chieh).

Dotting like mouse tracks.

Dotting in the form of a plum blossom.

Dotting in the form of 个 (ko).

Dotting like pine needles.

Dotting like a hanging vine.

Dotting in the form of a chrysanthemum.

1. The original editions (1679–1701) reproduced six pages each giving six examples of dotting leaves, in order slightly different from these, as in the Shanghai edition. The former included four more examples of dotting; in place of them the latter edition shows young bamboos and water grass (below, p. 68).

14

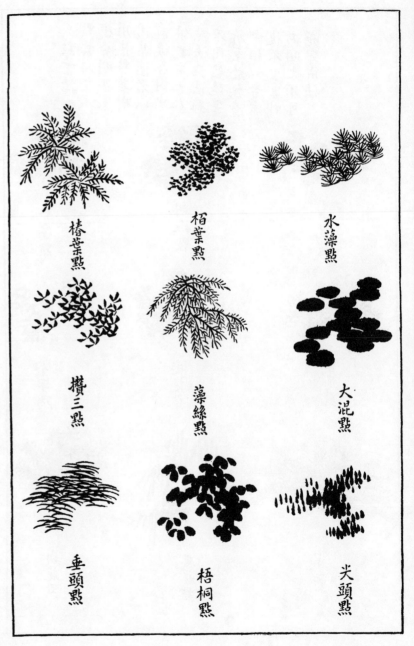

Dotting like the foliage of the red-leaf tree.[1]

Dotting like the foliage of the cedar or cypress.

Dotting like water grass.

Dotting in three strokes coming together.

Dotting like another kind of water grass.

Dotting in blobs, like a whirlpool.

Dotting like blades of drooping grass.

Dotting like the leaves of the *wu t'ung* tree.[2]

Dotting in sharp points.

1. *Cedrela odorata.*
2. *Sterculia plantanifolia.* The tree is illustrated on p. 117.

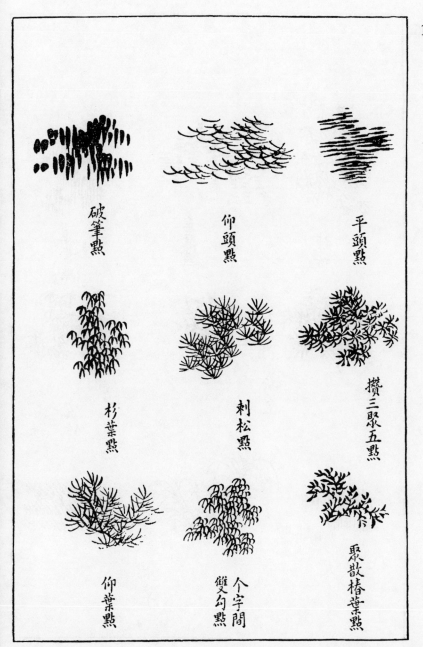

Dotting in the form of split brush points.

Dotting like grass blades raising their heads.

Dotting like flat heads.

Dotting like fir needles.

Dotting like sharp pine needles.

Dotting in groups of three and five strokes.

Dotting in the form of foliage pointing upward.

Dotting in the form of 个 (*ko*) with a hook added.

Dotting like a handful of loose red-leaf leaves.

16

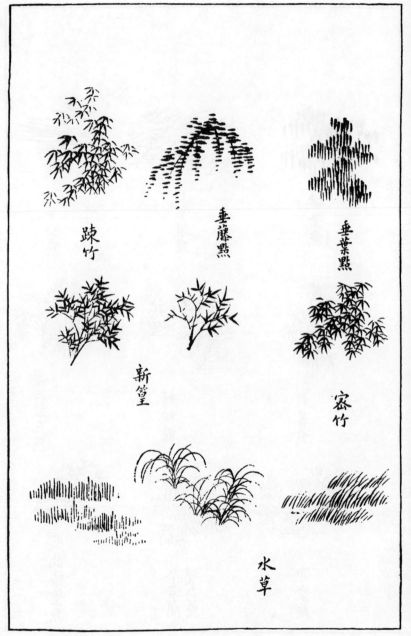

(Brushstrokes for) a dense cluster of bamboos.

Dotting like a hanging vine.

Dotting like falling leaves.

(Two examples of brushstrokes for) young bamboo.

(Brushstrokes for) a loose cluster of bamboos.

(Three examples of) water grass.

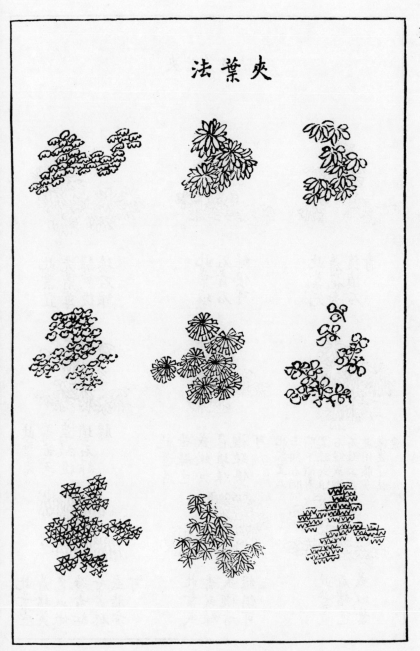

夾葉法

Methods of outlining leaves [1]

1. The original editions showed ten examples on two pages, the extra examples being similar to the center example on p. 71.

Methods of outlining and coloring leaves [1]

These leaves should first be outlined in flower blue (*hua ch'ing*) and then filled in with mineral blue.

For these leaves, use either mineral blue (*shih ch'ing*) or mineral green (*shih lu*).

These leaves should be outlined in grass green (*ts'ao lu*) and then filled in with mineral green.

On the upper three leaves of these groups of leaves, use rouge red (*yen chih*); on the lower leaves, a deep green. Fill in with mineral green; or use mineral green on (the backs of) the leaves. On the tips of the three upper leaves, use rattan yellow (*t'êng huang*). These (will then) resemble (the leaves of) the *sala* tree [2] and of the chestnut. [3]

These leaves should be outlined in a yellow-green or a light yellow and may be filled in with a harmonious green.

These leaves should be outlined in yellow and grass green, and richly filled in with mineral green.

These leaves should be outlined in umber (*chê shih*), or they may be painted red.

For these leaves, use either blue or green, or fill in in the blue-and-green style.

These leaves should be outlined in yellow ocher (*chê huang*) or a light yellow. If they are red leaves, they may be filled in with a vermilion or rouge red.

1. The original editions showed twenty examples on five pages. The two additional: one similar to the center example on p. 71, but with more abundant spray of leaves; the other similar to examples mid bottom and mid left on p. 71. Some of the instructions specify colors for outlining and for filling in, others merely name colors.
2. *Shorea robusta*, an immense timber tree, the kind under which Buddha was said to have been born and also to have died. *So lo*, the Chinese name, is also used for the horse chestnut (*Aesculus chinensis*).
3. Missing words in this passage have been filled in from the original editions.

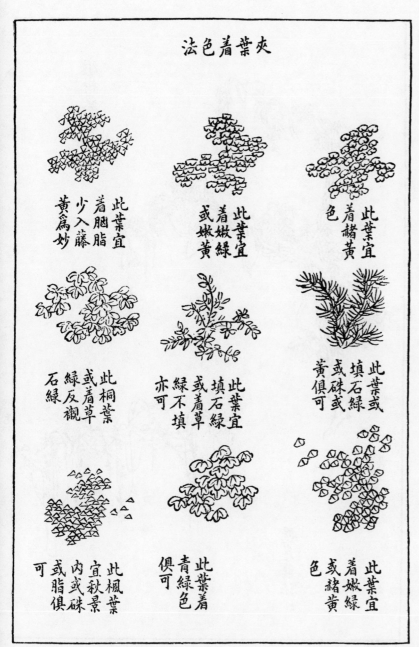

Methods of outlining and coloring leaves

These leaves should be outlined in rouge red mixed with a little rattan yellow.

These leaves should be outlined in a fresh green or a fresh yellow.

These leaves should be outlined in yellow ocher.

For these leaves of the *wu t'ung* tree, outline in grass green and use mineral green on the backs.

In painting these leaves, use either mineral green or grass green, or leave them without color.

In painting these leaves, use either mineral green, vermilion, or a yellow.

In painting these leaves of the red-leaf tree in autumn, use a vermilion or rouge red.

These leaves should be outlined in a blue-green.

These leaves should be outlined in a fresh green or yellow ocher.

20

Method of painting a vine [1] growing on a tree

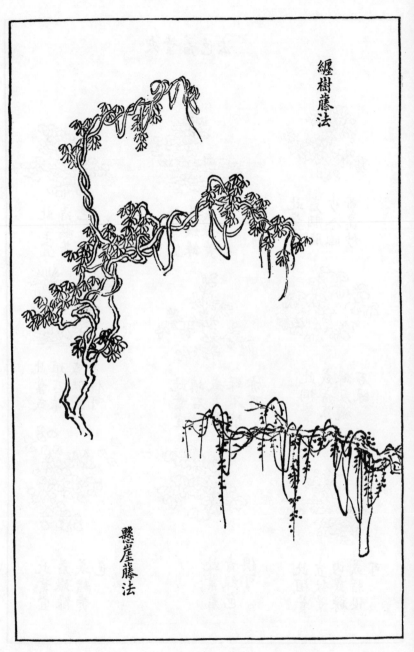

Method of painting a vine growing on a cliff

1. *T'êng,* a name used generally for vines, creepers, and other climbing plants, and also for the rattan or cane plant.

21

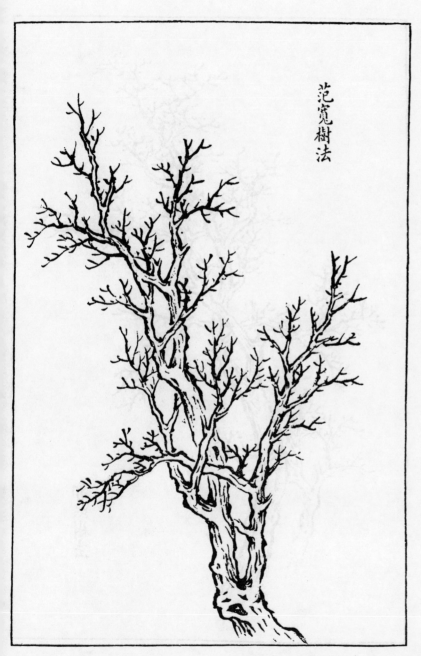

范寬樹法

Fan K'uan's style of painting trees [1]

1. Nine examples of trees without foliage are now shown in the styles of several masters. *Fa* (method) is translated "style" to cover both method and manner.

Kuo Hsi's style of painting trees

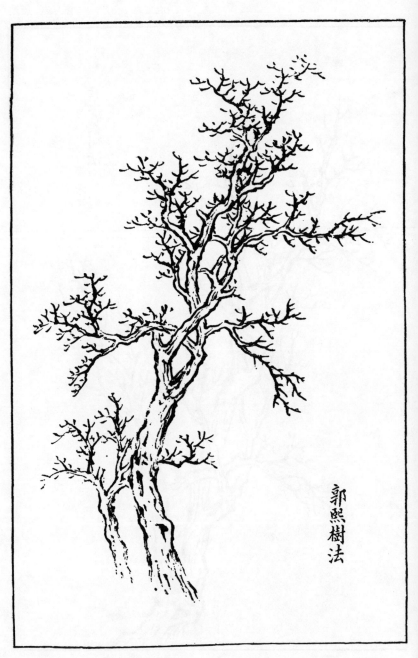

22

郭熙樹法

23

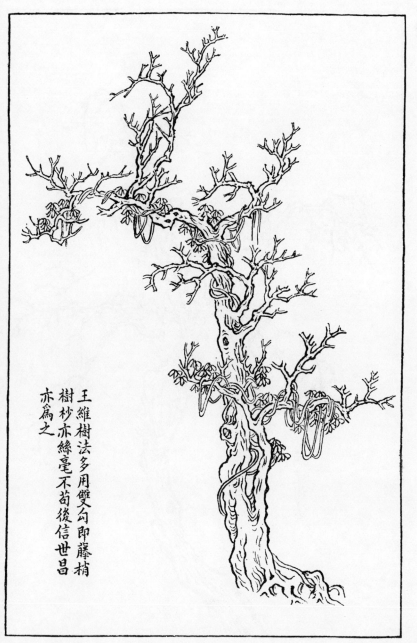

亦為之　樹杪亦絲毫不苟後信世昌　王維樹法多用雙句即藤梢

(Wang Wei's style of painting trees)

In painting trees, Wang Wei usually used the method called *shuang kou* (double contour or outline). Even when drawing the ends of vines or the tips of tree branches, he did not neglect a single detail. Later, Hsin Shih-ch'ang [1] painted and drew in this style.

1. This may be a misprint for the name of the XII-century painter Hsü Shih-ch'ang, to whom is attributed the painting entitled *Mountain Landscape, Cliffs and Stream, a Scholar's Abode* (Freer Gallery, Washington).

24

Ma Yüan's style of painting trees

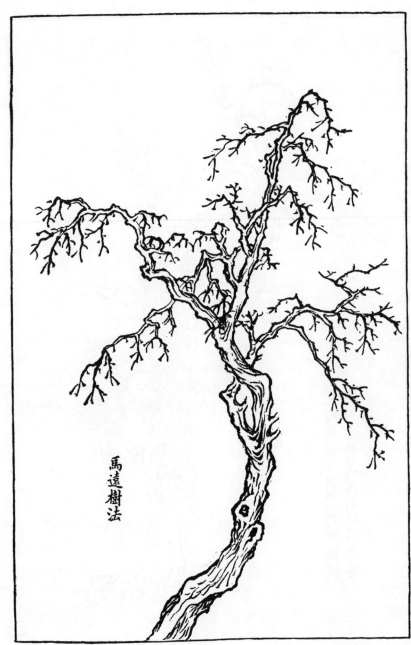

馬遠樹法

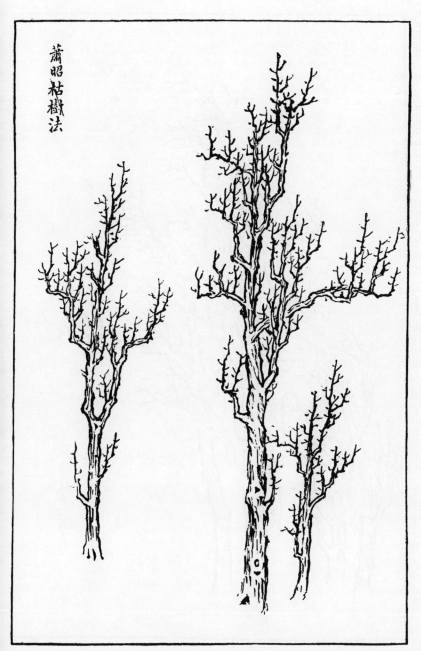

25

Hsiao Chao's style of painting dead trees

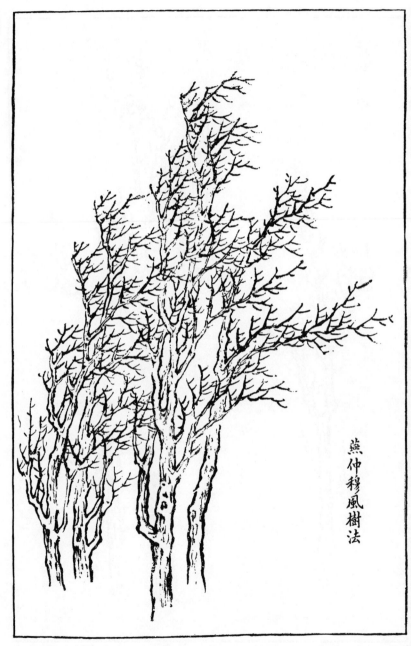

26

Yen Chung-mu's style of painting trees
in the wind

燕仲穆風樹法

27

曹雲西樹法

柯九思樹法

Left:
Ts'ao Yün-hsi's style of painting trees

K'o Chiu-ssŭ's style of painting trees

Ni Yün-lin's style of painting trees [1]

Li T'ang's style of painting trees

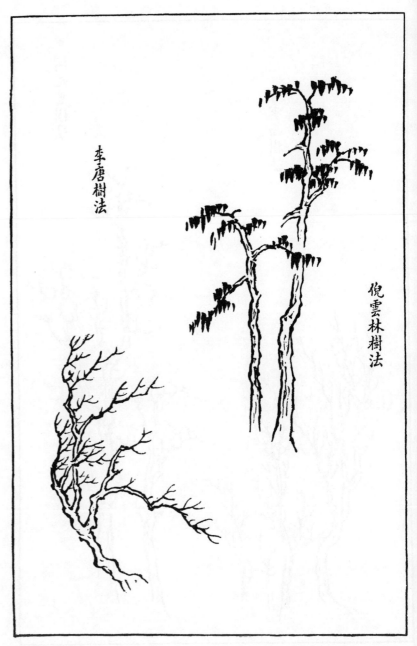

28

李唐樹法

倪雲林樹法

1. This example actually belongs to the next group, which contains examples of trees in leaf.

29

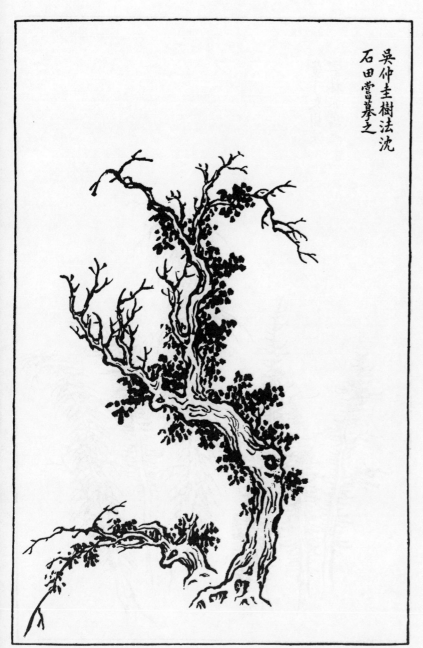

吳仲圭樹法沈
石田嘗摹之

Wu (Chên) Chung-kuei's style of
painting trees, which was copied [1] by
Shên (Hao) Shih-t'ien

1. *Mu*, the term for copying exactly, and sometimes used
to describe tracing; distinct from *fang*, free copying or in-
terpretation.

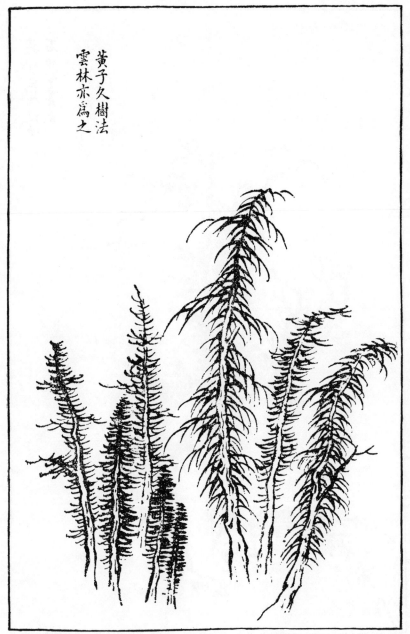

30

黄子久樹法
雲林亦爲之

Huang (Kung-wang) Tzŭ-chiu's style of painting trees.

(Ni) Yün-lin also painted in this manner

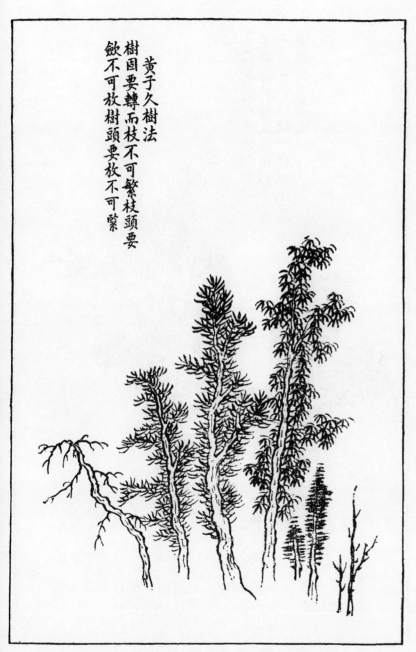

31

黃子久樹法
樹固要轉而枝不可繁枝頭要
欲不可放樹頭要放不可繁

Another example of Huang Tzǔ-chiu's
style of painting trees

Trees should twist and turn, but their branches
should never seem crowded. Branches are few at the
tops, but they should not appear scattered. Tree tops
should be loose because the branches are fewer; they
should not in any way seem thick.

32

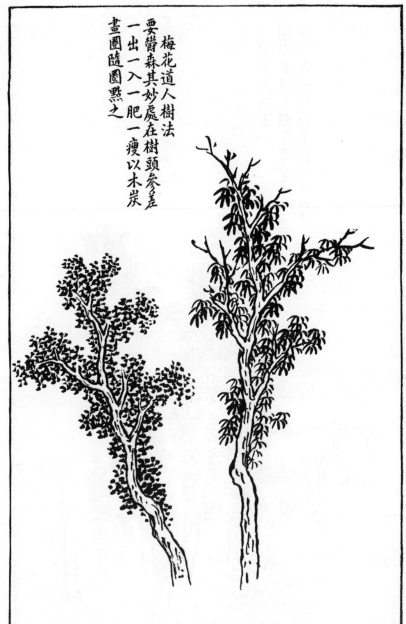

梅花道人樹法
要鬱森其妙處在樹頭參差
一出一入一肥一瘦以木炭
畫圖隨圖黯之

(Wu Chên) Mei-hua Tao-jên's style of painting trees

Thick tree tops should be painted in dark ink. (Wu Chên's) strong point was variety in painting tree tops: one branch shooting out, another turning back, one fat and one thin. He first used charcoal to place and outline the trees; then he proceeded with the dotting of the leaves.

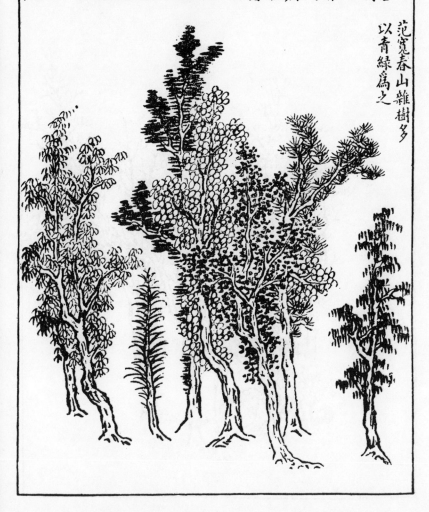

關董巨迨脫化之方妙哉
我之爐冶鎔化荆
今之學者又富以
冶鎔化古人之富以
諸人化古人之筆
顧人既已各具爐
有逆插取勢有順
善有配合有趨避
指揮如意多多益
靜聽旗鼓善將者
鹹淡得中盡成異
味又如卒伍四調
任人調和善庖者
區別如五味具在
者設不得不姑為
未可分而為入門
即宜講體與用雜
矣然體裁既知用
立標準以見體裁
既將諸家之樹各
雜樹總法

范寬春山雜樹多
以青綠為之

33 General methods of combining various kinds of trees

Examples have been given of the styles of several masters in painting trees. These show the established standards. After learning them, one should apply the various methods. While the manner of composition and the methods cannot be separated, the beginner has to examine them separately in order to become familiar with the details of each method. They cannot be ignored. It is as with the Five Flavors: results depend on their blending and proportions. An expert cook manages to produce dishes not too salty, yet not without flavor, in fact just right; moreover, he is able to create a great variety of flavors by different proportions of blending. Or it is as with soldiers, alert to the signals of drums and banners, who listen attentively for the Four Tones of Command. An able general gives the orders as he wishes, handling the situation with ease, however large the army. It is the same in painting trees; they should be paired or combined or separated with authority and style.

Ching (Hao), Kuan (T'ung), Tung (Yüan), and Chü(-jan) absorbed the methods of the ancients and added their own distinctive touches. Those who are studying painting should make use of this discussion and in turn study and absorb the methods of Ching, Kuan, Tung, and Chü. Their brushes will then become fluent and expert.

Fan K'uan's manner of combining various kinds of trees, which he painted in the blue-and-green (*ch'ing lu*) style.

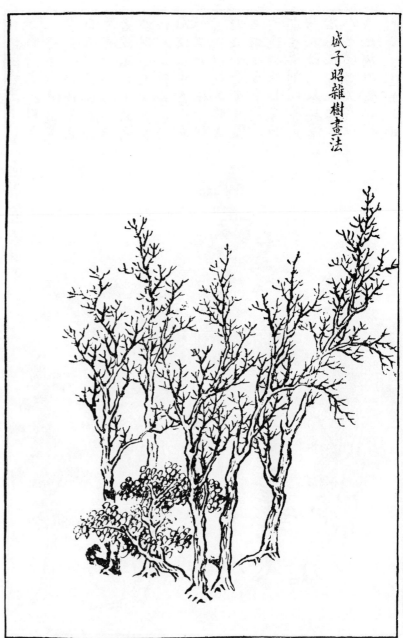

34

傚子昭雜樹畫法

Shêng (Mou) Tzǔ-chao's style of
combining various trees

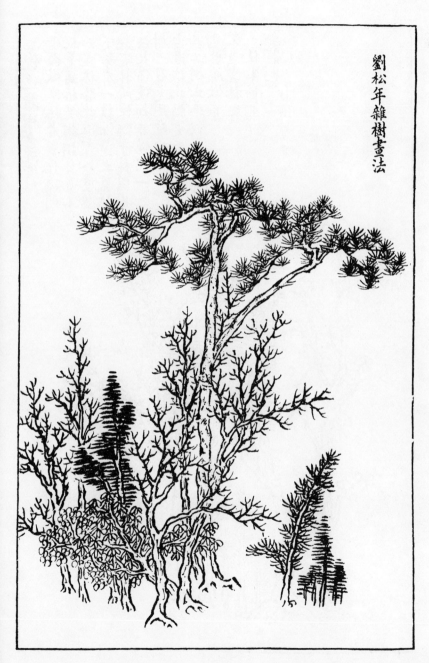

35

劉松年雜樹畫法

Liu Sung-nien's style of combining
various trees

36

Ni Yü's [1] style of combining various trees

Many painters who copy Yün-lin's style manage to produce only clumsy results—brushstrokes like bolts on a door, strong but awkward, or like the tracks made by a restless horse, confused and without direction. They do not understand that Yün-lin learned to attune his innermost self (to the *Tao*),[2] and that by the time he put brush to paper his conception was already suffused with the power of the spirit (*ch'i*). Look at his picture *The Lion Grove*. In it the method of painting trees has been completely realized. One can see from this work that it is not in the painting of one tree or one rock that immortality is achieved. This fragment of an example shows, to a small degree, a standard in the painting of trees. Those who have copied him imitated the way he painted one branch or one part, and failed to grasp the concept and spirit of the picture as a whole.

1. Ni Yü (Odd or Impractical Ni), *hao* or pseudonym of Ni Tsan. He is well known also as Yün-lin, and used several other names, including Yüan-chên, and such titles as Ching-ming chü-shih (The Unblemished Scholar).

2. Lit., "had entered deep into the mysterious." *Tang ao* (innermost self) was an expression used also for the corner where the household deity was kept.

倪迂雜樹畫法

世之傚雲林者多作頂門
棍繫馬樁輒詡詡自負不
知雲林於此道深入堂奧
下筆有一往深遠之氣試
觀雲林所作獅子林圖樹
其工樹立準以一
樹一石遂足睥睨千
古者故此幅更取
法大備便知非僅以一
見世所傚摹
不過雲林之
一枝半節非
全體也

37

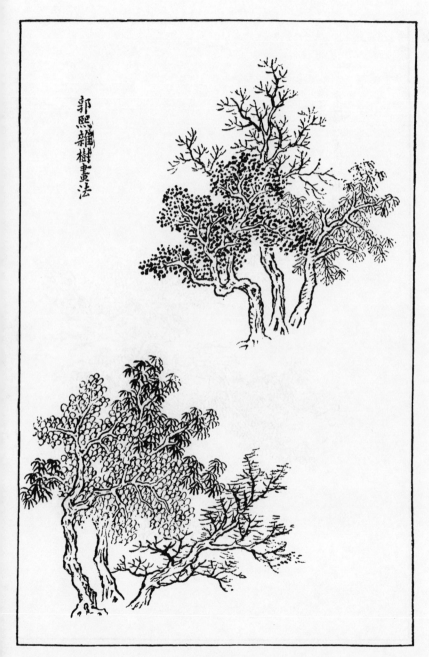

Kuo Hsi's style of combining various trees

38

李唐懸崖雜樹法

Li T'ang's style of painting trees
growing on a steep cliff

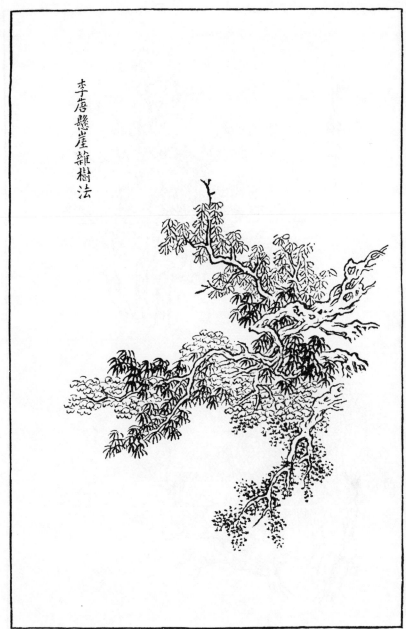

39

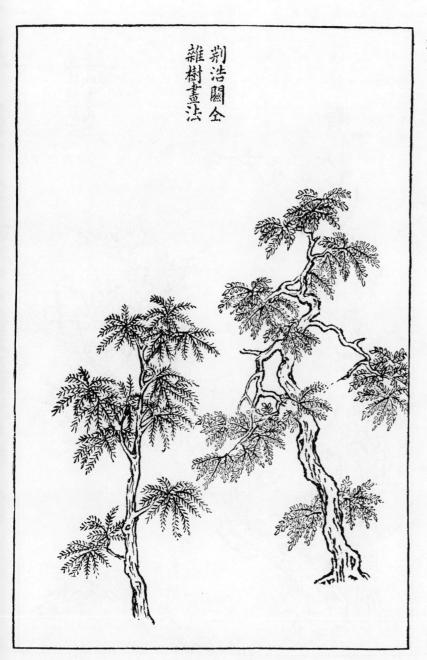

荆浩關仝
雜樹畫法

Style of Ching Hao and Kuan T'ung in
combining trees

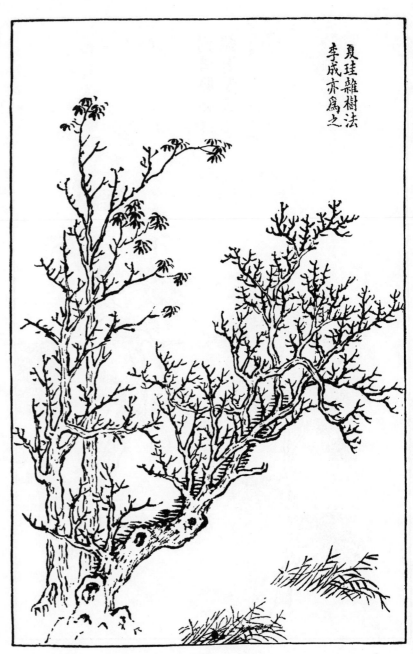

40

夏珪雜樹法
李成亦爲之

Hsia Kuei's style of combining various
trees; used also by Li Ch'êng

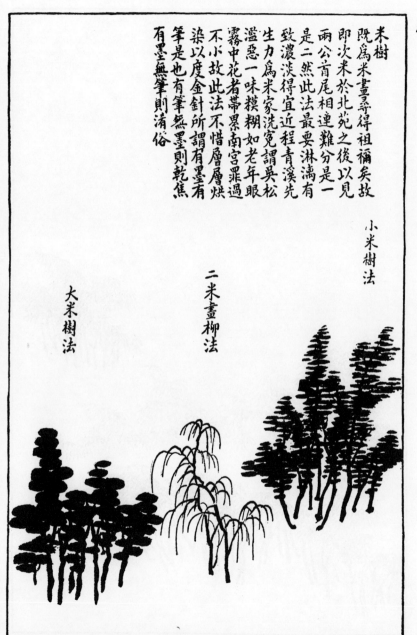

米樹

既爲米畫尋得祖襧矣故

即次米於北苑之後以見

兩公首尾相連難分是一

是二然此法最要淋漓有

致濃淡得宜近程吳洗先

生力爲米家洗寬謂吳松

瀉惡一味摸糊如老年眼

霧中花者帶累南宮罪過

不小故此法不惜層層烘

染以度金針所謂有墨有

筆是也有筆無墨則乾焦

有墨無筆則清俗

小米樹法

二米畫柳法

大米樹法

41 Mi trees (style of Mi Fei and his son,
Mi Yu-jên)

One can see (that Tung Pei-yüan) was the precursor
of the style used by Mi Fei and his son. That is the
reason examples of his style have been included. The
styles of Mi and his son are so similar that it is diffi-
cult to tell them apart. In their manner of painting,
the brush had to be used dripping wet and ink tones
handled with precision.

Recently Ch'êng Ch'ing-ch'i spoke up for the Mi
family. He said that Wu Sung was ignorant, his taste
undeveloped, and his vision blurred like the eyes of
old men. And he made reference to Nan Kung.[1]

In this method, the strokes build the picture layer
by layer in order to achieve full results. This is a good
test [2] of the saying *yu mo yu pi* (to have ink, to have
brush). When one has brush but not ink, the results
are dry and brittle. When one has ink but not brush,
the results are greasy and commonplace.

Left to right:

The elder Mi's method of painting trees.

The Mi method of painting willows.

Young Mi's style of painting trees.

1. Comment on a critics' dispute over the Mi style. The
mention of Nan Kung, praised by Confucius (*Analects*,
XIV) for his perception, was doubtless a barb at the Mi's
critics' lack of it. Moreover, Mi Fei's *hao* was Nan Kung.
2. *Tu chin chên* or *ting* (according to the golden needle,
or to estimate by the golden needle) might refer to the
critics' opinions and standards, or to steering by the com-
pass, which is also called the Golden Needle, and so, in an
abstract sense, to the Center (*Tao*).

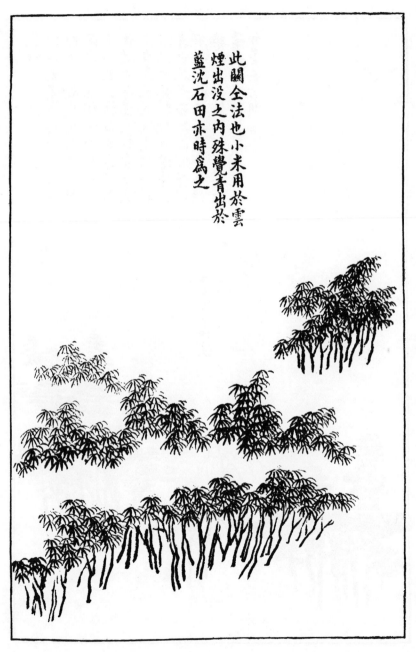

42

此關全法也小米用於雲
煙出沒之內殊覺青出於
藍沈石田亦時爲之

Young Mi also painted trees in the manner of Kuan
T'ung, shrouded and emerging from mist. One feels
he did it perfectly and even surpassed [1] his master.
Shên (Hao) Shih-t'ien also occasionally painted in
this style.

1. *Ch'ing ch'u yü lan* (as green comes from blue and is
superior to blue).

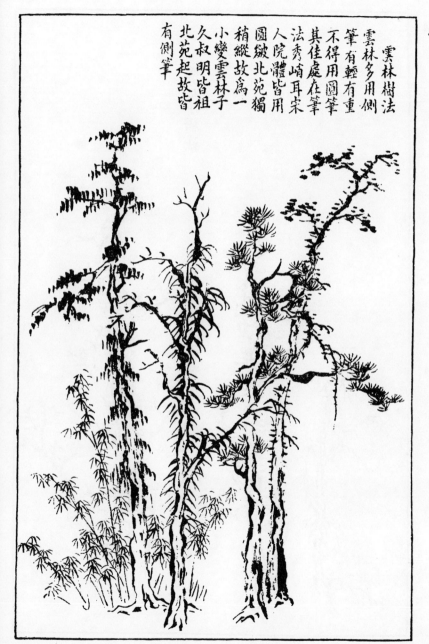

有側筆
北苑起故皆
久叔明皆祖
小變雲林子
稍縱故為一
圓皴北苑獨
人院體皆用
法秀崤耳宋
其佳處在筆
不得用圓筆
筆有輕有重
雲林多用側
雲林樹法

(Ni) Yün-lin's style in painting trees

Yün-lin usually used the side of his brush (*ts'ê pi*) whether applying it lightly or heavily; he did not use the brush in a perpendicular position in making the round strokes known as *yüan pi* or *yüan ts'un*. The advantage of the oblique brushstroke is in the sharp and pointed tip. The painters of the Imperial Academy, during the Sung dynasty, used the round stroke. (Tung) Pei-yüan used a free rendering of this type of brushstroke, and the modification became a new style. Yün-lin, Tzǔ-chiu (Huang Kung-wang), and (Wang) Shu-ming followed Pei-yüan: all used the side of the brush.

44

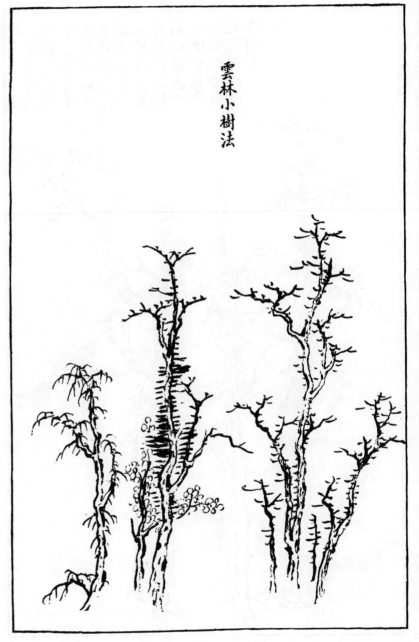

雲林小樹法

(Ni) Yün-lin's style of painting small trees

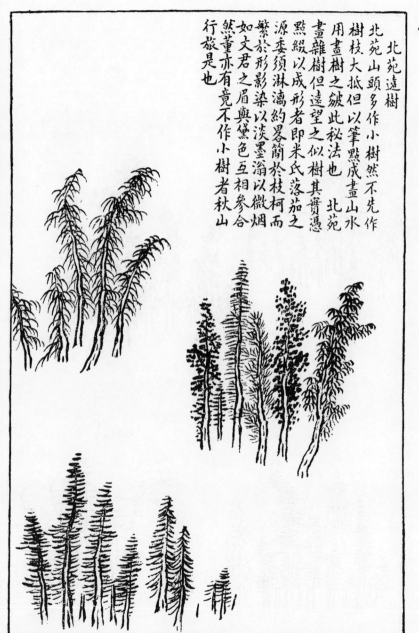

45

北苑遠樹
北苑山頭多作小樹然不先作
樹枝大抵但以筆點成畫山水
用畫樹之皴此秘法也　北苑
畫雜樹但遠望之似樹其實憑
點綴以成形者即米氏落茄之
源委須淋漓約暑簡於枝柯而
繁於形影染以淡墨瀚以微烟
如文君之眉與黛色互相參合
然董亦有竟不作小樹者秋山
行旅是也

Pei-yüan's [1] style of painting trees in the distance

Pei-yüan often painted small trees on the summit of mountains. He did not indicate branches but simply dotted in the trees, using only one kind of brush-stroke. This was a secret method. He painted trees that appeared to be of various kinds, but all were done with one kind of dotting. The Mi style of brush-work called *lo ch'ieh* (drops shaped like an eggplant) was derived from this. For this method one must apply the ink dripping wet, using few strokes where branches join and many among the shadow forms of the foliage. The trees should be tinted faintly with light ink, enveloping them in a mist like Wên Ching's eyebrows, which were touched up with *tai*.[2]

Often Tung did not paint the complete forms of small trees, as may be seen in his picture *Traveler on the Mountain in Autumn*.

1. *Hao* of Tung Yüan, *tzŭ* Shu-ta.
2. Wên Ching: a Han beauty who, according to the fashion of the period, shaved off her eyebrows and then drew them in with *tai*, a blue-black or dark-green mixture.

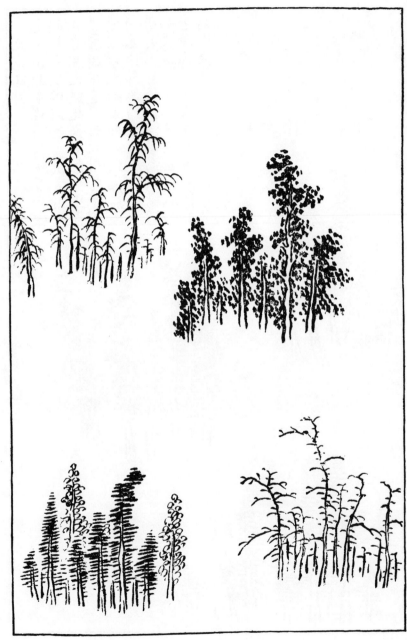

46

(Example of trees in the middle distance)

47

扁點極遠小樹
宜用淡墨點於
山凹處或於遠
山脚下染以淡
綠襯貼煙雲

Trees in the far distance are painted by means of small, flat dotting with light ink. They should be made in the hollows on mountains or at the foot of mountains in the distance. If color is used, apply light green to heighten the effect of mist and clouds.

48

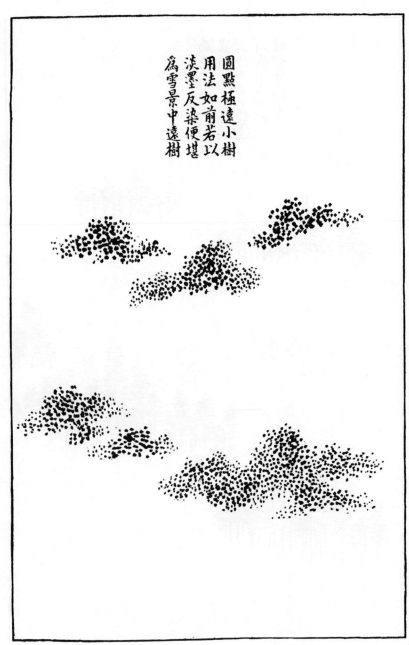

Trees standing even more distant than in the preceding example should be made with very small round dots and should be placed in the same manner. A light ink wash applied on the back of the picture will produce an effect of distant trees in a landscape in snow.

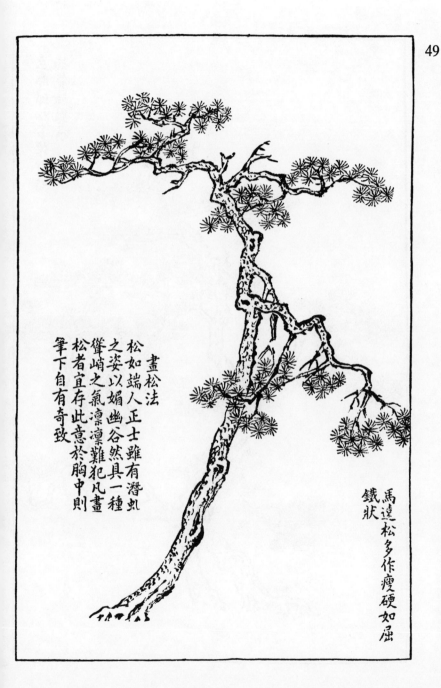

畫松法
松如端人正士雖有潛虬
之姿以媚幽谷然具一種
聳峭之氣凛凛難犯凡畫
松者宜存此意於胸中則
筆下自有奇致

馬遠松多作瘦硬如屈
鐵狀

Methods of painting pines

Pine trees are like people of high principles whose manner reveals an inner power. They resemble young dragons coiled in deep gorges; they have an attractive, graceful air, yet one trembles to approach them for fear of the hidden power ready to spring forth. Those who paint pine trees should keep this meaning in mind. The brush will then effortlessly produce extraordinary results.[1]

Pines painted by Ma Yüan were lean and strong as iron.

1. This paragraph illustrates three levels of meaning. The pine is a decorative subject loved for its sinuous grace, ruggedness, and venerable age. The pine trunk and branches are like the body of a young dragon, symbolic of earthly and imperial power, and also of the *Yang*. And, finally, a pine stands for the inner spiritual power and potential in individuals, the young dragon hidden (*ch'ien*, "to secrete": a pictograph of "water murmuring" that might be interpreted as the source or unconscious) and about to uncoil and rise from the deep gorge (*yu*, "deep," is the same character as in *yu ming*, the Underworld). *Sung chiao*, here rendered "ready to spring forth," is literally "to excite or to soar." *Sung* is composed of "ear" and "to obey," which suggests listening or tuning in with the *Tao*. The description of the young dragon hidden and about to uncoil implies a state of stillness and waiting to comply. *Chiao* (steep, harsh, vigorous) is composed of *shan* (mountain) and *hsiao* (to be like one's father—not degenerate), which might be summed up as "moral."

50

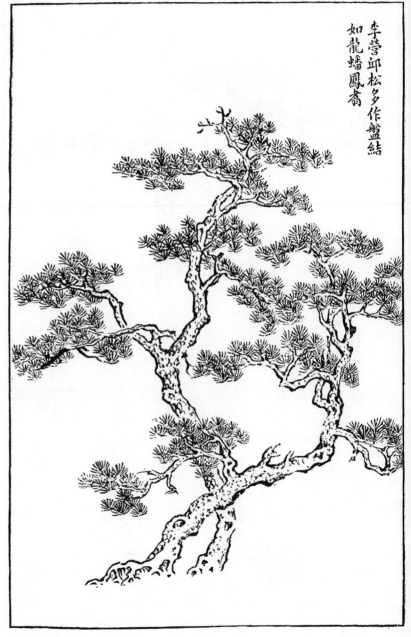

李營邱松多作盤結
如龍蟠鳳翥

Li (Ch'êng) Ying-ch'iu painted pines with the sinuosity of a coiled dragon or a soaring phoenix.[1]

1. The key to painting the pine tree is summed up in this relating of the pine, the dragon, and the phoenix, symbols of the *Yang* and of spiritual power emergent.

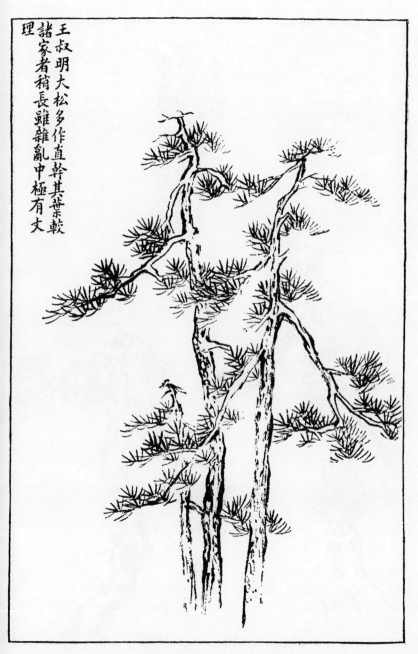

理諸家者稍長雖雜亂中極有丈
王叔明大松多作直幹其葉較

51

Wang (Mêng) Shu-ming liked to paint great pines with straight branches. Their needles were long compared with those painted by other masters. Although at first glance they sometimes seemed in disorder, they were drawn with skill and great style.[1]

1. *Wên li* (cultured or accomplished). *Li* is the Neo-Confucian "principle or fitness of things." *Wên li* therefore has the sense of one versed in the proper way of things, with the implication of style and quality (*wên*).

52

Ma Yüan often used the style known as *p'o pi tien* (split brushstrokes). His paintings abundantly reflected the inspiration of antiquity. To paint in this style is very difficult. In studying and practicing it, one must not proceed as in the poor copies made recently of the work of Wu (Wei) Hsiao-hsien, which were done with poor brushwork and without method.

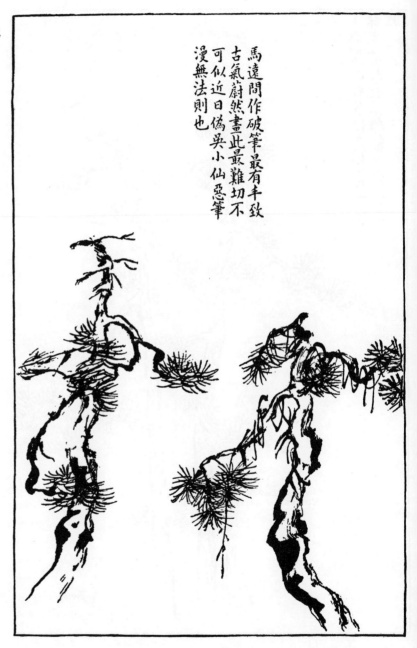

53

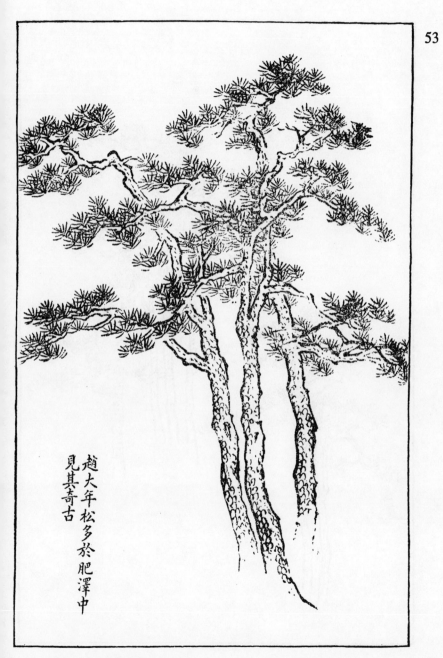

趙大年松多於肥澤中
見其奇古

Pines painted by Chao Ta-nien have an extraordinary majesty, sleekness, and elegance.

54

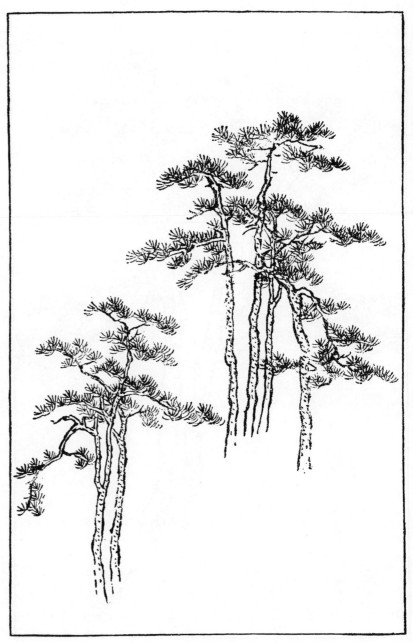

(The pines painted by Wang Shu-ming often were
not according to the classic pattern.)[1]

1. Text from the original editions.

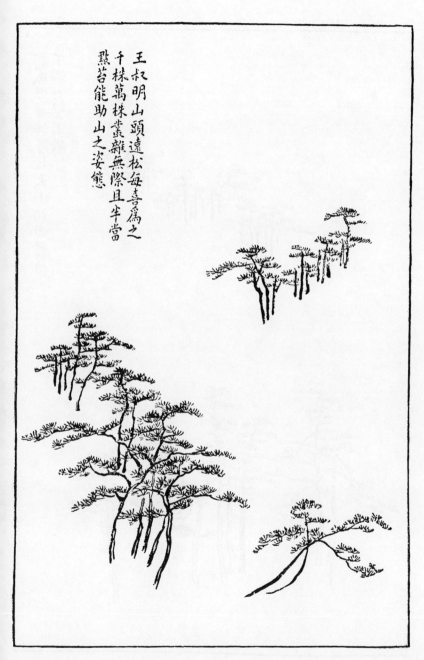

55

王叔明山頭遠松每喜為之
千株萬株叢雜無際且半當
點苔能助山之姿態

Wang Shu-ming liked to paint pines growing on the summits of distant mountains. He would paint a great many trees massed on the mountain, and use the effect of dotting moss (*tien t'ai*) to enhance the beauty of the mountain.

56

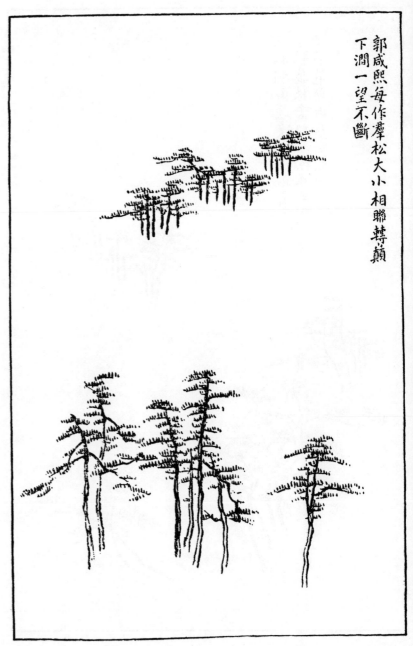

郭咸熙每作摩松大小相聯轉巔
下澗一望不斷

Kuo Hsien-hsi very often painted forests of pine,
with large and small trees in an unbroken line down
a cliff or mountainside.

57

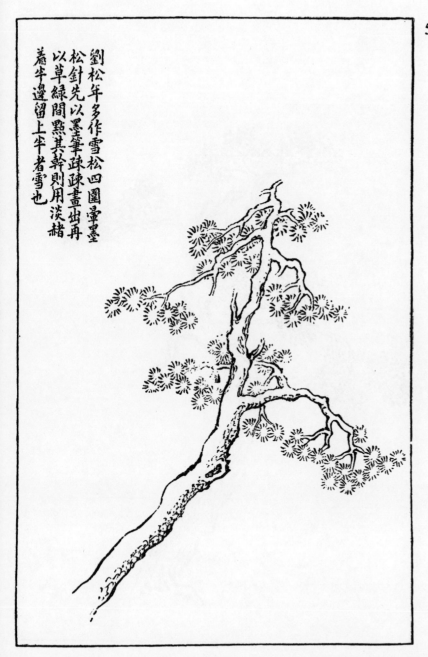

劉松年多作雪松四圍暈暈
松針先以墨筆疎疎畫出再
以草綠間點其幹則用淡赭
著牛邊留上牛者雪也

Liu Sung-nien painted numerous pictures of pines in snow. He usually enveloped the trees with a faint halo of light ink. He drew in the general lines of the needles with light ink and then dotted the branches here and there with grass green, adding touches of light umber on the undersides of boughs and branches, and leaving the upper part untouched to show where the snow lay.

58

古柏僧巨然及梅道人
多畫之

The (Buddhist) priest Chü-jan as well as (the Tao-
ist monk) Mei Tao-jên (Wu Chên) often painted
this kind of ancient cypress (*ku po*).

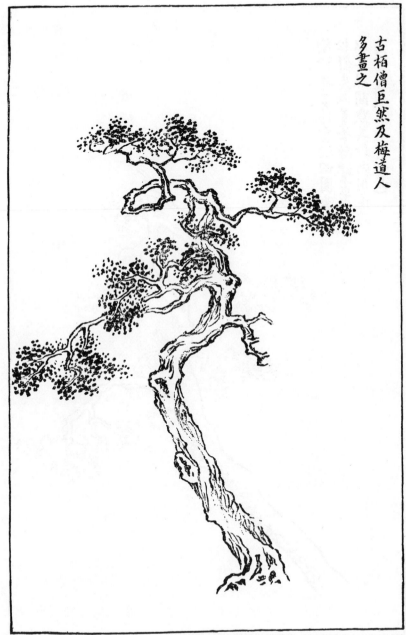

畫柳各法
畫柳有四法一句勒填綠一
但以汁綠漬出新稍則嫩黃
脚葉則老綠以分明晦一再
加深綠於綠點上輕點數小
墨點上罩石綠留邊一竟以
墨絲而點以濃綠染之大抵
唐人多句勒宋人多點
葉元人多漬染其
分枝取勢得迎風
搖颺之致一也又
垂條秋九月
春二月柳未
柳已裊颯未
可相混樹中之
柳如人中之西子
毛嬙仙中之宓妃列
子其淩波御風之態掩
映於水邊林下最不可少
故趙千里及趙松雪多畫之
而松雪於水邊村圓濃淡無窮又一法也

高垂柳宋人多畫之

59

Methods of painting willows

There are, in general, four methods of painting wil-
lows. The first is to outline (*kou lê*) and fill in with
green. The second is to use a light, fresh green to
draw in new shoots, a fresh yellow for the tips of
new leaves, and a dark green for shadows and ac-
cents. The third method is to add a dark green to the
light-green dotting first applied, and to touch up with
ink some of the parts where the green has been ap-
plied. Lastly, some parts may be left with only a few
fine ink strokes and a bit more dotting in dark green.

Painters of the T'ang period generally used the
outline method, Sung painters usually dotted in the
leaves, and many Yüan painters drew the foliage di-
rectly in color.

In dividing the branches to indicate their outlines,
it is important to take into account how the wind
stirs and spreads the willow leaves. This is a point to
watch. In the second month, in the early spring,
branches of willows do not bend over. In the ninth
month, in the autumn, willows are past their full
growth. The two aspects should not be confused.

Among trees, willows are like Hsi Tzŭ and Mao
Ch'iang among mortals, and like Mi Fei and Lieh
Tzŭ among the immortals,[1] whose manner of cross-
ing the waters and riding the wind is reflected in the
waters at whose edge willows cluster.

Chao (Ta-nien) Ch'ien-li and Chao (Mêng-fu)
Sung-hsüeh often painted willows this way. Sung-
hsüeh, in his picture *A Hamlet at the Edge of the
Water,* painted willows in ink monochrome with a
rare subtlety. This is another way to paint willows.

Painters of the Sung period often painted willows
this way, tall with dripping foliage.

1. Hsi Tzŭ and Mao Ch'iang were famous beauties of the
v century B.C.; Mi Fei, Spirit of the River Lo, and Lieh Tzŭ,
the IV-century-B.C. Taoist philosopher.

60

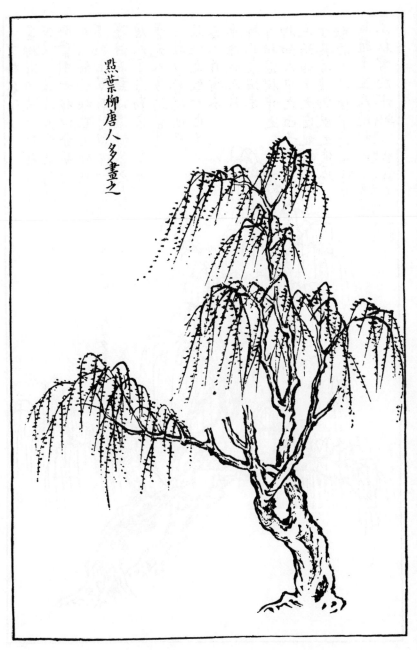

點葉柳唐人多畫之

The T'ang painters, when they painted willows, often used this dotting method for the foliage.

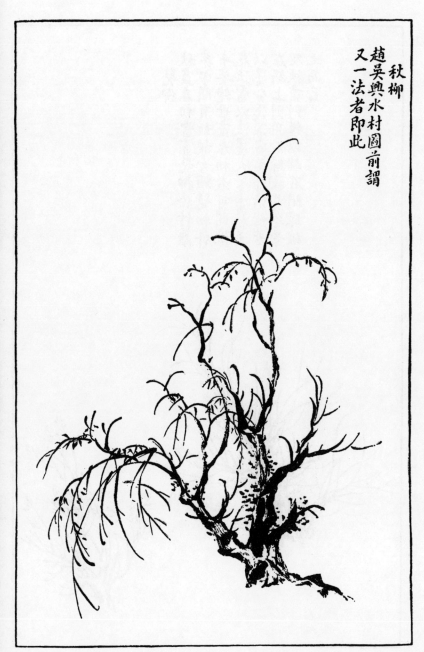

秋柳
趙吳興水村圖前謂
又一法者即此

61

Autumn willows

This is an example of willows painted by Chao (Mêng-fu) of Wu-hsing, who painted the picture mentioned earlier, *A Hamlet at the Edge of the Water*. This example is copied from that picture.

62

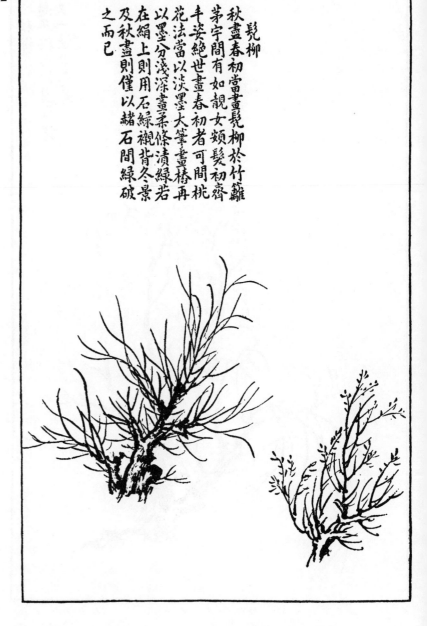

髠柳
秋盡春初當畫髠柳於竹籬
茅宇間有如靚女頻髮初
手姿絕世畫春初者可間桃
花法當以淡墨大筆畫椿再
以墨分淺深畫柔條漬綠若
在絹上則用石綠襯背冬景
及秋畫則僅以赭石間綠
之而已

Shorn willows

At the end of autumn and at the beginning of spring,
willows that look as though they had been cropped
should be painted against bamboo fences and near
hamlets; they are like a young girl whose hair has
been trimmed in a fringe on her brow. Their slender
grace is beyond words.

Willows painted in the early spring may be placed
with peach trees in blossom. The method consists of
using light ink with a free brush to draw the stems
and to indicate dark and light tones. If color is used,
paint the shoots green. If one is painting on thin silk,
mineral green may be applied on the back of the
painting. In painting winter and late autumn scenes,
for modeling use only umber mixed with a green.
That will do it!

63

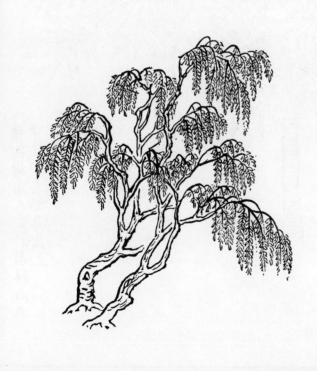

Outlining the leaves of the willow

Wang Wei and other painters of the T'ang period, as well as Ch'ên Chü-chung, painted in this style. I (Lu Ch'ai) personally find it stiff, and that is why I have put it last in this set of examples.

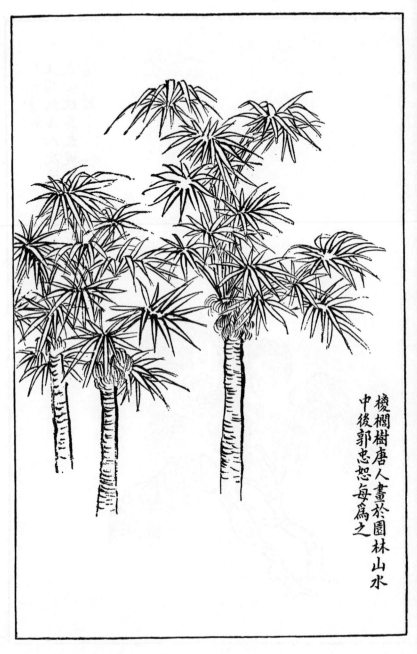

64

(Palm trees)

The painters of the T'ang period painted palms[1] in their forest and garden landscapes. Later on, Kuo Chung-shu painted them.

棕櫚樹唐人畫於園林山水
中後郭忠恕每爲之

1. *Tsung lü*, the coir palm (*Trachycarpus excelsa*) of central China.

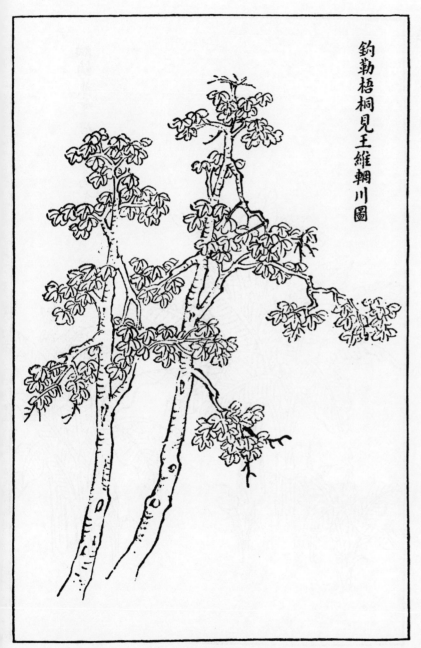

65

鉤勒梧桐見王維輞川圖

The *wu t'ung* tree [1] done in outline style (*kou lê*) may be seen in the painting by Wang Wei of his home *Wang Ch'uan*, which was also the title of the picture.

1. *Sterculia platanifolia*, the dryandra or Japanese varnish tree or Chinese parasol tree. Another *t'ung* is the woodoil (*Aleurites cordata*). The *wu t'ung* had a special significance since the phoenix of popular myths was said to have rested among its branches.

66

The painters of the T'ang period often painted
banana trees in this style of fine outlining (*hsi kou*).

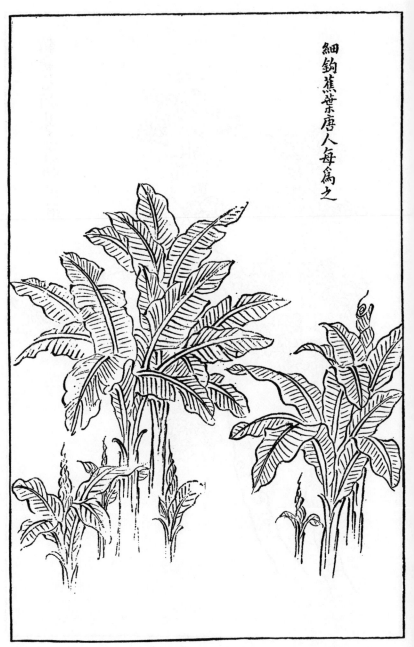

67

元人寫意梧桐或墨點
或習以綠點

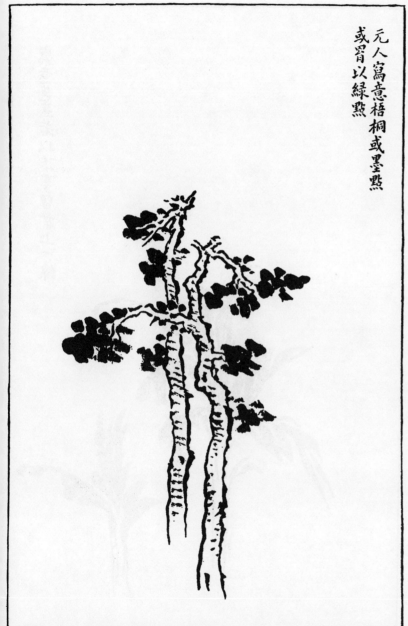

In painting the *wu t'ung* tree, the painters of the
Yüan period used the free-sketch or freehand (*hsieh
i*) [1] style, dotting in ink or dotting with ink and green.

1. Lit., "write idea or meaning." The Yüan painters fol-
lowed those of the Sung period in this style, which had been
partly a reaction to the T'ang manner of outlining.

68

If the banana tree is painted in the free-sketch manner in ink, the thin line of the central vein should be left untouched.

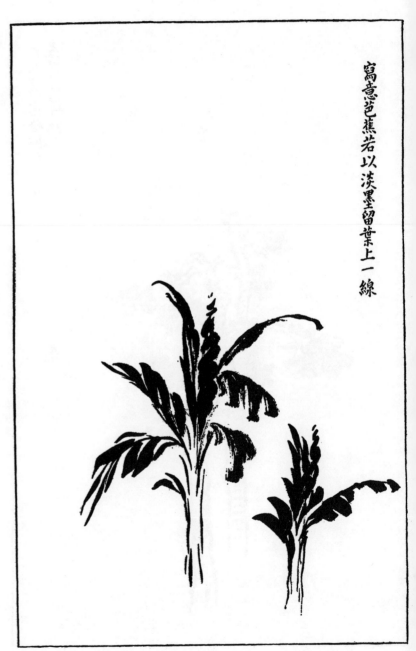

寫意芭蕉若以淡墨留葉上一線

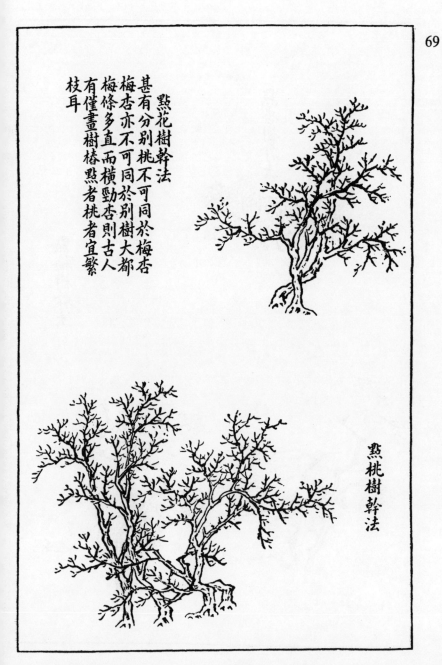

Methods of dotting fruit trees in blossom

There are many kinds of trees that blossom. The peach should not be painted to resemble the plum or apricot; these, in turn, should not be painted so they may be mistaken for other trees. Generally, the branches of the plum are characterized by a strong angular and crosswise pattern. In painting the apricot, the ancients drew in the trunk and dotted in the leaves and flowers. The branches of the peach tree, though complicated, should be clearly defined.

Dotting on branches of the peach tree.

Dotting on branches of the apricot tree.

Dotting on branches of the plum tree.

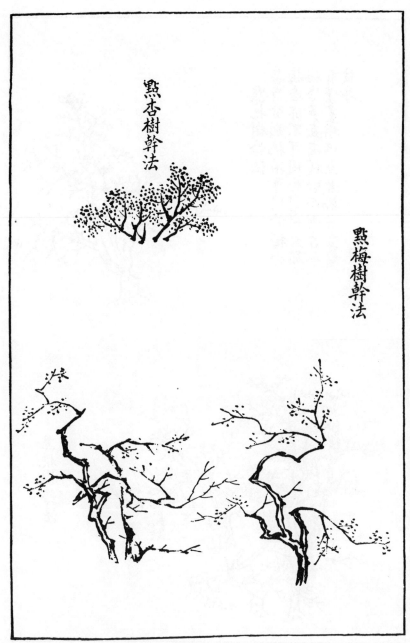

70

點杏樹幹法

點梅樹幹法

71

畫小竹法
雲林於石根樹底輒作幽
篁叢篠夕陽晚晚於茅屋
花箔間真欵欵有聲望而
知為幽人行徑要具梳風
掃月清逸之致不可龐雜
阻塞清氣畫有三種宜
視樹石之體而粗細配用
之

Method of painting young bamboos

(Ni) Yün-lin often painted a dense grove of dwarf bamboos at the foot of rocks and trees, and also sunset scenes of a hamlet around which cluster a screen of young bamboos. In looking at these bamboos, one has the feeling that they are like the hermits who follow unswervingly the *Tao*. With the power of their spirit, they could comb the wind and sweep clear the full moon. They should not be painted confused or crowded, for the air around them is clear and pure. There are three ways of rendering bamboo.[1] One should observe the trees and stones near them and match their ruggedness or delicateness.

1. *San chung* (three kinds or ways) may refer to the three manners shown in pp. 123 and 124 or to the three kinds of bamboo.

72

唐人畫樹既雙又鈎則點綴之
稚竹亦多飛白頗覺有致近
日仇十洲亦喜爲之

The painters of the T'ang period painted bamboos
in outline style [1] and filled in with color. For young
bamboos, they often used the method called *fei pai*
(flying white).[2] Today, Ch'iu Shih-chou likes to
paint in this manner.

1. *Shuang kou* (double contour or outline).
2. Brushstrokes in which the hairs of the brush separate
and produce an effect of swiftness and lightness.

畫葭葵法

宋時名手如巨然
李范諸家皆有漁
樂圖此起於煙波
釣徒張志和蓋顏
魯公贈志和詩而
志和自爲畫此唐
勝事後人蒙之多
寓意於漁隱而元
李尤多蓋四大家
皆在江南葭葵間
習知漁趣故也凡
他圖則必有主樹
至漁樂則煙波淼淼
渺樹不能爲之主
而主葭葵矣故此
作以殿草樹之後

Painting reeds and rushes

The masters of the Sung period, such as Chü-jan, Li (Ch'êng?), and Fan (K'uan?), all painted pictures entitled *The Pleasures of Fishing*. This was started by that lover of fishing known as Yen P'o, the pseudonym of Chang Chih-ho.

Yen Lu-kung presented a poem to Chih-ho, who painted a picture on the subject. This was a famous incident in the T'ang period. People after his time often tried to copy Chang and to find their pleasure in retreating to fish. In the Yüan period, there were still others. The Four Great Masters,[1] who all came from Chiang-nan (Kiangsu and Anhui), where reeds are abundant, knew the joys of fishing in solitude. In most other paintings, trees are the main interest. In pictures titled *The Pleasures of Fishing*, waves and mist are predominant; reeds and rushes, not trees, are the main focus of attention. That is why this section is placed at the end of the *Book of Trees*.

1. Chao Mêng-fu, Wu Chên, Huang Kung-wang, and Wang Mêng. Some Ming critics named Ni Yün-lin in place of Chao.

74

(Two more examples of reeds and rushes)

Book of Rocks

according to the early cosmogonic theory that the One became Two, Two became Three, and out of Three the multiplicity of things issued (*Tao Tê Ching*, Ch. 42, and *I Ching*, Appendix III). In other words, the One can only be expressed through the Three.

2. Wa Huang was the mythical Nu Wa, sister and successor of the legendary ancestor-emperor, Fu Hsi. Described as having the body of a serpent and a human head, she was a Chinese version of the snake goddess. She was connected with painting because she was said to have melted stones of the Five Colors and repaired the inverted bowl of Heaven, which had been damaged by a rebellious god.

Full title of this book: *Book of Mountains and Rocks* (*Shan Shih P'u*).

畫石起手當分三面法

觀人者必曰氣骨石乃天
地之骨而氣亦寓焉故謂
之曰雲根而無氣之石則為
頑石猶無氣之骨而可施於
骨豈有朽骨而可畫有朽
人韻士筆下乎是畫無氣
之石固不可而畫有氣之
石即覓氣於無可捉摹之
中尤難乎其難非胸中煉
有媧皇指上立有顛末未
可從事而我今以為無難
也蓋石有三面即三面者
石之凹深凸淺參合陰陽
步伍高下稱量厚薄以及
嵳頭蓋面員土胎泉此雖
石之勢也熟此而氣亦隨
勢以生矣秘法無多請以
字金針相告曰活

Indicating the three faces of a rock [1] in the first stages of painting rocks

In estimating people, their quality of spirit (*ch'i*) is as basic as the way they are formed; and so it is with rocks, which are the framework of the heavens and of earth and also have *ch'i*. That is the reason rocks are sometimes spoken of as *yün ken* (roots of the clouds). Rocks without *ch'i* are dead rocks, just as bones without the same vivifying spirit are dry, bare bones. How could a cultivated person paint a lifeless rock?

One should certainly never paint rocks without *ch'i*. To depict rocks with *ch'i*, it must be sought beyond the material and in the intangible. Nothing is more difficult. If the form of the rock is not clear in one's heart(-mind) and therefore at one's finger tips, as it was with Wa Huang,[2] the picture can never be completely realized. I have, however, at long last learned that this is not so difficult to achieve.

The three faces or aspects of a rock are to be found in the depths of its hollows and the height of its projections, in the rendering of which attention must be given to light and shadow (*yin* and *yang*), placing, and height and depth and volume. There are the following different formations of rocks: *fan t'ou* (alum head), *ling mien* (water-chestnut top), *fu tu* (half covered with earth), and *tai ch'üan* (source of a spring). While one must know the types of rocks, it is only through complete knowledge of their structure that the *ch'i* will emerge naturally as the forms are drawn.

There are not many secret methods in the painting of rocks. If I may sum it up in a phrase: rocks must be alive.

1. As with the four main branches of a tree, the principle of distinguishing the three faces of a rock (*shih fên san mien*) contains the essence of the *tao* of painting. Rendering the solidity and volume of a rock, the sculptural aspect, is achieved by drawing or "writing the form" with the brush, an art essentially of line. Rock formations and types are keenly observed, but the main concern is to transmit the living quality of *ch'i* in them. The technical and aesthetic aspects are given an extra dimension of meaning by the symbolism of the Three Faces of a Rock; the rock or mountain as the One, the *Tao*, given expression through the Three

(continued at left)

Methods of grouping and establishing the forms of rocks

2

I (Lu Ch'ai) said that the main thing in painting rocks was that they should be alive. Even before one indicates the three faces of rocks, their first outlining should be alive with *ch'i*. Each brushstroke should move and turn, with abrupt stops (*tun*),[1] sinuous as a dragon.

First, with light ink, place and outline the rocks. Then use darker tones to accent the outline. If one side is already dark enough, the other should be slightly lighter in tone to make the distinction between light and shadow and front and back.

Whether one is painting a thousand or ten thousand rocks, this step in beginning to compose them is basic. There are, however, several ways of composing a small rock among large ones or a large one among small.

Once the outlining has been done, the brushstroke for modeling (*ts'un*) should follow. Brushstroke methods vary among the different schools and the setting of the rocks determines their formations. Although there are many variations within the methods of one school, and even in the way in which rocks are painted on mountains or at the edge of water in one picture, there are in general only one or two basic ways of painting rocks.

Without going into the styles of various schools, one should mention the Mi style of painting mountains. (Mi Fei and his son) did not outline but used a method of dotting with ink in which the brushstrokes had the form of halos. This method created form not by outlining, but by building it up in strokes, layer by layer. The results had a marvelous dignity.

Group of four rocks. One rock.

(A pair.) [2]

Group of five rocks. Group of three rocks.

1. *Tun* (weight; to stop, to stamp). Here describing movement of the brush as it pauses, presses, and turns, rendering the angularity and volume of rock forms.

2. As in original editions.

130

畫石下筆法及層累取勢法

余所謂一字金針曰活者尤須於三面未分一筆初下具有磊落雄壯氣概一筆須有數頓使之嶠若游龍先用淡墨勾暎再以醮墨破之石廓如左勾眠勾背千則右宜稍淡以分陰陽向背千石萬石不外參伍其法參伍中又有小間太大間小之別畫成依有小皴漸有游及諸家鉤法不一石體因地而施即於一家之中尺幅之內或异於山或帶於水甚影不外此一二法則他即米山乃全是勾之中亦未嘗不具此法於不墨黑暈成不須勾廓者然於一層烘染處逼出其森巖也

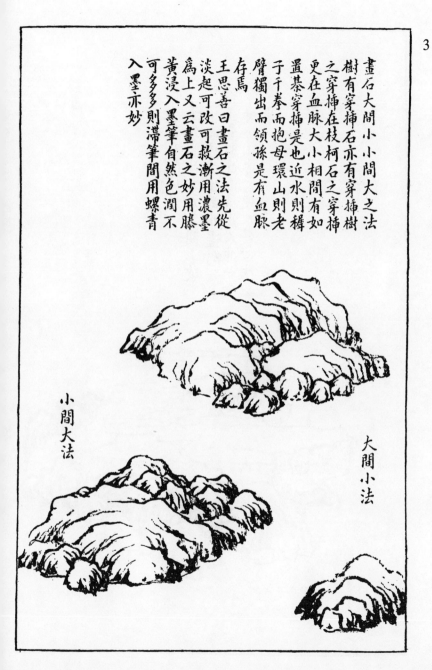

Two [1] examples of painting rocks: large rocks among small ones and small among large

Trees have one kind of intersecting lines, rocks another. In trees it is the ramification of branches, in rocks the markings of their veins. Large and small rocks mingle and are related like the pieces on a chessboard. Small rocks near water are like children gathered around with arms outstretched toward the mother rock. On a mountain it is the large rock, the elder, that seems to reach out and gather the children about him.[2] There is kinship among rocks.

Wang Ssŭ-shan (of the Yüan period) said: "In painting rocks it is best to begin by using light ink so that it will be possible to correct and make changes, then step by step to apply darker tones." He added: "In painting rocks, use rattan yellow skillfully blended with ink. The color will have a natural freshness. However, do not use too much or the brush will be overloaded. It is also good occasionally to use a touch of snail blue mixed with ink."

Example of large rocks among small ones.

Example of small rocks among large ones.

1. Original editions specify "two."
2. The distinction suggests its basis in the theory of the *Yin* (Feminine and Water Principle) and the *Yang* (Masculine and Mountain Principle).

Example of painting rocks along a slope

In painting rocks, Tzǔ-chiu (Huang Kung-wang) and (Ni) Yün-lin often placed them by slopes of earth. The scenes looked like places where one could sit or sleep. There should be such spots in landscapes, at the edge of water and under bamboos where hermits would like to linger. A painting should not depict exclusively mountain peaks and rocky wilderness that might arouse only fear in people's hearts.

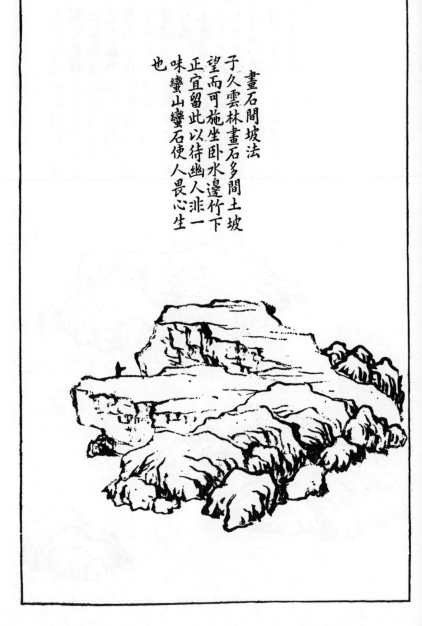

4

畫石間坡法
子久雲林畫石多間土坡
望而可施坐卧水邊竹下
正宜留此以待幽人非一
味蠻山蠻石使人畏心生
也

5

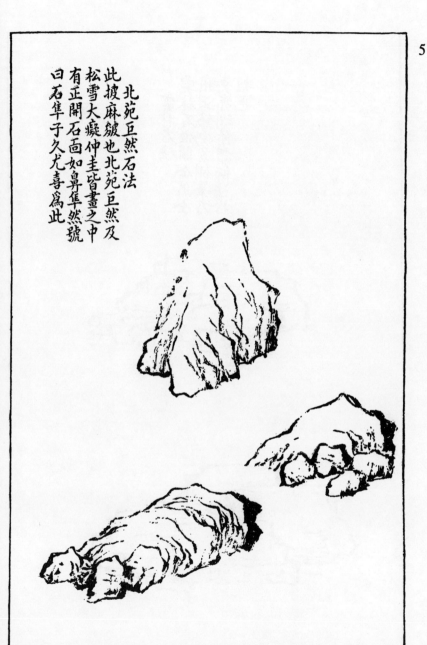

北苑巨然石法
此披麻皴也北苑巨然及
松雪大癡仲圭皆畫之中
有正開石面如鼻隼然號
曰石隼子久尤喜爲此

(Tung) Pei-yüan's and Chü-jan's style
of painting rocks

The brushstrokes for modeling in this example are
called *p'i ma ts'un* (spread-out hemp fibers). Pei-
yüan, Chü-jan, Sung-hsüeh (Chao Mêng-fu), Ta-
ch'ih (Huang Kung-wang), and Chung-kuei (Wu
Chên) all painted in this style.

In the center (of this example) is an upright rock
like the beak of a hawk. This is called *shih chun*
(rock nose).[1] Tzŭ-chiu (Huang Kung-wang) in par-
ticular liked to paint this form.

1. The nose was believed to be the first part of the body
to emerge at birth. Thus it represented a beginning and
prominence, as in the instance of drawing the dragon's nose
to symbolize the emergence of inner power.

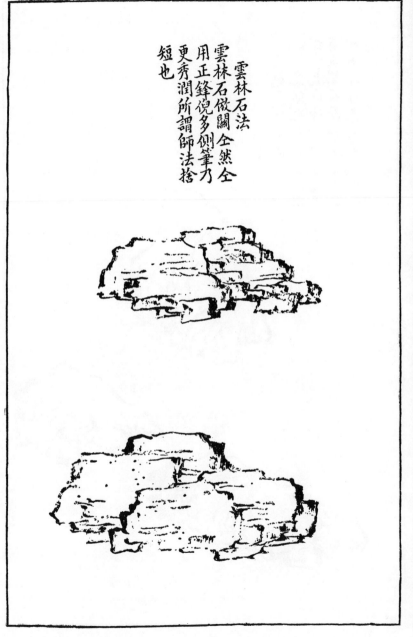

6

雲林石法

雲林石倣關仝然全
用正鋒倪多側筆力
更秀潤所謂師法捨
短也

(Ni) Yün-lin's style of painting rocks

In painting rocks, Yün-lin copied the style of Kuan T'ung. However, T'ung used the brush upright in the manner called *chêng fêng* (upright and pointed, also called *chêng pi*), while Ni more often used the brush obliquely in the manner called *ts'ê pi* (side of brush). The results were fresher and offered greater variety. As the saying goes: "Learn from the teacher but avoid his limitations."

7

他家所不及
熟且於熟處用生為
仲圭披麻皴最為純
吳仲圭石法

Wu (Chên) Chung-kuei's style of painting rocks

Chung-kuei knew so well how to use the *p'i ma ts'un* (brushstrokes like spread-out hemp fibers) that he appeared not to be making use of that stroke.[1] No other painter has equaled him in using this brushstroke for modeling.

1. As Lu Ch'ai said in his introductory remarks, "The end of all method is to seem to have no method."

135

8

王叔明石法
此披麻帶解索皴也
獨黃鶴山樵畫之山
樵爲松雪甥畫乃追
踪松雪而石有出藍
之譽

Wang Shu-ming's style of painting rocks

Here is an example of *p'i ma ts'un* (brushstrokes like spread-out hemp fibers) combined with *chieh so ts'un* (brushstrokes like raveled rope). Huang-ho Shan-ch'iao (Wang Mêng, *tzŭ* Shu-ming) was the nephew of Sung-hsüeh (Chao Mêng-fu). He followed the style of his uncle. In painting rocks, as the saying goes about blue,[1] he was superior even to his master.

1. *Ch'ing ch'u yü lan* (as green comes from blue and is superior to it).

9

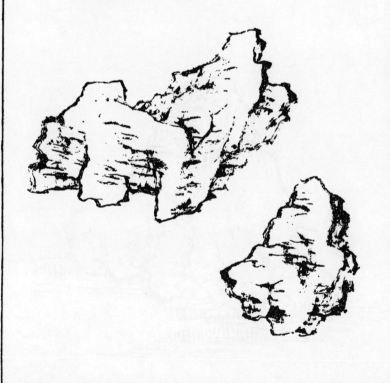

黃子久石法
子久常熟人有謂其畫多
作虞山石層層駘蕩者如
王宰蜀產多畫蜀中山水
玲瓏嵌空峴嶕巧峭各因
所見其語良是故子久實
本石法於荊關而自為減
躴笔如畫沙益見高簡

Huang (Kung-wang) Tzŭ-chiu's style of painting rocks

Tzŭ-chiu was from Ch'ang-shu (in Kiangsu), and it is said that he always painted the rocks of the Yü Mountains, the ranges of which were broad and magnificent. Wang Tsai, whose home was in Shu (Ssŭ-chuan), usually painted the landscape of Shu with its steep rocky mountain ranges, the forms of which appear to be skillfully hewn and carved. They painted scenes they knew well.

Tzŭ-chiu certainly learned thoroughly the methods of painting rocks of Ching (Hao) and Kuan (T'ung), after which he modified the style as he wished. His brush was so forceful that it seemed he wielded the tool of a sculptor. The results were evidence of his skill and taste.

Style of the two Mi's in painting rocks

Here is an example of the Mi style of dotting (*tien*) combined with a few *chih ma ts'un* (brushstrokes like sesame seeds). In painting lofty peaks and deep forests the Mi's [1] used this method, applying the strokes dot by dot and layer by layer. Their aim was to suggest mist and moistness. The manner in which the angles and corners of rocks were painted is hidden, but on closer examination of the outlines it may be seen that the brushstrokes were the kind called *p'i ma ts'un* (spread-out hemp fibers).

[1]. "Yüan-hui father and son." Mi Fei's *tzŭ* Yüan-chang and that of his son Yu-jên, Yüan-hui. The examples on p. 181, below, illustrate more vividly the Mi style.

10

麻
也

然
視
其
睚
眶
下
手
處
實
披

潤
爲
主
雖
不
露
石
法
稜
角

時
一
置
之
僧
層
點
染
以
煙

元
暉
父
子
於
高
山
茂
林
中

此
米
點
而
微
間
芝
麻
皴
也

二
米
石
法
麻
皴
也

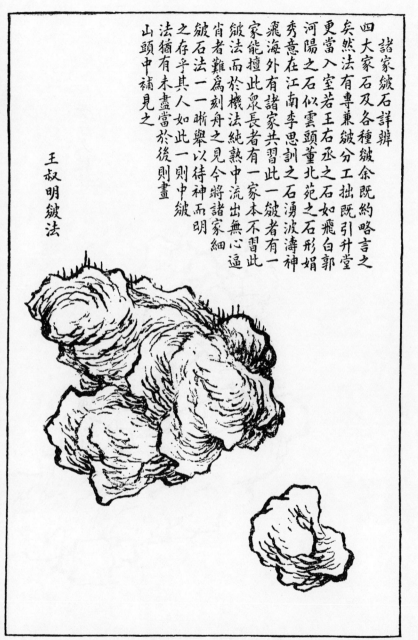

諸家皴石詳辨
四大家石及各種皴
矣然法有專兼皴分工拙既引升堂
更當入室若王右丞之石如飛白郭
河陽之石似雲頭董北苑之石形娟
秀意在江南李思訓之石湧波濤神
飛海外有諸家共習此一皴者有一
家能擅此衆長者有一家本不習此
皴法而於機法純熟中流出無心逼
肖者難為刻舟之見今將諸家細
皴石法一一晰舉以待神而明
之存乎其人如此一則中皴
法猶有未盡當於後則畫
山頭中補見之

王叔明皴法

11 **Details of the brushstroke methods of various schools**

I have mentioned some of the brushstroke methods used in painting rocks by masters of four main schools. There are many ways of combining different kinds of brushstrokes depending on the skill of the painter. Having examined some styles of brushwork, we should now continue.

Wang (Wei) Yu Ch'êng in painting rocks used the style called *fei pai* (flying white).[1] Kuo (Hsi) Ho-yang painted rocks in the style called *yün t'ou ts'un* (brushstrokes resembling cloud heads). Tung Pei-yüan's rocks, so elegant in form and style, are typical of Chiang-nan—"south of the River" (Kiangsu and Anhui). Li Ssŭ-hsün's rocks had forms like surging billows and their spirit seemed to soar beyond the oceans. There were painters who used one kind of brushstroke and others who perfected a repertory of several kinds. There have also been masters who at the start did not use any particular kind of brushstroke, but in the course of their experience developed specific types of strokes. One need not, however, make things more difficult by following such a procedure, which would be like imitating the man who made a hole in the boat to mark the spot where his sword had dropped into the water.

I shall now continue and show one by one the fine brushstroke styles of various schools. To what degree they may be learned is dependent on the capacity of the individual. Up to this point the examples are incomplete but later, in the section about painting the summit of mountains, I shall add the rest.

Brushstroke style of Wang (Mêng) Shu-ming

1. See p. 124, above.

12

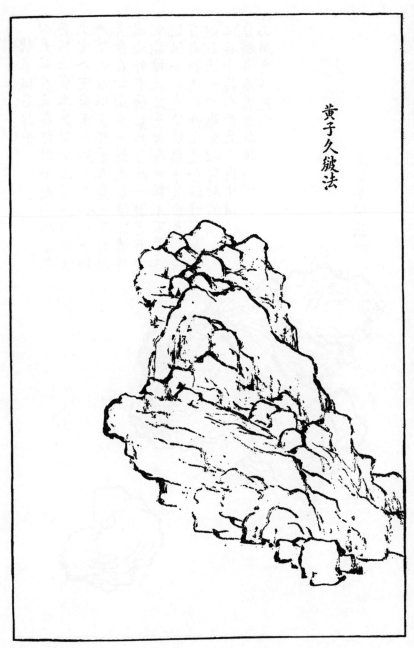

黄子久皴法

Brushstroke style of Huang (Kung-wang) Tzŭ-chiu

13

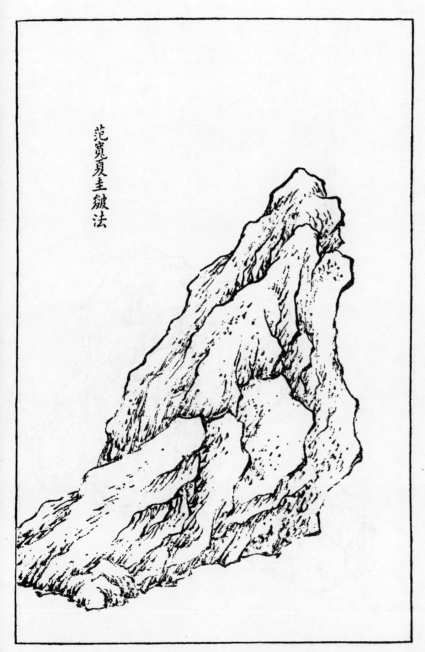

Brushstroke style of Fan K'uan and
Hsia Kuei

14

荊浩關仝皴法

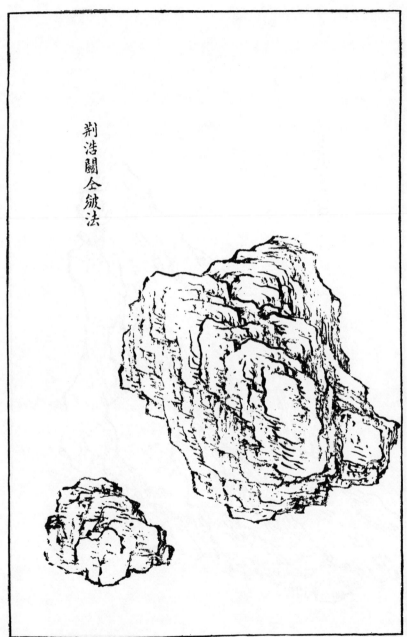

Brushstroke style of Ching Hao and
Kuan T'ung

15

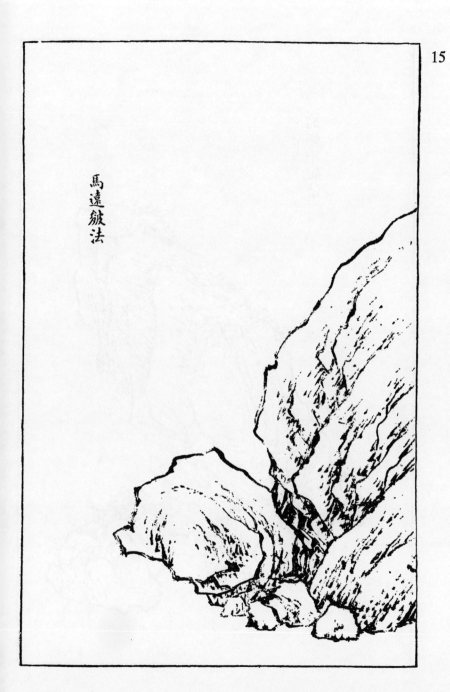

馬遠皴法

Brushstroke style of Ma Yüan

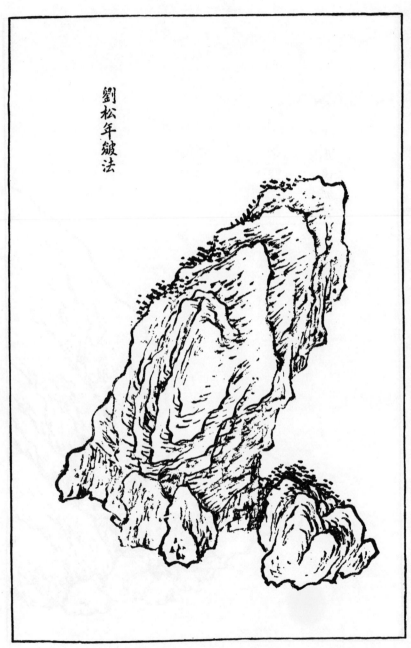

16

劉松年皴法

Brushstroke style of Liu Sung-nien

17

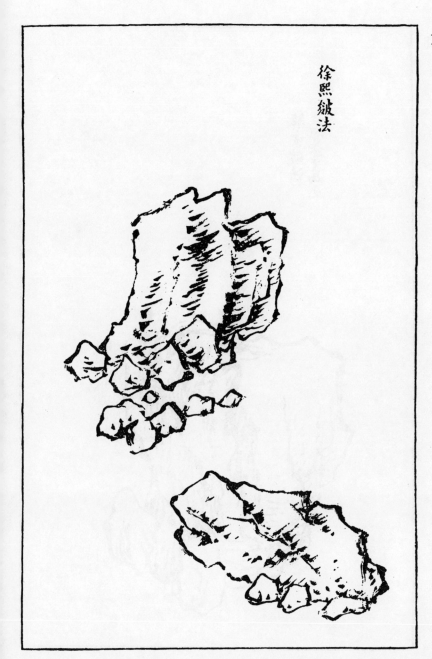

徐熙皴法

Brushstroke style of Hsü Hsi

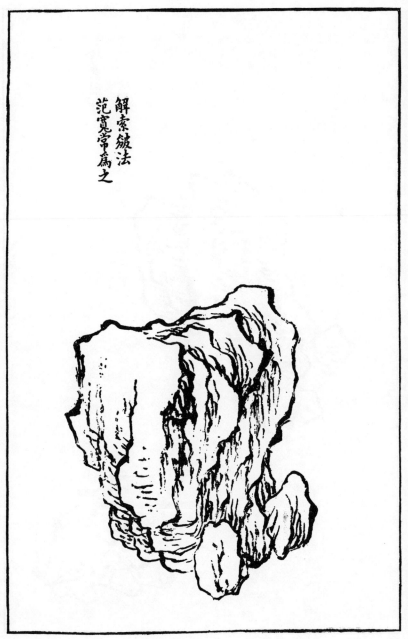

18

解索皴法
范寬常扁之

Example of *chieh so ts'un* (brushstrokes like raveled rope)

Fan K'uan often used this brushstroke.

19

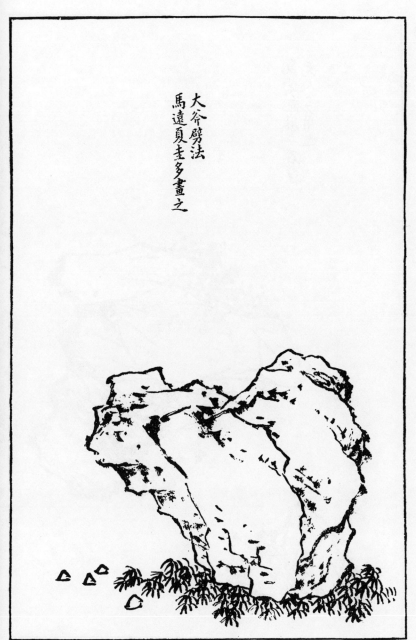

大斧劈法
馬遠夏圭多畫之

Example of *ta fu p'i ts'un* (brushstrokes like big ax cuts)

Ma Yüan and Hsia Kuei often painted in this style.

20

Example of brushstrokes called *luan ch'ai ts'un* (like brushwood in disorder) and *luan ma ts'un* (like hemp fibers in disorder)

Painters of the Yüan period often used this combination.

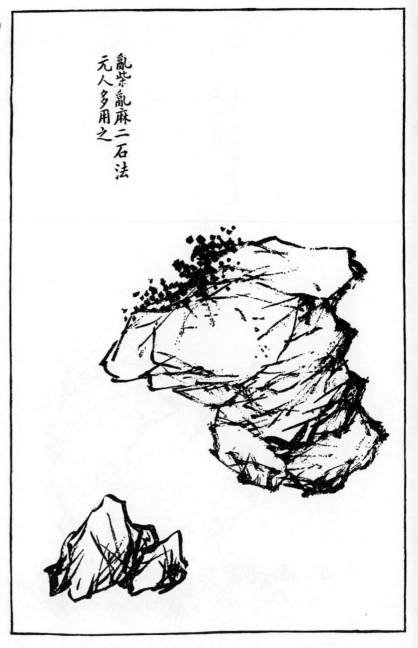

21

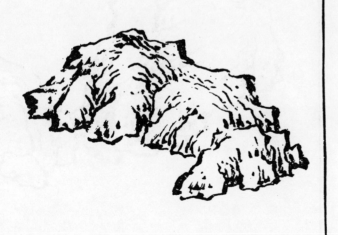

小斧劈法
本自劉松年李唐
唐寅學之深得其
與周東村沈石田
皆用之

Example of *hsiao fu pi ts'un*
(brushstrokes like small ax cuts)

After Liu Sung-nien's time, Li T'ang and T'ang Yin
learned to paint in this manner. They discovered the
secret of his style. Chou Tung-ts'un and Shên (Hao)
Shih-tien also painted in this manner.

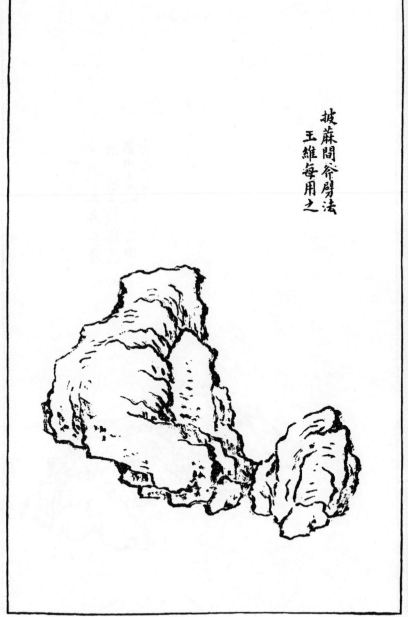

22

披蘇間斧劈法
王維每用之

Example of combining *p'i ma ts'un*
(brushstrokes like spread-out hemp
fibers) and *fu p'i ts'un* (brushstrokes
like ax cuts)

Wang Wei often used this combination.

23

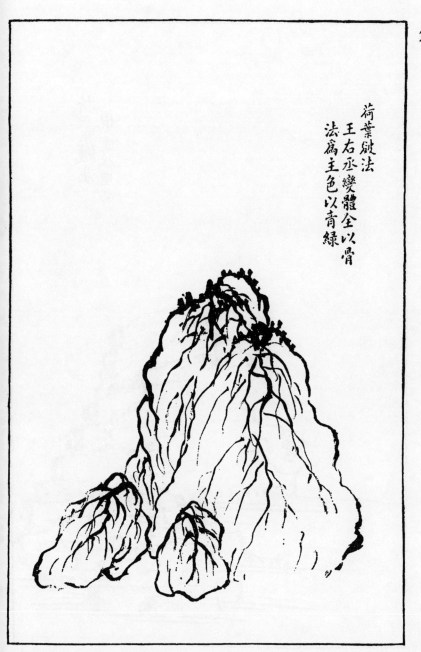

荷葉皴法
王右丞變體全以骨
法為主色以青綠

Example of *ho yeh ts'un* (brushstrokes like veins of a lotus leaf)

This is a modification of Wang (Wei) Yu Ch'êng's style of painting rocks. Here the principle of basic structure (*ku fa*) is supreme. If color is used, apply blue and green.

24

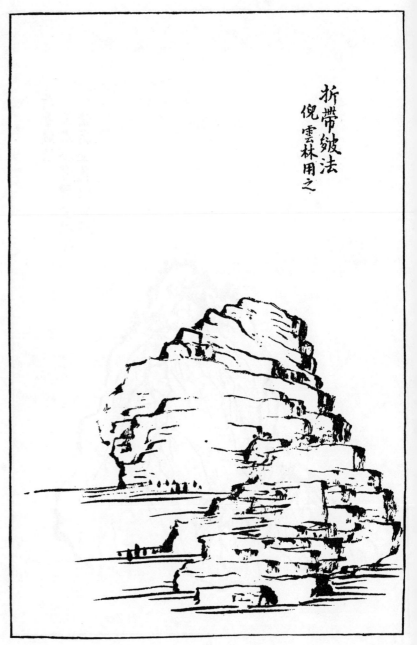

Example of *chê tai ts'un* (brushstrokes
like iron bands)

Ni Yün-lin used this brushstroke.

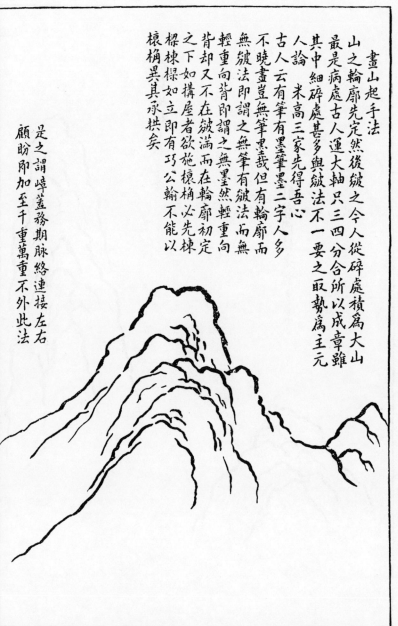

25 Method of beginning to paint mountains

First, establish the outline called *lun k'uo* (wagon-wheel rims); after this come the brushstrokes used in modeling (*ts'un*). Painters today are inclined to start here and there on a picture and, in building up a mountain, add a little bit first in one place and then in another. This is the wrong way to begin. The ancients worked on large scrolls and divided the space into three or four main parts. This is how they managed to accomplish what they did. Although their pictures contained many details and often several kinds of brushstrokes, the important fact was their knowledge of the structure and integration (*shih*) of the whole composition.

Yüan painters declared the three masters closest to their hearts were the two Mi's and Kao K'o-kung.

The ancients spoke of the principle *yu pi yu mo* (to have brush, to have ink). People do not know much about the two terms "brush" and "ink." But how can there be painting without brush and ink? When there is outline but no brushstrokes in modeling, that is *wu pi* (not having brush); when there is knowledge of brushstrokes for modeling but no indication of light and dark tones or of volume and depth, that is *wu mo* (not having ink). The tones indicating volume and depth are not to be found only in the brushstrokes for modeling; they should be present in the sketching in of the outline. As in building a house, the beams must be in place before putting up the rafters; and when the beams are in place, even a skillful Kung Shu [1] cannot change the basic structure by the way he puts in the rafters.

This is an example of the method called *chang kai* (encompassing the mountain range), in which the outline envelops all the peaks in one composite and crowning peak. Adding the strokes, the *mo lê* (veins and arteries), connects and balances the peaks to left and to right. Whether one draws one thousand or ten thousand more peaks, all are based on this method.

1. Lu Pan, god of carpenters.

153

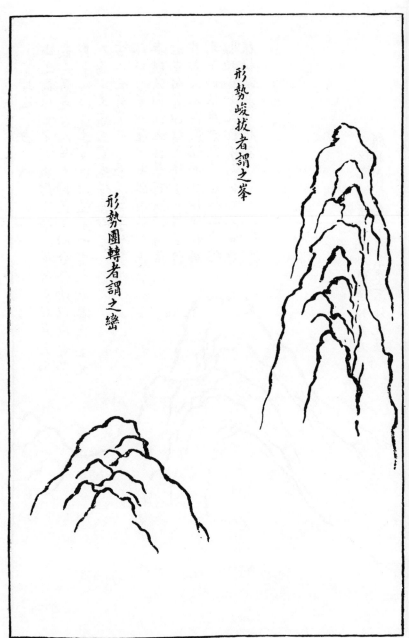

26

A steep, erect peak is called *fêng* (pointed).

A peak with a rounded summit is called *luan* (rounded).

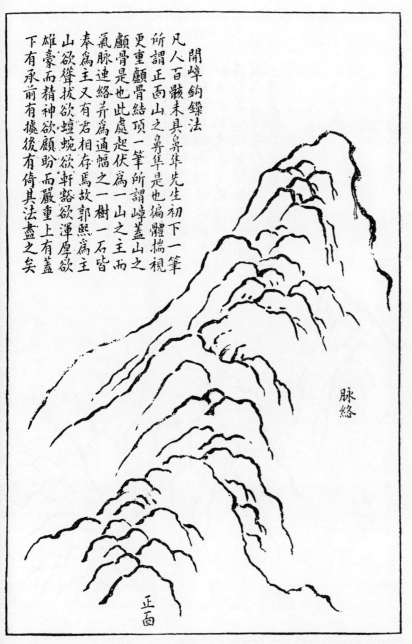

開嶂鉤鐩法

凡人百骸未具鼻隼先生初下一筆
所謂正面山之鼻隼是也偏體端視
更重顛骨結頂一筆所謂嶂蓋山之
顛骨是也此處起伏爲一山之主而
氣脉連絡亓爲通幅之一樹一石皆
奉爲主又有君相存焉故郭熙爲主
山欲聳拔欲蟬蜿欲軒豁欲渾厚欲
雄豪而精神欲顧盻而嚴重上有蓋
下有承前有據後有倚其法盡之矣

脉絡

正面

27 Method of establishing the outline and interlocking brushstrokes [1]

In human beings, before the hundred bones of the body are formed, the nose first begins to take shape. In the drawing of mountains, the first brushstrokes outlining the central peak, as it were, on the face of the mountain, are called *pi chun* (hawk's beak).[2]

In estimating the body of the mountain and placing its head, the brushstroke over the top, called *chang kai* (encompassing the mountain range), is the top of the skull of the mountain. This is the dominating form of the mountain, but its *ch'i* is in the joining of brushstrokes like veins. Other features of the picture, whether tree or rock, pay homage to the summit. The relationship is like that between an emperor and his ministers. For this reason, when Kuo Hsi painted mountains, he made the main one lofty, vibrant, expansive, sturdy, heroic, and also with an air of spiritual purity. It is essential that this all-encompassing outline is used and that there is support below, in front, and in back.

Outlines of peaks resembling veins (*mo lê*).

The face of a mountain.

1. *Chang kai* (the encompassing outline of a range); *kou so* (interlocking strokes outlining peaks); the analogy of the dome of Heaven, the head, and the *Tao* is the thread of this explanation.
2. See p. 133, above.

Method of rendering the ceremonial aspect [1] of mountains

28

Mo-chieh (Wang Wei) said: "To paint mountains, one must first know their spiritual forms [2] and so be able to distinguish between the pure and impure elements. One may then determine the various attitudes of the peaks and select the position of the host and the guests. When there are too many peaks the effect will be confused; too few, the effect will be dull."

Among mountains there are peaks which are high and others which are low. On a high peak the veins are at the base and the limbs [3] are spread out; the base is thick and strong, encircled by numerous peaks with rounded summits. This is the appearance of a high peak, and certainly it must be so, otherwise it would be isolated and abandoned. On a low peak the veins are at the top and the summit is flat, giving an impression that the top and brow are touching; the base is wide and extensive, firmly implanted in the earth, so that it is impossible to measure. This is the appearance of a low peak, and certainly it must be so, otherwise it would be thin and feeble.

In order to make clear the use of the *lun k'uo* (wagon-wheel rims) and the *mo lê* (veins) outlines, the brushstrokes for modeling (*ts'un*) are not included here. There are many kinds of such brushstrokes, as shown in the examples of rounded peaks copied from works of the masters.

1. Lit., "host and guest bowing to each other."
2. *Ch'i hsiang*, "the forms of their *ch'i*"; literally "symbols of their *ch'i*"; distinct from *ch'i ku* (*ch'i* of bone, the structural *ch'i*), as on p. 129, above, where it is used in reference to people and rocks; and distinct also from *ch'i shih* (structural integration or style based on *ch'i*), as on p. 217, below, where it is used in an analogy of clouds and people with *wên shih* (air or style of being cultured, the result of possession and cultivation of one's *ch'i*).
3. Original editions: *kung* (arms); Shanghai edition: *ku* (legs).

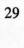

29

30

Example of a main peak in itself a mountain

The preceding pair of examples showed the grouping of guest peaks to create the atmosphere of a mountain range.[1] Here is one example of a main peak that constitutes the whole mountain. As it raises its head and spreads its arms, all the forms are included and united within it. There is no need of superfluous scenery. As for the picture, the effect will be massive. The main intention has been to render clearly and without embellishment.

Compare this example with the preceding example, in which the mountain is like a great emperor presiding in his audience hall, the ministers prone around him. In this picture, the mountain is like an emperor deep in silent thought at a moment when he is alone in his palace. Wang (Wei) Yü Ch'êng often painted a mountain like this one.

主山自為環抱法
前圖猶藉客峯以成氣象茲則特舉主山
自為環抱一法以其昂首舒臂眾象包羅
無暇外景畫中更為深嶪所謂直賦本事
無暇襯貼者是與前則大君臨明
堂摩侯朝拱此則蒸黙思道深宮獨處之
時為王右丞嘗用此畫主山

1. Again *ch'i hsiang* (see p. 156 n, above), in the sense of "circumstances, manner," significant in its literal meaning of "symbols of the *ch'i*" of a mountain range.

31

又賓主朝揖法

Another aspect of the host-guest relationship
among mountain peaks

32

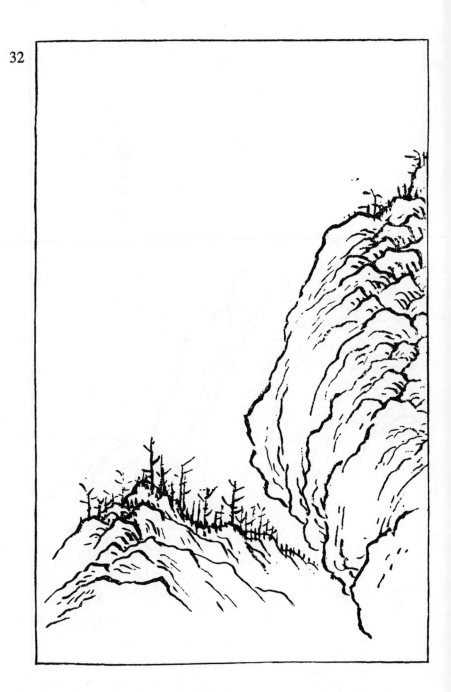

33

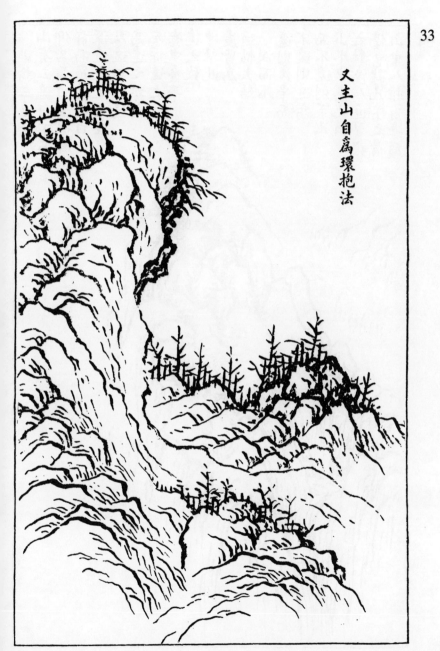

又主山自為環抱法

Another example of a main peak as
a mountain

Remarks about the three types of mountain perspective

Mountains have three kinds of perspective: looking at a peak from base to top is called *kao yüan* (high distance or perspective in height); looking across from a mountain in the foreground to mountains in the back of a painting is called *shên yüan* (deep distance or perspective in depth); and looking from a place in the foreground into the far distance across a flat landscape is called *p'ing yüan* (level distance or perspective on the level).

A painting of a mountain with perspective in height presents a precipitous view; with perspective in depth gives an effect of a repetition of planes; and with perspective on the level the effect is of a flat landscape extending into a vast distance. These principles control the whole composition of a picture. If the mountain is massive (deep) but is drawn without perspective, it will appear flat; if it extends horizontally but is drawn without perspective, it will appear to be too close; if it is high but is drawn without perspective, it will appear low. When these faults are made in a landscape painting, they are like vulgar and shallow characters, or like runners and menials (who are crude and insensitive). When the hermits in these pictures see such things, it is enough to make them abandon their families, flee their huts, and, holding their noses, run away as fast as they can!

Example of *kao yüan*

34

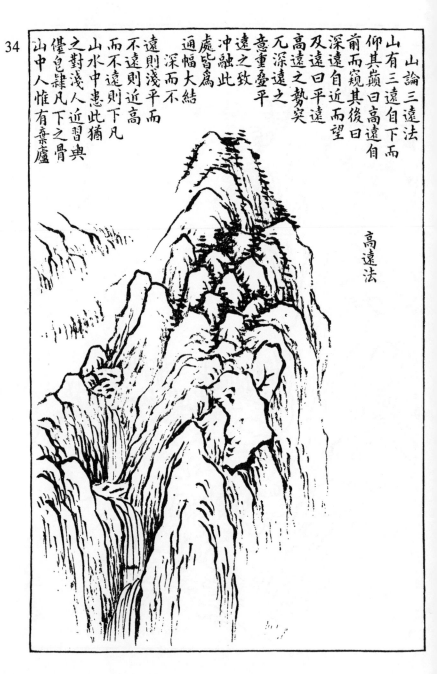

山論三遠法
山有三遠自下而
仰其巔曰高遠自
前而窺其後曰
深遠自近而望
及遠曰平遠
高遠之勢突
兀深遠之意
重疊平遠之
致沖融此
處皆爲
通幅大結
深而不
遠則淺平而
不遠則近高
而不遠則下凡
山水中惠此猶
之對淺人近凡
之習氣下之骨
僅皂隸凡
山中人惟
有裹廬

高遠法

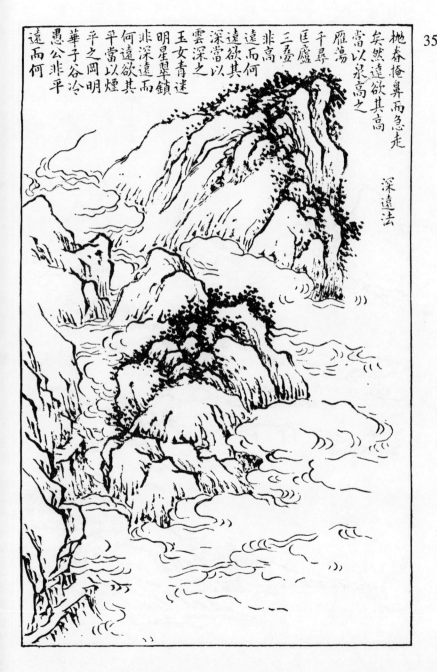

When mountains are drawn with perspective and one wishes to accentuate their loftiness, they may be made to appear higher and grander by drawing in springs and waterfalls; wild geese may be drawn flying around the base of mountains of a thousand *hsin*,[1] and huts may be placed at three different levels on the mountain. If this doesn't convey perspective in height, what does? When mountains are drawn with perspective and one wishes to emphasize their depth, clouds will help the effect, also Yü Nü (Jade Lady, the moon) veiled by mists and bright stars imprisoned at the summit of the mountains. If this doesn't convey perspective in depth, what does? When mountains are drawn with perspective and one wishes to emphasize their range and extension, they can be made to spread out even more expansively by the suggestion of mists; flowers and their companions, cranes, may be drawn on knolls or ridges, and Yü Kung[2] resting in the valley. If this doesn't convey perspective on the level, what does?

Example of *shên yüan*

1. A *hsin* is about 9½ feet.
2. A legendary giant of the valley of Mount Pei.

163

ROCKS

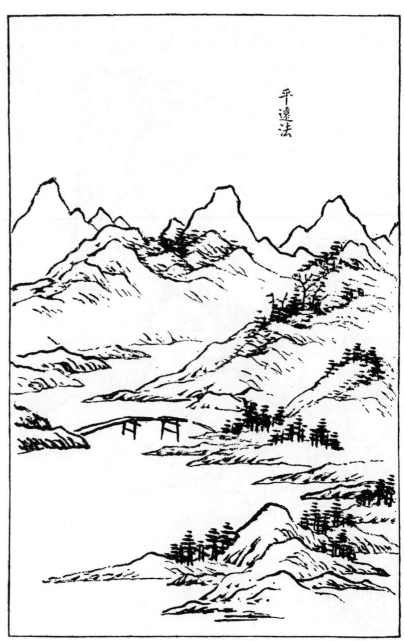

Example of *p'ing yüan* (perspective on
the level)

164

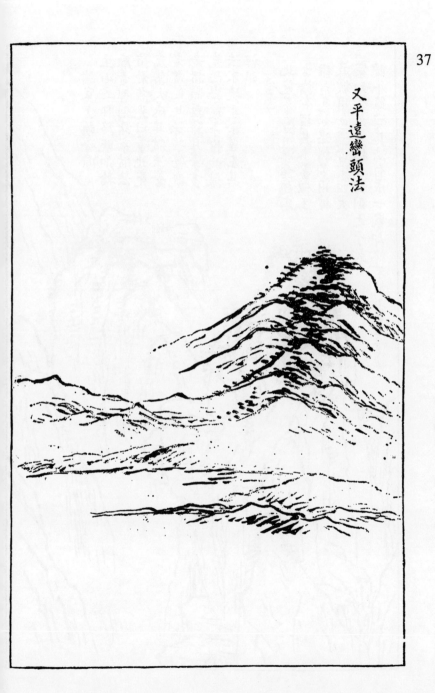

又平遠巒頭法

37

Example of *p'ing yüan* perspective toward rounded peaks

Various masters' styles in painting rounded peaks (*luan t'ou*)

When one has learned how to draw the *mo lê* (veins) of a main peak, the next step is usually the rendering of the *lun k'uo* (wagon-wheel rims) outline. After that, it is a question of which school to follow in brushwork. Tung Pei-yüan is a good example of a painter who mastered all the various kinds of brushstrokes; his brushwork is well worth serious study. And this is a good point at which to start.

When one has experience in handling the brush, the variety of styles will not seem so difficult. While learning, however, one should be careful not to acquire bad habits of the hand and wrist. The brushwork methods shown here cannot develop bad habits in brushstrokes. How could I lead you astray (when I have selected examples from established masters)?

Example of the style of Tung Yüan (*tzǔ* Pei-yüan)

Pei-yüan's rounded mountain peaks have a purity and profundity of conception as great as that found in the works of the ancients. The critics consider his ink paintings to be like the work of Wang Wei, and those in color like (Li) Ssǔ-hsün's. He often used *p'i ma ts'un* (brushstrokes like spread-out hemp fibers), using few strokes [1] and color quite thickly.

The Four Great Masters of the Sung period [2] and Tzǔ-chiu (Huang Kung-wang) and (Ni) Yün-lin all worked in this manner. Tzǔ-chiu in his later years changed his style, however, and himself founded a school; but he did not go beyond this point.

1. Three characters are missing which in the original editions specify "very few lines" or *ts'un* (brushstrokes for modeling).
2. Lu Ch'ai was probably referring to Ching Hao, Kuan T'ung, Tung Yüan, and Chü-jan, often mentioned together in the records and in the Manual; he was, in fact, quoting Ming and Ch'ing critics. The Sung masters were so numerous it would be difficult to pick the four outstanding.

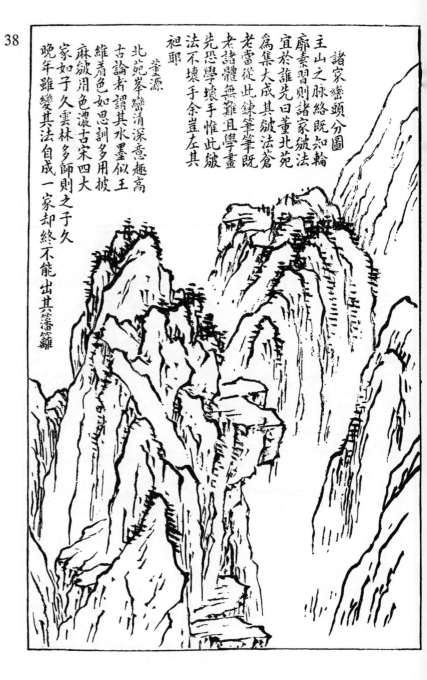

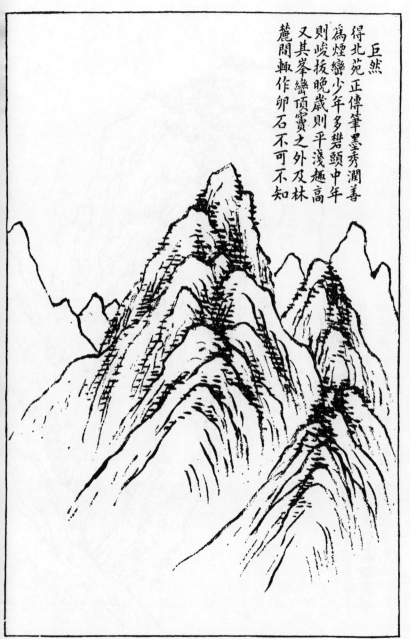

巨然
得北苑正傳筆墨秀潤善
為煙巒少年多礬頭中年
則峻拔晚歲則平淺趣高
又其峯巒頂寶之外及林
麓間輒作卵石不可不知

Chü-jan

He followed directly the style of Pei-yüan, and his brush and ink were fresh and delicate. He excelled in depicting rounded peaks shrouded in mists. In his early period he often used the brushstrokes for modeling called *fan t'ou* (alum lumps); the pictures of his middle period are notable for their high precipitous mountains. In his later period, he liked to paint mountains rising suddenly in a flat landscape. A characteristic feature of his work is the manner in which he painted rounded rocks at the edge of hollows on mountain peaks, and at the base of trees along ridges and at the foot of hills. Note this.

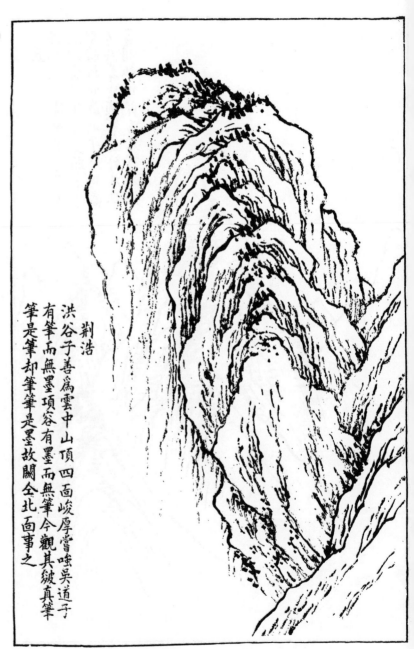

40

荆浩

筆是筆却筆筆是墨故關仝北面事之
有筆而無墨項谷有墨而無筆今觀其皴真筆
洪谷子善爲雲中山頂四面峻厚嘗唉吳道子

Ching Hao

Hung Ku-tzǔ (Ching Hao) excelled in painting mountain tops among clouds. Their forms were steep and sturdy. He once laughed at Wu Tao-tzǔ and said that he "had brush" but "did not have ink." He also said of Hsiang Jung that he "had ink" but "did not have brush." Now, on examining his brushwork, it is evident that he "had both brush and ink." For this reason, Kuan T'ung studied and followed his methods.

41

關仝
仝師浩晚年有出藍之譽脫略毫楮
筆簡而愈壯景少而愈長輪廓較多
玉印疊疊素雅秀無比也李成師事之
郭忠恕亦宗其法

Kuan T'ung

T'ung took (Ching) Hao as his master, and in his later years he surpassed him and was accorded greater praise.[1] Although in his later period he painted less, his brushwork remained powerful and eloquent. His landscapes were therefore fewer in number, but in quality they were superior to his earlier works. Often his outlines (*lun k'uo*) of mountains were touched with snow, a characteristic elegant beyond words. Li Ch'êng chose him as his master, and Kuo Chung-shu also followed T'ung's style.

1. Two characters of the last phrase are missing in the Shanghai edition; they follow the expression about "green out of blue," indicating superiority in skill and results, and add that he was eulogized for it. (See pp. 94 n and 136, above.)

42

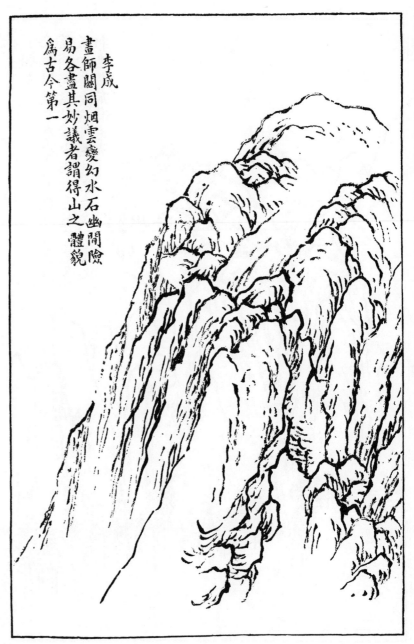

畫師關同烟雲變幻水石幽間險
易各畫其妙議者謂得山之體貌
爲古今第一

李成

Li Ch'êng

His paintings were done in the style of Kuan T'ung. In them the clouds and mists seemed to shift and change constantly. His rendering of water among rocks expressed the solitude of lonely, secret places. He was as skillful in painting rugged and dangerous places as in painting safe and peaceful scenes. The critics say that he, of all painters since antiquity, understood and rendered the form and substance of mountains.

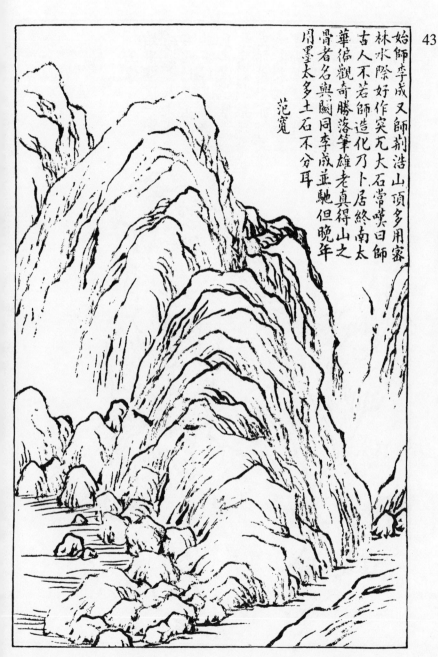

Fan K'uan

At first he painted in the style of Li Ch'êng; later he followed the style of Ching Hao. He liked to paint many trees on the summits of mountains and large flat rocks at the water's edge. He is said often to have sighed and remarked, "It is not as easy to learn from the ancients as from nature." He lived at Tai Hua, near Chung-nan (Mountain?, Shensi), where on all sides he could look out at the wonders of nature. His brushwork was truly powerful and imaginative; he really grasped the structure of mountains. His fame equaled that of Kuan T'ung and Li Ch'êng. In his later years, however, he was inclined to use too much ink, so that there was not enough distinction between earth and rocks in his paintings.

44

Wang Wei

At first he used light washes (*hsüan tan*) and then, quite suddenly, he changed his method and used the outline method with sharp-angled, and choppy strokes (*kou cho fa*). Yu Ch'êng (Wang Wei) started what has since been called "the literary man's style of painting" (*wên jên hua*), which has also been described as "the Southern School style." Prominent among those who carried on this style of painting were Tung (Yüan), Chü(-jan), Li Ch'êng, and Fan K'uan. Ching (Hao), Kuan (T'ung), Chang Tsao, Pi Hung, and Kuo Chung-shu also followed his methods. So did the two Mi's, Wang (Hsin) Chin-ch'ing, Li Lung-mien, Chao (Mêng-fu) Sung-hsüeh, and painters through Chü-jan, down to the Four Great Masters of the Yüan period, Huang (Kung-wang), Wang (Mêng), Ni (Yün-lin), and Wu (Chên), who may be considered direct descendants (of Wang Wei). In the Ming period, Wên (Pi) and Shên (Chou), though later in time, "inherited the mantle and bowl." [1]

1. *Chieh i po*, one who has been initiated into a sect or appointed successor in order to transmit a doctrine.

衣鉢塵土矣仙輩日就孤禪北宗雅以至戴文進吳小做之得其工未得其錢舜舉友仇十洲俱宗思訓元之丁野夫夏圭李唐劉松年皆是傳號小李將軍宋亦力視父為未及却亦道稍變其勢者思筆總不能夢見其子昭着色工畫往往宗之滿中氣勢峻嶒後人家法却肉中有骨豐將軍善用金碧為一勁是為北宗號大李小斧劈皴也筆極遒李思訓

45

Li Ssŭ-hsün

He used the *hsiao fu p'i ts'un* (brushstrokes like small ax cuts). His brushwork was vigorous, and the style has come to be known as "the Northern School style." He was called "Big General Li." He was expert in painting landscapes in the *chin pi* (gold-green) style,[1] and started a school working in this manner. There was bone under the flesh in this style, that is, structure as well as decoration. Although this was an ornate style, it also had spirit (*ch'i*) and vitality.

Those who followed this style worked in what is called the *kung hua* (detailed and precise) manner. They were never able to equal Li. His son, Chao-tao, also worked in this style though he modified it. Critics speak of the similarity in brush power (*pi li*) of father and son, but actually there is no comparison; the elder Li was far superior. Even the nickname was transmitted, however, and the son was called "Little General Li."

In the Sung period, (Chao Kan),[2] Chao Po-ch'ü, (Chao) Po-su, Ma Yüan, Hsia Kuei, Li T'ang, and Liu Sung-nien all followed (Li) Ssŭ-hsün. In the Yüan period, Ting Yeh-fu, Ch'ien Shun-chü, and Ch'iu (Ying) Shih-chou were his followers. Although they all worked in Li's style, they lacked his skill. With Tai Wên-chin, Wu Hsiao-hsien, and (Chang P'ing-shan) [3] came the day when the marvels of the Northern School style finally dissolved into dust.[4]

1. Filling in with blue and green, outlining in gold.
2. As in the original editions.
3. As in the original editions.
4. Lit., "mantle and bowl became dust."

46

唐
擴
思
訓
之
皴
而
盡
筆
力
以
驣
之
又
變
小
斧
劈
而
為
大
斧
劈
矣
宋
徽
宗
云
近
日
李
唐
可
比
思
訓
時
號
二
李
劉
松
年
原
師
張
敦
禮
神
氣
精
妙
名
過
於
師
後
又
將
二
李
之
大
小
斧
劈
而
鎔
為
一
家
李
唐

Li T'ang

T'ang developed the brushwork style of (Li) Ssŭ-hsün, and his *pi li* (brush power) grew to equal Li's. He made a slight change by substituting "big ax cuts" brushstrokes for modeling in place of the ones like "small ax cuts."

Emperor Hui Tsung of the Sung dynasty said: "Li T'ang may be considered equal to Ssŭ-hsün." From that day they have been spoken of as "the two Li's."

Liu Sung-nien at first studied with Chang Tun-li.[1] His paintings had skill and *ch'i,* and his reputation far surpassed that of his master. Later he took the style of the two Li's, using both kinds of "ax cuts" strokes and combined them in a new manner.

1. See text of next example.

47

劉松年

松年思張訓禮舊
名教禮避光宗諱
故改今名張學李
唐今人只知松年
之畫上追思訓而
不知河源之溯實
賴乎張

Liu Sung-nien

Sung-nien followed the style of Chang Hsün-li, who changed his original name, Tun-li, to avoid using the personal name of Emperor Kuang Tsung. Chang learned from Li T'ang. People today only know that the paintings of Sung-nien equal those of (Li) Ssŭ-hsün, but they do not know that the source was Chang.[1] (The situation is similar to the case of Ou-yang Hsiu, whose training and skill in writing were derived directly from Ch'ang-li (Han Yü). This fact was not generally known even at the beginning of the Sung dynasty, when Yung-shu (Ou-yang Hsiu) was given credit and Ch'ang-li neglected.)

1. Shanghai edition text ends here; the rest is added from the original editions.

48

郭熙
山水寒林宗李成得煙雲隱
見之態布置筆法獨步一時
早年巧贍工致晚年落筆亦
壯山輒作雲頭頗覺雄麗古
人云夏雲多奇峰天開圖畫
則熙實師造物矣元人惟宗
董巨曹雲西唐子華姚彥卿
朱澤民則宗郭熙

Kuo Hsi

In his landscapes of forests in winter, Kuo Hsi fol-
lowed the style of Li Ch'êng. He had great skill in
rendering mist and cloud effects, and his composi-
tion and brushwork were without equal in his time.
In his early period, he developed skill in precise and
detailed compositions (*kung hua*), and later, even
when he painted less often, his brush remained pow-
erful. He often used the brushstrokes for modeling
called *yün t'ou ts'un* (cloud heads), which had
strength and grace.

The ancients said: "Summer clouds have strange
forms like mountain peaks. Heaven creates pictures."
Kuo Hsi may truly be said to have imitated nature.

In general, the painters of the Yüan period worked
in the style of Tung (Yüan) and Chü(-jan); how-
ever, Ts'ao Yün-hsi, T'ang Tzŭ-hua, Yao Yen-
ch'ing, and Chu Tsê-min painted in the style of Kuo
Hsi.

萧照
照畫得北苑法
而縐以道勁過
之猶喜爲奇峰
怪石望之有波
濤汹湧雲屯風
捲之勢

Hsiao Chao [1]

Chao painted in the style of (Tung) Pei-yüan, and
eventually his brushwork had even greater vigor. He
liked to paint strangely shaped peaks and oddly
formed rocks. To look at them, it is as though one
were looking at billowing waves and floating clouds
—their roll and movement are rendered with great
style.

1. This and the next three examples are arranged in a
different order in the original editions.

50

師巨然其皴法稍變
俗呼爲泥裏拔釘以
苔輒作長點如錐亦
有一種蒼奧處

江貫道

Chiang Kuan-tao

He followed the style of Chü-jan, although his brush-
stroke method was slightly different. His brush-
strokes were jokingly described as looking like "pull-
ing nails out of the mud" because he often painted
moss in long strokes resembling awls. There was in
his work something original and significant, however.

51

李公麟

集顧陸張吳諸名家以為己
有作畫多不著色論者謂其
山水似李思訓瀟洒如王右
丞當為宋畫第一

Li Kung-lin

Uniting in his work elements from the styles of Ku
(K'ai-chih), Lu (T'an-wei), Chang (Sêng-yu), and
Wu (Tao-tzŭ), he created a style of his own. He
worked mostly in ink and little in color. Critics spoke
of his landscapes as resembling the work of Li Ssŭ-
hsün, and also said that they had the same free spirit
that is found in the work of Wang (Wei) Yu Ch'êng.
He is the first among the painters of the Sung period.

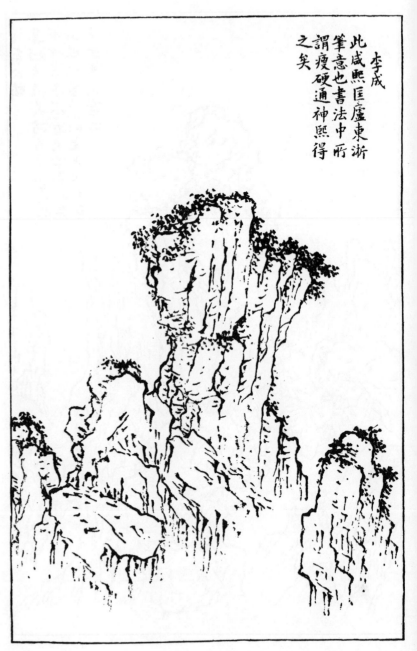

52

李成此成熙匡廬東浙
筆意也書法中所
謂瘦硬通神熙得
之矣

Li Ch'êng

This is an example of the style of Hsieh-hsi (Li Ch'êng, copied from his painting entitled) *K'uang Lu East of the River Hsi*. In calligraphy, one speaks of leanness, vigor, universality, and spirit. In painting, Hsi possessed all these qualities.

米芾

襄陽用王洽之潑墨參以破墨
積墨焦墨故融厚有味人謂米
氏善於用墨而余獨謂善於用
筆米筆施之書中時有奴張見
於畫內惟覺圓厚圓猶可熟習
薄者學此猶高君之欲昌於叔
度顏回終未可也米芾雖學王太
洽寶發源乎北苑近人學米芾
摸糊與太明露乃交失之米明
露處如微雲河漢明星燦然如
人則成鐵綿穿豆鼓矣米模糊
處如神龍矯矯隱見不測今人
則冀草堆壤蕪穢不治矣然則
何以學米曰用筆如錐用墨如
飛又曰惜墨如金弄筆如丸筆
墨之跡交鎔乃是真米

53

Mi Fei

Mi Fei of Hsiang-yang used the *p'o mo* (splash ink) style of Wang Hsia, combining it with the *p'o mo* (broken-ink outline) style and the methods known as *chi mo* (massing ink) and *chiao mo* (dry ink). His work had mellowness and solidity, and is of great interest.

People say that the Mi's were expert with ink, but I personally would say they had skill with brush. In calligraphy the Mi brush might seem turgid, but in painting it displays a stroke rounded and powerful. The rounded strokes may be acquired through practice, but the strokes with power are rooted in one's intrinsic resources. He who does not possess this particular gift and sets out to acquire it is like the Prince of Shang, who tried to surpass Shu Tu and Yen Hui.[1] It is an impossibility.

Although Mi Fei learned his style from Wang Hsia, the actual source was (Tung) Pei-yüan. Painters today imitate the Mi style, or rather they blur their rounded strokes or make them too clear-cut and hard, thus losing the essence of the style. The clear spaces in Mi's paintings are like the small clouds over the Milky Way through which the brilliant stars shine. When, however, painters today imitate this brushstroke style, they only seem to be stringing beads on an iron thread. The places in Mi's paintings that are meant to be indistinct are those secret places where the divine dragon is coiled, partly hidden, so that it is possible only to guess its whole form. Painters today, attempting to render this effect, turn out what looks like a rubbish heap.

How, then, may one learn to paint in the Mi style? I say that one must wield the brush like an awl, use ink like a bird in flight, use it sparingly as though it were gold, form rounded brushstrokes, and achieve harmony of brush and ink. That is the approach to the Mi style.

1. Shu Tu (Huang Hsien) of the Han period, famed for his noble character, and Yen Hui, favorite disciple of Confucius. There is a discrepancy here if Shang-chün referred to Wei Yang, who held the title of Prince of Shang in the IV century B.C., for Shu Tu's dates place him in the II century.

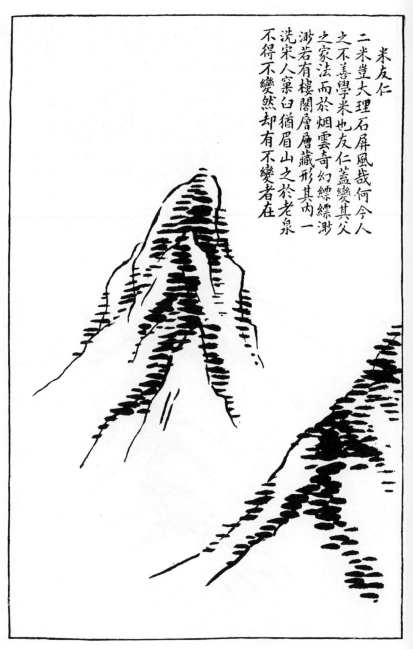

Mi Yu-jên

The two Mi's were like two panels of a massive marble screen. No one today seems able to paint as they did. Yu-jên changed his father's style only slightly. His clouds were strange and mysteriously evocative, making it seem that dwellings and many-storied mansions were hidden at various levels on the mountains. It might be said that he purified the Sung painters' pattern of style. However, as in the case of trying to compare Mei-shan (Su Tung-p'o) with Lao Ch'üan (Su Hsün, his father), it is really not possible to make a comparison between the two Mi's. And with all the modifications the Mi style remained essentially unchanged.

Ni Tsan (*hao* Yün-lin)

Ni, Huang (Kung-wang), Wu (Chên), and Wang (Mêng) are called the Four Great Masters of the Yüan period. Tzŭ-chiu (Huang Kung-wang) and Shu-ming (Wang Mêng) derived their style from (Tung) Pei-yüan; they handled the brush obliquely in the manner called *ts'ê pi* (side of the brush). Yün-lin used the side of the brush to an even greater extent. His brushstrokes were kept to the minimum so that it was like looking into deep pools and voids. The result was simplicity itself and, were it possible, something even simpler! Painters often use their brushes too freely, with the result of confusion in brushwork that, in some instances, helps to hide the defects in the strokes. In Yün-lin's pictures, even in the parts where there are no brushstrokes, form exists, and it is certainly impossible there to hide any defects.

His outlining of rocks was in squared forms, structurally exactly like that found in the paintings of Kuan T'ung; but T'ung used the manner known as *chêng pi* (upright brush), whereas Ni wielded his brush in the *ts'ê tsung* (side and relaxed) manner, which was not merely using the flat of the brush as though it lay on the paper, nor is it using the tip; it signifies a handling of the brush easily and with superb vitality. That is the reason one sees along the outlines of his rocks only a sharp edge and points. He

(*continued on next page*)

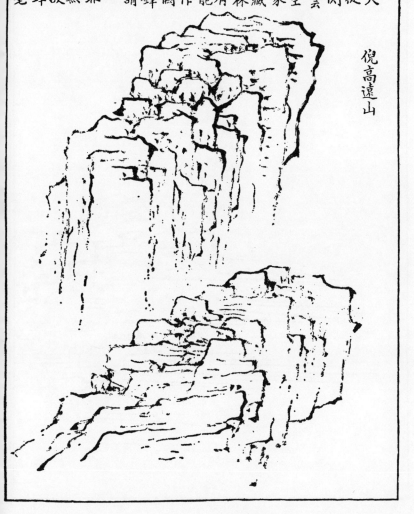

Ni's rendering of perspective in height.

55

used his brush with great rapidity; its point was sharply tipped and exhibited strength of spirit (*ch'i li*). This method is very difficult. In learning it, if one does not begin first by studying the methods of Pei-yüan and other masters and becoming thoroughly familiar with all the various brushstroke methods, it is impossible to attain that stage at which Yün-lin evoked form in places where there were no brushstrokes.

Nowadays, when painters see any pictures of low mountains with mounds and gullies, they tend to attribute them to Yün-lin. This is the reason he has been underestimated. I speak of him seriously and with attention to details, distinguishing in his achievement of *t'i shih* (structural integration) what he rendered in *p'ing yüan* (perspective on the level) and in *kao yüan* (perspective in height). Examining his rendering of the latter, one may discern the influence of Kuan T'ung; and in his rendering of the former he did not discard what he had learned from Pei-yüan.

56

Ni's rendering of perspective on the level.

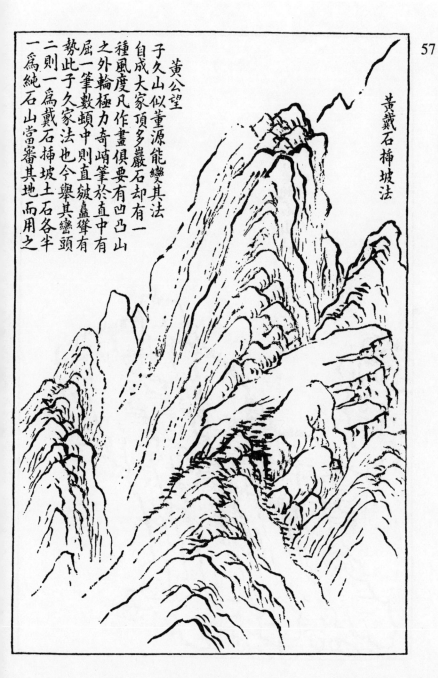

黃公望

子久山似董源能變其法
自成大家頂多巖石却有一
種風度凡作畫俱要有凹凸山
之外輪筆極力奇崎筆於直中有
屈一筆數頓中則直皴蟲聳有
勢此子久家法也今舉其蟲頭
二則一為戴石插坡土石各半
一為純石山當審其地而用之

黃戴石插坡法

Huang Kung-wang (*tzŭ* Tzŭ-chiu)

57

The mountains of Tzŭ-chiu resemble those painted by Tung Yüan. He was able to modify the latter's style, and eventually he became a great master in his own right. He drew the summit of mountains steep and precipitous, in his own particular style.

In painting mountains, one should indicate hollows as well as projections. The contour of a mountain should be strong and firm as well as imaginatively drawn to convey the sense of height and ruggedness. As the brush moves, the strokes should also turn and bend, and should often stop abruptly in the manner known as "stamping" (*tun*); in the middle of a stroke, however, the brush should move surely and smoothly. This is the manner of Tzŭ-chiu and his school. Here (and on the following page) are two examples of rounded peaks copied from his works. One is of rocky slopes, half earth and half rock, and the other is of a rocky peak. One should carefully decide just where to use these types.

Huang's method of painting rocks and slopes.

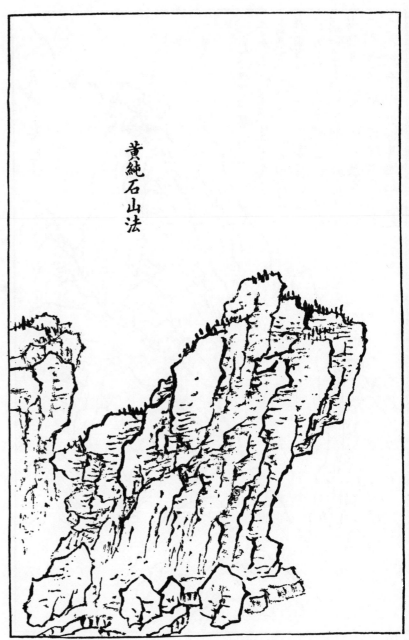

58

黄純石山法

Huang's method of painting a rocky peak.

59

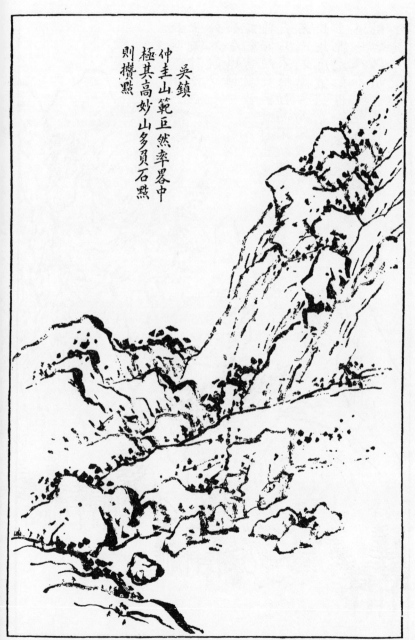

吳鎮

仲圭山範巨然率畧中

極其高妙山多頁石點

則攢點

Wu Chên (*tzŭ* Chung-kuei)

Chung-kuei's mountains were done in the style of
Chü-jan. His skill and subtlety were revealed in what
he chose to leave out. He usually painted rocky
mountains done in the brushwork method called
tsuan tien (dotting in tufts).

60

王蒙
叔明輒用
古篆隸法
雜入皴中
如金鑽鏤
石鶴嘴劃沙
雖師趙吳興實自出爐冶
尖石不稱勁而不板圓而
不成毛圓方而不露圭角
其墓唐宋諸家無不一一
通肖元季推爲第一大凡
學一人不可死在一人範
圍如叔明者其於諸家真
宄髮無遺憾矣

Wang Mêng (*tzǔ* Shu-ming)

Shu-ming often used, among his brushstrokes in painting, strokes of the old styles of writing called *chuan* (seal characters) and *li* (official style).[1] The strokes were as though a golden needle had engraved them on stone or a crane's beak had inscribed them in the sand. Although he followed the style of Chao (Mêng-fu), of Wu-hsing, he actually, as it were, made his own kiln, forged his own mold. His brushstrokes were pointed but in no sense weak, powerful but not stiff at all, rounded but not like balls of fur, square without corners. He followed the styles of the T'ang and Sung masters, and his work bears many points of resemblance to characteristics of their styles. The Yüan period considered him its most outstanding painter.

When one is following the style of one master, it is important to guard against dying within that influence. Shu-ming took all the details he was looking for from the methods of the masters but did not linger in them, and went on from there without regret.

1. Chang Huai-kuan, of the T'ang period, established a classification of ten styles of writing: the old forms of characters on ancient bronzes (*ku wên*, ancient script), the two seal styles (*ta chuan*, Great Seal, and *hsiao chuan*, Small Seal), the three variations of the official or clerical style (*li*), the regular or model style (*k'ai*), the "running" style (*hsing*), the grass style (*ts'ao*), and the dry brush manner called *fei pai* (flying white). Generally speaking, the *chuan* and *li* styles have simplicity and strength of form of a monumental kind, in contrast to the lithe and dancing manner, which nevertheless has power, of the "running" styles.

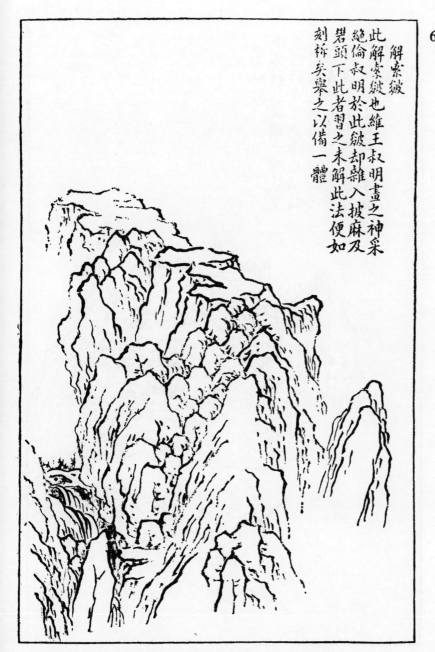

解索皴

此解索皴也維王叔明畫之神采
絕倫叔明於此皴却離入披麻及
礬頭下此者習之未解此法便如
刻畫矣舉之以備一體

61

Brushstrokes like raveled rope (*chieh so ts'un*)

This is an example of the brushstrokes for modeling called "raveled-rope strokes." Only Wang Shu-ming used this type of brushstroke, and the result was beyond description.[1] He also combined it with *p'i ma ts'un* (brushstrokes like spread-out hemp fibers) and *fan t'ou ts'un* (brushstrokes shaped like alum lumps). Many painters have tried to copy this style but they did not really grasp the method and produced brushstrokes which were stiff and angular. These make up one group of brushstrokes for modeling (*ts'un*).

1. *Shên ts'ai chüeh lun* (divine portion surpassing the ordinary).

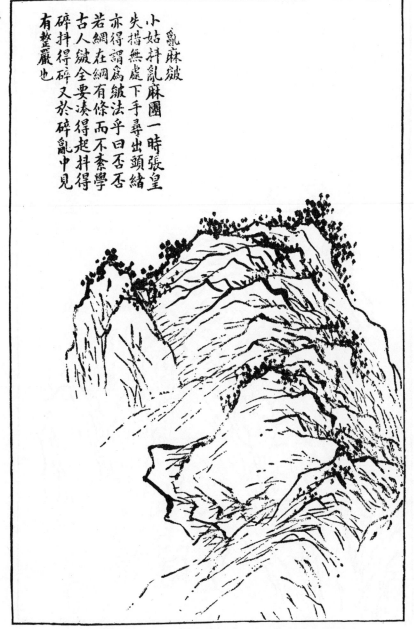

62

亂麻皴

小姑抖亂麻團一時張皇
失措無處下手尋出頭緒
亦得謂為皴法乎曰否否
若綑在綱有條而不紊學
古人皴全要湊得起抖得
碎抖得碎又於碎亂中見
有整嚴也

Brushstrokes like entangled hemp
fibers (*luan ma ts'un*)

This kind of brushstroke, improperly used, can cre-
ate confusion, such as a child makes in trying to dis-
entangle a bundle of hemp fibers. Can one call this a
brushstroke method? Definitely not! As in fishing
one must not let the cord around the net get en-
tangled, so, in learning the brushstroke methods of
the ancients, one must know not only how to put
them together but also how to separate them. Even if
the brushstrokes get mixed, one should be able to
bring some order out of the muddle.

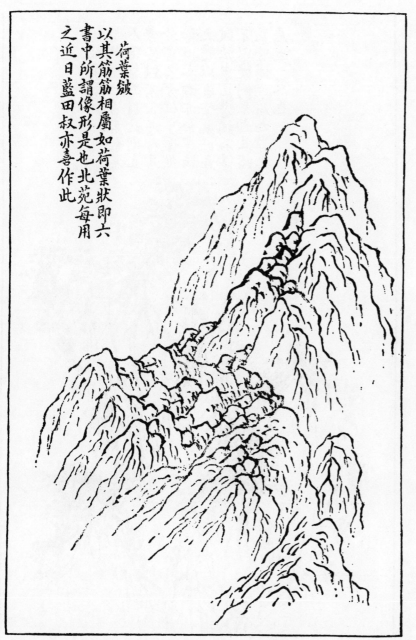

荷葉皴
以其筋筋相屬如荷葉狀即六
書中所謂像形是也北苑每用
之近日藍田叔亦喜作此

63

Brushstrokes like the veins of a lotus
leaf (*ho yeh ts'un*)

This brushstroke gets its name from the similarity of
its form to the veins of a lotus leaf. It is also related
to the *hsiang hsing* (imitative symbols) among the
Six Classes of Characters.[1]

(Tung) Pei-yüan often used this brushstroke. In
our day, Lan T'ien-shu likes to use it.

1. *Lu Shu* (Six Classes of Characters), the way charac-
ters were formed as distinct from styles of writing them. The
Shuo Wên dictionary, published *c.* A.D. 100, established the
six categories: *hsiang hsing* (imitative symbols), characters
which were actual drawings of objects; *chih shih* (indicative
symbols), a more abstract form of characters, as in *ming*
(bright) composed of the two characters for "sun" and
"moon"; *hsing shêng* (phonetic combinations), characters
in which one part indicated meaning and another the sound
of the word; *hui i* (logical combinations), characters in
which each part was significant to the meaning of the
whole; *chuan chu* (transmitted meaning), characters whose
meaning was changed by turning parts of the character—
e.g., *shang* (up, above, high) turned upside down becomes
hsia (down, below, low); *chia chieh* (borrowed meaning or
meaning by extension)—e.g., *ch'ang* (long) used to signify
"advantageous," "surplus," as well as "older" (taller).

64

Brushstrokes like entangled brushwood
(*luan ch'ai ts'un*)

Thus far I have given examples of the brushstroke methods of several of the masters. Now I shall give a few more, in much the same manner, but without identifying them with particular painters. This manner of presentation needs a slight modification, since the brushstrokes like entangled brushwood and the similar ones like entangled hemp fibers mark a change in brushstroke methods; they should not be considered a style or method, and should be treated as exceptions. They were used by the masters only occasionally, and in such a way that it is impossible to identify them with the style of any one master.

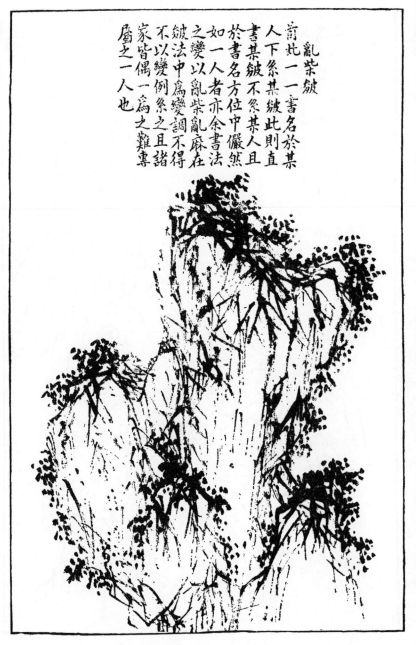

畫坡法

坡有石坡有土坡有土

石相雜坡安置坡處有

上平下廣穩覆如盂者

有上開下合亭立如菌

者有形勢不一而坡面如象

鼻者宜削平坡側如

風雪折剝文理天生即

搭繢密像土石之久經

宜如削平坡側宜勾

披麻中亦宜稍雜入斧

劈取峭坡面如用石

淡標及草綠則坡側當

坡側宜用赭石畫中用

稍加藤黃號赭黃者則

用赭石宜用赭石或用赭則

墨但於邊上用淡赭以

分層廓

65

Methods of painting slopes and plateaus

There are slopes and plateaus of rocks, of earth, and of both rock and earth. Their particular formations depend on where they are placed in a picture. They should be flat when located near the summit of mountains and expansive at the base. They should be firm like an upturned bowl. The upper part of some of these forms is wide, joined in a straight line to a lower slope, and like a mushroom in shape; there are others, lost in the clouds, the shape of which is like an elephant's trunk. Their forms have great variety, but the platform parts are always flat and solid.

The brushstrokes indicating the sides of plateaus should be strong and firmly joined, for they depict forms of earth and rock that have stood long against wind and snow. And these forms should have an air of complete naturalness, born of Heaven.[1] *P'i ma ts'un* (brushstrokes like spread-out hemp fibers) should be used, combined with a few ax-cut strokes (*fu p'i ts'un*). If color is used, mineral green with a little light red and touches of grass green should be used for the platform parts and umber for the sides. If umber is used on the face of slopes, it should be mixed with a little rattan yellow, the result being a yellow ocher. On the sides, one should apply umber or use it just to accent the outlines.

1. *Wên li Tien shêng,* a cultivated style or air born of Heaven. (See p. 103 n, above, on *wên li.*)

193

66

(Huang Tzŭ-chiu liked to paint slopes. Near the
summits of his mountains he added layer on layer
of rocks forming slopes or plateaus. With each stroke
he strove for individuality.) [1]

1. Text missing in Shanghai edition, translated from the
original editions.

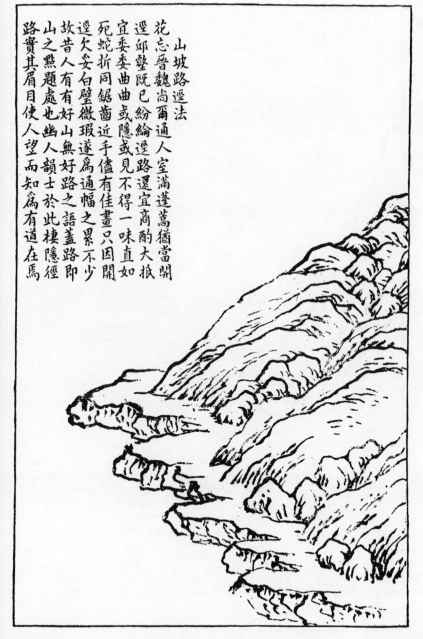

山坡路逕法

花志晉魏尚爾通人室滿蓬蒿猶當開
逕邱壑既已紛綸逕路還宜商酌大抵如
宜委委曲曲或隱或見不得一味直如
死蛇折同鋸齒近手儘有佳畫只因開
迤欠妥白壁微瑕遂扁通幅之累不少
故昔人有有好山無好路之語蓋路即
山之點題處也幽人韻士於此棲隱徑
路實其眉目使人望而知扁有道在焉

67

Example of painting a path or a pass on a mountain slope

The flowers blossoming again cover the traces made in Chin and Wei times.[1] People are still able to make their way through the undergrowth, but the places of retreat that those men of olden times made for themselves are now overgrown. The paths should be opened up again.

We have discussed mountains and slopes, and should now pay some attention to paths and roads. In general, they should be winding and sinuous, partly hidden, partly visible. They should never be straight like a dead snake, nor should they be jagged like the teeth of a saw. Painters today, even when they have arrived at the stage at which they are able to produce beautiful pictures, often draw the details of paths incorrectly and their pictures are like white jade marred by defects. This one feature can spoil a whole painting. That is what the ancients meant when they commented on beautiful mountains without beautiful paths. Paths on mountains are one way of indicating the theme of a painting. Hermits and poets use them to come and go from their retreats; thus, paths are clues and indicate the presence of a disciple of the *Tao*.[2]

1. About the III and IV centuries.
2. In this paragraph, the characters *lu* (road, path, way) and *ching* (pass, approach) are used except at the end, where the character *tao* is used, suggesting a double meaning in the last sentence. The last sentence is: "truly eyebrows and eyes (by extension: arrangement, order, and clues, or to indicate) make people look, then know that *Tao* therein." Paths thus were a means of indicating the *Tao* by suggesting the presence of followers of the *Tao* in a painting and by representing life and a form of vitality on a mountain; technically, they contributed to movement in a composition.

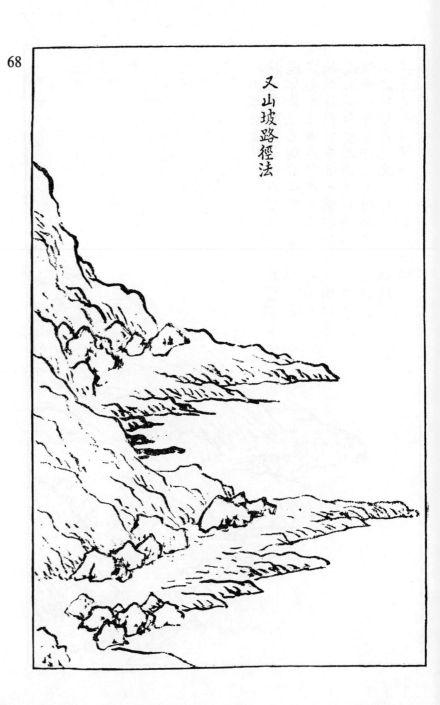

68

又山坡路徑法

Another example of a path or a pass on a mountain slope

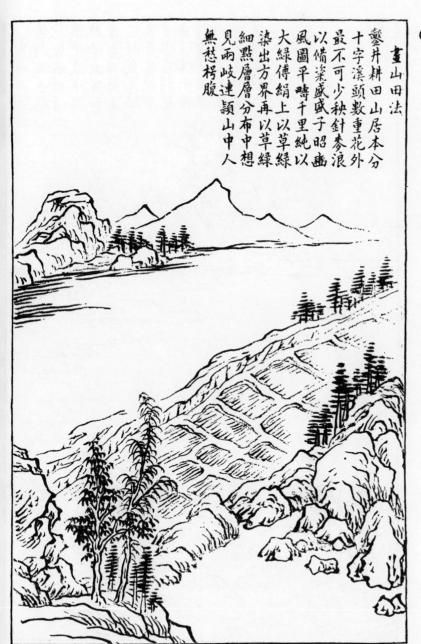

畫山田法
鑿井耕田山居本分
十字溪頭山居數重花外
最不可少秋針麥浪
以備粢盛盛子昭畫
風圖平疇千里純以
大綠傅絹上以草綠
染出方界再以草綠
細黕層層分布中想
見兩岐連頴山中人
無愁枵腹

69

Example of painting fields and mountains

Digging wells and plowing fields occupy those who
live among the mountains. Where streams divide,
and among fields of flowers in a landscape, one
should indicate sprouts of rice plants and waves of
wheat or millet, some of which will serve as sacri-
ficial offerings.

Shêng (Mou) Tzǔ-chao, in his illustrations of the
customs of Pin, drew fields of hemp measuring a
thousand *li*. He used a bright green [1] on the silk and
grass green to accent the borders of the fields. He
also dotted finely with grass green. In his arrange-
ment of the various levels of the mountains, one can
recognize the twin summits of the Ch'i Mountains
(of Pin); and, judging by the appearance of the
fields, the people who lived there never had to worry
about hunger.

1. *Ta lu* (great green) could be just a brilliant green or
might refer to *t'ou lu* (first green), similar to emerald.

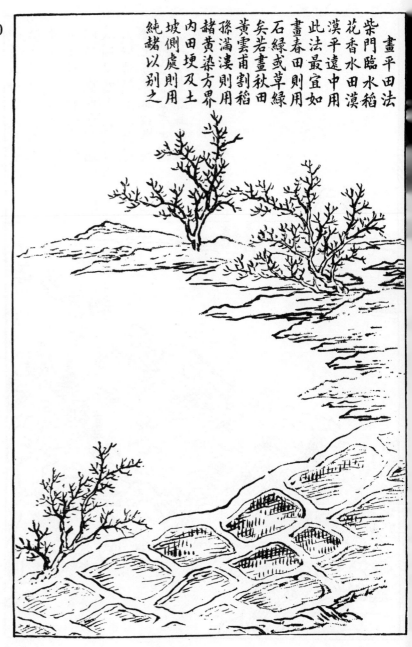

畫平田法
柴門臨水稻
花香水田漠
漠平遠中用
此法最宜如
畫春田則用
石綠或草綠
矣若畫秋田
黃雲甫割稻
孫滿漊方畫
赭黃染則用
內田埂及土
坡側處則用
純赭以別之

Example of painting fields on the level

The thatched gate is near the water's edge. The air is
fragrant from the scent of rice flowers. Fields under
water extend far into the distance. With such a theme
one should paint fields in spring using mineral green
or grass green. If one is painting fields in autumn,
when the clouds of ripe yellow wheat are about to be
gathered and the second crop of rice is filling the fur-
rows, yellow ocher should be used on the corners
and borders of the fields and along slopes and
ditches, and then accented by touches of umber.

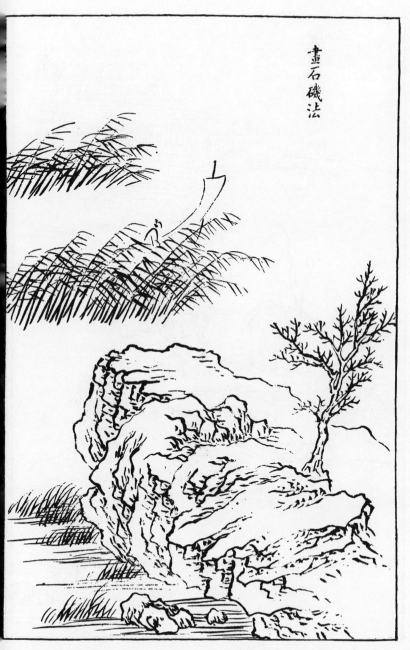

畫石磯法

71

Method of painting a rocky ledge at the water's edge

72

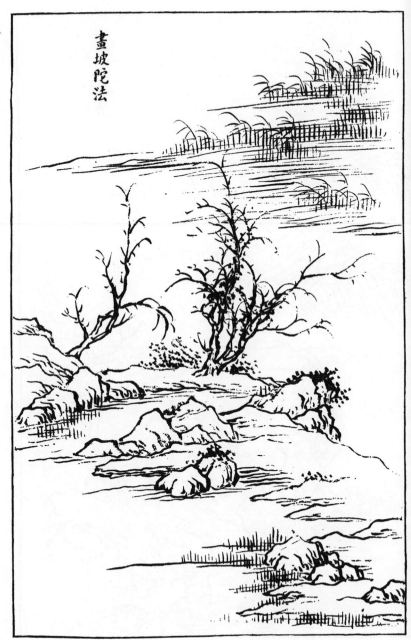

Method of painting a small slope or bank at the water's edge

石壁露頂法

73

Method of painting a rocky cliff with its summit clearly visible

74

Method of painting a rocky cliff with its
base clearly visible

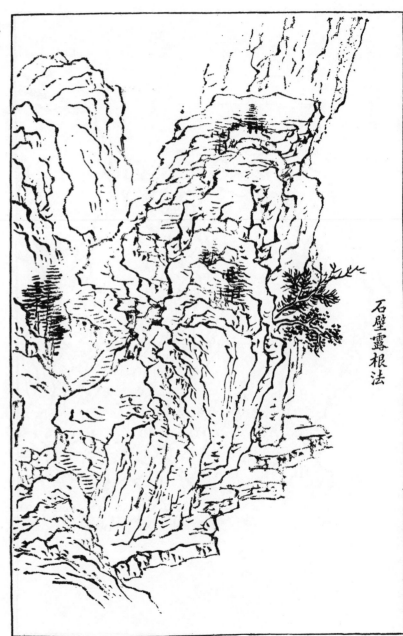

石壁露根法

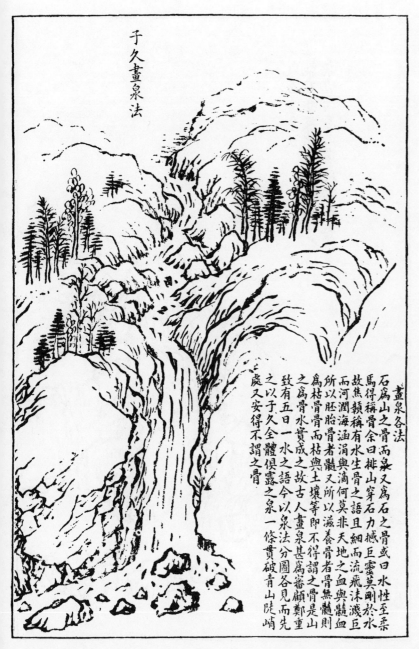

Methods of painting waterfalls

Rocks form the bone structure of mountains, and waterfalls form the structure of rocks. Some say that water is by nature weak, so how can it be described as forming structure? I say: see how water strikes the mountain and pierces the rocks; it has supernatural strength, nothing is stronger. It was for this reason that Chiao Kung [1] said that water is structural. Moreover, is not water, whether trickling, flowing, spraying, foaming, splashing, or in rivers or oceans, the very blood and marrow of Heaven and Earth? Blood nourishes the embryo and the marrow nourishes the bones. Bones without marrow are dead bones. Such bones are like dry soil and can no longer be called bones. Mountains are bones, since water has formed them, and for this reason the ancients paid careful attention to painting waterfalls. They had the saying: "Take five days to place water in a picture." Here are several examples of waterfalls, the first being taken from a work of Tzŭ-chiu (Huang Kung-wang) in which the whole waterfall is shown cutting through a steep mountain gorge. Once again one must ask, how can water not be called the bone of mountains?

Tzŭ-chiu's style of painting a waterfall

1. Scholar, *c.* 70 B.C., who was called Master of Ching-fang and was reputed to have been the author of the *I Lin,* a work of prognostication based on the *I Ching* diagrams. The quote is literally "have water born bone," which may be rendered "water creates structure." The Taoist bent is clear.

Method of painting a waterfall among rocks

The waterfall flows among the layers of rocks. It should be painted so that one almost hears the sound of the water. The flow should be directed through the empty places among the rocks and in their hollows, over and among all the rocks.

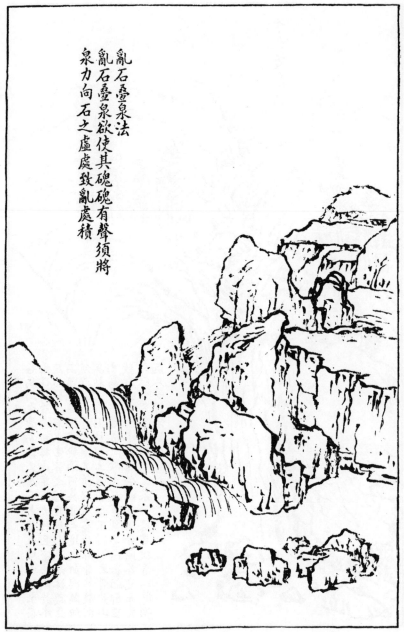

76

亂石疊泉法
亂石疊泉欲使其砅砅有聲須將
泉力向石之虛處致亂處積

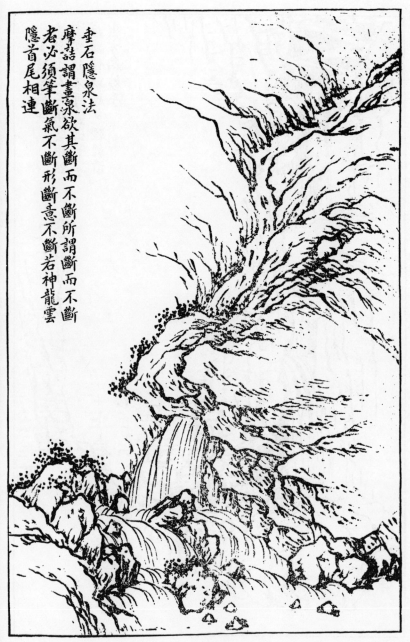

Method of painting an overhanging rock that hides part of the waterfall

Mo-chieh (Wang Wei) said: "When one is painting a waterfall, it should be so painted that there are interruptions but no breaks." [1] In this matter of "interruptions but no breaks," the brush stops but the spirit (*ch'i*) continues; the appearance of the flow of water has a break but the idea (*i*) of it is uninterrupted. It is like the divine dragon, whose body is partly hidden among the clouds but whose head and tail are naturally connected.

1. *Tuan êrh pu tuan* (stopped or broken yet not broken). May also be taken as an illustration of *wu wei*, the Taoist idea of outer passivity and intense inner activity, in which continuity of attention is uninterrupted; applied also to all kinds of long, sweeping brushstrokes, as in the rendering of orchid leaves and stems of bamboos.

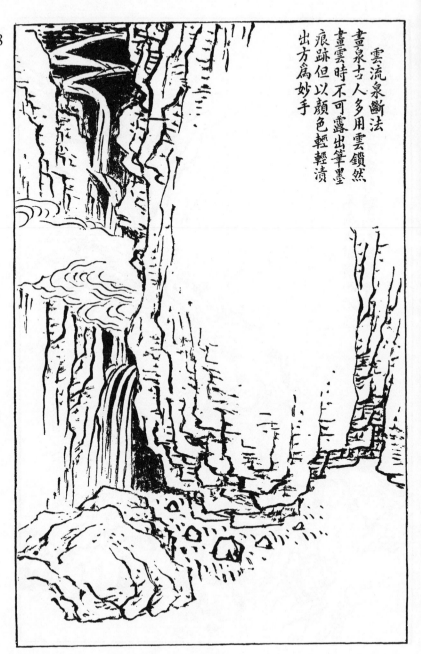

78

雲
流
泉
斷
法

畫
泉
古
人
多
用
雲
鎖
然

畫
雲
時
不
可
露
出
筆
墨

痕
跡
但
以
顏
色
輕
輕
漬

出
方
為
妙
手

Method of rendering a cloud hovering over a waterfall and partly hiding it

In painting waterfalls, the ancients often used the device called *yün suo* (cloud lock), by which a cloud partly submerges the waterfall. In painting the cloud, one must be careful not to show any trace of brush or ink. It is indicated only by a light wash of color. This is the sign of a skilled hand.

79

山口 分泉法

Method of indicating a stream winding
through a valley and flowing into a waterfall

80

Method of representing overhanging
cliffs and waterfall

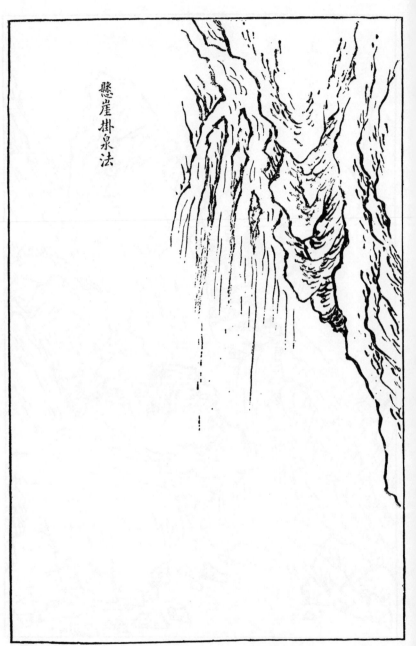

懸崖掛泉法

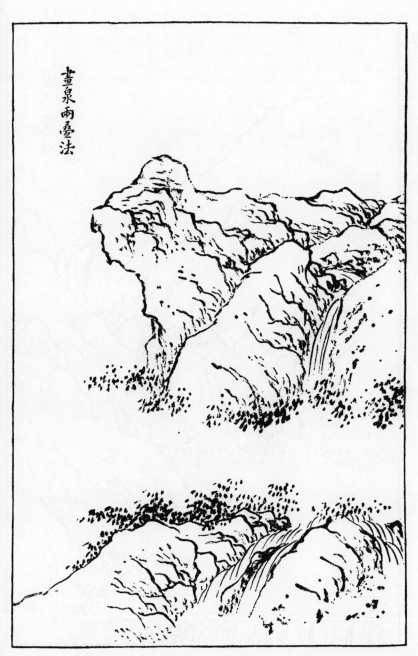

81

Method of painting a stream in two sections

82

Method of painting a stream in three
sections

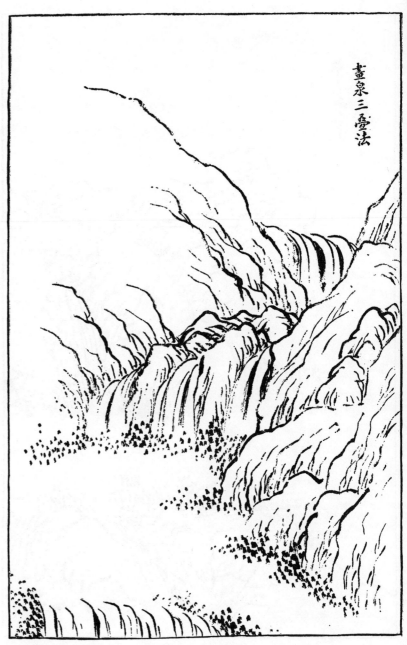

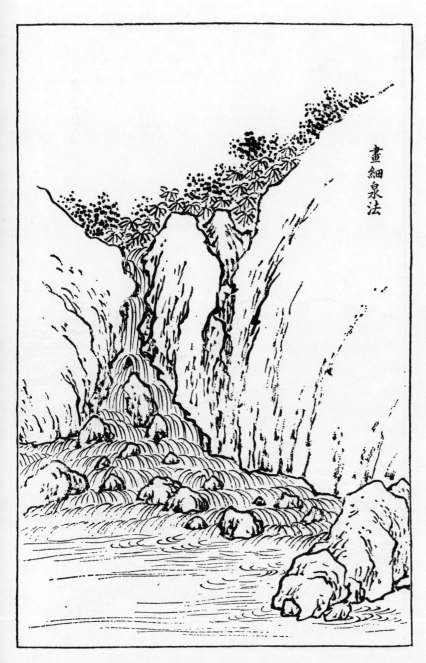

83

畫細泉法

Method of depicting a small stream
opening out into rapids

84

畫平泉法

Method of painting a stream flowing
over level places

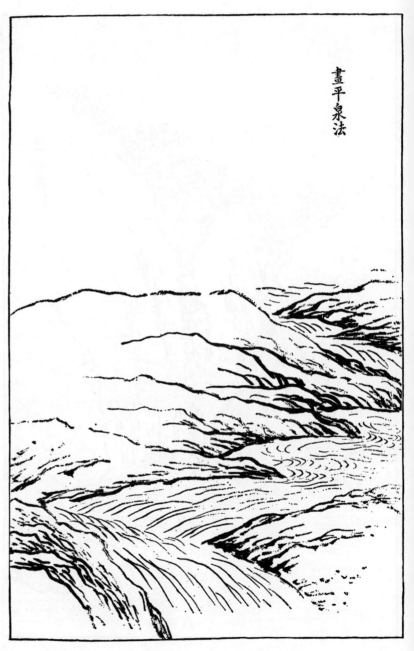

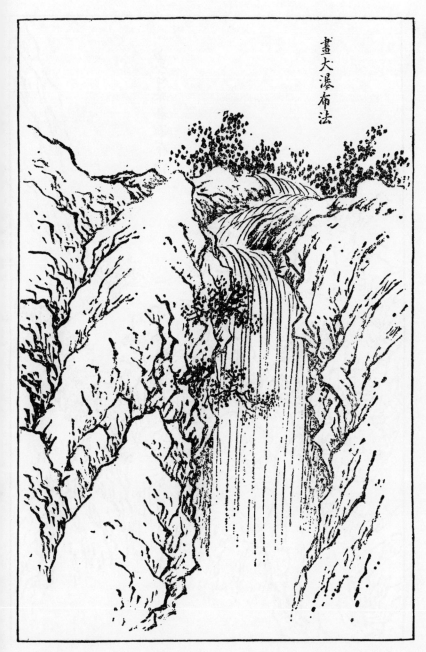

畫大瀑布法

Method of painting a large waterfall

Method of painting a rocky bridge
spanning a waterfall

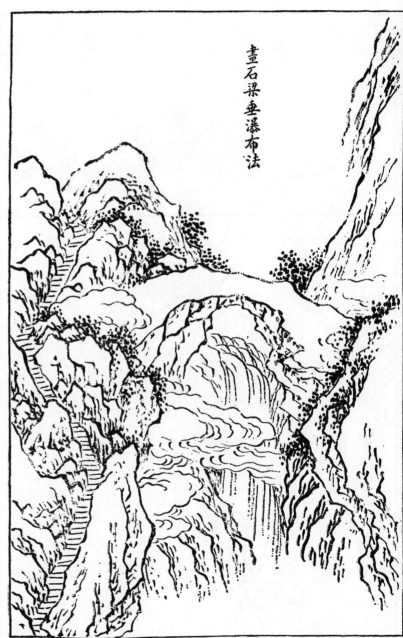

86

畫石梁垂瀑布法

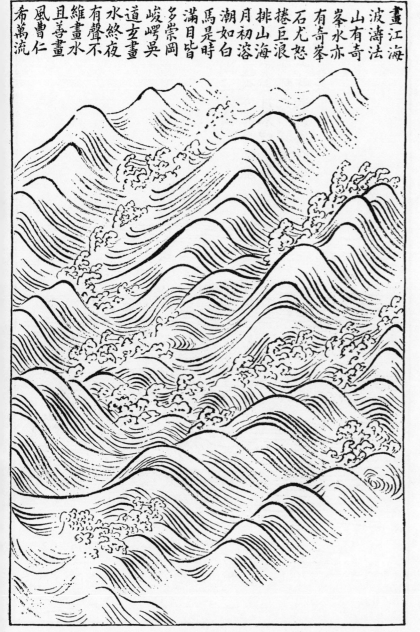

畫江海波濤法
山有奇峯水亦有奇峯
石尤怒
捲巨浪排山海
月初溶潮如白馬是時
滿目皆多崇岡峻嶺
道玄畫吳
水終夜有聲不
維畫水且菩畫
風曹仁希萬流

87

Method of painting billows

Mountains have strangely shaped peaks and water also has strangely shaped peaks. Rocks are like great billows that roll and smash against mountains. When the moon is reflected on water, the waves are like galloping white horses, and at that moment one sees lofty mountains and peaks in their full grandeur. Wu (Tao-yüan) Tao-hsüan painted pictures in which the whole night seemed filled with the sound of waters. He not only painted water beautifully but excelled in painting the wind. Ts'ao Jên-hsi, when he painted water, filled it with ten thousand currents [1] (without any effect of confusion. He was a master at painting calm waters as well as waves stirred by the wind. Here we conclude the examples of painting deep and flowing waters.)

1. The section ends here in the Shanghai edition; the rest is translated from the original editions.

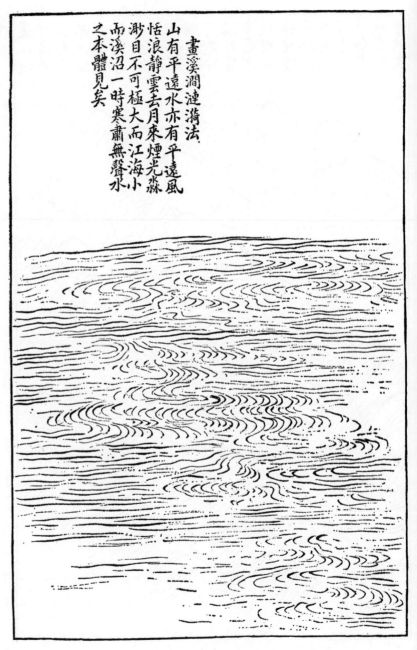

88

之本體見矣
而溪沼一時寒肅無聲水
渺目不可極大而江海小
恬浪靜雲去月來煙光淼
山有平遠水亦有平遠風
畫溪澗漣漪法

Method of painting the rippling of
shallow waters

In the painting of mountains, *p'ing yüan* (perspective
on the level) should be observed. This is also true of
painting water. When the wind subsides, waves and
ripples calm down. When the clouds part, the moon
emerges. The moonlit mists are vast and boundless,
and the eye cannot see their limits. Rivers, seas,
brooks, and ponds all in one moment may suddenly
become cold, calm, and silent. Thus the nature of
still waters may be revealed.

Method of painting clouds in *hsi kou* (small hook) outline style

Clouds are the ornaments of sky and earth, the embroidery of mountains and streams. They may move as swiftly as horses. They may seem to strike a mountain with such force that one almost hears the sound of the impact. Such is the nature (*ch'i shih*, spirit and structural integration) of clouds.

Among the ancients, there were two key methods in painting clouds. First, in vast landscapes of numerous cliffs and valleys, clouds were used to divide (and to hide) parts of the scene. Richly verdant peaks soared into the sky and white scarves of clouds stretching horizontally separated and imprisoned them. Where the clouds parted, green summits rose. As the literati say: "In the midst of hustling activity steal moments of quietness." Let the Five Colors cast such a spell on the spectator. Second, in a landscape where mountains and valleys extend into the distance, clouds were used as a means of uniting them. The clouds sometimes filled space where there were no mountains or water, billowing like great waves of the ocean and soaring like mountain peaks. As the literati say: "Invite guests, recite poems, and improve your style." [1]

I have placed this section on clouds here at the end because the ancients included clouds in their discussions of the main principles of painting mountains. In the emptiness of clouds there are no traces of brushwork, an ultimate feature of landscape (mountain-water) composition. Thus, paintings of mountains are often called cloud-landscapes and also cloud-water pictures.

1. Literally *wên shih* (cultural foundation), here "improve your air of culture" representing character and literary accomplishment.

Method of painting clouds in *ta kou* (large hook) outline style

In using color to paint clouds, washes of pure color should be applied. The clouds should appear to have volume but should show no traces of ink. In the style called *ch'ing lu shan shui* (blue-and-green landscape), however, when the method requires fine modeling brushwork, the drawing of the clouds should harmonize with the rest of the picture: a light ink should be used for outlining and a light wash of pale blue for tinting.

The painters of the T'ang period had two ways of painting clouds. One, known as *ch'ui yün fa* (blow-cloud method), consisted of applying white powder lightly on the silk to simulate clouds floating on the wind—light, clear, and graceful, a most pleasing effect.[1] The other method, known as *kou fên fa* (white outline method), is similar to touching up with gold the outlines of clouds in *chin pi shan shui* (gold and blue-and-green landscape), which Little General Li used with great liveliness (*ch'i*) and style.

1. The T'ang art historian, Chang Yen-yüan, commented on this method: ". . . the ancients did not obtain wonderful results in their painting of clouds. Moistening the silk and sprinkling white powder over it in the blow-cloud method produces a natural effect that may seem wonderful; but, since there is no brushwork in it, it can hardly be called painting."

人物屋宇譜

Book of Jên-wu

(The painting of *jên-wu* in landscapes)

In landscape paintings, in addition to scenery there should be figures (*jên*) and other living things (*wu*). They should be drawn well and with style, though not in too great detail. And they should, of course, fit the particular scene. For instance, a figure should seem to be contemplating the mountain; the mountain, in turn, should seem to be bending over and watching the figure. A lute player plucking his instrument should appear also to be listening to the moon, while the moon, calm and still, appears to be listening to the notes of the lute. Figures should, in fact, be depicted in such a way that people looking at a painting wish they could change places with them. Otherwise the mountain is just a mountain, the figures mere figures, placed by chance near each other and with no apparent connection; and the whole painting lacks vitality.

Jên-wu in a landscape should be pure as the crane, like hermits of the mountains, and should never bring into a picture the air of the city and market place to mar the spirit of the painting. In the pages which follow are examples of figures strolling, standing, sitting, reclining, contemplating, and listening. In some cases, the accompanying text is quoted from T'ang and Sung poems, showing how *jên-wu* in a landscape is similar to an inscription or title in a painting. The subject of a scroll is often indicated by the *jên-wu* in it. The ancients liked to write inscriptions on their paintings. The excerpts chosen here are not, however, necessarily the only ones for the poses shown. Certain kinds of inscriptions should go with certain pictures. Here, only a few examples are offered. Once a beginner understands the various kinds of pictures done by the ancients and the substance of the accompanying inscriptions, he will be able to find appropriate ones for himself.

"Wandering leisurely, one easily strays. Reciting to oneself, the voice quite naturally is raised high."

"Hands slipped in sleeves are warm. There is no feeling of cold."

"With hands clasped behind, walking on a mountain in autumn."

Full title of this book: *Book of Figures* (*jên*), *Other Living Things* (*wu*), *and Houses* (*wu yü*).

2

獨立蒼茫自咏詩

採菊東籬下
攸然見南山

明月荷鋤歸

"Standing alone in the open, reciting a poem."

"Having gathered chrysanthemums by the bamboo fence to the east, joyfully contemplating the Southern Mountain."

"Returning home by moonlight, hoe on shoulder."

"Looking at the mountain, remembering a poem, straightway writing it on the face of the cliff."

("Chance meeting with an old neighbor; chatting and laughing, forgetting the hour to turn homeward.")[1]

1. As in the original editions.

4

撫孤松而盤桓

倚杖聽鳴泉

"Lingering by a solitary pine, reluctant to leave."

"Leaning on a staff, listening to a singing stream."

5

"Carrying coins strung on a cord, crossing a rustic bridge."

"Pointing at a flight of rooks like dots against the blue-green hills."

6

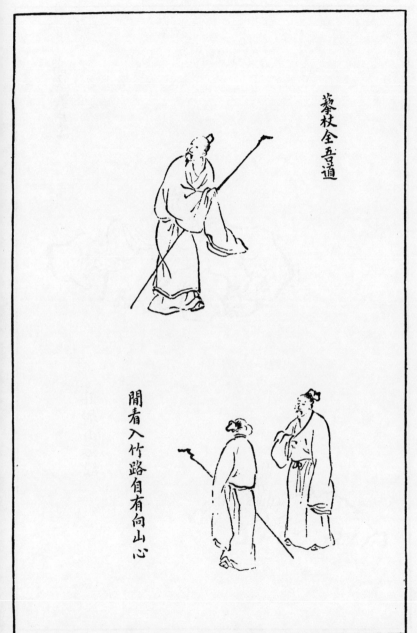

"My staff of bramble helps me on my way."

"Walking leisurely among bamboo, my thoughts naturally turn to the mountains, and I yearn to go."

"My heart is lifted as the cloud on high."

"Lying down, reading the *Shan Hai Ching*." [1]

1. *Mountain-River Classic,* an ancient treatise on geography, partly mythological, classed as fiction in the Ch'ing period.

8

"Sitting on a rock flat as a mat, with head bent, watching the long, flowing stream."

"Lying high up on the mountain among the clouds, his garments become damp and cold."

9

行到水窮處坐看雲起時

"Having walked to where the waters flow no more, they sit and watch the clouds rise."

拂石待煎茶

"Leaning on a rock, they wait for tea to be brewed."

二人對酌山花開

時還讀我書

10

"Face to face, the two drink and serve each other among the flowers on the mountain."

"From time to time I read my book."

11

"Today the weather is lovely. In the clear air we play the lute."

"Together we enjoy an extraordinary essay."

今日天氣佳清吹與彈琴

奇文共欣賞

12

"The sounds of the chessboard dispel all sense of time."

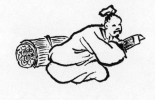

"Sitting at a window in the sun, leafing the pages of the *Pai Yün*." [1]

1. *Pai Yün P'ien* (White Cloud Pages), a Yüan-dynasty collection of poems and philosophical excerpts.

13

"The mountain stream is clear and shallow. Meeting we sit and bathe our feet."

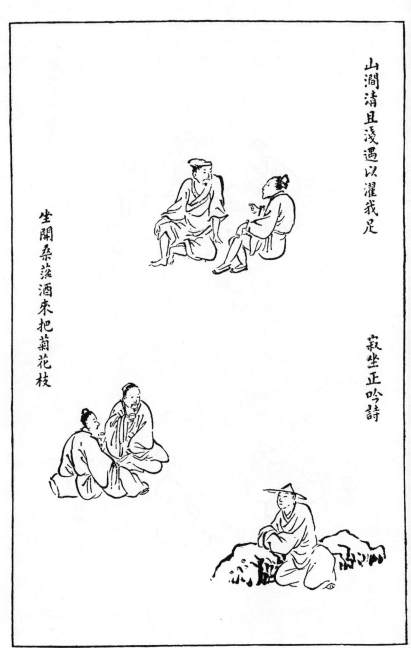

山澗清且淺遇以濯我足

寂坐正吟詩

坐開桑落酒來把菊花枝

"Sitting, drinking under the mulberry tree. It is the season to gather chrysanthemums."

"Sitting quietly alone, reciting a poem."

14

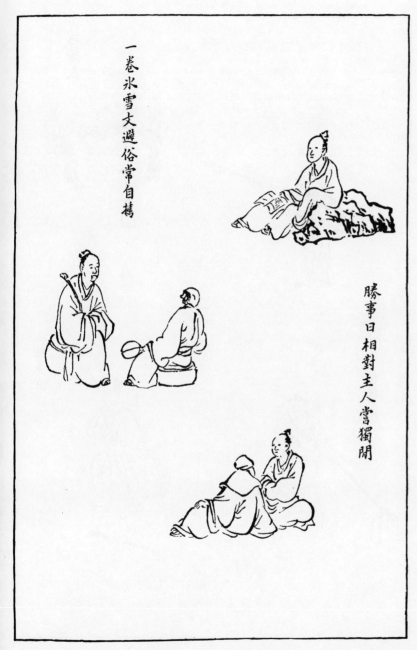

一卷冰雪文避俗常自携

勝事日相對主人嘗獨閒

"A copy of the *Ping Hsüeh Wên*[1] I often carry with me leads my thoughts away from the commonplace."

"Master and attendant sitting together; the master alone has leisure."

1. *Ice and Snow Essay*, by Tu Fu (?).

15

(Fishing.) [1]

Carrying two bundles of brushwood on a shoulder pole.

Spring plowing.

Returning from fishing.

1. As in the original editions.

16

Holding pole.

Paddling with oar.

(Punting.) [1]

(Sculling.) [1]

1. As in the original editions.

17

"Dipping feet in a stream flowing ten thousand *li.*"

"In a vast lake one lone old fisherman."

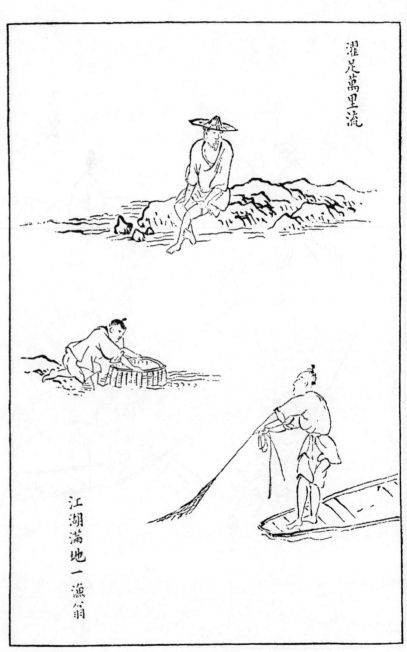

18

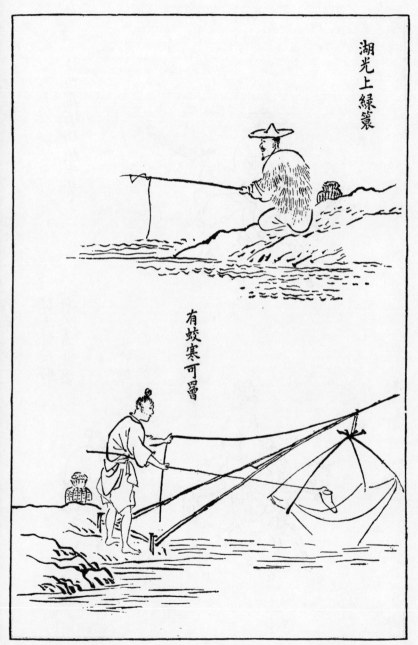

"Reflections from the lake play on the green of the grass raincape."

"A cold, wet fish may land in the large square net."

19

"Meditating on a poem while crossing a bridge on a donkey."

"The traveler's horse eyes the spring grass. People on foot watch the sunset clouds."

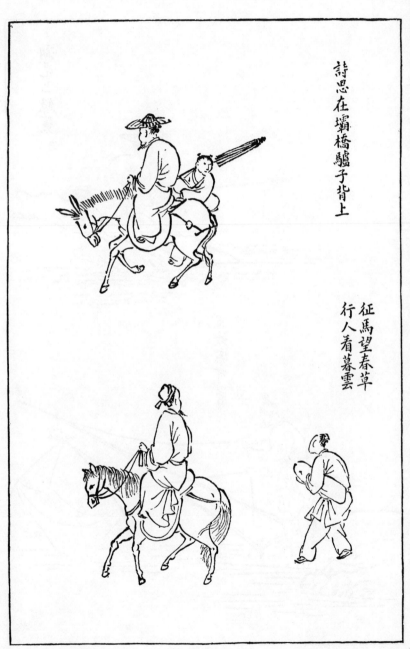

詩思在灞橋驢子背上

征馬望春草
行人看暮雲

20

春郊見駱駝

"On the outskirts of a town in spring one sees a camel."

花間吹笛牧童過

"Among the flowers there is music of a flute. A shepherd boy is passing."

Holding books.
Lifting a kettle.

Passing cups of tea.
Carrying a vase.

22

掃地式　捧硯式

折花式　抱琴式

Sweeping the ground.

Holding an inkstone.

Bearing a branch of blossoms.

Carrying a lute.

Brewing tea.
Washing earthenware utensils.

Clasping knees.

Washing medicinal plants.

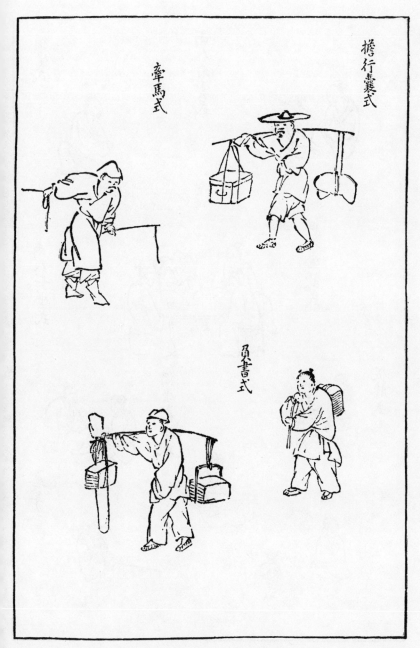

24

Leading a horse by a rope.

Carrying bedding and box.

(Carrying bundles of books on a shoulder pole.) [1]

Carrying books.

1. As in the original editions.

25

Two people watching clouds.
Sitting alone.

Four people sitting and drinking together.

Sitting knee to knee.
Two people sitting facing one another.

Sitting alone, reading.

Sitting cross-legged.
Sitting with a slackened fishing line.

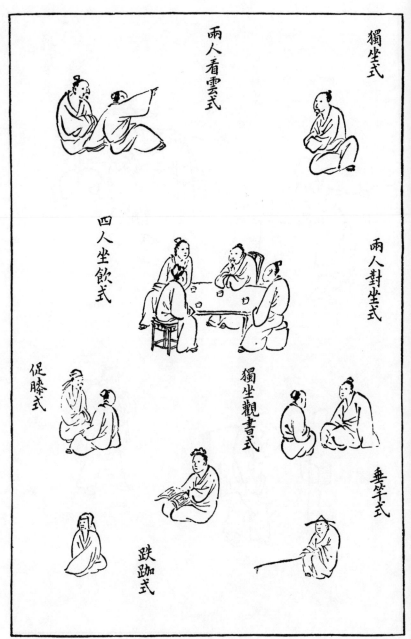

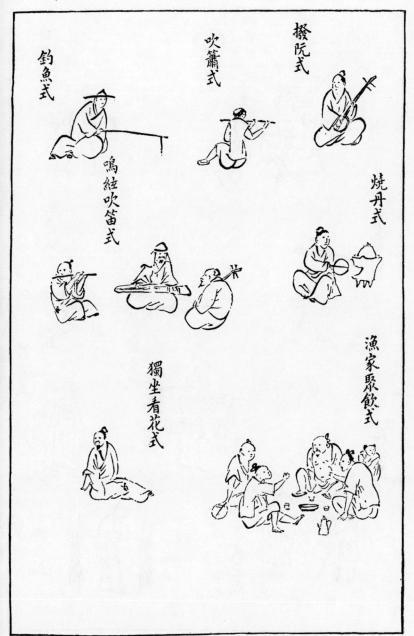

26

Fishing.

Playing a *hsiao* flute.[1]

Strumming on a *yüan* guitar.

Playing a stringed instrument and the *ti* flute.[1]

Brewing herbs.

Sitting alone, contemplating flowers.

Fisherman and family gathered for a drink together.

1. Both examples show side flutes, although the captions differentiate between the *hsiao* flute, held in front, and the *ti*, held to the side.

Raising whip in starting forth.[1]
Carrying bundles on a shoulder pole.

Covered by open umbrella.
Pushing a small carriage.

Carrying bundles on a shoulder pole.
Leading a child.

Picking flowers.
Carrying a kettle.
Carrying in balance two bundles of brushwood.

1. In the original editions, this page of examples fol-
lows p. 247.

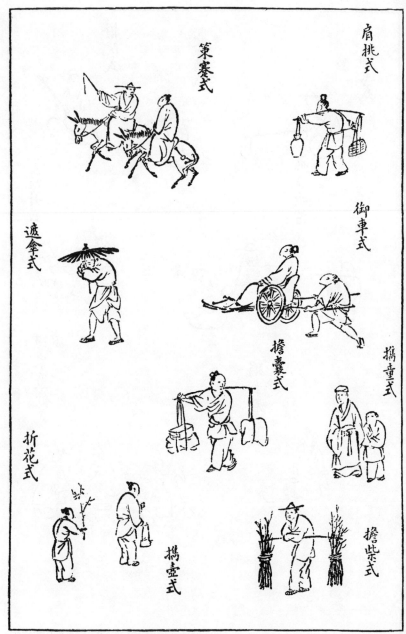

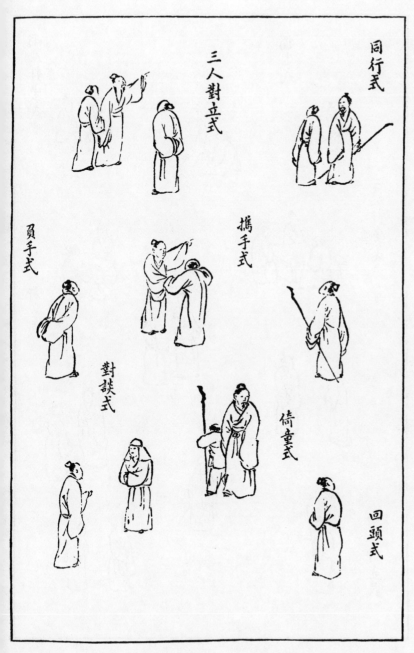

28

Three people standing, facing one another.

Walking together.

Hands clasped behind.

Grasping hands.

(Trailing his staff.) [1]

Being led by a child.

Facing one another, chatting.

Turning his head.

1. As in the original editions.

Sitting alone.

Two people sitting, facing one another.[1]

Three people sitting, facing one another.

Two people strolling.[2]

One person strolling alone.

1. For the three examples in the upper right.
2. For the four pairs of figures in the center and lower right.

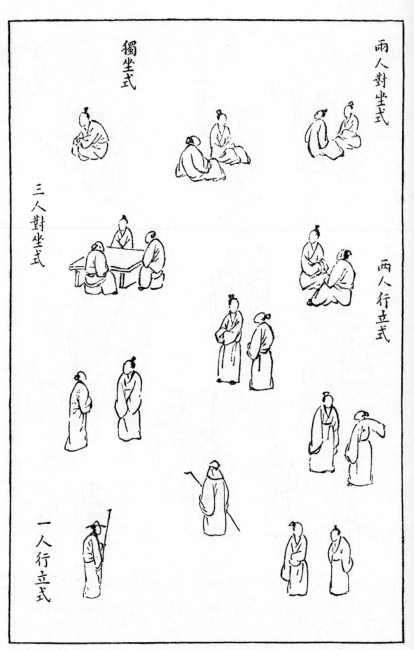

29

獨坐式

兩人對坐式

三人對坐式

兩人行立式

一人行立式

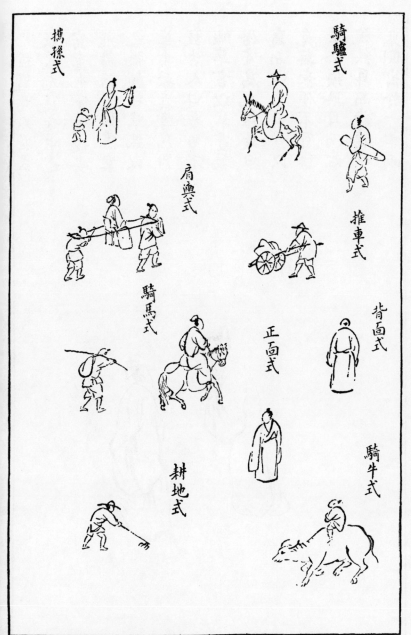

30

Leading his grandchild.
Riding a donkey.

Carriers and sedan chair.
Pushing a cart.

Riding a horse.
Back view.

Front view.

Raking earth.
Astride a water buffalo.

Examples of painting figures in free-sketch style

31

Here are some examples of the style called *hsieh i* (write idea), giving the swiftly drawn impression of an idea. In this style, it is very important that the brush move with speed and vitality.[1] Such was the calligraphy of Chang the Madman,[2] who was expert in *ts'ao shu* (grass writing), which is more difficult than *chên shu*[3] (regular writing). That is the reason the ancients said: "If you paint hurriedly, you will not have the necessary relaxed approach to grass writing." Painting in the grass style (*hsieh i*) is more difficult than the copying-stroke-by-stroke style (*k'ai hua*). That is the reason for the saying: "Drawing[4] must be linked with the idea (*i*), for without meaning (*i*) the brush cannot function properly." Figures, even though painted without eyes, must seem to look; without ears, must seem to listen. This should be indicated in one or two touches of the

(*continued at right*)

極寫意人物式
數式尤寫意中之
寫意也下筆最要
飛舞活潑如書家
之張顛狂草然以
草書較真書爲難
故古人曰匆匆不
暇草書以草畫較
楷畫爲尤難故曰
寫而必糸曰意以
見無意便不可落
筆必須無目而若
視無耳而若聽旁
見側出於一筆兩

1. Lit., "fly-dance-life-splash."
2. Chang Hsü, VIII-century poet, one of the Eight Immortals of the Wine Cup.
3. Or *k'ai shu*. See p. 188 n, above, for styles.
4. *Hsieh* (writing), emphasizing the close relationship with calligraphy.

32 brush. Eliminate details to achieve the simplest expression and the effect will be the most natural. Actually there are things which ten hundred brush-strokes cannot depict but which can be captured by a few simple strokes if they are right. That is truly giving expression to the invisible.

得方爲入微
此一兩筆忽然而
所不能寫出者而
然實有數十百筆
而就至簡天趣宛
筆之間删繁就簡

JÊN-WU

(Examples of painting
figures in free-sketch style)

33

34

(Examples of painting
figures in free-sketch style)

35

36

(Birds and animals in a landscape)

37

Various kinds of birds and animals exist as parts of a landscape. While they may seem a small matter, they actually are of great importance. If one is painting a landscape in the spring, the season should be properly indicated: pigeons coo, swallow their feed. If these are not signs of spring, what is? If one wishes to paint an autumn scene, the season should be properly indicated: a wild swan in flight, a wild goose on its nest. If these are not signs of autumn, what is? Such details and the changing aspects of mountains and trees indicate the different seasons.

When one is painting the dawn, that time of day should be properly indicated: birds fly out of their nests in the woods, a watchdog barks. If these are not signs of the dawn, what is? If one wishes to paint

(*continued at right*)

Horse rolling in a meadow in the spring.

Two horses drinking at a stream.

Donkeys, laden, trotting.

春郊滾馬式

雙馬飲泉式

負驢式

山水中鳥獸各式此種雖
屬細事然所關者甚大如
要畫春春畫不出第畫一
鳴鳩乳燕非春而何如要
畫秋秋畫不出第畫一飛
鴻宿雁非秋而何然此猶
於山樹可以分別者也至
要畫曉曉畫不出第畫樓
鳥出林吠厖守戶非曉而
何要畫暮暮畫不出第畫

256

全然牛畫鴉鳴將非禽雞
在下馬陣將雨暮藏棲
此中風之雪則而於于
生知以則鳩何樹塒
動穎及

牧牛行卧式

白羊行卧式

38 the time of sunset, those hours should be properly indicated: chickens perch in their roosts, birds rest among the trees. If these are not signs of early evening, what is? Before the first drops of rain, the (crane) [1] cries; before snow falls, the crows fly away in flocks; and when the wind begins to gather force, oxen and horses grow restless. The rhythm of life (*shêng tung*) is expressed in a painting by such details.[2]

Oxen standing.[3]

White sheep walking and lying down.

1. Here, *chiu* (pigeon, dove); in the original editions, *kuan* (crane).
2. The seasons, weather, and time of day or evening represent aspects of the order and mutations of nature (*Tao*).
3. The original editions showed four oxen "walking and lying down" and different versions of five white sheep "walking and lying down."

Two deer.

Deer calling.

Dog lying down.

Dog barking.

40

Flying cranes.

Two cranes.

Crane calling.

41

Pairs of swallows flying up and down.

Birds perched on a branch.

42

Rooks [1] among the clouds.

Rooks in flight.

Starlings perched on a bough.

1. *Ya*, used generally for rooks, crows, ravens, and starlings.

261

43

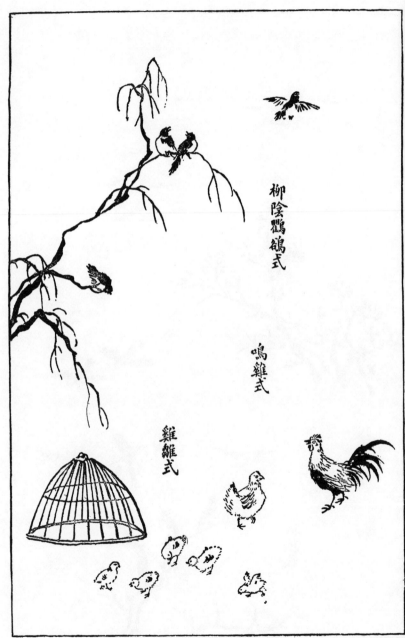

Starlings on a willow bough.

Rooster crowing.

Hen and chicks.

44

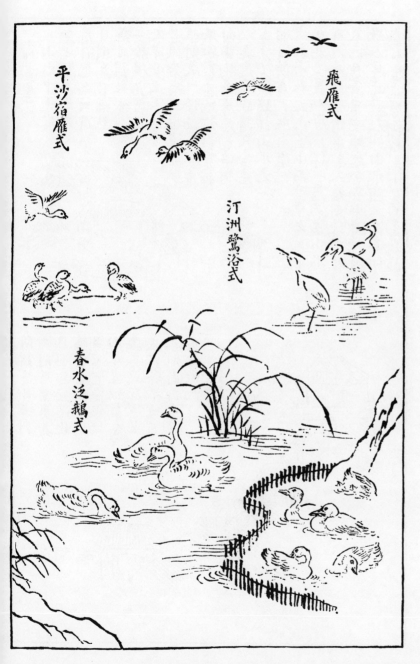

平沙宿雁式

飛雁式

汀洲鷺浴式

春水泛鵝式

Wild geese in flight.

Wild geese resting on a sand bank.

Egrets at the water's edge.

Geese on the water in the spring.

Methods of drawing buildings

45

Most landscapes contain dwellings of one kind or another, the doors and windows of which are like eyes and eyebrows. When people have no eyes or eyebrows they are blind or diseased. While eyes and eyebrows may be beautiful in themselves, their effect is due to their placing on the face. Of either feature there should not be too much. If a man had eyes all over his body, he would be a monstrosity. What is the difference when houses are drawn without thought of location and arrangement, of back and front views, with story piled on story? I therefore speak now of different ways of drawing buildings.

The face of a landscape, too, should be studied in all its aspects so that its eyes may be placed in a natural way. Whether in large pictures, several feet long, or in small ones, only inches long, people and dwellings should be placed in but one or two places. A landscape with people and dwellings in it has life, but too many figures and houses give the effect of a market place. Few painters today know how to place

(continued at right)

Doors and windows are like eyes and eyebrows; halls and inner rooms are also like eyes. Eyebrows should be graceful; so likewise walls should curve, encircle, and join. Eyes should not be too prominent; therefore the inner rooms should be spacious and quiet, their emptiness filled with *ch'i* (the atmosphere of the spirit). Two examples are shown here: at the top, the houses are those suitable for flat areas; below are buildings rising on the levels of a slope of a mountain. These are two basic patterns.

264

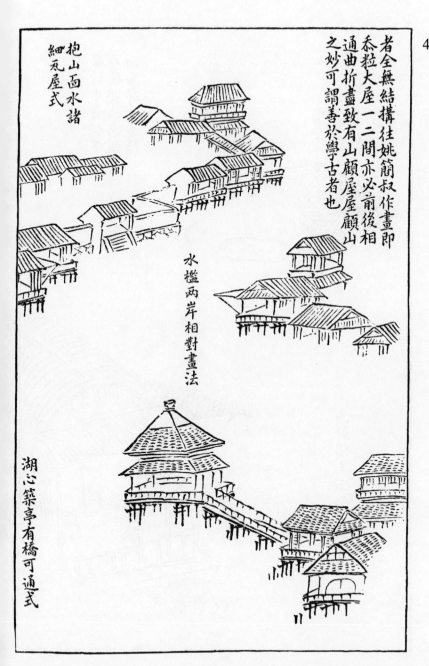

抱山面水諸
細瓦屋式

水檻兩岸相對畫法

湖心築亭有橋可通式

者全無結構往姚簡叔作畫即
黍粒大屋一二間亦必前後相
通曲折盡致有山顧屋屋顧山
之妙可謂善於學古者也

46 houses in a landscape. Although some may be skill-
ful in landscape painting, there are very few who
draw houses properly. The houses often look like
snail shells or the mud houses children build. They
lack construction altogether.

Recently Yao Chien-shu painted some pictures
in which houses were as small as grains of rice,
yet his command of the brush was such that the
fronts could be easily distinguished from the backs,
and the way the houses connected was clearly visible;
their arrangement, moreover, was perfect. Looking
at the groups of houses, one could feel their relation
to the mountains. One may certainly say, he learned
from the ancients.

Upper left:
Small tiled houses at the water's edge, as though
hugging a mountain.

Structure on an embankment.

Pavilion in the middle of a lake with a small con-
necting bridge.

265

47

A secluded pavilion for study, which may be placed near bamboos or *t'ung* trees; the shades and windows on all four sides may be opened to the view.

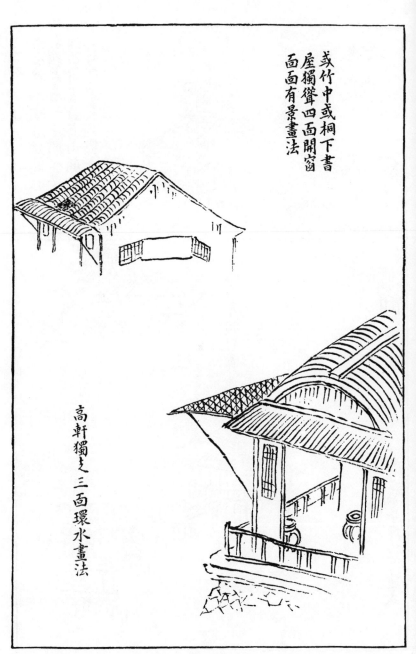

或竹中或桐下書
屋獨聳四面開窗
画面有景畫法

高軒獨之三面環水畫法

A high balcony, surrounded on three sides by water.

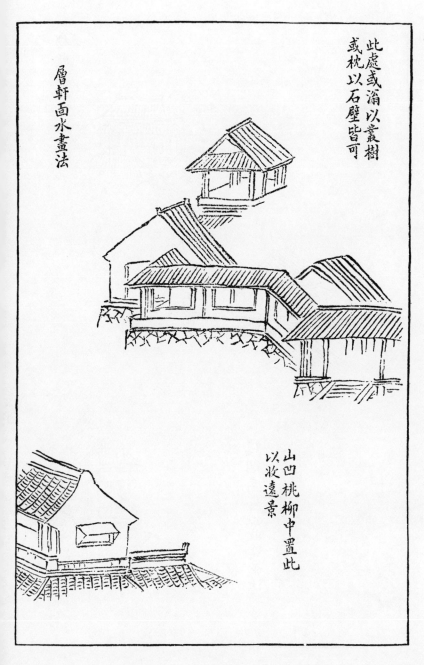

層軒面水畫法

此處或瀹以叢樹
或枕以石壁皆可

山凹桃柳中置此
以收遠景

48 Method of painting a winding structure with balconies overlooking the water

A structure that may be placed among dense trees or on a rocky cliff.

A structure that may be placed in a valley among peach and willow trees, with a view of the distant landscape.

49

A front view of the top of a palace or mansion.

A side view of the top of a palace or mansion.

The top of a storied structure, built high to give a distant outlook.

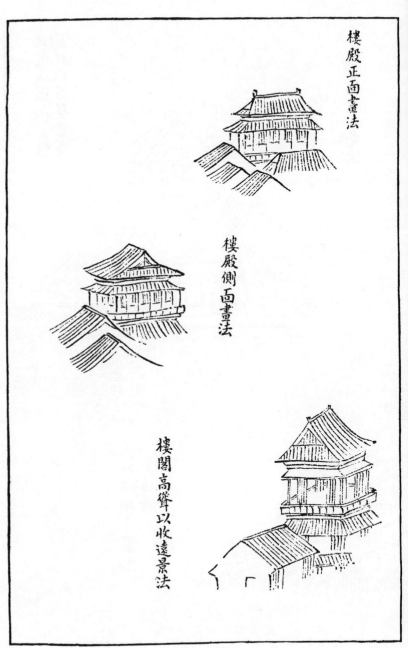

樓殿正面畫法

樓殿側面畫法

樓閣高聳以收遠景法

50

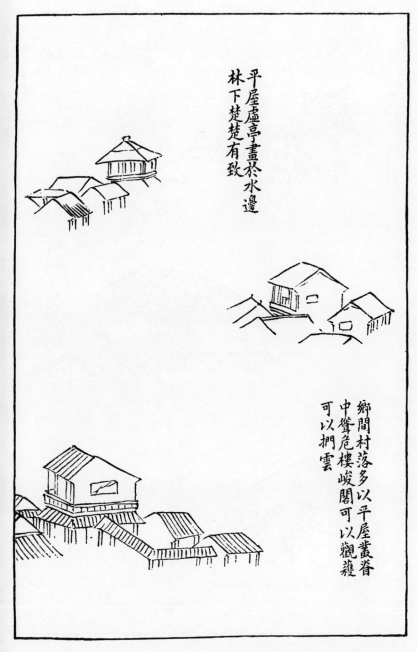

平屋虛亭畫於水邊
林下楚楚有致

鄉間村落多以平屋叢眷
中聳危樓峻閣可以觀穫
可以捫雲

Lookout pavilions may be added in painting low houses by water or at the edge of a forest.

Village dwellings are usually low in construction, with a building among them rising above the roof tops. This building should be of such height that from it one may survey the harvest or even feel that there one might touch the clouds.

269

51

Drawing the spines of palace roofs, seen from a distance.[1]

Manner of drawing roofs, like shelves, of three adjoining houses.

Roofs, like shelves, of two adjoining houses.

1. In the original editions, examples 51–54 are in a different order (53, 54, 51, 52).

52

茅屋兩間平畫法

Manner of drawing two thatched huts parallel to each other.

茅屋兩間斜置法

Two thatched huts, placed obliquely.

茅屋一間畫法

Example of a single thatched hut.

53

Bell towers in the distance.

Pavilion for study, seen from a distance.

Stone wall of a simple house and garden with an elegant pavilion.

54

汛地斥堠江景中最宜

棧閣宜畫於蜀道及俯江絕壁之下

夏景村莊茅屋式中於近窗設有遮陰在地

河房式

Structures suitable for high ground, with a view of a river.

Thatched dwellings suitable for villages in summer landscapes. The windows of these houses can be shaded or open to the sun.

The kind of structure suitable for paintings of Shu (Ssǔchuan), where the mountains are rugged and precipitous. They should be placed against steep cliffs at the bend of the river.

A house by a river.

Methods of drawing gateways

It is not necessary to see the innermost rooms of dwellings in the mountains to know their peaceful seclusion. A glimpse of the gate is enough to recognize the abode of a follower of the *Tao* and to make one wish to linger. To be able to evoke such a feeling is evidence of true skill.

(Example of a thatched gate.) [1]

Example of a gate and a wall. The pattern of the stones of the wall resembles the skin of a tiger.

Example of brick wall and doorway.

1. As in the original editions.

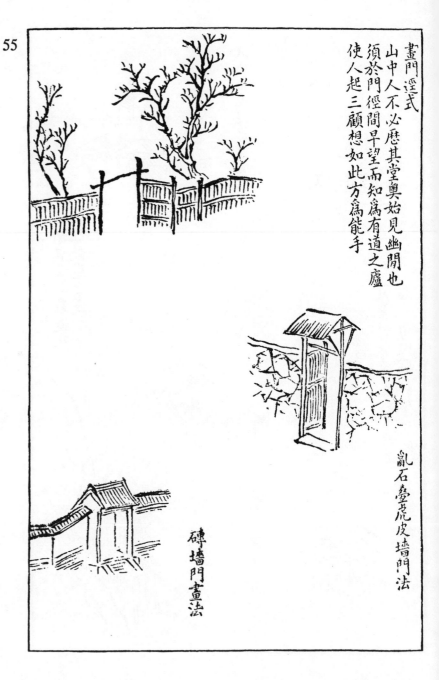

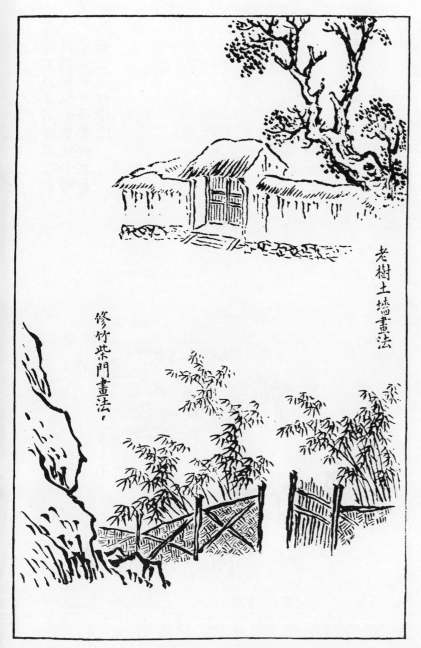

56

老樹土墻畫法

修竹柴門畫法，

Example of gate built in an earthen wall, in the shade of an old tree.

A brushwood gate by a cluster of bamboo.[1]

1. *Hsiu chu* (to trim bamboo); used of a cluster of bamboos. Also a phrase describing a person "becoming a Buddhist."

57

紫扉藤草石磴草埋瓦
比斷鱗壁如龜坼於極
荒茫中有極生動之氣
惟王叔明擅場

A hut and its gate. A rambling vine is growing across the top of the gateway, the stone steps are buried in grass, the tiles are like broken fish scales, and the cracks in the walls resemble the markings on the shell of a tortoise. The scene is completely natural, filled with the power (*shêng tung*) of the ch'i. Wang (Mêng) Shu-ming painted such scenes. (This kind of hut and gateway may be used in landscapes in the rain or snow.) [1]

1. In the original editions, the last sentence was an additional, separate remark.

58

(In painting this kind of dwelling and gate, the ancients filled the scene with meaning and, moreover, rendered it with elegance, sometimes adding appropriate touches of gray-green.) [1]

1. Text from the original editions.

59

両正一側屋堂畫畫法

丁字畫堂法

Example of two houses parallel, and a third along-side.

Example of houses placed in the form of the character 丁 (*ting*).

60

自門內反畫出門逕
法然必須四圍有樹
層層遮掩

石側樹底露出山家後門法

Example of inside view of a gateway. On all sides, trees should be added.

Example of back door of a mountain dwelling that may be situated near rocks and trees.

Examples of rustic scenes which may be used in landscapes

Mansions and pagodas of jade are abodes of divinities. But there are dwellings that are not for divine beings, such as huts and lean-tos, the roofs of which are beanstalks overgrown with melon vines. I have, therefore, put this section on small rustic scenes after storied mansions and pavilions. Such scenes should be included in landscapes, for all that exists on earth under Heaven has its place and may be put into paintings.

An observation post or signal tower.

Lean-to of beanstalks.

62

花架式

Trellis for flowers.

水閘式

Milldam or lock.

63

Example of a wall following the natural course of a river, or the foot of a mountain.

Example of the front view of a city gate.

Example of the side view of a city gate with observation post.

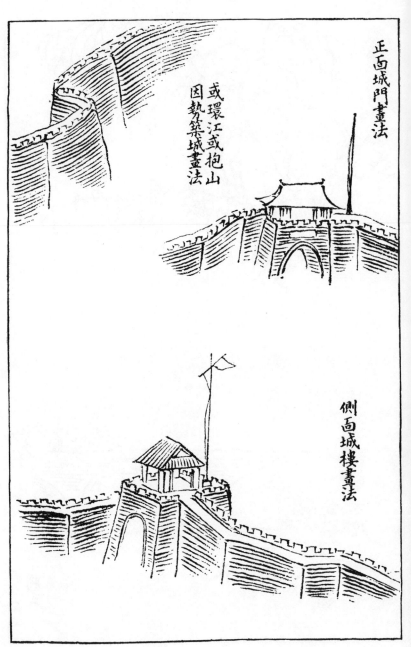

正面城門畫法

或環江或抱山
因勢築城畫法

側面城樓畫法

64

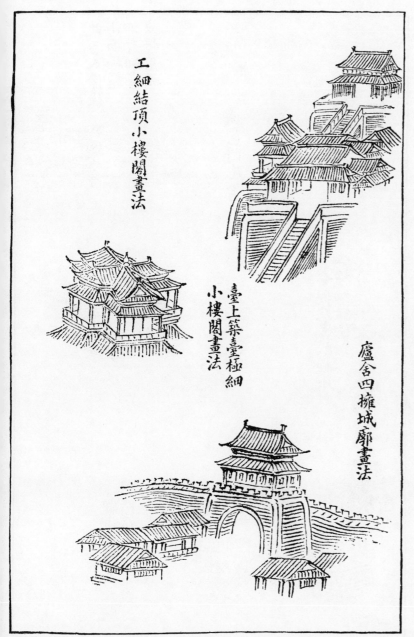

工細結頂小樓閣畫法

臺上築臺極細小樓閣畫法

盧舍四擁城廓畫法

Example of terraces raised high above the houses, drawn in fine detail.

Example of tops of buildings and verandas, drawn in fine detail.

Example of houses around a city gate.

These three examples, used in paintings concerned with precise detail, show detailed drawings of build- **65** ings and walls at a distance.

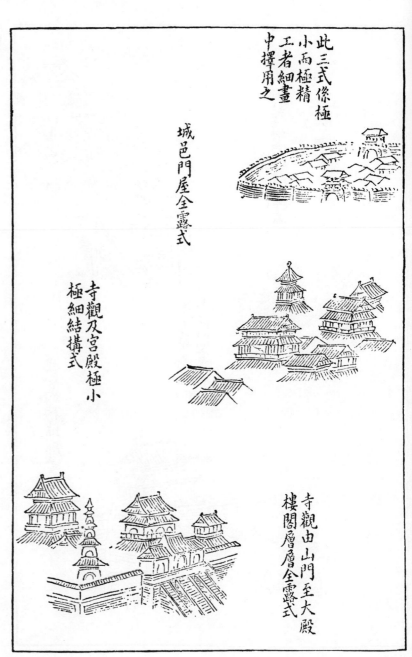

此三式係極
小而極精
工者細畫
中擇用之

城邑門屋全露式

A section of a city wall, with gate and houses.

寺觀及宮殿極小
極細結搆式

A view of a temple and a palace rising among the roof tops, drawn in fine detail.

寺觀由山門至大殿
樓閣層層全露式

A temple and pagoda, showing the entrance to the main temple among other terraced buildings.

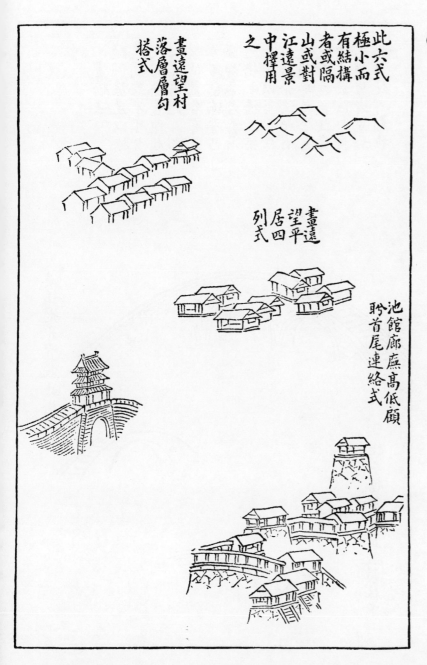

These six examples are shown on a very small scale, but are well constructed. They should be used in scenes in the far distance, on an opposite mountain, or the far side of a river.

A village in the distance, seemingly composed of layer on layer of roofs.

Groups of houses on flat ground, seen from a distance.

(A wall tower of a city, seen from a distance.) [1]

Houses, some adjoining each other, built on various levels high over water or a moat.

1. As in the original editions. The text mentions six examples, but only five are shown.

285

Methods of drawing bridges

67

In paintings in which there are steep precipices and water flowing endlessly, bridges may be drawn to sustain the continuity of the *ch'i*. They should seldom be missing from pictures. Usually where there is a bridge there will be signs of people; the mountain is not deserted. There is always good reason why a bridge is located in a particular place. Bridges built of small rocks and rising in the form of a mound are usually found in Wu (Kiangsu) or Chê (Chekiang). Bridges supported by heavy pillars of stone to withstand erosion by floods and bearing a structure like a small house are usually found in the provinces of Min (Fukien) and Yüeh (Kuangtung and Kuangsi). Furthermore, there are bridges built high and steep, suitable for spanning a dangerous, narrow divide; and there are bridges made of thin layers of stone, suitable for level ground. Between these two extremes are all other kinds of bridges.

Type of bridge suitable for placing among the **Wu** Mountains or across the Yüeh River.

Two bridges of the kind built as a breakwater below a forest.

畫橋法

絕澗陡崖以橋接氣最不可少

凡有橋處即有人跡非荒山比

然位置各有所宜

忌石薄而脊凸

如阜者吳浙之橋也

隆屋以重石柱上架

而防奔湍相嚙也

屋壘石架之橋以重石柱

者有閩粵之橋也

者宜於危梁陡磴

更有橫擔者宜於險壑薄

石橫擔者宜於平沙

他可類推

吳山越水宜設此橋

此二橋勢宜置磯頭林下

68

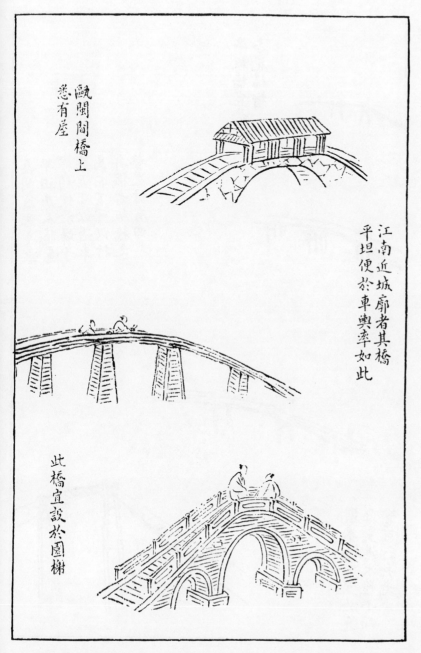

甌閩間橋上

悉有屋

Bridges of the Ou River in Min (Fukien) all have small covered structures on them.

江南近城郭者其橋

平坦便於車輿率如此

Bridges near cities south of the River (Yangtze, in Kiangsu and Anhui) are all constructed low, and so are convenient for carts and sedan chairs.

此橋宜設於園榭

A type of bridge suitable for parks.

Among the flat rice fields and small hills in the central provinces, where the mulberry grows, the people put up small footbridges that women and children find convenient. Carts and horses cannot use them, nor are boats able to pass underneath them. They are made of wood and are generally of four kinds.

69

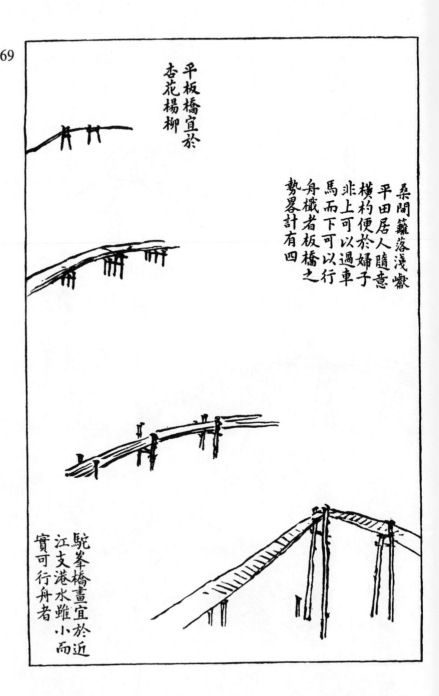

(Two examples of) wooden footbridges suitable to be placed among apricot trees and willows.

(A wooden footbridge, narrow as a wasp's waist, that may be placed across mountain streams.) [1]

A wooden footbridge, like a camel's hump, that may be drawn across a tributary of a river; there may be little water but enough for a boat.

1. As in the original editions.

288

70

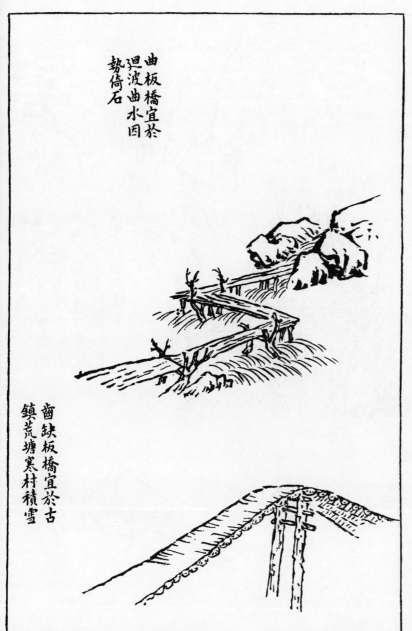

曲板橋宜於
迴波曲水因
勢倚石

齒缺板橋宜於古
鎮荒塘寒村積雪

A wooden footbridge, built in a zigzag form, that may be drawn over churning waters since it is built on rocks in the water.

A wooden bridge with gaps, as though it had lost some of its teeth, suitable for a scene of an old village in the middle of bare fields, or in a painting of such a village in snow.

Methods of drawing water wheels

In painting a water wheel in a rushing torrent that leaps forward like a galloping horse, one should feel the force, the foam and splash, of the water. Such a scene shows how people living in the mountains have had to exercise their ingenuity and are constantly having to draw upon it.[1] In painting any aspect of a landscape one's main concern should be for life movement (*shêng tung*); for movement is evidence of life.

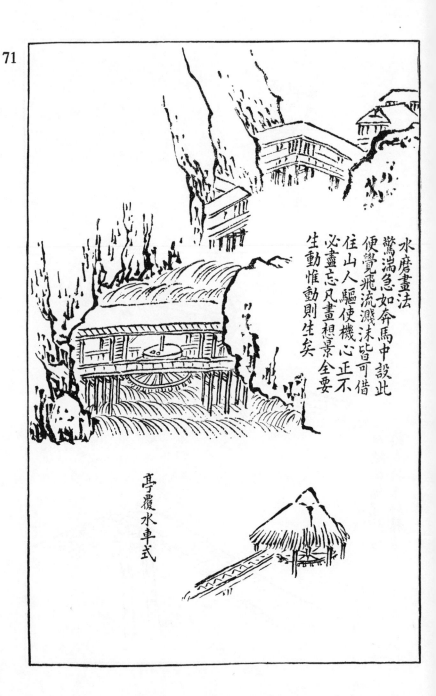

A water wheel with a thatched structure over it.

1. Characteristically, this sentence is rendered in its surface sense, but has an underlying moral meaning: the phrase about using ingenuity consists of "forced to draw on the moving power of the heart," followed by "the principle of uprightness (*chêng*) should not be neglected."

72

井亭式
宜畫於
道旁樹
下以待
遊人憩
息

桔槔畫法秧針
綠滿杏酪紅深
攜老挈幼連秧
而攀龍骨車歌
聲輟而復起東
作佳境實無踰
此

Example of a square pavilion or kiosk, such as seen on the roadside, in the shade of trees, where strollers may stop and rest.

Another type of water wheel. When rice sprouts are green and the juice of the apricot begins to turn a deep red, old and young roll up their sleeves and join together in climbing the dragon's backbone (walking the treadmill). Their chanting stops and then starts again. In painting a spring landscape of abundance, one can include nothing quite so effective as such a scene.

Examples of pagodas and towers

73

If one is painting landscapes with scenes in the far distance, towers and pagodas should be included. Painting mountains with great precipices and numberless hills and ravines cannot be done in an ordinary fashion. Such views should include pagodas to increase the effect of distance. People looking at these pictures feel that, reaching out, they could touch the stars, whose *ch'i* governs rivers and mountains. This accounts for the observation that mountains in a painting are not completely right without some arranging by men. Liu Sung-nien liked to paint such landscapes.

Buddhist stone pagodas.

(An abandoned pagoda.) [1]

An eight-sided glazed-tile pagoda.

1. As in the original editions.

塔鈴語月寺鐘吼霜於
萬籟俱寂中有此清冷
聲响空林古逕點綴其
間使人生世外想

遠塔式

Distant pagodas.

栅欄寺門式

鐘樓式

寺門式

74 The bells in the tower talk to the moon. The bells of the temple ring out in the early frosty morning. The stillness of night and dawn is broken only by these clear cold sounds and their echoes. In paintings of lonely forests and their well-trodden paths, this effect should be suggested so that people looking at them feel their thoughts lifted beyond this world.

Distant pagodas.

Temple gate and fence.

A bell tower.

A monastery gate.

Methods of drawing many-storied buildings

In painting, the drawing of many-storied buildings is to other methods of brushwork what, in calligraphy, the styles named after the Chiu Ch'êng Palace and Ma Ku Altar [1] are to the regular style (*k'ai shu*).

Some who believe themselves independent claim that they follow no rules. Actually, the stage at which one is most free in brushwork is the time when, in attempting to surpass the ancients, one is most keenly aware of their presence and methods. Often those without method will find in taking up the brush that all ten fingers suddenly freeze into a knot and for a whole day not a dot of ink is dropped. Among the ancients, Kuo (Chung-shu) Shu-hsien should be mentioned, for his brushwork was bold. A scroll of more than ten feet received just a sprinkle of ink from his brush; then here and there he drew angles of buildings and some trees. This might seem to be working without rule or method. However, he sometimes used a square and rule, dotting in towers and buildings. Then suddenly there would be ridge-poles and rafters, pillars and posts, finished with doors and wooden screens in front of them, colorful and stretching out like clouds in the wind. The brushstrokes were as distinct as bristles. One could have walked along the verandas and ascended the many stories of the buildings. No painter today equals him in skill.

It may be observed that the ancients worked without rules only because they first paid careful attention to technique. One cannot work daringly with-

(*continued at right*)

A building of several stories and terraces.

1. Characters on two famous stone engravings of the VII and VIII centuries, the style of which was copied and regarded as being most elegant.

起挑飛簷四面皆正臺閣式

必由戒律進步則
終身不走邪岔否則
涉野狐界劃淪畫
家之玉律學者之
入門

遠殿式

76 out taking great pains. Drawing by square and rule (*chieh hua*) cannot be put down as work only of artisans. The method should be examined and studied. Its practice is similar to the disciplines of Ch'an (or Zen) Buddhism. Those who study Buddhism must begin first with its disciplines, so that for the rest of their lives they will not stray [1] or be involved with evil influences. Drawing with square and rule is a similar discipline of purification in the art of painting, among the first steps for a beginner.

Winged pheasants facing in four directions, atop a main building.

Section of a palace seen from a distance.

1. *Kun* (boil over).

Wide veranda around a section of an imperial palace.

78

迴廊曲檻宮式

Winding veranda and porches of a palace.

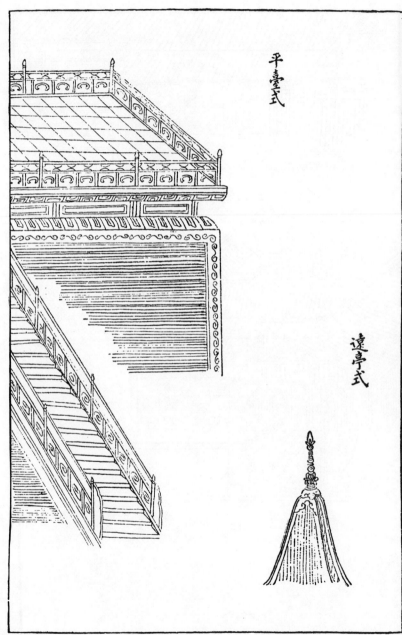

79

Section of a terrace.

Pavilion top in the distance.

平臺式

遠亭式

80

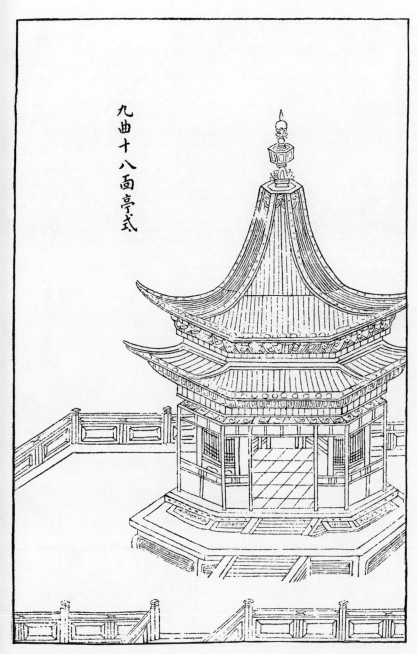

九曲十八面亭式

A nine-angled, eighteen-sided pavilion.

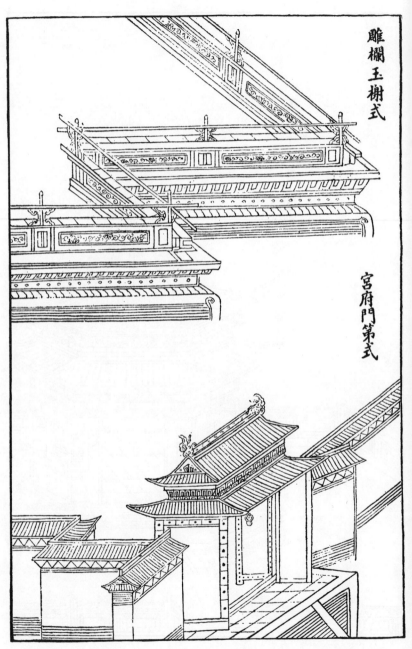

81

雕欄玉砌式

宮府門第式

A marble terrace with carved balustrades.

A palace gate.

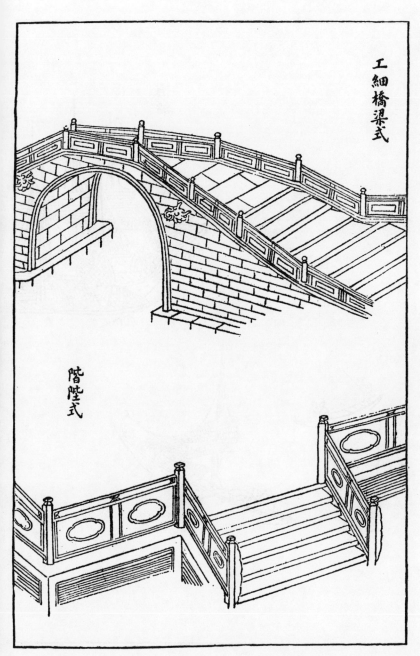

82

工細橋梁式

A bridge of intricate construction.

階陛式

A flight of imperial steps.

83

泊
船

Boats at anchor.

(A boat passing.) [1]

(A boat setting sail.) [1]

1. As in the original editions.

84

雙帆齊掛船

A boat with two sails unfurled.

雨景漁艇

A fishing boat which may be used in scenes in the rain.

A boat carrying a load of wine.

戴酒船

85

江船
此上彼下
揚帆撐篙
谷用氣力
以見長江
有上下風
也

捕魚罾宜畫
於平沙叢葦
與落雁宿鷗
爭汀煙江月

River boats

Up and down the river (boats move), sails outspread, poles in use to hold the course. All on board bend every effort, for on the Yangtze River the wind has great force.

Fishermen with their nets may be drawn near sandbanks where reeds are thick. Wild geese may be added, drawn as they fly down to rest, and cormorants bickering in the mist on the flats or in the reflection of the moon on the river.

峽船宜畫於川景三峽以百尺倒挽大舟流斷不可畫於吳越平波閒

大署

86

Boats on the gorges

This kind of boat is suitable for a painting of the Three Gorges of Ssŭchuan. With a hundred-foot line, the men are pulling against the current. This scene should never be placed in a painting of the calm waters of Wu (Kiangsu) or Yüeh (Kuangtung and Kuangsi).

(Fishing with) a large square net.

87

(Boats on a lake) [1]

(This kind of scene is suitable when the waters are calm—for instance, on the lakes of the Ku River, in Chekiang. The scene depicts the lull before loading the cargoes of wine that will encourage the composing of poems.) [1]

Rowing boats

A scene among the reeds in the moonlight in which one seems to hear the paddling of oars.

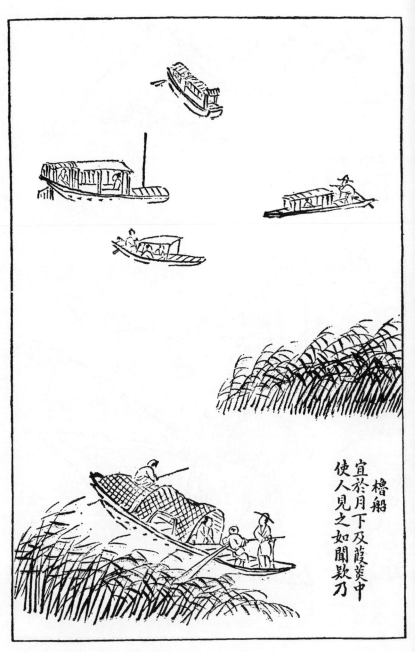

1. Text from the original editions.

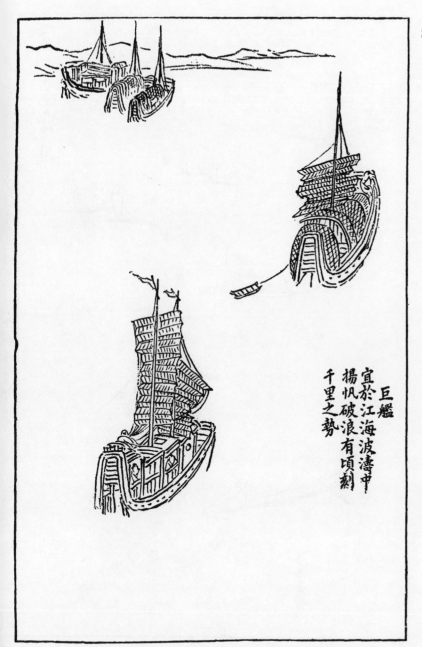

88

Junks

Junks should be drawn sailing on the river or sea. Spreading their sails, cleaving the waves, they can sail a thousand *li*.

巨艦
宜於江海波濤中
揚帆破浪有頃刻
千里之勢

89

Boats sailing in the far distance
and foreground

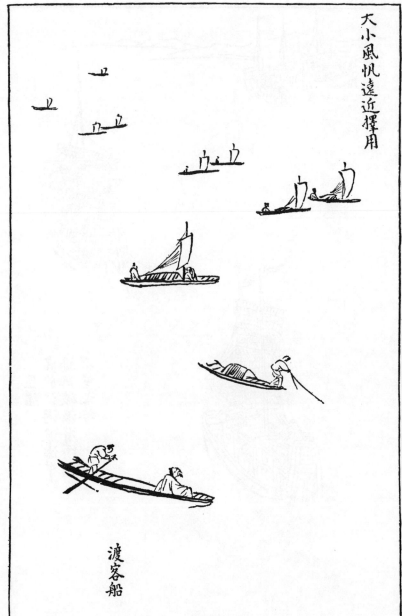

(Casting a net from a boat.) [1]

Ferrying a passenger.

1. From the original editions.

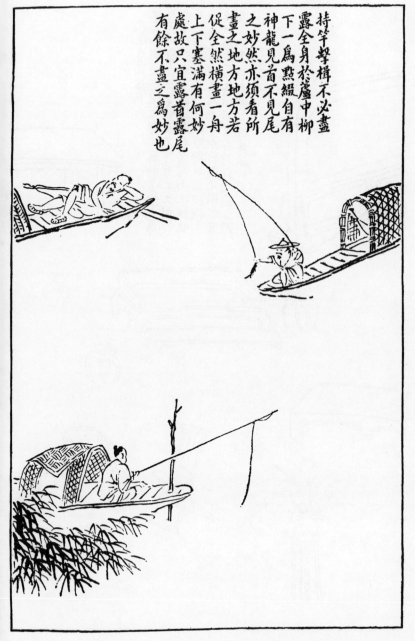

持竿擊楫不必盡
露全身於蘆中柳
下一為點綴自有
神龍見首不見尾
之妙然亦須看所
畫之地方地方若
促全然橫畫一舟
上下塞滿有何妙
處故只宜露首露尾
有餘不盡之為妙也

In drawing a figure who is rowing, it is not necessary to show the whole boat. Boats drawn among reeds and under willows are primarily for decoration. As in drawing the divine dragon with the head but not the tail, it is the placing that is important. If the site is small and an entire boat is drawn, the boat will seem to fill the whole space, crowding the composition. What skill is there in this? Under such circumstances one end of the boat should be shown, not the whole craft. That takes skill.

Examples of chairs, tables, screens, and couches

91

When palaces, pavilions, and terraces have been drawn, how can they be left empty? There should be tables and seats, something to lean on and something to sit on. They should not be drawn with too much detail; that would be banal. But they should not be drawn too sketchily, nor without method or arrangement; that would be untidy. When the landscape is beautiful and the houses and pavilions also beautiful, and the few furnishings are expensive but unbecoming, it is like a flaw in an otherwise perfect piece of jade.

In general, when the house is drawn facing left, tables and couches should follow the same arrangement. When turned right, the furniture should likewise be arranged. Furniture should balance, face to face and side to side, whether the pieces are large or small. That is the basis of arranging furniture.

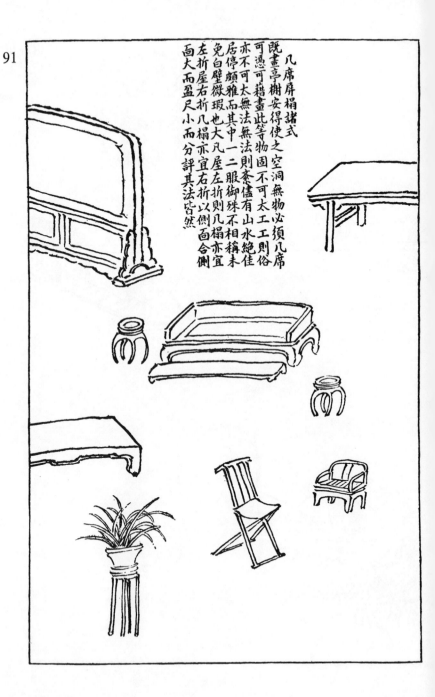

几席屏榻諸式
既畫亭榭安得使之空洞無物必須几席
可畫亭榭安此等物固不可太工則意
可憑可籍畫無法無山水絕佳
亦不可太儘有則意御殊不相稱未
居停頗雅而其中一二服御殊不相稱未
免白壁微瑕也大凡屋左折則几榻亦宜
左折屋右折几榻亦宜右以側面合側
而大而盈尺小而分評其法皆然

92

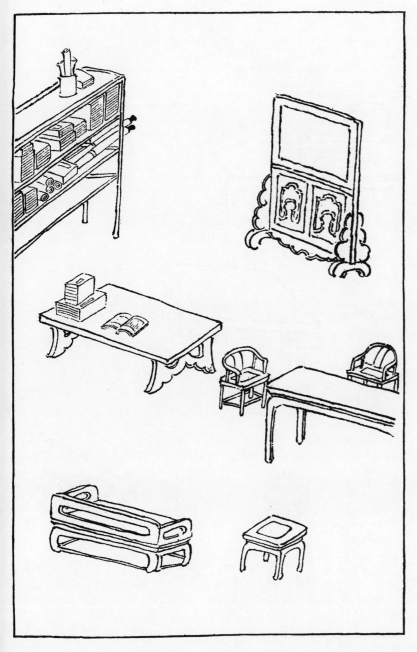

(Examples of chairs, tables,
screens, and couches)

93

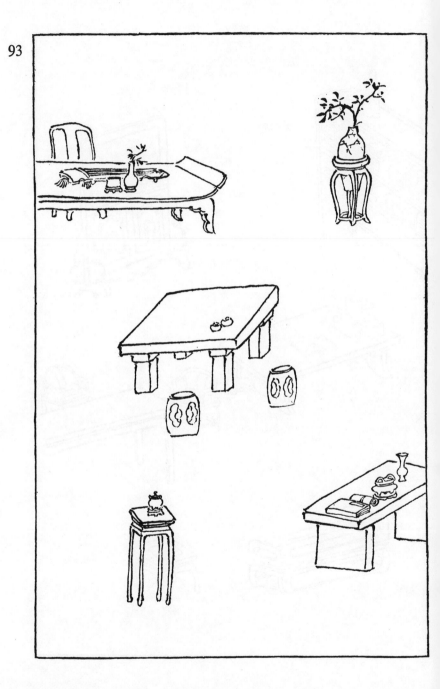

94

[In the original editions (1679, 1701) and in the Shanghai (1887–88) edition, the *Book of Jên-wu* was followed by a fifth book, here omitted, of additional examples copied from works of various masters: 10 double pages, 10 album paintings, 10 fan paintings, and 12 additional double pages, increased in the Shanghai edition to 68 single pages. This book, and the four preceding books given here, comprised Part I of the *Chieh Tzŭ Yüan,* i.e., the entire contents of the first (1679) edition.]

PART II

Book of the Orchid

Book of the Bamboo

Book of the Plum

Book of the Chrysanthemum

[The Shanghai edition contained, prefacing Parts II and III, a testimonial by Ho Yung, who had also written the preface to Part I (see above, p. 3). The testimonial consisted of conventional remarks on painting and calligraphy and praise of the Manual.]

Preface to Parts II and III
of the First Complete Edition (1701)[1]

M ANY years ago, I compiled the first part of this Manual of painting for publication by the owner of the Chieh Tzǔ Yüan (Mustard Seed Garden). Mr. Shên Yin-po, the publisher, showed the work to his father-in-law, Mr. Li Li-wêng, and asked his opinion of it. (Li-)wêng at that time was convalescing at Wu-shan. On looking through the book, he exclaimed, in great excitement: "Here I am, in this house high up with a view of the city and the surrounding countryside, sometimes clear, sometimes veiled by mist. I see it at all hours of day and evening, under all sorts and conditions of weather. There is always something unfathomable in the beauty of its various aspects, and my one regret has been that I am not able to put some part of it into a painting. With this book I may now perhaps realize this ambition!" Now, many years have passed. (Li-) wêng is dead. The Chieh Tzǔ Yüan has changed hands three times. However, Part I of the Manual is still in great demand, and the publishing house of Chieh Tzǔ Yüan is still well known. It is surprising how wide the interest has been in the book and in those responsible for its publication, and how they and the Chieh Tzǔ Yüan continue to be known. Indeed, many people interested in painting have asked about a second volume.

1. Wang Kai, *tzǔ* An-chieh (Lu Ch'ai in the Manual), here introduces the first complete edition of the *Chieh Tzǔ Yüan Hua Chuan* (Part I, republished; Parts II and III new), published in 1701, twenty-two years after Part I first appeared. This preface was placed, as here, at the beginning of Part II.

This preface was actually bound in Book 6, but it is presented here because in content it is prefatory to Parts II and III. The omitted preface by Ho Yung, described at left, was also bound in Book 6.

Mr. Shên Yin-po, son-in-law of (Li-)wêng, gathered together and showed me their joint collection of paintings of flowers, plants, insects, and birds by celebrated artists. It is a stack of material as bulky as the girth of an ox. I and my younger brothers, Mi-ts'ao and Ssŭ-chih, were allowed to copy what was needed from the original works in order to compile Parts II and III of the Manual. I appreciate (Mr. Shên's) not concealing my humble name in connection with this work. Our association has, in fact, been so congenial and lasting that, although now we are both growing old, we are working together to prepare the concluding part of the work. Such a relationship is indeed rare, and therefore I have complied with his wish to complete the whole work under its original title, *Chieh Tzŭ Yüan Hua Chuan*. The circumstances are similar to those under which Lo Pi, *tzŭ* Ch'ang-yüan, of Lu-ling, wrote his *Lu Shih* (Great History): it is not known as *Lu Ling Lu Shih* (Lu-ling's Great History) but as *Hsi Hu Lu Shih* (West Lake Great History), for Ch'ên (Tzŭ-lung), *tzŭ* Wo-tzŭ, and his associates (who compiled the additional books of the *Lu Shih*) carried on their studies at the West Lake (Hsi-hu or Hu-shang). Thus credit is given where credit is due.

The rest of this Manual is composed of two parts: one (Part II), dealing with the orchid, bamboo, plum, and chrysanthemum, and the other (Part III), dealing with various kinds of mountain flowers, marsh plants, grasses, insects, and birds. Each section has introductory notes and instructions, arranged in a simple way, to aid the beginner.

Mr. Shên has a deep interest in calligraphy and painting and has spared no expense in commissioning the finest craftsmen to work on the (wood-block) reproductions of the examples. From my own experience, I would say that painting flowers and plants is more difficult than painting landscape. Even on ordinary silk, results are often clumsy; and it is even more difficult, therefore, to reproduce such original paintings on wood blocks. When the blocks for this work were completed, the results were far beyond all expectation: every detail of the brushstrokes had been beautifully brought out. I was delighted and wished that Li-wêng could have been there so that we could have joined in our praise.

Someone said to me: "In painting bamboo, Wên T'ung, of Hu-chou, was the best, but this branch of painting, according to tradition, began with Li P'o (of the Five Dynasties period); in painting the orchid and chrysanthemum, Chao (Mêng-fu), of Wu-hsing, was the best, but this branch of painting began with Yin Chung-yung (of the IX century); in ink painting of the plum

tree, the Buddhist monk Chung-jên, of the Hua Kuang Shan monastery, was the best, but this branch of painting began with T'êng Chang-yu (of the Five Dynasties period); in painting birds, fish, and insects, Hsü Hsi was the best, but this branch of painting began with Hsüeh Chi and Pien Luan. I wonder if it is possible to trace the origins of these categories of painting to (examples of) still earlier periods that these painters might be said to have followed?"

I replied: "They were all influenced by the poets of ancient times. Look in The Three Hundred Pages: [2] mentioned are blossoms of the peach and plum; rushes, duckweed, and white southernwood; creepers, lotus, and wild grapevine; and the water chestnut, peony, and ripe plum. Birds and insects also are mentioned: the ringed pheasant, pigeon, oriole, swallow, and wild goose; bees, cicadas, and green grasshoppers. According to the nature and disposition of each, their forms and sounds are vividly described in the poems. Isn't this classic the masterpiece of all time in realistic painting? There also is the great encyclopedia, the *Êrh Ya,* in which may be found detailed descriptions of all these classifications. Moreover, there is the *Li Sao* (Falling into Trouble: Ch'ü Yüan's poem, 295 B.C.), which describes (plants, flowers, birds, and animals) in illustrating the range of human emotions. These three works really constitute a complete reference work on flowers, plants, and birds. Sometimes, before painting, I sit thoughtfully with brush in hand and draw inspiration from leafing through the pages of these works; my fingers then become agile, my thoughts surge like water from a spring. Sometimes, before composing poems and essays, I paint one or two small things on a sheet of paper and so collect emotions and ideas. In such ways, one may often gather inspiration from the skill and ideas of celebrated artists of the past, like drawing water by rope and bucket from a well. In the art of painting, wielding the brush is of first importance, next the handling of the ink, and finally, color."

When Mr. Shên heard these remarks, he was delighted and exclaimed: "What you have said is of value not only to those who are interested in painting plants and flowers and birds and insects, but also to those who are learning to write poems and essays. Let me add that I am aware of your exceptionally faithful remembrance all these years of my late father-in-law and of the Chieh Tzŭ Yüan, and I appreciate it. You remarked that the *Lu Shih* became famous through its association with the West Lake. I suggest that, were it not for the *Lu Shih,* the West Lake would

2. The *Shih Ching* (Book of Odes) (cf. tr. by Karlgren).

not be so well known, and I would make the same observation about your association with the Chieh Tzŭ Yüan."

Written by Wang Kai of Hu-ts'un at the time of the full moon in mid-autumn of the cycle of Hsin-ssŭ in the reign of K'ang Hsi (1701).

[In the 1701 edition, an additional foreword was supplied by Chu Shêng (*tzŭ* Hsi-an), who helped to prepare the illustrations for the *Book of the Orchid* and the *Book of the Bamboo*. The foreword dealt with these books and mainly repeated historical notes given in their opening sections. Originally it was placed at the beginning of the *Book of the Bamboo;* in the Shanghai edition it was placed here, at the beginning of Part II.

[The 1701 edition also contained, at this point, prefatory notes by the publisher, Shên Hsin-yu (*tzŭ* Yin-po), which were omitted in the Shanghai edition. They are an extraordinary mixture of information and salesmanship. Among Shên's notes, in addition to laudatory remarks about the Manual, the following points pertain to the painters who worked on the book: Wang Shih (*tzŭ* Mi-ts'ao) was responsible for the editing of Parts II and III, and he and his brother Wang Nieh (*tzŭ* Ssŭ-chih) prepared most of the illustrations for Part III, while the flower painters Wang Yün-an and Chu Hsi-an prepared the illustrations for Part II. Shên drew attention to his own notes on colors at the end of the work (which are included in this translation: below, pp. 579 ff.), and also took the opportunity of advertising some other publications of his house, on music, chess, calligraphy, seals, social decorum, business correspondence, human relations, etc.]

Book of the Orchid

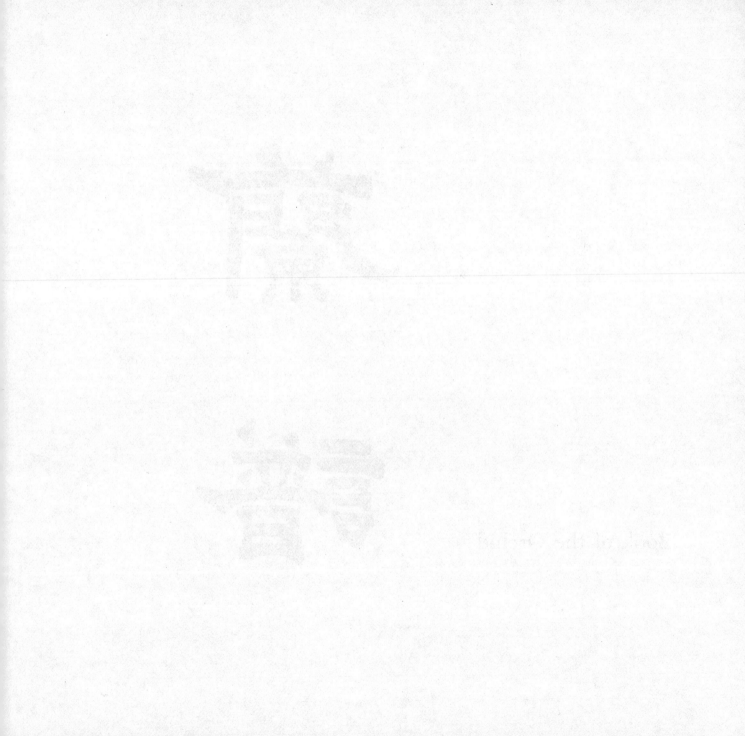

Ch'ing Tsai T'ang Discussion
of the Fundamentals of Orchid[1] Painting

MI-TS'AO[2] says:

Before attempting to paint finished pictures of the orchid, one should study the works of the ancients. Later one may inject one's own ideas. First, however, one should know the various methods; the rules phrased for memorizing by chanting (*ko chüeh*)[3] should be learned, and one may then start with the basic strokes contained in the character *ch'iu*.

In learning to write, one begins with simple characters made up of a few strokes and proceeds to complicated characters with several strokes. In the same way, in learning to paint flowers, one begins with those with few petals and proceeds to those with many petals, from small leaves to large, and from single stems to bunches. Each division of subject matter is classified here so that beginners may learn them thoroughly, not only beholding them with their eyes but retaining the impressions in their minds. In calligraphy, one first learns to write *ch'iu*, which contains the eight basic strokes; though there are hundreds and thousands of characters, the fundamental strokes are

求

1. *Lan,* general term for orchidaceous plants, used for orchids and irises, also sometimes for the artemisia and cassia.

2. *Tzŭ* of Wang Shih. Wang Kai (*tzŭ* An-chieh, Lu Ch'ai of the Manual) referred, in his preface to Parts II and III, to his elder brother, Wang Shih, and his younger brother, Wang Nieh, as coauthors with him of the two parts.

3. *Ko* (sing, chant) *chüeh* (secret), an expression used here about learning the rules of painting. Chanting by phrases was a common practice in the process of memo-rizing, applied notably to the classics learned in childhood. *Chüeh* is also used in terms describing the mysterious and occult, magic formulas, etc., and suggests the relationship with the mantras (the chanting of religious texts), the sounds of which were believed to set up vibrations in a manner that might be described as "tuning in" with the Infinite. A relevant statement appears in the *Shu Ching* (Book of History): "Poetry is the expression of earnest thought; singing is the prolonged utterance of that expression" (Legge, *The Shoo King,* Part II, Bk. I, v.).

all found in *ch'iu*. Likewise in painting flowers: when the beginner has learned the basic steps, he will have started on the way to acquiring experience and skill.

General background of orchid painting

Since Chêng So-nan, Chao I-chai, and Kuan Chung-chi,[4] there have been many painters renowned for their ink monochrome paintings of orchids. They may be divided into two general groups: the literati, who in certain inspired moments produced extraordinarily spontaneous results in brush-work; and some women painters of orchids, in whose works the *shên* (divine) quality seemed to float across the painting. Both groups were wonderful.[5] Chao Ch'un-ku and Chung-mu [6] worked in what might be called a family style. Yang (Wu-chiu) Pu-chih and T'ang Shu-ya (of the Sung era), nephew and uncle, both were extraordinarily skillful. Yang Wei-kan and (Chao) I-chai, of the Yüan period, had the same *tzŭ,* Tzŭ-ku. All of these painters were famous for their pictures of orchids. Up to Ming times, there were Chang Ching-chih, Hsing Tzŭ-ching, Wu Ch'iu-lin, Chou Kung-hsia, Ts'ai Ching-ming, Ch'ên Ku-pai, Tu Tzŭ-ching, Chiang Lêng-shêng, Lu Pao-shan, and Ho Chung-ya. Their ink conjured forth a variety of fragrances; from their inkstones grew nine fields of orchids. Each was at the peak of his period. In painting orchids, women painters followed (Lady) Kuan Chung-chi; there were Ma Hsiang-lan, Hsieh Su-su, Hsü P'ien-p'ien, and Yang Wan-jo. All were beautiful courtesans, a fact that some may think casts a shadow on the orchid. However, (ever since the two princesses of Hsiang were given as concubines by their father to his successor), the orchid fields of the River Hsiang have reflected a blush of shame and yet continue to bring forth no ordinary flowers or common grass.

Order of brushstrokes in painting orchid leaves

The art of painting orchids depends entirely on the drawing of the leaves, and therefore the drawing of the leaves should be the first consideration.

4. Chêng Ssŭ-hsiao, *tzŭ* So-nan, and Chao Mêng-chien, *hao* (nom de plume) I-chai, *tzŭ* Tzŭ-ku, of the XIII century. Kuan Chung-chi (Tao-shêng), Lady Kuan, wife of the Yüan master, Chao Mêng-fu. See Vol. 1, Pl. IX, an orchid scroll attributed to Chêng So-nan (1239–1316).

5. The same terms are used to describe the merits of these groups that were applied to the Three Classes, quoted by Lu Ch'ai in his introductory discussion: *i* (impetuous and extraordinary), *shên* (divine), *miao* (wonderful).

6. *Tzŭ* of Chao Yung, son of Chao Mêng-fu, the latter here referred to as Ch'un-ku.

The first brushstrokes one should learn are those known as *ting t'ou* (nail ends), *shu wei* (rat's tail), and *t'ang tu* or *t'ang lang tu* (belly of a mantis); next, the stroke called *chiao fêng yen* (cross stroke forming the eye of a phoenix); then the stroke called *p'o hsiang yen* (breaking the eye of the elephant). Finally, one should learn the strokes for the leaves wrapping the base, the sheath at the roots that resembles the form of a fish's head (*chi yü t'ou*). Thus one draws leaves bending one way and raised in another, conveying the life movement (*shêng tung*) of the plant. Leaves should cross and overlap but never repeat in a monotonous manner. Distinction should be made between the leaves of the grass or ordinary orchid (*ts'ao lan*) and those of the marsh orchid (*hui lan*): the latter are slim and supple, the former wide and strong. The above brushstrokes are the first steps in painting orchids.

Painting leaves to the right and left

In painting leaves, there are methods of drawing them to the right and to the left. The drawing of a leaf is described as "writing" it in the stroke called *p'ieh*. This is the stroke and the term used in calligraphy. When the hand moves from left to right the brushstroke is called *shun* (positive), and from right to left *ni* (negative). Beginners should first practice the *shun* stroke until they are able to handle the brush with ease. The counterstroke *ni* should be practiced until brush movement in both directions is mastered. This will give some experience with the brush. Skill in manipulating the brush only in one direction is limited experience and incomplete knowledge of method.

Painting leaves grouped sparsely or densely

Leaves are painted in a few strokes, and they should have a floating grace in rhythm with the wind, (moving like a goddess) in rainbow-hued skirt with a moon-shaped jade ornament swinging from her belt. No breath of ordinary air touches them. Leaves should half veil the orchids, and some should certainly be painted behind the flowers, supporting them; they should be drawn growing from the roots, though not in such a way as to appear bunched up. When one is able to convey the whole idea (*i*) without painting every leaf, then one indeed wields an experienced brush. One

should study attentively the works of the ancients and practice drawing three leaves, then proceed to five leaves and then to scores of leaves. When there are only a few leaves, they should not have the appearance of being sparse; when there are many leaves, they should not appear entangled and in confusion—a matter of fine discrimination.

Painting the flower of the orchid

In painting the flowers, one should know how to draw them bending over as well as standing erect, how to draw their faces as well as backs, how to draw them in bud and in full bloom. The stems should appear wrapped by the leaves; the flowers should emerge from them. They should be seen face up, from the back, high and low; thus they will not be repeated in a monotonous fashion, all in a row. There should be leaves behind some of the flowers as though half hiding them. Some flowers should, however, stand free of the leaves, for they should not seem to be bound. The marsh orchid, although it resembles the ordinary grass orchid, is not as beautiful or as graceful. On a straight stem, the flowers face different directions and open at different times. The stem is straight and erect but the flowers are heavy, as though they hung from the stem. Each stem and flower has its particular position and angle. In drawing the flowers of both the grass and marsh orchids, one should be careful to avoid the effect of the five petals spread out like fingers of an open hand. They should partly cover each other, some curving toward their stem and others stretching out. They should be delicate, joined among themselves, and reflecting each other. After long practice and thorough familiarity with the methods, heart and hand will be in accord. At first, however, it is advisable to follow closely the prescribed methods; thus, eventually, one may reach perfection.

Dotting the heart

Dotting the heart of the orchid is like drawing in the eyes of a beautiful woman. As the rippling fields of orchids of the River Hsiang give life to the whole countryside, so dotting the heart of the flower adds the finishing touch. The whole essence of the flower is contained in that small touch. How can one therefore possibly neglect it?

Use of brush and ink

Chüeh Yin, Buddhist monk of the Yüan period, said: "When the emotions are strong and one feels pent up, one should paint [7] bamboo; in a light mood one should paint the orchid, for the leaves of the orchid grow as though they were flying and fluttering, the buds open joyfully, and the mood is indeed a happy one."

The beginner should concentrate at first on practicing with his brush. The strokes should be made with elbow raised. They will then be natural and light, appropriate to the form to be drawn, firm without being tense, full and lively. As for ink, there should be a happy combination of light and dark tones. Leaves should be dark and the flowers light; the dotting of the heart should be dark and the sheath of the stem light. This is a fixed rule. If color is used, dark tones should be used on the face of the leaves and light on the back, dark tones for leaves in front and light for those in the back. This rule should be thoroughly absorbed.

Outline method

The ancients used the outline method in painting orchids. It was the method called *shuang kou* (double contour or outline), one of several ways of painting orchids. In using it, if one only copies the shape, filling in with color, blue and green, the essence of the flower will be lost and it will be devoid of grace. But this particular method should not be omitted in discussing the various methods, and that is the reason it is mentioned here.

Rules of painting the orchid arranged in four-word phrases [8]

The secret of painting the orchid rests basically in the circulation of the spirit (*ch'i yün*). Ink should be of best quality. Water clear and fresh. Inkstone clean of old ink. Brush of quality and flexibility.

7. *Hsieh* (write).
8. For the sake of clarity, the four- and five-worded rules have to be translated in longer phrases. Many of the rules, as in the first sentence, were made up of two sets of four words. Brevity will perhaps convey the effect of the short phrases, although it was, of course, the uniformity that was helpful in memorizing.

First draw four leaves. They should vary in length. A fifth leaf crosses them. In this there is grace and beauty. At the crossing of each leaf add another; place three in the center, four on the sides, and complete with two more leaves.

Ink tones should be varied. Old and young leaves should mingle. Petals should be light, stamens and calyx dark. The hand should move like lightning; it should never be slow or hesitant. Everything depends on structure and style (*shih*) by means of the brush.

Flowers should have a variety of positions: front, back, and side views. If they are to make an agreeable composition, they should be placed naturally (*tzŭ jan*). Three buds and five blooms compose a picture. Flowers in wind or sunlight are elegant. In frost or snow, leaves begin to droop.

Stems and leaves should have movement like the tail of a soaring phoenix; the calyx should be light as a dragonfly. At the base of the plant there is a sheath of leaves that should be drawn in roughly with the brush; stones should be added, drawn in the *fei pai* (flying white) method. Place one or two orchid plants by a plantain tree as though they were ordinary grass, or on a secluded bank; add them to one or two stalks of green bamboo, or draw them beside thorny brambles. These improve the composition. Follow Sung-hsüeh (Chao Mêng-fu), for that is the true tradition.

Rules of painting the orchid arranged in five-word phrases

In painting the orchid the first stroke is (the arc-shaped stroke) called *p'ieh*. The brush should be handled through the wrist with agility. Brushstrokes should not be equal in length. When the leaves grow in bunches, crisscrossing, bending, and drooping, they should have *shih* (style and structural integration). Bending over or facing up, each has a special aspect; distinction, moreover, should be made between the forms in the foreground and those in the background. There should be variety of ink tones. Flowers and more leaves should be added, also the sheath that covers the base. The flowers should first be drawn in light ink; soft and pliant, they are supported by their stems. Differences between the inside and outside of petals should be shown, each form being very delicate. The stem should be wrapped in a fine young leaf. Flowers gain distinction when their stamens are dotted with dark ink. In full bloom a flower stands erect with face upwards. The mood is that of a fair and happy day. When flowers are painted in a breeze, they should seem to be

weighted with dew. Buds are closed as though they were firmly holding their fragrance. The five petals of the flower should not be arranged like fingers of an outstretched hand. They should be like fingers, though with one or two curled and one or two straight. The stem of the marsh orchid should be strong and upright, its leaf strong and vibrant, the leaves spread out on all sides more than with the ordinary orchid. Flowers hang from the tips of the stems; their subtle fragrance can be conveyed by the movement of the wrist. Through brush and ink it is possible to transmit their essence.

The second stroke added to form the eye of a phoenix (*chiao fêng yen*).

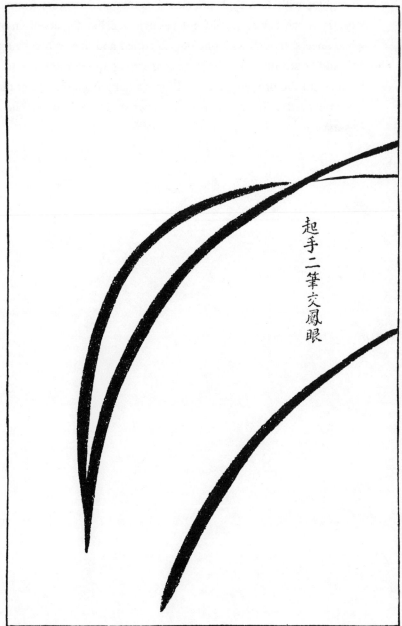

2 Examples of the *p'ieh* stroke for leaves

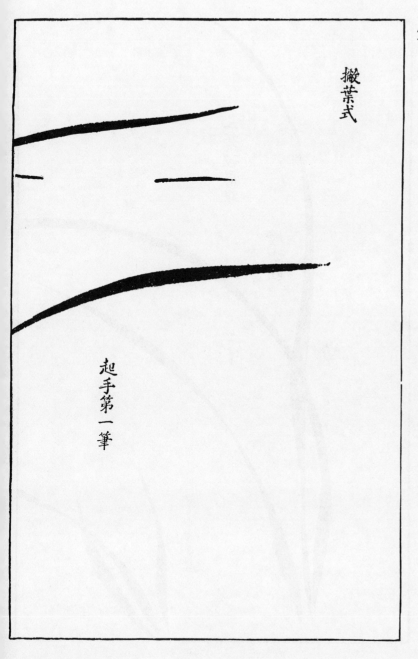

The first stroke in painting orchid leaves.[1]

1. Applies to the single leaf and the lower leaf of the pair.

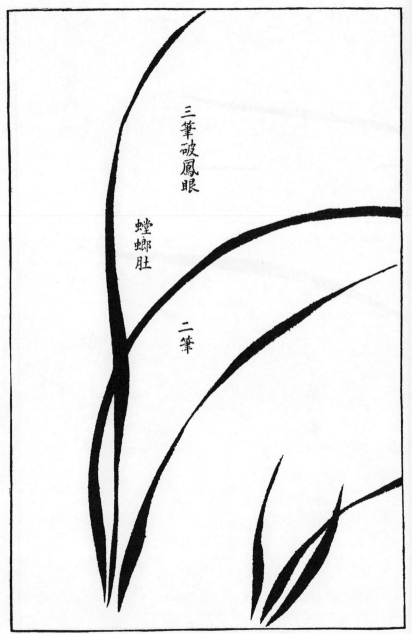

3

三筆破鳳眼

螳螂肚

二筆

Right and across: [1]
 The first stroke.

Left and across:
 The second stroke.

Center and upward:
 The third stroke, crossing to form the eye of the phoenix.

 Belly-of-a-mantis (*t'ang lang tu*) stroke (name of the third stroke).
 "Idea present, brush absent" (hiatus in first stroke).
 Rat's-tail stroke (end of first stroke).

Right:
 Three strokes at the base of a plant, formed by carp's-head (*chi yü t'ou*) strokes.[2]

1. The first six explanations apply to the main group of three leaves on this page. Three of the legends are written on the facing page.
2. Text on facing page.

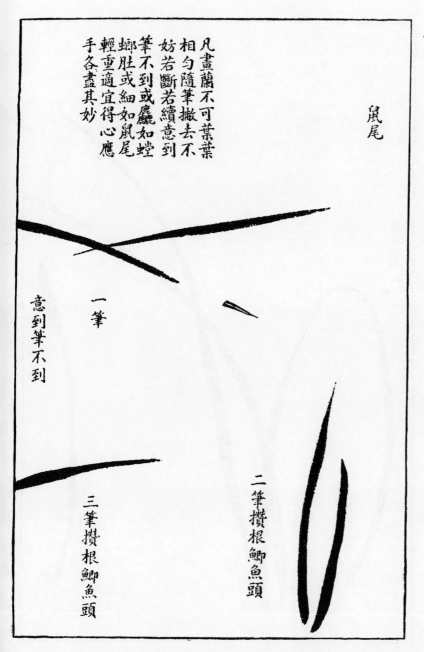

凡畫蘭不可葉葉
相勻隨筆撇去不
妨若斷若續意到
筆不到或麤如螳
螂肚或細如鼠尾
輕重適宜得心應
手各盡其妙

鼠尾

一筆

意到筆不到

三筆攢根鯽魚頭

二筆攢根鯽魚頭

4 In painting orchids, the leaves should not all be painted the same length. As the brush moves at a slant there may occasionally be a break in the stroke. This does not matter. (Done properly,) it illustrates the principle that the idea has continuity even though there is a break in the brushstroke: *i tao pi pu tao* (idea present, brush absent). Moreover, a stroke may be fat like the belly of a mantis or thin as a rat's tail (*shu wei*). The pressure of the brush should conform with the concept in the heart; the hand will then achieve perfection in skill.

Two strokes for leaves, issuing from the base in the form of a carp's head.

ORCHID

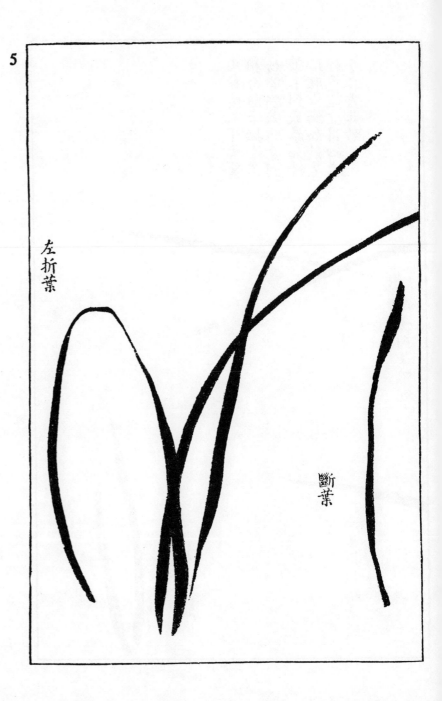

A leaf bending to the left.

A broken leaf.

6

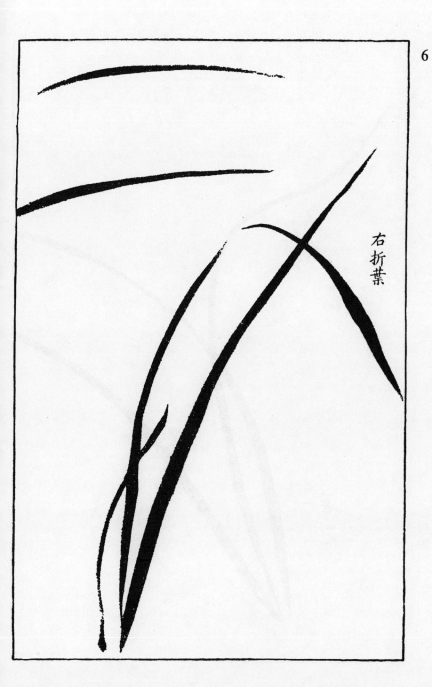

右折葉

A leaf bending to the right.

ORCHID

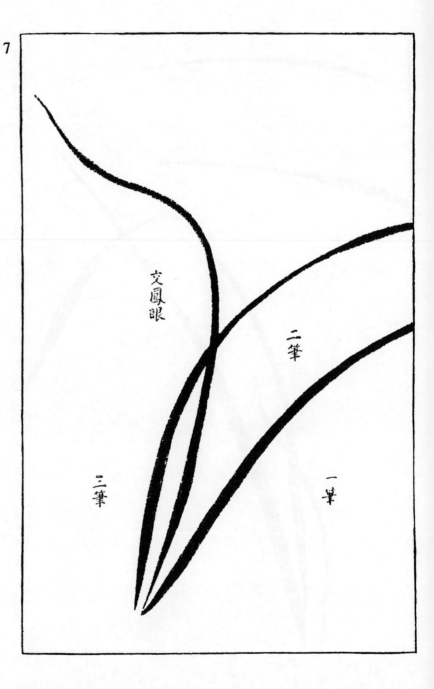

The first stroke.[1]

The second stroke.

The third stroke.

(The third stroke, a leaf called) *chiao fêng yen*, crossing to form the eye of a phoenix.

1. The strokes are given in the order in which they are practiced, starting at the base of the plant: right, left, and center. The crossing of the second and third strokes makes a form like the eye of a phoenix.

8

In all of the preceding examples, the first to third strokes show the beginner how to proceed from left to right. This is the *p'ieh* stroke, an easier stroke to start with. Here are examples of brushstrokes moving from right to left. This is a step from the easy to the difficult.

In the painting of orchids, the base of the plant should be indicated. While there may be scores of leaves, they should not be drawn the same length or without some order. They may be painted in light or dark tones, depending on the circumstances. This should be thought out and carried through with intelligence and discrimination.

9

之得亂葉攢次以故初筆前
　所濃不根以便也學皆起
　是淡可雖進由茲者自手
　在得更多凡易作順左一
　神宜穿至畫而右手而筆
　而穿插數蘭難發易右至
　明　十須循式撇為三

10

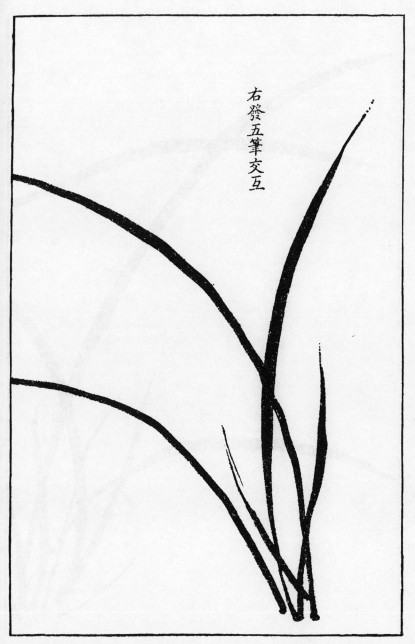

Five strokes beginning at the right, joined and crossing to the left.

11

12

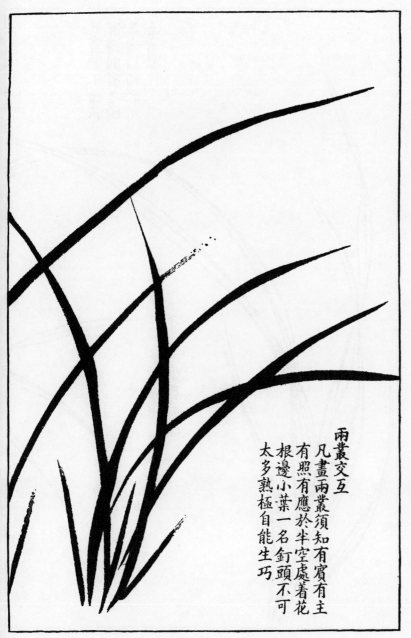

兩叢交互

凡畫兩叢須知有賓有主
有照有應於半空處着花
根邊小葉一名釘頭不可
太多熟極自能生巧

Two orchid plants with leaves crossing

In painting two orchid plants, one should keep in mind the host-guest (*p'in chu*) simile. There is a host group of leaves and a guest group, in a relationship like a light giving forth illumination and receiving reflection.

The two plants should be placed in a fairly open space. The small leaves at the base of the plants should not be too numerous. They are called *ting t'ou* (nail ends) strokes. After sufficient practice, skill in this method will come naturally.

In the painting of orchids, a plant may be drawn with few leaves or many. In drawing a plant with 13 many leaves, care should be taken not to make them appear a solid mass. In drawing a plant with few leaves, the effect should not seem stiff and awkward.

A plant with few leaves, leaning to one side.

凡畫蘭不出稀
密二則密之所
忌者結稀之所
忌者拙

偏發稀葉

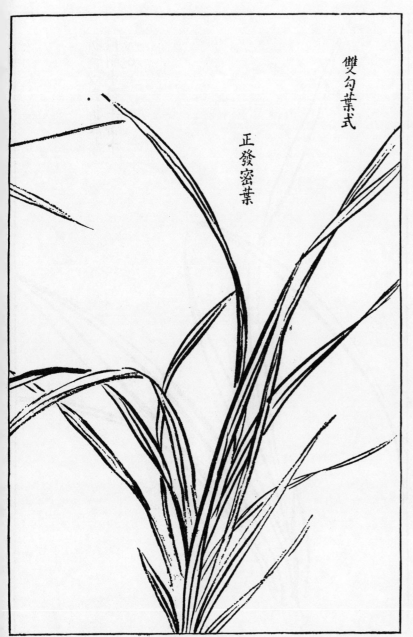

雙勾葉式

正發密葉

14 Examples of leaves drawn in
shuang kou (outline) style

A plant with many leaves growing upright and
close together.

343

15

In leaves bending back, the supple curve of the forms adds style to the composition. The suppleness must, however, have strength and the curve be pleasing to the eye.

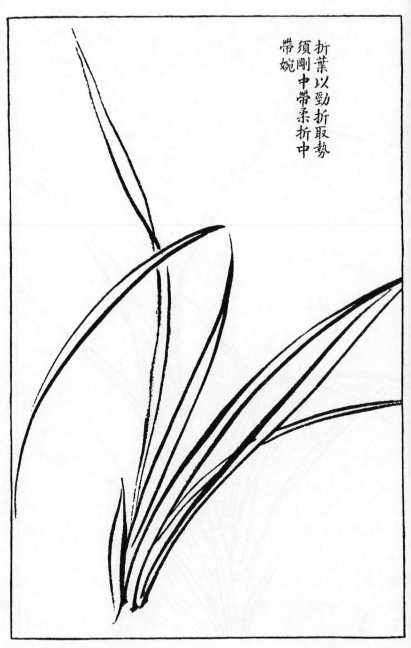

折葉以勁折取勢
須剛中帶柔折中
帶婉

16

17

18

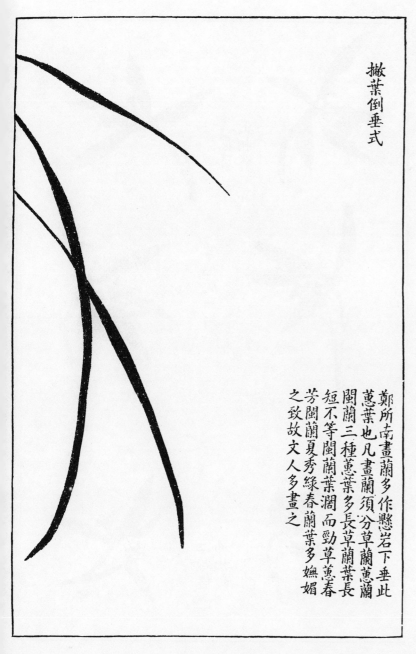

撇葉倒垂式

鄭所南畫蘭多作懸岩下垂此
蕙葉也凡畫蘭須分草蘭蕙蘭
閩蘭三種蕙葉多長草蘭葉長
短不等閩蘭葉潤而勁草蕙春
芳閩蘭蘭夏秀綠春蘭葉多嫵
之致故文人多畫之　　　　媚

Example of leaves pendant

Chêng (Ssǔ-hsiao) So-nan[1] (1239–1316) often
painted orchids growing suspended from a crag.
In this example, the leaves are those of the marsh
orchid. Distinction should be made between the
grass or ordinary orchid (*ts'ao lan*), the marsh
orchid (*hui lan*), and the Fukien orchid (*Min lan*).
The leaves of the marsh orchid are usually long;
there is great variation in length among the leaves of
the grass orchid; and those of the Fukien orchid are
broad and supple. The grass and marsh orchids have
the fragrance of spring, the Fukien orchid has a sum-
mer freshness. The leaves of the spring orchids have
the most charm. That is why the literati often painted
them.

1. See Vol. 1, Pl. IX.

ORCHID

Examples of painting [1] flowers

Two flowers back to back.

Two flowers face to face.

Two flowers, one bending toward the other, which is looking up.

1. *Hsieh* (write). Gradations of tones were unfortunately lost in the lithographic reproduction of the first Shanghai edition and the later editions based on it. The tones gave the petals form and delicacy, and finishing touches such as the dark accents of the stamens. The tips of the petals, where the brushstrokes began, were dark, and the rest of the form much lighter.

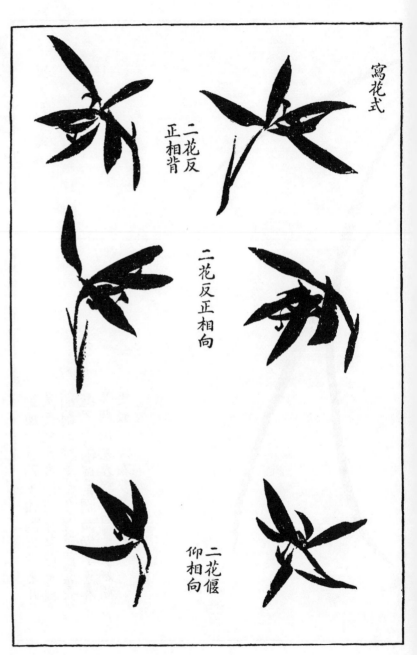

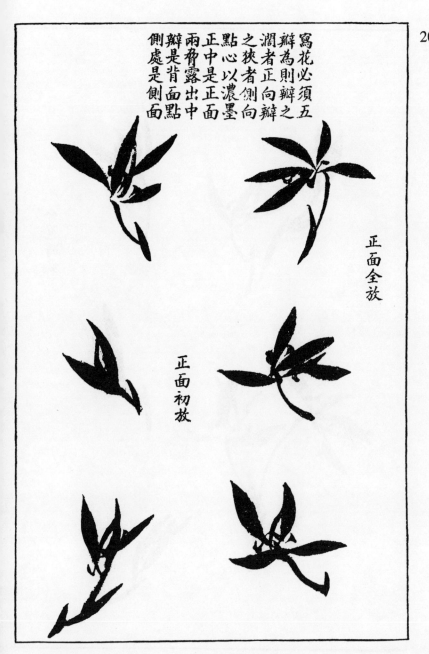

正面全放

正面初放

写花必須五
瓣為則瓣之
潤者正向辮
之狹者側向
正心是正面
點心以濃墨
中是正面
兩脅露出中
辮是背面點
側處是側面
面

20 In the drawing of flowers, each should have five
petals. The larger petals are straight and broad, the
smaller and narrower petals curl. Use dark tones of
ink to dot the stamens. When the stamens are in the
center among the petals, the flower is facing front.
When shown on either side of the middle petal, as
though in its armpits, the flower is being viewed from
the back. When the stamens are dotted in on the side,
the flower is being seen from the side.

Left column:
 Flowers front view and in bud.

Right column:
 Flowers front view.

21

Buds beginning to open.

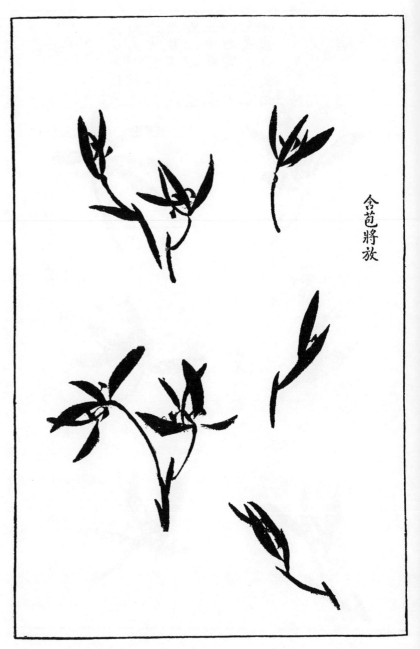

含苞將放

(Flowers at the same stage.) [1]

1. As in original edition.

22 **Examples of dotting the heart**

The form of the three dots (of the stamens) in the heart of the orchid is like 山 (*shan*). Whether the flower is straight, turned over, leaning to one side, or facing upward, the dotting of the stamens in these various positions depends on the position of the petals. This is a fixed principle. In addition to the three dots of stamens, a fourth is sometimes added, because petals are often mingled and, among a group of flowers, one should avoid being repetitious. This does not violate the rules. The same kind of dotting is used for the marsh orchid.

Right column:
 Correct forms of the three dots.

Mid column:
 Examples of the three dots with a fourth added.

Left column:
 More examples of four dots.

心妨中遇有定辮仰蘭
同恐隔帶格字或心
此蹦蕾辮為或宜正三
　同雷及四正惟或點
蕙破不泉點側相反如
花格　花者用此或山
點　　　至蘭

點心式

三點正格

三點兼四點格

四點變格

351

Examples of flowers in outline (*shuang kou*) 23

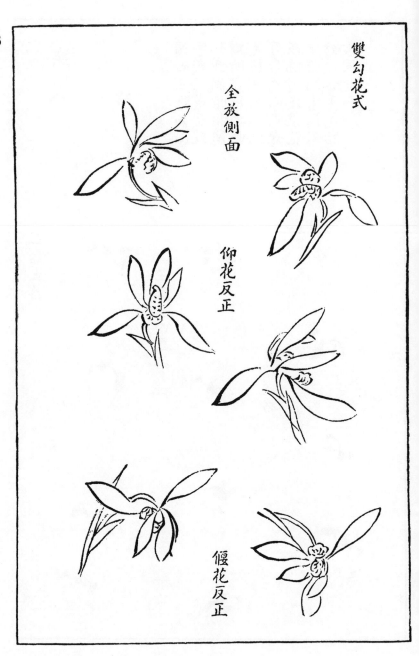

Side view of flower in full bloom.

Front and back views of flowers in upright position.

Back and front views of flowers bending over.

24

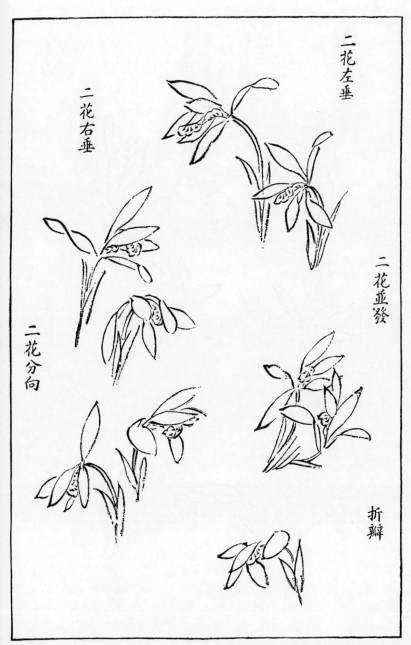

Two flowers leaning to the left.

Two flowers leaning to the right.

Two flowers side by side.

Two flowers turned back to back.

Fading petals.

ORCHID

(Examples of buds)

In painting the buds of orchids, there are various ways with two, three, or four brushstrokes. They issue from a sheath as with flowers in full bloom.

Buds opening.

Buds about to open.

Tight buds.

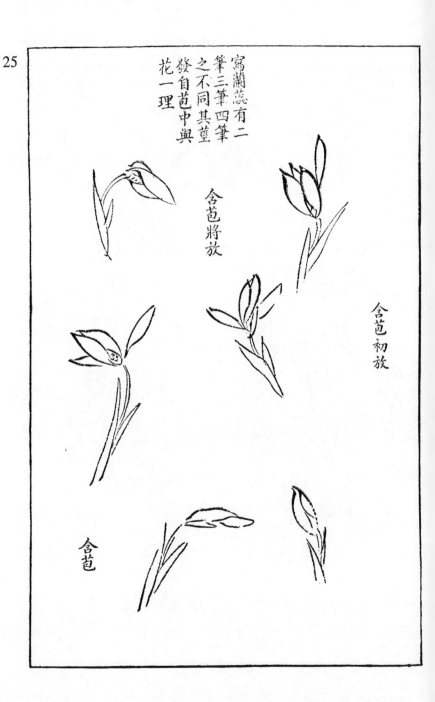

354

26 (Examples of painting [1] orchids) [2]

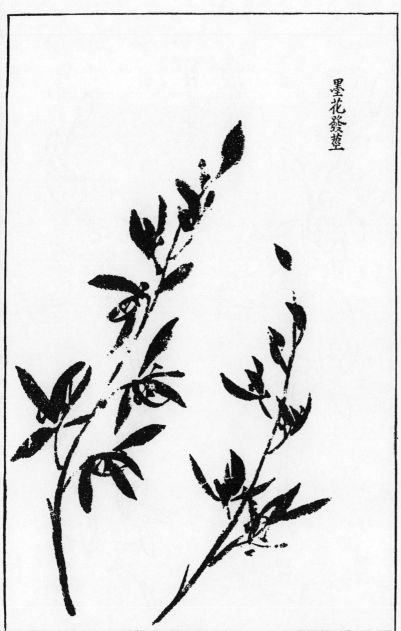

Flowers on their stems, in ink monochrome.

1. *Hsieh* (writing).
2. Heading as in original edition for these two pages.

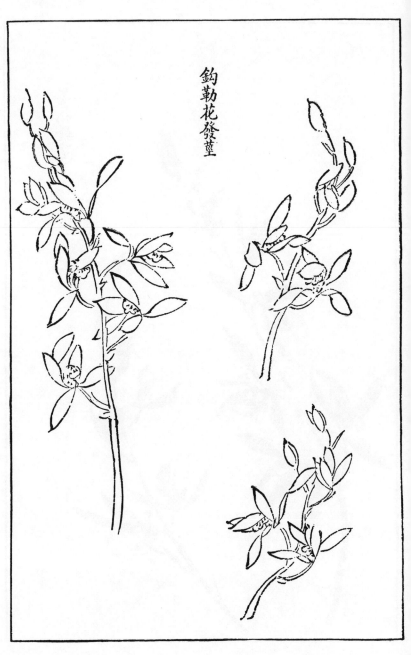

27

鉤勒花發莖

Flowers on their stems, in outline (*kou lê*) style.

[A section of additional examples followed: in the original edition, 16 double pages; in the Shanghai edition, 16 single pages, preceded by remarks by Wang Shih that he himself described as "pleasantries," repeating names of masters already mentioned in the instructions and noting his part in compiling Parts II and III. His brother, Wang Nieh, added concluding remarks, of about four short sentences, stating that the illustrations were examples of masters' styles and eulogizing orchid painting.]

Book of the Bamboo

Ch'ing Tsai T'ang Discussion
of the Fundamentals of Bamboo Painting

General background of bamboo painting

L I (K'AN), of Hsi-chai, in his *Chu P'u* [1] (Treatise on the Bamboo), wrote: "In learning to paint (*hsieh*, write) bamboos in ink, I first studied with Wang Tan-yu [2] and also learned from the methods of Huang-hua Lao-jên (Huang T'ing-chien). Since Huang-hua had applied himself to learning all he could from Wên (T'ung) of Hu-chou, I searched for genuine works of (Wên) Hu-chou and studied their subtleties. I also studied the methods of the ancients in outlining (*kou lê*) and applying color."

These methods were developed by Wang (Wei) Yu Ch'êng, Hsiao (Yüeh) Hsieh-lü, Li P'o, and Huang Ch'üan (of the T'ang period), and Ts'ui Po and Wu Yüan-yü (of the Sung). Some say that, before the time of Yü-k'o (Wên T'ung), only the outline method, with color filled in, was used. And some say that Lady Li, [3] of the Five Dynasties period, traced the shadows of bamboos thrown on a window by the moonlight and that this marked the beginning of bamboo painting in ink. But Sun Wei and Chang Li, in the T'ang period, were renowned for their ink

1. Published at the beginning of the XIV century. It was the basis of the *Book of the Bamboo*, as well as for most other works on bamboo painting.

2. Li K'an worked with Wang T'ing-yün and Wang Man-ch'ing (Waley, *Introduction to the Study of Chinese Painting*, p. 181); either may have had the *tzŭ* Tan-yu; both worked in the style of the great Sung painter of bamboos in ink, Wên T'ung.

3. The story is quoted in Giles, *An Introduction to the History of Chinese Pictorial Art*, p. 75; see also Hirth, *Scraps from a Collector's Notebook*, p. 93.

monochrome paintings of bamboos, so that this style did not originate in the Five Dynasties period. Shan Ku (Huang T'ing-chien) said that Wu Tao-tzŭ painted bamboos in ink that were very true to nature; thus it would seem that ink painting of bamboo began with Tao-tzŭ.[4] The T'ang painters were masters of both color and ink methods. From the time of Wên Hu-chou, ink painting of bamboo began to be the only method.[5] In truth, he was like the sun at its zenith, dimming torches and all other light. And in each succeeding generation there has been someone who transmitted his methods.

(Su) Tung-p'o, contemporary of Hu-chou, chose him as his teacher (in bamboo painting). Both were masters, like a lamp and its light illuminating the glories of the past and present. Yüan-yen and Shu-hsien of the Chin dynasty, Hsi-chai (Li K'an) and his son, Tzŭ-jan Lao-jên, and Lo-shan Lao-jên, of the Yüan dynasty, and Wang (Fu) Mêng-tuan and Hsia (Ch'ang) Chung-chao, of the Ming dynasty: all were like the petals of one flower, for the glory of each added to that of the others. That is one of the reasons Wên Hu-chou, Li Hsi-chai, and Ting Tzŭ-ch'ing compiled books to pass on their methods and schools of thought. One may call this abundance!

Sung Chung-wên used red in painting bamboos. Ch'êng T'ang used purple in his bamboo compositions. Chieh Ch'u-chung painted bamboos in the snow. Yüan Yen-liang painted bamboo shoots. This information may not be found in books, as these are exceptional methods. As in Buddhism, there are many saints.

Principles of ink painting of bamboo

In bamboo painting, the first step is concerned with the stems: space should be left between the sections of the stem for the knots; the sections between knots near the ends of the stems should be short, those forming the middle of the stem should be long, while at the base of the plant they

4. Middle T'ang period (VIII century). Traditionally Wu Tao-tzŭ is lauded as the great figure painter. He is said to have painted bamboo in color, but the attribution to him of the origin of ink painting of bamboos may have been part of the veneration accorded this master.

5. Wên T'ung (X century), tzŭ Yü-k'o, according to the comments of his contemporaries, in particular the poems and colophons of his friend Su Tung-p'o, and discussions of later periods, was the greatest master of bamboo painting in ink; his wide and continued influence certainly justifies naming him as its source and inspiration. He was the ideal "gentleman-painter," a term coined by Su Tung-p'o and applied thereafter to the Sung masters of the Southern school and their followers among the literati in subsequent periods. Wên T'ung fulfilled the ideal in his character and in what he created, particularly as bamboo painting, among all the categories, was closest to calligraphy and poetry, which were traditional concerns of scholars and gentlemen, and whose symbolism stressed moral character and ideals.

again are short. Avoid painting bamboo stalks that appear swollen, withered, or too dark in tone. And they should not all be of the same height. The edges of the stems should be distinct. The knots should firmly join the sections above and below them, their forms being like a half circle or like *hsin* without the dots.

心

At about the fifth knot above the soil, the branches and foliage begin to grow. In painting leaves, the brush should be saturated with ink; brushstrokes should move smoothly and without hesitation. The leaves will then be naturally (*tzǔ jan*) pointed, tapering, and sharp, unlike the leaves of the peach and the willow. The hand should be in turn light and heavy. Leaves arranged in a form resembling *ko* have the dividing third leaf. Leaves drawn in the form of *jên* should be clearly separated. Leaves at the top of the plant should be arranged in the style called *tsuan fêng wei* (gathered in the form of a phoenix's tail). The branches to the left and to the right should be clearly defined in their relationship, each branch issuing joint by joint, each leaf issuing from the stem.

个 人

In wind, fair weather, rain, or dew [6] respectively, bamboos behave in a characteristic manner. Whether they are bending over or standing upright, hidden or exposed, each aspect has a particular form and integration.[7] Each movement of turning, bending, drooping, or rising holds a specific idea (*i*) and principle (*li*) [8] that must be observed and felt through the heart for full understanding of the expressiveness of bamboo. If one stem is not firmly placed or one leaf not properly added, the whole composition may be spoiled, as one slight flaw mars a piece of jade.

First principles of composition

In ink compositions of bamboo, the four parts of the plant to be considered are stem, knot,

6. *Fêng ching yü lan* (wind, clear or fair weather, rain, dew), a phrase often used for the four main kinds of weather in which bamboos, flowers, and other plants are painted.

7. *Hsing shih* (form and structural integration, power and style).

8. Neo-Confucianist *li* (principle, law, essence) in the sense of "soul of things"; it has been translated "inherent reason of things," "universal principle," and "fitness of things," in other words, that which is a reflection of the *Tao*. ("that must be observed and felt through the heart"), The rest of the sentence showing the influence of Taoist-Zen theories, refers to the idea of the painter identifying himself with the object, which, as Su Tung-p'o many times pointed out, was Wên T'ung's supreme achievement. Su wrote that craftsmen could depict form, but only those of surpassing ability and perception (the gentlemen-painters) could comprehend and transmit to paper the *li* of forms.

branches, and leaves. If the rules [9] are not followed, time and effort will be wasted and the picture never completed.

Ink should have dark and light tones. Brush should be deft and vigorous. In learning the brushstrokes from right to left and from left to right, one gradually learns also to discern variety of ink tones, coarseness or fineness of brushwork, and what has splendor and what lacks vitality.

The way in which a leaf grows from a branch should be clearly defined. Shan Ku (Huang T'ing-chien) said: "If the branches do not issue from the knots correctly, the leaves will be in disorder and have no proper support."

Each brushstroke should be a living idea (*shêng i*), each aspect natural (*tzŭ jan*). All four sides of the plant should be properly related and each branch and leaf alive. Only thus can bamboo be painted. But, while many from ancient times to the present have painted bamboo, there have been only a few who truly excelled. The tendency has been to make bamboo compositions either too simple or too complicated. In some instances, the stem has been beautifully placed, bending with grace, but the branches and leaves have been exaggerated and poorly composed: while the bamboo has been well placed, the direction of the leaves and the front and back of the cluster have not been properly related; or the leaves have the appearance of having been cut out by a knife; or the composition of the whole group of bamboos resembles a flat board with thorns sticking out. The grossness and banality of poor compositions of bamboo! One should not mention them.

In general, even those painters who were considered exceptional managed only to achieve the stage of making a pleasing or an exact composition. They did not reach perfection. Wên (T'ung) of Hu-chou alone was outstanding. Heaven gave him great powers, releasing his talent and inner resources; his brush had divine assistance, and he seemed one with nature. He may seem to have galloped through all rules and methods, to have gone beyond worldliness and the commonplace. Yet, following his heart, he was able to realize his whole conception without transgressing the rules. Those who come after him should not fall into grossness or banality. They should attend to what they ought to learn.

9. *Kuei chü*, the pattern of custom, also referring to the compass and square; an analogy to the Circle and the Square of Heaven and Earth. Therefore, here, rules with a very deep significance.

First principles of painting the stems

If only one or two stems of bamboo are being painted, the ink tones may be rendered as one pleases. If there are more than three stems, those in the foreground should be painted in dark tones and those in the back in light. If the same tone is used for all, it would be impossible to distinguish their relative positions.

From tip to root, although the stems are painted section by section, the continuity of the idea (*i*) expressed through the brush remains intact.[10] In drawing the stem, one should leave spaces for the knots. At the base and the tips of the stems, the sections of the stem should be short; in the middle of the stem they should be long. Each stem should have its proper tone. Each stroke of the brush should be even and firm. The edges of the stems should be slightly concave.

Above all, be careful to avoid swollen or distorted stems, uneven ink tones, coarseness of texture, a dryness that looks like decay, a density of ink that may look like rot, and equal spacing between knots. It is imperative to avoid these faults. I have seen painters, whom one can only call gross, use rattan cane, a piece of acacia bark, or a roll of paper soaked in ink to paint bamboo stems in ink, which then were of the same thickness, flat as a board, lacking any suggestion of roundness. One can only laugh at such tricks and not imitate them.

First principles of painting the knots

When the stems are drawn, the knots, which come next, are very difficult. The upper part of a knot should cover the lower; the lower part should support the upper. Although there is a space between the two parts, the continuity of the idea (*i*) is intact. The two ends of the upper part turn up, the middle part curves down in the shape of the crescent moon. Thus one may see that the stem is rounded. With each brushstroke the idea advances rapidly, without hesitation. Naturalness (*tzŭ jan*) is necessary to the continuity of the idea.[11] The knots should not be too large or too small, nor should they be of equal size. When they are equally large, they will look like rings; when equally small, like sticks of ink. They should not be too curved nor the space between

10. Lit., and more vividly, "like the thread of a string of coins."

11. This deceptively simple statement has several layers of meaning referring to the qualities of *tzŭ jan* and *chên* in painting and in the painter himself.

too large. If they are too curved, they will look like the joints of a human skeleton, and if there is too much space between the two parts of the knot, the life and continuity of the idea will be lost.

First principles of painting the branches

In the painting of bamboo branches, terms have been given to the various parts and aspects. The places where the leaves sprout are called *ting hsiang t'ou* (fragrant spots). The form of three leaves forking out at the tips of the branches is called *ch'üeh chao* (bird's claw). Upright forked branches are called *ch'ai ku* (hairpin shapes). A branch shown with stems in the back and leaves in the front is termed *to tieh* (heaped cluster). A branch painted showing the backs of the leaves and inside the cluster is termed *pêng t'iao* (scattered around).

Brushstrokes should be strong and full, sustained by the idea of life. The brush should move briskly, in no way dilatory. Old branches are rigid and straight, their joints large and knotted. Young branches are supple and pleasing to look at, their joints small and smooth. When there are many leaves, the branches bend; when there are few, the branches straighten up. Branches in the wind or in the rain vary in form accordingly. They should be depicted fittingly—this is something that can not be fixed by rules.

Yin-po and Yün-wang [12] drew branches and knots in one sweep of the brush. Since this is not a traditional method, there is no need to discuss it here.

First principles of painting the leaves

Brushstrokes should be powerful and distinct, setting down the living quality (*shih*) [13] of the leaves yet at the same time evoking "emptiness." Each stroke should be extraordinarily expressive.

12. Without the surnames it is difficult to identify these two painters. However, Su Tung-p'o was said to have painted bamboo stems in one stroke, explaining that they grew that way, thereby invoking the idea (*i*) and the soul or essence (*li*) of the bamboo.

13. *Shih* (living quality, that of being substantial and actual), different from *shih* (structural integration), though both at times are translated "power." (See Appendix for Chinese forms of the two *shih*.) Here the substantial quality is stressed by contrast with the space around the forms, *hsü* (emptiness, receptivity to the *Tao*); together they are capable of expressing an aspect of the *Tao* and thus have power to lift the spectator "beyond the ordinary, out of the world." *Shih* (state of being actual) has been described in the *Lankavatara Sutra* (tr. Suzuki, p. 43) as "the ocean dancing in a state of waveness."

If there is the slightest hesitation, the leaves will look thick and will lack the essential sharpness of form. This is an exceedingly difficult step in painting bamboo, and if talent is lacking, one might as well forget there is such a thing as painting bamboo in ink.

There are certain things to be avoided that the beginner should know. When leaves are large, they should not be painted to resemble those of the peach tree; when small and slender, they should not resemble those of the willow. Leaves should not be placed separate and alone. They should not be placed side by side in a row or in the form of *i*, though not crossed like *hsing,* or 乂 丼
spread out stiffly like the five fingers of an outstretched hand or like the wings of a dragonfly. When leaves are laden with dew, or when they are in rain, snow, or wind, each of the various positions, back and front, bending or straight, has its own aspect. They should never be rendered incorrectly. That would be like staining the silk with black ink strokes.

Method of outlining (*kou lê*)

First take a stick of willow charcoal, to place the stem of the bamboo. Then draw in the branches to left and to right. Next, use brush with ink to outline the leaves. When the leaves are drawn, the stem, branches, and knots should follow. The leaves at the top of the stems are drawn one by one, in the form called *ch'üeh chao* (bird's claw). Leaves should be arranged some together, forked, and some facing away from each other. The whole composition should be clear. Variation in ink tones (in the outlining) should distinguish the plants in front from those in the back, the former being painted in dark tones, the latter in light. Thus may bamboo be rendered in outline. In its way of handling the parts in light or shadow, foreground and background, and of placing the stems and drawing in the leaves, this method is similar to that of painting bamboo in ink. Each method complements the other.

Summary of ink painting of bamboo phrased for memorizing by chanting [14]

Huang-lao (Huang T'ing-chien) was the first to teach the outline method. (Su) Tung-p'o and Yü Ko (Wên T'ung) started the painting of bamboo in ink. Lady Li traced the shadows of bamboos

14. *Ko chüeh.* As in the *Book of the Orchid,* these sections summarizing the rules were phrased for memorizing in four- and five-character sentences, which cannot be translated with the same uniformity and brevity.

on a window. Hsi-chai (Li K'an), Hsia (Ch'ang), and Lü (Chi) all painted bamboos in the same style, the main stem being drawn in the *chuan wên* (seal style) of calligraphy, the knots in the square and plain *li shu* (official style), the branches in the *ts'ao shu* (grass style), and the leaves in the *k'ai shu* (regular style).[15] There are not so many brushstroke styles and methods. There are, however, four factors essential to full experience in bamboo painting. Silk or paper should be of good quality. Ink should be fresh. Brush should be swift and sure. And do not start until the conception (*i*) is clear: the idea of each leaf and branch should be complete in one's mind before being drawn.

分 个 Begin with leaves composed in the form of *fên* and continue with leaves in the form of *ko*. Where in nature the leaves are sparse, in the painting they should be the same. And where there are many leaves, thus it should also be in the picture. But it should be borne in mind that where many leaves are drawn, they should not be tangled; and where leaves are few, branches should be drawn filling blank spaces.

 Where bamboos are painted in the wind, their stems are stretched taut and the leaves give an impression of disorder, their joints bend, and startled rooks fly out from the foliage. Bamboos in rain bend. How could it be otherwise? In fair weather, bamboo leaves compose themselves in

人 pairs like *jên*. A cluster of young bamboos should be composed on a foundation of a strong forked branch with small leaves at the tips of the branches, joined by groups of larger leaves in the body of the plant. Bamboos laden with dew resemble those in rain. In fair weather they do not bend; in rain they do not stand erect; heavy with dew, their tops bend and almost touch the lower branches.

个 In blank spaces draw leaves in the form of *ko*, with the heads of the branches bending over. To paint bamboo in snow, apply a piece of oiled cloth[16] to the back of the silk and draw branches like those in rain; the forms of the leaves not covered by snow are jagged like saw teeth. When the oiled cloth is removed, an effect will be presented of the cold brilliance of snow on the leaves.

 There are certain general faults in the painting of bamboo that one should remember to avoid. First of all and basically, *shih* (structural integration) should always be the main concern,

15. Not literally in these writing styles, though with certain similarities in brushwork. The context serves to illustrate the intimate relationship between painting and calligraphy and the lengths to which the literati tried to identify the two arts, bamboo painting being particularly amenable to such an identification.

16. *T'ieh yu fu* (stick oiled cloth), a technical trick used in painting bamboo in snow.

but unless heart [17] and idea (*i*) are attuned, there can indeed be no good results. It is essential to have serenity, something that can arise only from a tranquil soul. Avoid making stems like drumsticks. Avoid making joints of equal length. Avoid lining up the bamboos like a fence. Avoid placing the leaves all to one side. Avoid making them like *hsing,* or like dragonfly wings, or like the fingers of an outstretched hand, or like the crisscrossing of a net, or like the leaves of the peach or willow. At the moment of putting brush to paper or silk, do not hesitate. From the deepest recesses of the heart should come the power that propels the brush to action. How can one be apprehensive of committing faults that are all too human and not feel even more concerned that the *Tao* might be obstructed?

Old stems of bamboo, their long branches warding off the cold and snow, have the appearance of protecting the treasures they are holding. In wind, fair weather, rain, snow, moonlight, mists, or clouds, and in all seasons, what is precious in bamboo is safely locked in by its fine knots. Paintings inspired by the River Hsiang, by the beauties of the gardens by the River Ch'i, by the famous poem about Ngo-huang, by the Seven Virtuous Sayings, by the Thousand Acres of Ten Thousand Stems of Bamboo, should all delight and move the beholder.

Rules of painting the stems phrased for memorizing

The sections of the stems between the knots in the middle of the plant are long, and the sections at the top and near the base are short. The slight curve of the stem should start at the knots. Each section of the stem is marked off by knots, but these should not be of the same length. Careful attention should be given to light and shadow and to rendering them in the proper ink tones.

Rules of painting the knots phrased for memorizing

When the stems are drawn, proceed to the knots. Variety of dark ink tones should be clearly defined. Whether the branch curves or is straight, the knots should be drawn rounded and with vitality. The branches all issue from the knots.

17. *Hsin* (heart-mind).

Rules of placing the branches phrased for memorizing

The branches should be placed to left and to right, and never all on one side. Leaves at the tips of the branches should be drawn in the manner called *ch'üeh chao* (bird's claw); the whole form should issue from the point of the brush.

Rules of painting the leaves phrased for memorizing

In painting bamboo, leaves give the most difficulty. They should issue through the finger tips and the point of the brush. Distinction should be made between old and young bamboos and also between the light and dark (*yang* and *yin*) among the ink tones. Branches support the leaves. Leaves cover the stems. When leaves are added to other leaves, there is an effect (*shih*) of flying and dancing.

Leaves are drawn one by one in groups of two, three, and five. In spring, the shoots of young bamboos begin to sprout. In summer, bamboos bend over their own dark shadows. In autumn and winter, they should be presented with a touch of frost and snow. It is in the rendering of all these various aspects that the painting of bamboo takes its place in the high company of the pine and the plum tree. In fair weather, its leaves and branches are slightly inclined and still. In cloudy weather and in gentle rain, the leaves and branches bend over and hang. In a light breeze, the leaves should not be drawn horizontal, like *i;* in rain, they should not be in the form of *jên*. Leaf by leaf, each should embellish the others. Be careful to avoid painting them too close together, making them seem heavy or repetitious. Ink tones should be used most judiciously in making the proper distinction between branches in the back and in the foreground.

There are four things to be avoided in painting bamboo leaves. In composing them, do not make them the same length or in a row. When leaves are pointed, do not make them like reeds; when they are thin and delicate, do not make them like willow leaves. When leaves are in groups of three, be careful not to make them like *ch'uan*. When leaves are in groups of five, do not make them like the fingers of an outstretched hand.

For groups of leaves in one, two, and three brushstrokes, double *fên* and *ko*. They must be

一　人

川

分　个

well arranged, and a few additional leaves should be added. The brushstrokes should be well defined so that it is clear which groups belong together and which leaves are connecting links in the composition.

To sum up, in painting bamboo, first draw the stems, the branches, and the knots. (After that, the leaves.) In studying the works of the ancients, it may be observed that the secret of bamboo painting lies in the drawing of the leaves. I have therefore discussed it in detail and phrased the rules so they may be easily remembered; thus the methods of the ancients may be passed along.

BAMBOO

Examples of drawing stems and knots [1]

Downward, starting at right: [2]

The first brushstroke.

Knot in the form of 乙 (*i*), used at the top of the joint.

Knot in the form of 八 (*pa*), used on the lower part of the joint.

The first few strokes of a stem.

A thin stem.

1

發竿點節式

初起手一筆

點節乙字上抱

點節八字下抱

起手二筆三筆直竿

細竿

1. Gradations of ink tones were lost in printing the lithographed Shanghai edition; stems should be lighter in the middle of sections between knots; a variety of ink tones should show in branches and leaves. The examples therefore illustrate the drawing rather than the ink painting of bamboo; as the painters expressed it, "have brush but not ink."

2. Legends on this page and on pp. 380–83 are read in the Chinese order, beginning at top right, downward.

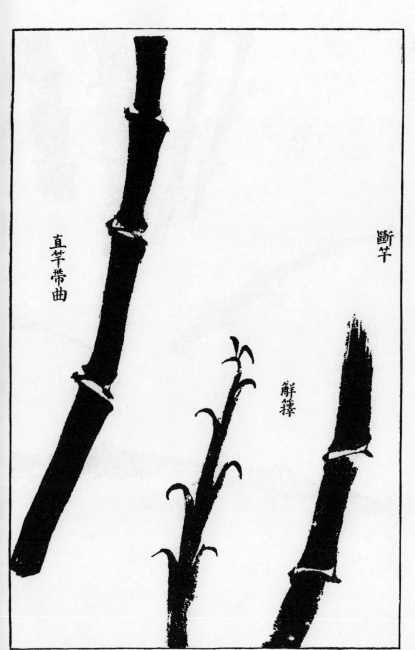

2

直竿帶曲

斷竿

解籜

Left to right:

 A slightly curved stem.

 A young bamboo shoot.

 A broken stem.

Base of a stem.

Base of a ragged bamboo shoot.

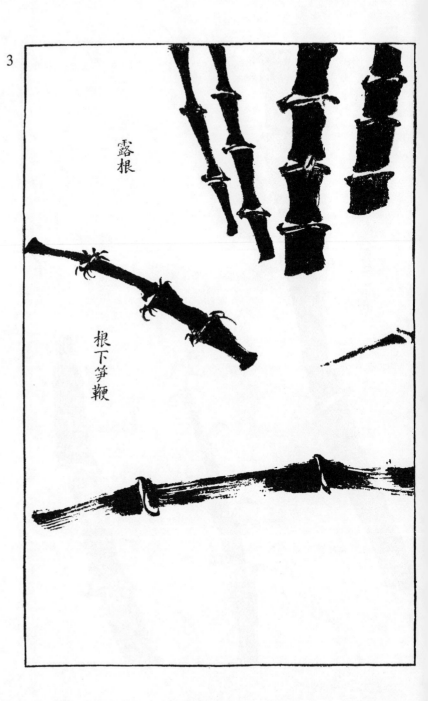

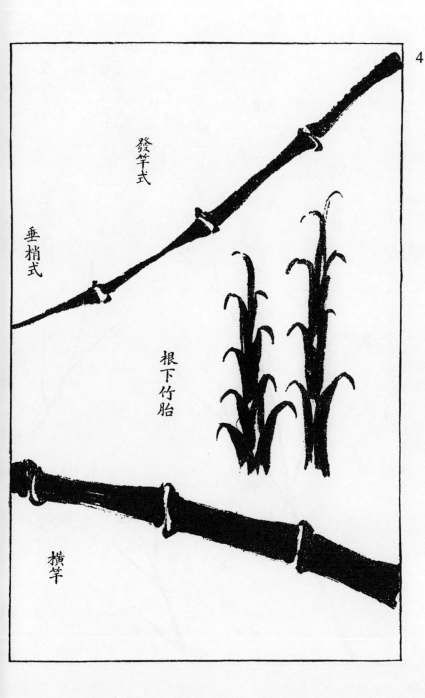

4　Examples of stems of bamboo

Tip of a hanging bamboo.[1]

Bamboo shoots at the base of a plant.

A horizontal stem.

1. Middle character, *shao* (tip), not in original edition.

Examples of branches of bamboo

Branches at the top of a plant.

First brushstrokes of branches in a form like stag horns (*lu chüeh*).

Brushstrokes of branches like birds' claws (*ch'üeh chao*).

Brushstrokes of a branch in a form like a fishbone (*yü ko*).[1]

1. Refers to small branch at lower right.

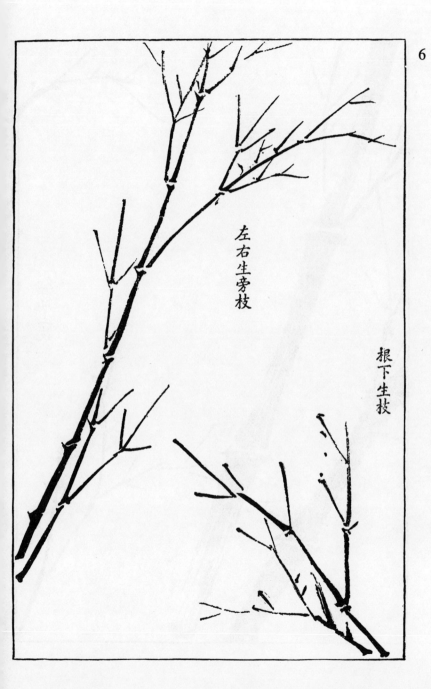

6

左右生旁枝

根下生枝

Branches growing left and right from a main stem.

Branches at the base of a plant.

Branches growing from a pair of stems.

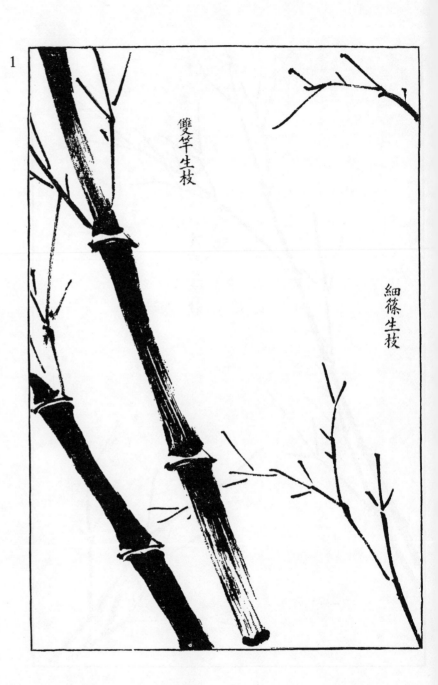

1

雙竿生枝

細篠生枝

Branch of a dwarf bamboo.

8 Examples of branches and main stems

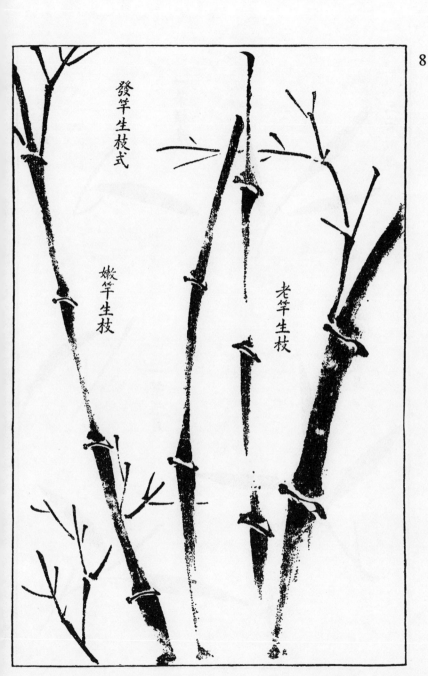

發竿生枝式

嫩竿生枝

老竿生枝

Left:
 Branches growing on young stems.

Right:
 A branch growing on an old stem.

Examples of bamboo leaves

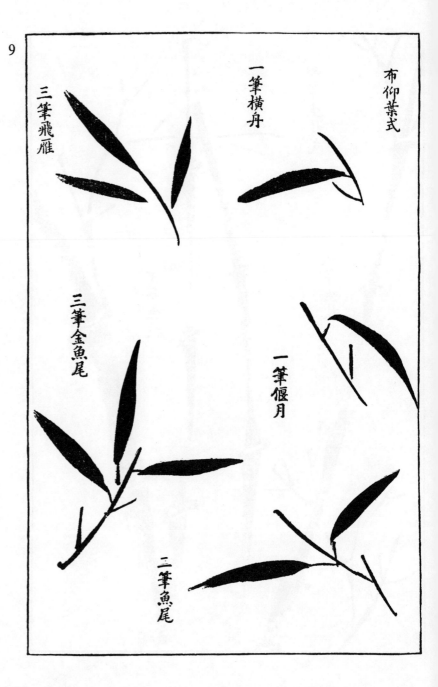

Downward, starting at right:

One brushstroke, like a side view of a boat (*hêng chou*).

One brushstroke, like a crescent moon (*yen yüeh*).

Two brushstrokes, like a fish's tail (*yü wei*).

Three brushstrokes, like a wild goose in flight (*fei yen*).

Three brushstrokes, like a goldfish's tail (*chin yü wei*).

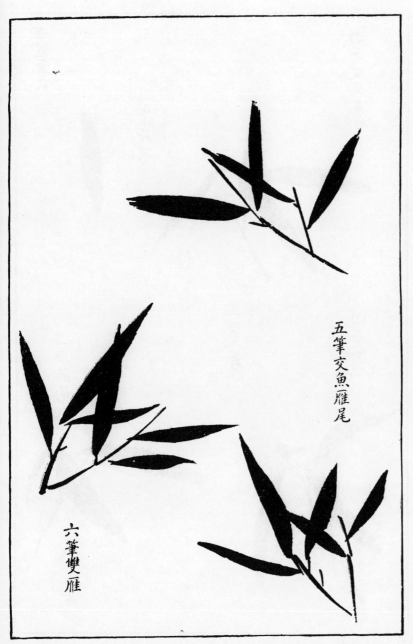

10

Downward, starting at right:

(Four brushstrokes, in "fish's tail" forms.) [1]

Five brushstrokes, combining strokes called "fish's tail" with those called "wild goose in flight."

Six brushstrokes, doubling the three strokes of the "wild goose in flight" form.

1. As in original edition.

Examples of leaves pendant

11

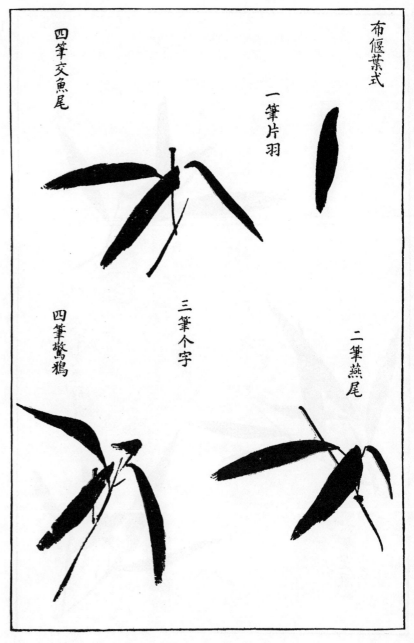

Downward, starting at right:

One brushstroke, like a feather.[1]

Two brushstrokes, like a swallow's tail (*yen wei*).

Three brushstrokes, in the form of 个 (*ko*).

Four brushstrokes, in "fish's tail" form.[2]

Four brushstrokes, like a startled rook (*ching ya*).

1. Text not in original edition.
2. An example at top left, not shown with this explanation nor in the original edition.

12

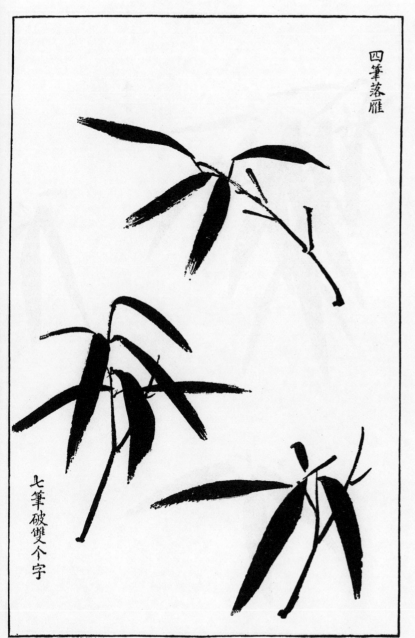

Downward, starting at right:

Four brushstrokes, like a wild goose alighting (*lo yen*).

(Five brushstrokes, like a swallow in flight, *fei yen*.) [1]

Seven brushstrokes, based on doubling the form of 个.

1. As in original edition.

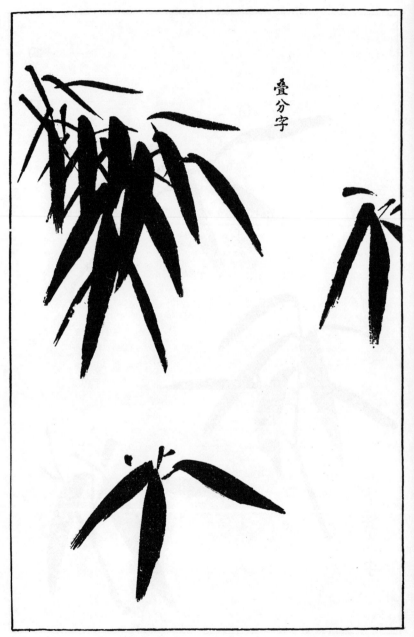

13

(Group of leaves mingled in brushstrokes) repeating form of 分 (*fên*).

(Six brushstrokes—two examples—in the form of 个 [*ko*].) [1]

1. As in original edition, referring to the other two examples on the page.

14 (Examples of leaves spread out) [1]

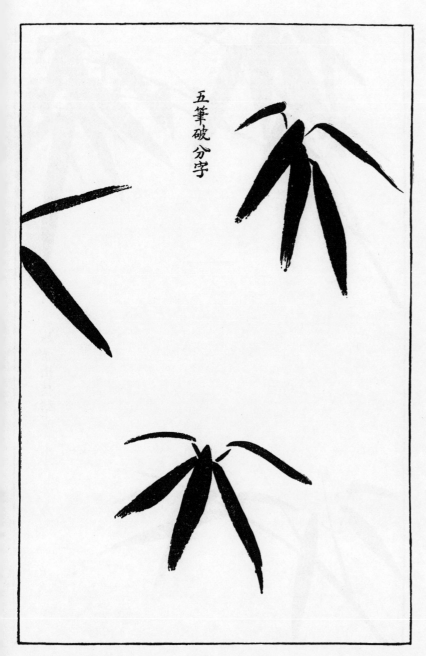

Five brushstrokes, in the form of *fên* 分.

1. Heading as in original edition.

15

(Old leaves growing at top of a plant.) [1]

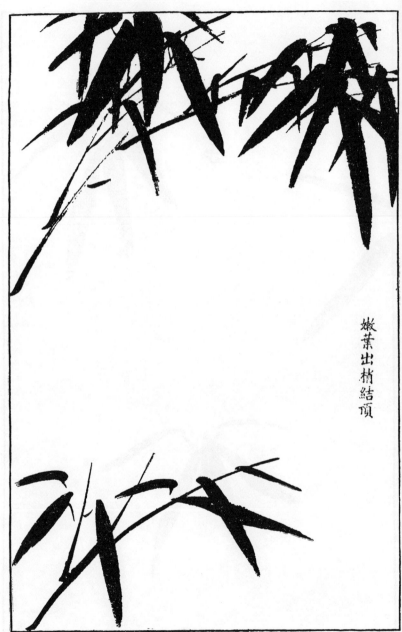

Young leaves growing at top of a plant.

1. As in original edition.

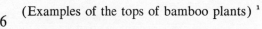

16 (Examples of the tops of bamboo plants) [1]

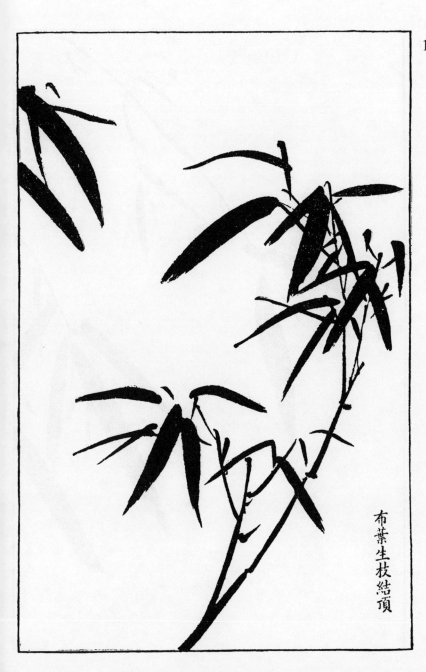

Arrangement of leaves and branches at top of a plant.

17

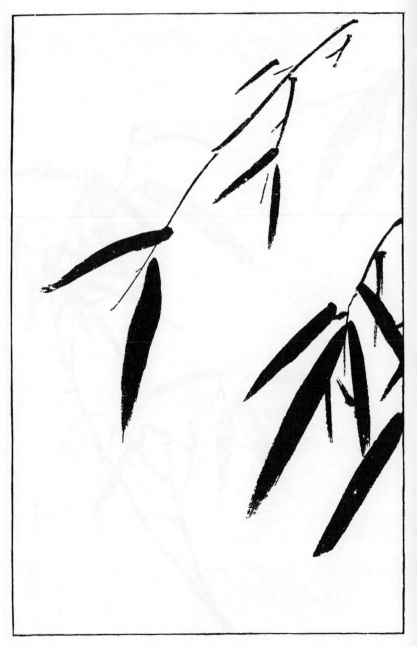

(Large and small branches of bamboo growing over a wall.) [1]

1. As in original edition, referring to examples on both this and facing page.

388

18

垂
梢

Tips of hanging branches.

19

横梢式

新篁斜墜嫩枝

Example of a branch growing horizontally

Horizontal branch of a young bamboo.

Examples of tips of new shoots of a
bamboo plant

21

New shoots of bamboo after shedding the sheath,
growing from the right.

22

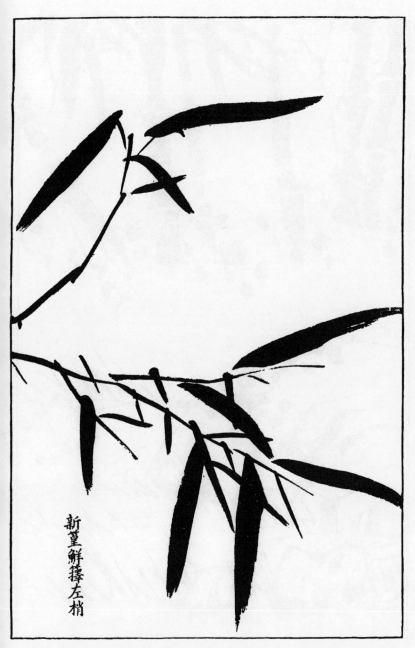

新篁鮮擇左梢

New shoots of bamboo after shedding the sheath, growing from the left.

23

24 Examples of arranging the bases of bamboo plants

下截見根

安根式

A base drawn as though cut in two.

根下苔草泉石

Moss, grass, water, and rocks around the base of stems of bamboos.

395

[A section of additional examples followed: in the original edition, 24 double pages; in the Shanghai edition, 28 single pages. It contained introductory remarks by Wang Shih, repeating information already given in the book about the close relationship of calligraphy and painting and the four styles of writing as applied to bamboo painting.]

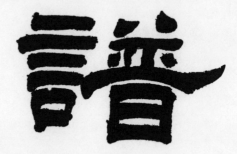

Book of the Plum

[A testimonial preceded the *Book of the Plum* and the *Book of the Chrysanthemum,* signed by a Yü Ch'un and dated Nanking, 1701, praising the work of the Wang brothers and in particular these two books.]

Ch'ing Tsai T'ang Discussion
of the Fundamentals of Plum[1] Painting

General background of plum painting[2]

AMONG the painters of the T'ang period, many were famous for their paintings of flowers and plants, yet none was outstanding for paintings of the plum. Yü Hsi painted a picture entitled *Plum Tree and Pheasant in Snow,* but, strictly speaking, it belonged in the category of *ling mao* (feathers and fur). Liang Kuang painted a set of four pictures entitled *Flowers of the Four Seasons,* in which the plum was one among other kinds of blossoms and flowers, the others being the crab apple, water lily, and chrysanthemum. Li Yo was one of the first to be known for pictures of plum branches and blossoms; his reputation as a painter, however, was not great.

In the period of the Five Dynasties, T'êng Ch'ang-yu and Hsü Hsi painted the plum in outline (*kou lê*) style, filling in with color. Hsü Ts'ung-ssŭ alone rejected the traditional approach and did not outline and color in the accepted manner; instead he painted directly in color. This is the method called *mo ku* (no bone). Ch'ên Ch'ang made a further change by using the *fei pai* (flying white) method in painting the trunk, branches, and stems, dotting in the blossoms in color. Ts'ui Po used only light tones of ink. Li Ch'êng-ch'ên did not paint the blossoms of the

1. *Mei* is a general term for various trees of the genus *Prunus* or plum and is used also in speaking of the blossoms or fruit.

2. The names of many painters are mentioned that no longer have meaning, and their works no longer exist. They represented the tradition in flower painting, however, and some introduced important changes in technique.

peach or pear but only those of the plum. He had a profound understanding of the beauty of the water's edge and the forest's deep shade, and made them his specialty. The Buddhist monk Chung-jên painted the plum in ink washes. The monk Hui-hung used glue made from acorns in painting on fans made of raw silk; holding them up and looking through them, one could see the shadows of the plum branches. After them, many painted the plum. Mi (Fei) Yüan-chang, Ch'ao Pu-chih, T'ang Shu-ya, Hsiao P'êng-t'uan, and Chang Tê-ch'i were all skilled in the art of painting the plum in ink. Yang (Wu-chiu) Pu-chih alone did not use ink washes; he invented the *ch'üan* (ring) technique, by which the forms (of the flowers) at the tips of branches were as effective as if white had been applied. Painters who made use of this method were Hsü Yu-kung, Chao (Mêng-chien) Tzŭ-ku, Wang (Mien) Yüan-chang, Wu (Chên) Chung-kuei, T'ang Chêng-chung, and the monk Jên-chi. Jên-chi said that it took him forty years to use successfully the "ring" method.

In the Sung and Yüan periods, Mao Ju-yüan, Ting Yeh-t'ang, Chou Mi, Shên Hsüeh-p'o, Chao T'ien-chê, and Hsieh Yu-chih were well known for their paintings of this subject. Yu-chih used color darkly and thickly. In this he copied Chao Ch'ang, though he could not equal his talent. In the Ming period, there were many skillful painters in this line. There were no groups such as we might call schools; each painter had an individual approach, and they are all too numerous to name here.

Since the T'ang and Sung periods, it may be said there were four schools of plum painting. There were those who used the outline (*kou lê*) method and color. This was begun by Yü Hsi (IX century), developed by T'êng Ch'ang-yu (IX century), and perfected by Hsü Hsi (X century). There was the method of painting the plum directly in color in the style called "no bone," which was invented by Hsü Ts'ung-ssŭ (XI century); many worked in this manner up to the time of Ch'ên Ch'ang, who modified it. Ink painting of the plum was started by Ts'ui Po (XI century) and was perfected by the monk Chung-jên, Mi (Fei), and Chao (Pu-chih). The method of "ring" outlining of the flowers without adding color was invented by Yang (Wu-chiu) Pu-chih (XII century). Wu (Chên) Chung-kuei (early XIV century) and Wang (Mien) Yüan-chang (late XIV century) developed this method and influenced the whole period.

This, briefly, is the background of plum painting.

Summary of Yang Pu-chih's [3] rules of painting the plum

When trunk and branches are slender, blossoms are small; when the tips of the branches are fresh, flowers are luxuriant. At the points where the branches connect and fork, flowers are numerous and mingle together. Where the tips of branches are few, flowers and buds also are few.

The trunk is drawn sinuous like a dragon, giving an impression of iron power. Tips of long branches are like arrows, of short ones like spears. Where there is space at the top of the picture, the top of the tree is indicated; where there is too little space, no attempt is made to show the top.

When the plum tree is painted on a cliff or at the edge of water, its branches are curiously twisted and bear few blossoms, in fact, only buds and half-opened buds. When the plum tree is painted "combed by the wind" or "washed by the rain," there are many spaces on the branches, blossoms are wide open, and some of them crushed. When the plum tree is painted in mist, branches are delicately drawn and the blossoms depicted with tenderness as though they held smiles and gentle laughter on the boughs. When the plum tree is painted in a rising wind or after a light fall of snow, branches bend, the trunk seems old, and flowers are few. When the plum tree is painted in sunlight, the trunk stands proudly erect and the blossoms seem to give forth rich fragrance. Beginners should examine these various aspects and study them well.

There are many examples available for study of works of the schools of plum painting: in some, the blossoms are few, nevertheless fragrant and lovely; in others, the many flowers are alive; in a few, past their prime but still beautiful, the flowers are pure and clear almost to transparency and yet robust. How can words adequately describe all this?

T'ang Shu-ya's [4] rules of painting the plum

The plum tree has branches, roots, joints, and knots, and on it is moss. It may be in a garden, on a cliff, at the water's edge, or by a bamboo fence. The places where it may be found growing are as various as its many forms.

3. Yang Wu-chiu, *tzǔ* Pu-chih, of the Sung period, was said to have learned plum painting from Chung-jên and to have written the last chapter of the latter's *Mei P'u* (Treatise on the Plum Tree), which has served since South-ern Sung times as the basis of all other works on plum painting, including this book of the Manual.

4. There is little to identify T'ang Shu-ya. In the *Book of the Orchid*, he is mentioned as a relative of Yang Pu-chih.

Its blossoms have four, five, or six petals, generally five. The four- and six-petaled blossoms grow on the thorny plum (*chi mei*) but are unusual on other varieties. The roots may be old or young, crooked or straight, outspread or knotted, sometimes ordinary in shape but sometimes creating wonderfully strange forms. As for the tips of the branches, there are some like the handles of acorn cups and others straight like the ends of iron rods; there are some like the claws of cranes, some like dragon's horns, some like stag's antlers, some like the tips of an archer's bow, some like fishhooks.

The forms of the plum tree may be large or small, seen from the back or the front, leaning or upright, crooked or straight. The blossoms have many forms, like grains of pepper, like the eyes of a crab, and sometimes like a smile. They may be wide open or closed or about to drop. Their forms are never the same; there is no limit to their variety. To catch their very essence in the fewest brushstrokes and with the least amount of ink, one must take Nature as teacher, be conscious of her law (*li*) and practice constantly with the brush. Thus the divine spirit will grow and gradually pervade one's whole heart and intelligence. Thought (*ssŭ*) may then grasp the form (*hsing*) and structural integration (*shih*) of the blossoms. Attention should be given to the structure of the whole tree in all its strange and wonderful shapes. Brush and ink should be free from restraint and tension.

The roots and the base of the tree are tortuous in some parts and outspread in others, the ends of the branches like flying plumes, the blossoms with their heads grouped like *p'in*. Old branches are distinct from young ones; blossoms are well arranged and their stamens drawn accordingly; and there are long and short branches.

Each flower is attached to a calyx, each calyx to the stem and branch, and the branch in turn to the trunk. The trunk seems to have the scales of a dragon, the scales being like old scars. No two branches are of the same length. Groups of three blossoms are arranged like the feet of a bronze tripod. The calyx is long, the sepals short. On the highest branches, the blossoms are small with long calyx and stems. There are points at which blossoms are luxuriant, but they should not be entangled. Branches and their tips are rendered in dark ink tones, the stalks of the blossoms in even darker tones. Old and dried branches give an impression of being at leisure; crooked branches appear to have a certain calmness. If one is able to represent the blossoms as though wrought in jade, and the trunk as a dragon or a whirling phoenix, it is evident that one's heart

dwells on the hills of Ku or among the mountains of the Yü range; one's brush will bring forth branches like lithe young dragons. Under such circumstances, how can one be disconcerted by the infinite number of shapes or fear the many possible variations?

Hua-kuang Ch'ang-lao's [5] precepts on plum painting

In composing the flower and its calyx, the stamens should be drawn correctly and with precision, the filaments long, the anthers short. The stamens are strong and the calyx tapering and pointed. When the stamens are upright, the flower also is upright; when they lean to one side, the flower likewise is inclined.

Branches do not grow in opposite directions (from the same point on bough or trunk). Nor do blossoms grow side by side symmetrically. When there are a number of blossoms growing close together, they should not appear to be entangled; when blossoms are few, they should not give an impression of sparseness. Old branches, though dry and decaying, should nevertheless convey an idea (*i*) of compactness. Sinuous branches should give an impression (*i*) of growing and stretching out. Blossoms should seem to join each other by mutual consent, and branches likewise should seem to depend on each other.

The heart should be at ease and the hand swift. Ink should be light and brush almost dry. Blossoms should be round, not to be mistaken for those of the apricot. Branches should be thin and fine but not like those of the willow. The purity of the bamboo and the strength of the pine are manifest in the plum.

Principles of establishing the composition of the plum tree

Group flowers in the form of *p'in*. Cross branches in the form of *yu*. Give the main branches the sturdiness of *ya*. Form the tips of branches like *hsiao*.

Flowers should be grouped some in clusters, some scattered, but never in disorder. Branches should be fine, delicate, and young; then they will not have any aspect of weirdness about them.

5. The monk Chung-jên lived at a monastery called Hua Kuang Shan, from which he acquired his other name. There apparently was another and younger Chung-jên at the same place, and the designation of Ch'ang-lao (aged and venerable) might refer to the older monk. At any rate, the Chung-jên mentioned here was the author of the famous *Treatise on the Plum* and was renowned for his ink paintings of the plum tree.

Numerous branches and few blossoms indicate that the *ch'i* (of the tree) is complete. Old branches bearing large blossoms indicate that their *ch'i* is healthy. Young branches bearing delicate blossoms indicate that their *ch'i* is subtle.

Attention should be given to the relationship of high and low branches, long and short ones. Branches are numerous in some parts and few in others, and both thin and thick. Some branches fork, others are widely separated; some are vigorous, others as though passive. Branches should not be shown growing side by side at the same height. Neither should blossoms be painted growing side by side symmetrically; nor indeed, two trees in such a position.

Tortuous and strong branches are joined to others pliant and weak; among small blossoms are some large, like princes among their ministers. In the same way, among the smaller branches are some long and some short, like parents and children. Among the buds there is the same pairing, like husband and wife, the *Yang* and the *Yin*. These principles are not the only ones, but they should be consistently applied.

Explanation of the symbolism of plum painting [6]

The symbolism (*hsiang*) of the plum tree is determined by its *ch'i*. The blossoms are of the *Yang* principle, that of Heaven. The wood of its trunk and branches are of the *Yin* principle, that of Earth. Its basic number is five, and its various parts and aspects are based on the odd and even numbers. The peduncle, from which the flower issues, is a symbol of the *T'ai Chi* (the Ridgepole of the Universe, the Supreme Ultimate, the Absolute), and hence it is the upright form of the calyx. The part supporting the blossom is a symbol of the *San Ts'ai* (Three Powers of Heaven, Earth, and Man) and consequently is drawn with three sepals. The flower issuing from the calyx is a symbol of the *Wu Hsing* (Five Elements) and is drawn with five petals. The stamens growing in the center of the flower are symbols of the *Ch'i Chêng* (Seven Planets: the five planets with the sun and the moon) and so are drawn numbering seven. When the flowers fade, they return to the number of the *T'ai Chi,* and that is why the cycles of growth and decline of the plum tree are nine.[7]

6. This section and those that follow, through the "Ten kinds of plum tree," are the most direct expressions in the Manual of number symbolism based on the *I Ching,* although at certain points the analogies seem somewhat labored.

7. The Taoist work the *Lieh Tzŭ* (c. 400 B.C.) explained this symbolism of the One to Nine as follows: "The changes of one produce seven, the changes of seven pro-

All these aspects of the plum tree are based on the *Yang* and therefore are associated with the odd numbers.

The roots from which the plum tree grows are a symbol of the *Êrh I* (Two Forms: *Yin* and *Yang*), and this is the reason the trunk is divided into two parts. The main branches symbolize the four seasons and so are composed facing the four directions. The branches symbolize the *Lu Hsiao* (Six Crosswise Lines of the *I Ching* hexagrams) and so have six main "crossings" (for a complete tree). The tips of the branches symbolize the *Pa Kua* (Eight Trigrams of the *I Ching*) and so have their eight knots or forks. The whole tree with its trunk, branches, and blossoms symbolizes the complete and perfect number (Ten), and therefore ten kinds of plum trees have been designated. All these aspects concerned with the wood parts pertain to the *Yin* and are even numbers. But this is not all.

The front view of a blossom shows the form (*hsing*) of a circle and thus is a symbol (*hsiang*) of Heaven. A flower in back view has angles forming a square and thus is a symbol of the Earth.[8] Branches bending over have an aspect of Heaven, covering the Earth; upright, they appear like the pillars of Earth supporting Heaven.[9]

The stamens also are symbolic. When the blossom is in full flower, it symbolizes the stage called *lao* (ripe) *Yang,* the full development of the flower just before the first step of fading, and the stamens number seven. When the blossom is faded, it symbolizes *lao* (ripe) *Yin,* and the stamens number six. The half-opened flower symbolizes *shao* (lesser) *Yang,* and the stamens number three. When the blossom has partly faded, it symbolizes *shao* (lesser) *Yin,* and the stamens number four.

The bud symbolizes the entity of Heaven and Earth. Its stamens are not yet visible, although their essence (*li*) is already contained within the bud. Therefore one calyx and two sepals are indicated; Heaven and Earth are still an undivided entity, and Man (represented by the third sepal) has not yet appeared. The flower with its stem and calyx symbolizes the beginning of the interac-

duce nine. Nine is the climax. It changes again and becomes One"—i.e., 1 (Monad), 7 (*Yin* and *Yang* and the Five Elements), 9 (the 7 and Heaven and Earth), symbolizing the process of evolution and constituting the universe as a whole (1 and 10). (Forke, *The World-Conception of the Chinese,* p. 35 and n.)

8. An interesting parallel of this interpretation of Heaven on the face and Earth on the back is a Ptolemaic relief in the Boston Museum of Fine Arts, a limestone slab with the head of a ram god (deity of Day, Light, Heaven, and the *Yang*) on the face, and on the back of the slab the head of a cat goddess (deity of Night, Darkness, Earth, and the *Yin*).

9. *T'ien fu ti tsai,* "covered by Heaven, supported by Earth."

tion of the powers of Heaven and Earth; when the *Yin* and *Yang* begin to separate, the cycles of growth and decay and endless mutation are started, symbolizing the materialization and natural development of all things. There are, therefore, eight knots (comings together, connections of branches), nine stages or changes, and ten species of the plum. As may be seen, all these symbols come from Nature itself.

One calyx

In form, the numerous calyxes are similar to cloves. They are attached to the branch and issue from it, successively one to the left and one to the right, but never side by side. The calyx should be drawn with precision and in strong brushstrokes. It should not bulge on one side, or the flower also would be out of shape.

Two trunks

The plum tree is spoken of as having two trunks, since its trunk should be drawn divided into two main parts, one large and one smaller, representing the *Yang* and the *Yin*, one to the right and one to the left, which also govern the placing of the branches in front and in the back. The *Yin* branches should not dominate the *Yang* ones; the smaller should in no way dominate the larger. The body of the tree is thus naturally established.

Three sepals

In drawing the sepals, they should be formed like *ting*, broad at the top and narrow at the base. They are attached to the calyx. The point where two sepals meet is the base of the corolla. With peduncle, stem, and calyx, the sepals constitute one form and should at no point be disconnected.

Four directions (of the main branches)

There should be method in arranging the position of the main branches from top to base and base to top, from right to left and left to right. Every aspect should be taken into consideration.

Five petals

The petals should be drawn with the brush held obliquely; they should be neither too pointed nor too rounded. When the flower is wide open, showing its seven stamens, it is as though it could be filled with dew. When the flower is half opened, only part of it may be seen. In full flower, the whole blossom is seen. The different stages should be properly indicated.

Six branches

There are branches that bend and others that are upright; some that repeat these positions, some that are forked, some that are snapped off. They should be properly spaced, attention being given to their positions in the background and foreground, at the top and below, together and separate; then the tree will be a living idea (*shêng i*).

Seven stamens

The stamens should be drawn with strong brushstrokes. The pistil in the center of the flower is long and without a head. The six stamens around the pistil are shorter and should be of different lengths. The pistil is the "fruit" stamen and is drawn without a head. Taste it, the flavor is sour. The stamens are drawn with heads (anthers). Taste them, they are bitter.

Eight types of crossings of branches

There are branches with long tips and branches with short tips; some are young; some are in a cluster. Some are intertwined and some are solitary. Sometimes they are forked, and sometimes they have strange and wonderful shapes.

The structure and integration (*shih*) of each branch and each fork must be rendered correctly for perfect results. If each is in its proper position, the idea or conception (*i*) will be complete and the pattern of the tree will not be marred.

Nine transformations

First there is the calyx. Then, the bud. From the bud emerges the form, with petals closed. The petals issuing from the calyx gradually open. There is then the half-opened flower. Next, the full blossom. The process continues in the decline of the flower. The flower is half dead. The stage of fading is also a beginning, that is, of the transformation of the blossom into the green fruit.

Ten kinds of plum tree [10]

Consider the different kinds of plum trees that may be painted. There are old and withering plum trees, young ones, those with abundant blossoms, the mountain plum, those whose blossoms are few and scattered, the wild plum, the ordinary plum, the kind that grows by a river, the garden plum, and those grown in pots. The forms vary and the distinction should be clearly indicated.

Summary of plum painting phrased for memorizing by chanting

There are certain secrets in painting the plum tree. First, establish the idea (*i*). Brush should be nimble, inspired with a certain madness.[11] The hand should move like lightning, without hesitation. Branches should spread, some straight, some crooked. Ink tones should be varied, light and dark, and never retraced. Roots should never be gross or broken. Do not put too many blossoms near the tips of branches. Young branches should resemble those of the willow, old ones should look like a kind of whip. Tips of branches should be drawn in *lu chüeh* (stag horn) brushstrokes. Some branches are straight as the strings of a lute, some pointing upward like the arc of a bow, some curved like a fishing pole. Twigs bear no blossoms. The base is straight, pointing to Heaven. Trunk and branches of a withering tree are knotted. Minor branches and twigs should not be too numerous and should never cross in the form of *shih*. Blossoms should not all be whole and perfect. Branches to the left are easy to render; to the right, difficult. To draw them perfectly depends on the control of the hand even to the little finger. Space should be left on branches for adding the

10. Apart from different species.

11. The expression *k'uang tien*, literally "mad at the top of the head," may be explained by the character *tien*, used by Taoists to describe true inspiration, i.e., the achieve- ment of the state in which the heart-mind is emptied and the spirit is freed from the body and receives inspiration from Heaven through the midpoint of the top of the head.

blossoms. When they are added, the soul of the flower should seem to be intact. On young branches, blossoms are single and separate. On old branches, blossoms are few. On branches that are neither young or old, the idea (*i*) transmitted through the blossoms should be one of luxuriant abundance. The various aspects of old and young plum trees should be clearly indicated. The knots and bends on some branches are like the joints of a crane's legs, while some old trees are marked as with dragon's scales. Branches should surround the trunk, their tips gathering to complete the pattern.

In profile, the calyx shows three sepals. It should be properly joined to the stem. In full view (from below), the calyx shows five sepals. In a full view of the heart, the calyx is a circle.

The trunk of an old plum tree should be knotted, though not with too many "eyes"; its twisted limbs should not be too rounded.

The flowers of the plum tree have eight "faces": straight, side-view, facing upward, inclined, open, dropping, half-opened, and about to shed its petals. When the petals are awry and the flowers are bending over, the wind is blowing through the branches. When there are many blossoms, they should not seem crowded; few, they should not appear sparse. Plum blossoms are subtly fragrant, their complexion pure as jade. Two solitary blossoms growing at the top of a tree, high and tranquil, the tip of the branch like a thorn between them, resemble a branch of the pear tree.

Begin to draw a blossom at its heart, which has the form of the hole in the center of a coin. Stamens number seven and are strong as the whiskers of a tiger. The pistil is long and the stamens around it short. The anthers should be dotted in like grains of pepper or the eyes of crabs, adorning the elegance of the blossoms.

By means of the brush, light and dark ink tones are indicated. The calyx should be dark. The bark of the tree also should have a pleasing depth of tone. Young branches and tips should be rendered in light tones. The points at which the branches join should also be light. Trunks of old trees should be drawn partly with a half-dry brush. Thorns should be added in blank spaces. Around joints and knots, the brushstrokes should be like overlapping scales. There are as many ways of drawing the bark of the plum tree as there are of drawing the blossoms. The tortuous and crooked form of the trunk and limbs should suggest *nü*.

With these basic rules and principles in mind, one should be able to produce strange and wonderful forms. Invention does not stop with the idea, although one should always keep in mind the dignity of the plum tree and what is appropriate to it. The foregoing covers the approach to plum painting and should not be treated lightly.

Principles of painting the trunk and the main branches of the plum tree phrased for memorizing

女 Trunk and main branches should be drawn in a form similar to *nü*. Other branches and stems fork from this main form. Some of the spaces along the branches are filled with blossoms. Root and base of the tree are done in dark ink tones, ends of the branches in light tones. Small blossoms cluster at points where one branch issues from another. Where there is space on branches and no flowers, smaller branches should be added. The *ch'i* of a main branch causes it to grow upright, reaching up, as it were, to Heaven. On this branch no flowers should be drawn, thus increasing its effect (*i:* idea, meaning).

The four elegances of the plum tree phrased for memorizing

A few blossoms, not a superabundance, are an elegance. Leanness of trunk, not plumpness, is an elegance. Age, not youth, is an elegance. Blossoms half opened, not in full bloom, are an elegance.[12]

Essentials of plum painting phrased for memorizing

In painting the plum tree there are Five Essentials to be kept in mind. First, the trunk should be venerable, gnarled and bent with age. Secondly, the main branches should twist in wonderful forms, turning roughly in some places and finely coiled in others. Thirdly, branches should be clearly defined, with great care given to the way they connect as well as to the unity that they form. Fourthly, the tips of the branches should be strong, their elegance being in the concentration of robustness. Fifthly, the blossoms should be wonderfully lovely and elegant down to the least detail.

In painting the plum, there are also certain things that are to be avoided. Above all, one must avoid wielding a brush that is not true,[13] a point frequently discussed by the ancients. (Other points

12. The application of the Mean embodied in the Four Elegances might be summarized as discrimination, inner power (represented by sinuosity), maturity, and growth (represented by a stage of mutation rather than completion).

13. *Tien* (see n. 11), the Taoist expression describing the state of being inspired or in contact with the *Tao* and hence achieving trueness (*chên*) and complete naturalness (*tzŭ jan*).

to be avoided are:) flowers without calyxes, old branches without knots, whole branches without spaces (suggesting other forms), young trees with too many thorns, too few branches with too many blossoms, tips of branches not in the form of stag horns (*lu chüeh*), a trunk not properly rooted or meaninglessly coiled, blossoms and branches without arrangement, young branches with moss on them, tips of branches all drawn in the same style, old trees that are not venerable, young trees that are not fresh, what is depicted left vague and what is implied not clearly depicted, a hesitant brush producing knots like those of the bamboo, auxiliary branches placed too high, flowers growing on the trunk, anthers like crabs' eyes too heavily drawn, withering anthers too heavy or, on the other hand, too thin, trunk and main branches not similar in form to *nü* and *an*, ends of branches in disorder, branches not enfolding the trunk, no scattering of petals when the wind blows, clusters of blossoms like a fist, blossoms not as they should be by nature, too few, too mixed, too uniform, too crowded. If any of these faults is present, the whole effect will be spoiled.

女　安

The Thirty-Six Faults in plum painting phrased for memorizing

Branches like crooked fingers. Retracing of brushstrokes. Hesitant brush. Wielding a brush that is not true. Branches lacking a living idea (*shêng i*). Branches without perspective. Old branches without knots and wrinkles. Young branches with wrinkles. Too many scattering petals. A plum tree in moonlight with a round moon.[14] An old tree laden with blossoms. A twisting branch with two similar curves. Flowers all facing in one direction. Full-blown blossoms on a plum tree in the snow. Equal thickness of snow on every part of a plum tree painted in the snow. The seasonal aspect (*ching*) represented without the appropriate features. Mist at the same time as moonlight. Old trees in dark ink tones. Fresh young trees in pale tones. Crossed branches without blossoms. Withering branches without moss. Distortion of the place where a branch is connected. Flowers in full bloom drawn in an exact circle. No distinction between light and shadow (*yin* and *yang*). Neglect of the host-guest relationship. Blossoms as large as peaches or as small as plums. Blossoms on a dead branch. Buds at forks of branches. Thin trunks with heavy branches. Blossoms lined up in a row. Too few blossoms on the light side, too many in the shade. Two blossoms side by side at the same level. Two trees of equal height.

14. Perhaps because roundness was primarily symbolic of the sun.

PLUM

Examples of first steps in painting
the plum tree

Downward, starting at right:

Twig pointing upward, in two brushstrokes.

Twig hanging down, in two brushstrokes.

Twig hanging down, in three brushstrokes.

Twig pointing upward, in three brushstrokes.

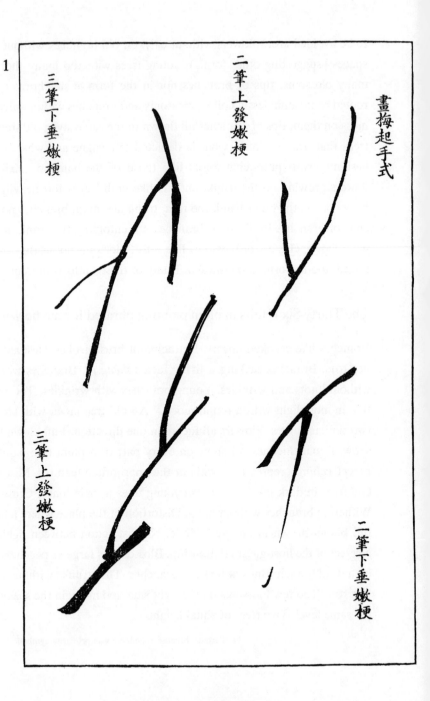

畫梅起手式

二筆上發嫩梗

三筆下垂嫩梗

三筆上發嫩梗

二筆下垂嫩梗

2

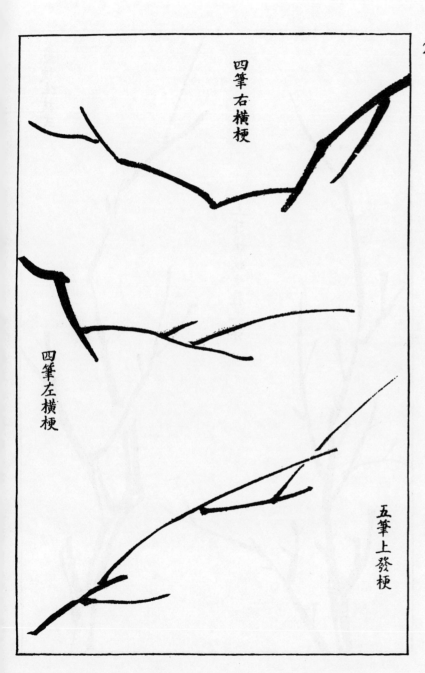

四筆右橫梗

Horizontal twig, growing from right, in four brush-strokes.

四筆左橫梗

Horizontal twig, growing from left, in four brush-strokes.

五筆上發梗

Twig pointing upward, in five brushstrokes.

Examples of drawing twigs growing
from branches

Two ways of drawing twigs growing from branches
pointing upward.

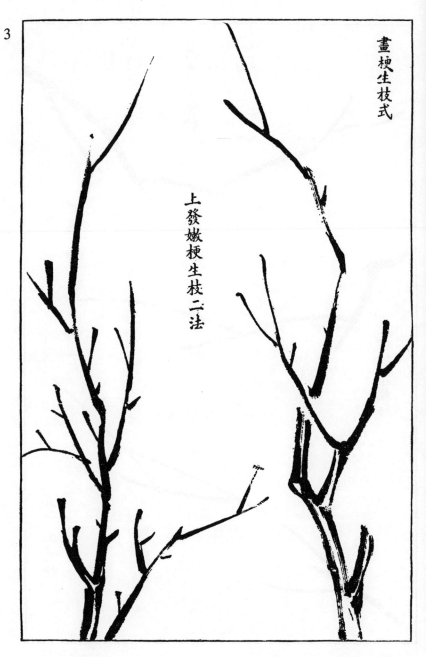

4

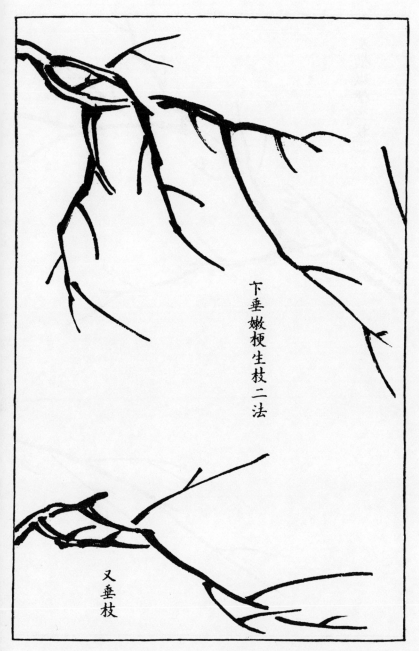

下垂嫩梗生枝二法

又垂枝

Two ways of drawing twigs growing from hanging branches.

Another hanging branch.

5

左横嫩梗生枝

Twigs growing from a horizontal branch from the left.

6

折枝生梗

右横嫩梗生枝

Twigs growing from a broken-off branch.

Twigs growing from a horizontal branch from the right.

Intersecting branches and twigs from the left, with spaces for filling in the blossoms.

8 Examples of branches and twigs with spaces left for blossoms

Intersecting branches and twigs from the right, with spaces for filling in the blossoms.

Examples of drawing the base

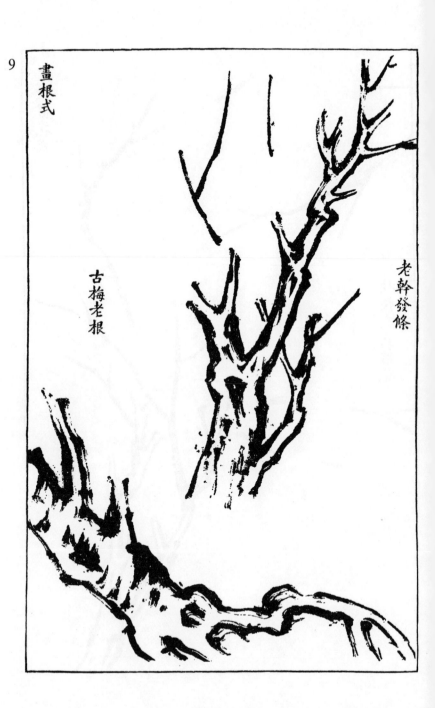

9

畫根式

老幹發條

古梅老根

Old trunk with branches and twigs.

Old roots of an ancient plum tree.

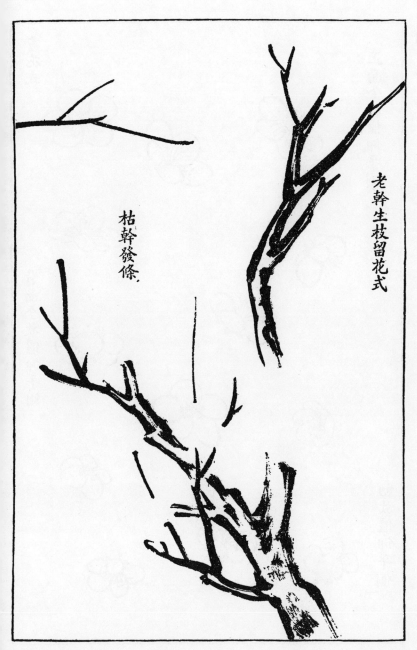

10 Example of branches and trunk of old
tree with spaces left for blossoms

老幹生枝留花式

枯幹發條.

Old tree with branches and twigs.

PLUM

Examples of drawing blossoms

Face of blossoms: full view, tilted and facing upward and at eye level.

Back of blossoms: full view, tilted, bending over and at eye level.

Blossoms beginning to open: tilted, facing upward, at eye level and from the side.

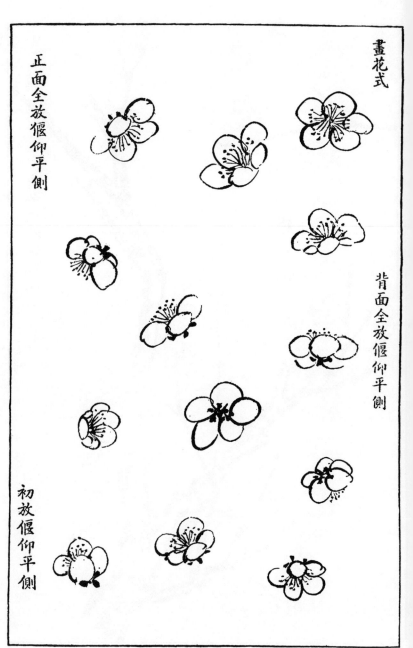

422

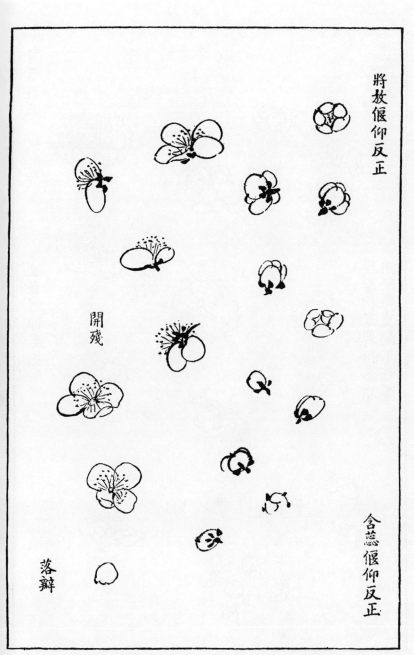

Downward, starting at right:

Blossoms about to open, tilted, facing upward and down.

Buds tilted, facing upward and down.

Fading blossoms.

Fallen petal.

Examples of double-petaled blossoms

13

Blossoms beginning to open, tilted, facing upward and down.[1]

Whole blossoms, fully opened, tilted, facing upward and down.[2]

The calyx of double-petaled blossoms may be tinted pink, and for this reason it is outlined and not dotted in with ink.

1. Applies to the three blossoms at the top left.
2. Applies to the seven blossoms in the right half of illustration.

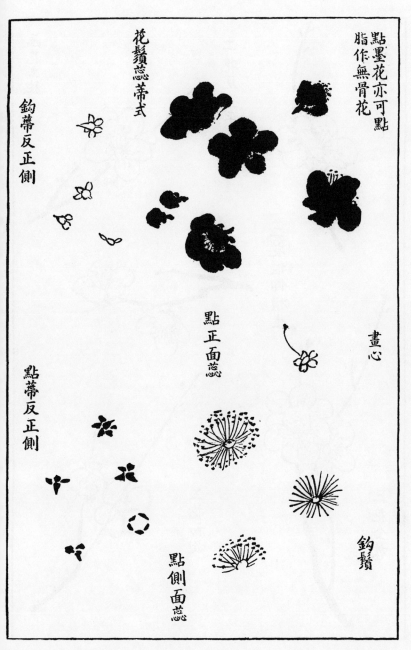

脂墨花亦可點
作無骨花

花鬚顆蕊蒂式

鈎帶反正側

點帶反正側

點正面蕊

畫心

點側面蕊

鈎鬚

14　Examples of blossoms, stamens, pistil,
and calyxes

Outlining the calyx and sepals: front, back, and
side views.

Blossoms in ink which also may be done in red,
the method being the "no bones" style.

Drawing the heart of the blossom.

Dotting the calyx and sepals: front, back, and
side views.

Dotting the stamens, front view of blossom.

Dotting the stamens, side view of blossom.

Drawing the filaments.

425

Examples of drawing blossoms
growing on branches

15

Two blossoms back to back on an upright branch.

Two blossoms back to back on a (nearly horizontal) branch.

Two blossoms on a horizontal and bent branch.

Three blossoms fully opened.

Three blossoms beginning to open.

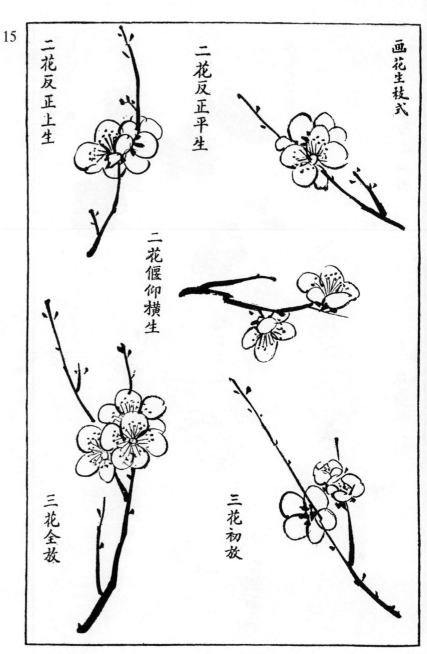

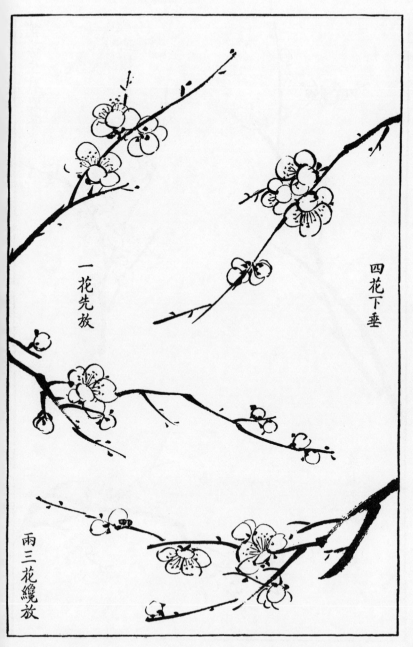

16

一花先放

四花下垂

兩三花纔放

(Four blossoms on an upright branch.) [1]

Four blossoms on a hanging branch.

The first blossom to open on a branch.

Two or three blossoms just opening.

1. As in original edition, at top left.

Examples of dotting the calyx and
drawing buds on branches

17

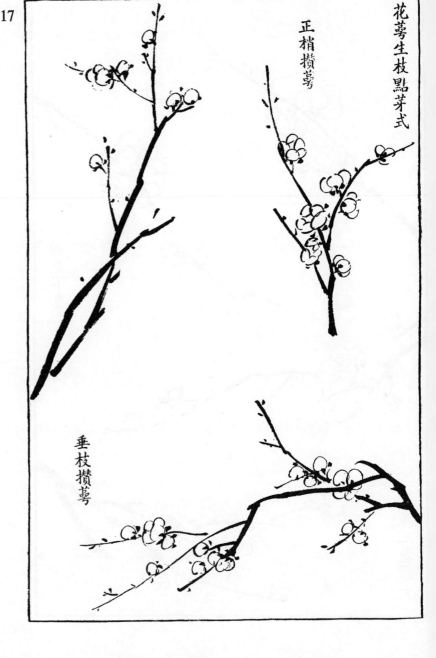

(Buds and blossoms on a slightly inclined
branch.) [1]

Group of blossoms at the tip of a branch.

Buds and blossoms on a hanging branch.

1. As in original edition.

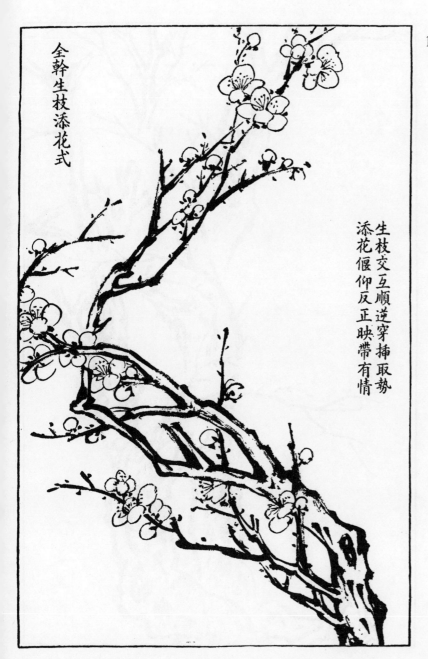

全幹生枝添花式

生枝交互順逆穿插取勢
添花偃仰反正映帶有情

18

Example of a trunk and branches with
blossoms added

Structural integration (*shih*) is obtained by drawing
branches intersecting according to their positions and
by adding blossoms in various positions, tilted, facing
upward and down, combining to give a brilliant,
harmonious effect.

19

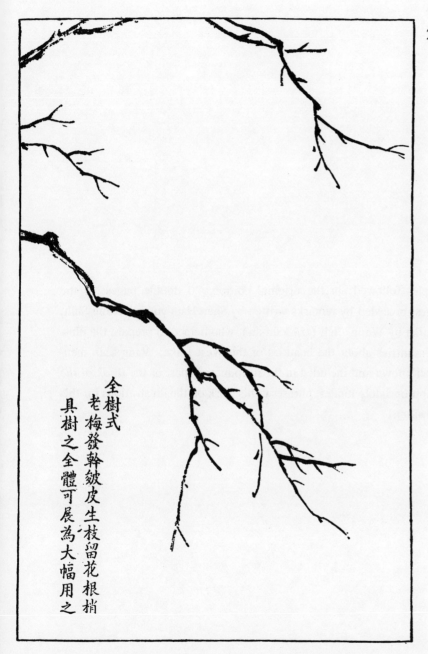

Example of a whole tree

From the wrinkled bark of the trunk of an old plum tree branches grow. In composing the tree from top to roots, space should be left in which blossoms may be added. Starting with this basic structure, more branches and blossoms may be added, depending on the space available in the picture.

[A section of additional examples followed: in the original edition, 20 double pages; in the Shanghai edition, 25 single pages, preceded by remarks written by Shên Hsin-yu and Wang Shih, and with some concluding remarks by Wang Chih (*tzŭ* Yün-an), who helped to prepare the illustrations. Shên's words were pleasantries about the beauties of the West Lake; Wang Shih mentioned a few historical notes, well known and included in the introductory part of the *Book of the Plum;* Wang Chih referred in appropriately modest phrases to his work on the illustrations for this and the *Book of the Chrysanthemum.*]

Book of the
Chrysanthemum

Ch'ing Tsai T'ang Discussion
of the Fundamentals of Chrysanthemum Painting

(General background of chrysanthemum painting) [1]

THERE are many different kinds of chrysanthemums and great variety in their colors and forms. Without knowledge of the methods of *kou lê* (outline) and *hsüan jan* (wash and tint), it is impossible to paint them (*hsieh hsiao*, write their likeness).[2]

According to the *Hsüan Ho Hua P'u* (Hsüan Ho Palace Catalogue of Paintings; Sung period), Huang Ch'üan, Chao Ch'ang, Hsü Hsi, T'êng Ch'ang-yu, Ch'iu Ch'ing-yü, and Huang Chü-pao were all well known for their paintings of chrysanthemums; all painted pictures of winter chrysanthemums. Up to the Southern Sung, Yüan, and Ming periods, only the literati and retired scholars treated the subtle fragrance of the chrysanthemum as a special subject of painting. They expressed it in ink, not using any color. They excelled in expressing its purity. Others after them were renowned for ink painting of the chrysanthemum, among them Chao (Mêng-chien) I-chai, Li Chao, K'o (Ch'iu-ssǔ) Tan-ch'iu, Wang (Yüan) Jo-shui, Shêng Hsüeh-p'êng, and Chu Shu-hsien. In their works it may be perceived that the chrysanthemum is "defiant of frost and triumphant in autumn," a saying that expresses the essence (*ch'i*) of its character. In painting the

1. Heading as in original edition.
2. As with orchid, bamboo, and plum, painting the chrysanthemum as an independent subject was a fairly late development (about the x century), inaugurated and influenced by the literati. The associations of the chrysanthemum as the flower of late autumn, announcing the coming of winter and able to blossom in the cold, were developed through the XIII century.

chrysanthemum, this idea must be clearly understood so that the transmittal of it originates in the heart and passes through the wrist to the brush. Color can not convey the idea.

I (Wang Shih, *tzŭ* Mi-ts'ao) have been commissioned to arrange these four books of the *Chieh Tzŭ Yüan* concerning the "subtle fragrance of the River Hsiang" (i.e., the orchid) and the "knotted stems of the gardens of the River Ch'i" (the bamboo), (the two plants praised as symbols of) virtue [3] in the poem (*Li*) *Sao* (Falling into Trouble), in the *Ch'u Tz'ŭ* (Elegies of the State of Ch'u), and in the *Wei Fêng* (Airs of the State of Wei, in the *Book of Odes*); the "branch that, in the south, flowers in the winter" (the plum); and the "flower whose fragrance lingers along the bamboo fence to the east" (the chrysanthemum). These, like the solitary mountain in its dignity and calm, share a bond with people of noble character. These plants are unique. They represent the *ch'i* of the Four Seasons.[4] Is it not fitting that, to make this work on painting complete, each of these plants should be discussed?

General principles of composing the plant

The chrysanthemum is a flower of proud disposition; its color is beautiful, its fragrance lingers. To paint it, one must hold in his heart a conception of the flower whole and complete. Only in this way can that mysterious essence be transmitted in a painting. Some of its flowers should bend and some face upward; they should never be too numerous. Some of its leaves should be covered and some face upward, never in disorder. In brief, each branch, each leaf, each flower, each bud, must be rendered in its own full character.[5]

Although the chrysanthemum is usually placed in the category of herbaceous plants, its proud blossoms brave the frost and it is classed with the pine (i.e., with trees and ligneous plants). Its stem is solitary and strong, yet as supple as the stems of spring flowers. Its leaves are rich and sleek, yet they have aspects as varied as those that quickly fade. Its blossoms and buds should be shown in different stages of development, each in relation to another. The essence (*li*) of the plant

3. *Chün tzŭ* (the princely or noble man, "the superior man"), the Confucian ideal.
4. Orchid, spring; bamboo, summer; plum, winter; chrysanthemum, autumn.

5. An inadequate rendering of *tê* (inner power), a term in Chinese thought implying moral strength and character, which is accord with the *Tao*. Trueness (*chên*) and naturalness (*tzŭ jan*) of each detail of the plant reflects the stage of development of these qualities in the painter.

should be kept in mind, whether the stem is bent or straight: when the flowers are fully opened, the stem is weighted and therefore bends, while a stem bearing only buds is naturally lighter and stands straighter. A straight stem should not, however, be drawn as though it were rigid, nor should an inclined stem bend too far. These are the general rules of painting the plant. Specific methods apply to the painting of each part, the flower, calyx, stem, leaf, and base.

Principles of painting the flowers

Each flower is different, the petals being variously formed: oval, rounded, long, short, broad, narrow, thick, or delicate, in a loose or a dense cluster. There are some that are split into two- or three-pronged petals, some with broken petals, some with petals that stick out like thorns, some with petals that curl or are rolled up. The forms are numerous. Long- and single-petaled flowers are generally flat and circular like a mirror, and the heart of the flower can be seen like a honeycomb or a sprinkling of golden grain. Flowers with small, short petals have a rounded form almost like a ball, and the heart of the flower is hidden. Although petals have a great variety of forms, all grow from the same kind of base or peduncle. However loose or few or however numerous, they must be drawn issuing from that base. The form of the flower will then be integrated, as it should be.

Flowers are of various shades of yellow, purple, pink, and pale green. The heart of the flower is dark in tone, while the outside petals are lighter; and between these dark and light tones there is a wide range of other tones. In painting white flowers, use white even in outlining and to indicate the veins of the petals.

All the above points depend on the painter's conception (*i*) of the flower and his ability to transmit it.

Principles of painting the buds and peduncle

To paint flowers, one must know how to paint buds, half open, just about to open, and not yet opened. Each form is different. A half-open bud seen in profile shows its peduncle. In young buds, the petals are clustered together at the heart of the flower; the structural integration (*shih*) of the

whole flower is already contained in that form. In buds that are just opening, the green leaves of the husk are beginning to break, a first petal is emerging like a small bird's tongue licking the nectar of a flower or like a fist with one of the fingers extended. In buds about to open, the petals hold close their fragrance but begin to show a hint of their color. Buds that are not yet open resemble pearls or jade buttons. Like stars on stems, they should be rendered individually, each flower for its own subtle charm.

To paint buds it is necessary to know how to paint the peduncle of the flower. Although the head of each flower may vary in form (according to the stage of its development), the structure of the peduncle is the same. Unlike other plants, it is composed of what seem like layers of young leaves. When the bud is round, although the flower may be of any color, the husk and the whole form is green. At the moment the bud opens, a touch of the color of the petals is suggested. The characteristic beauty of the chrysanthemum is in its flower, but its spirit (*ch'i*) is concentrated in the bud. The petals that emerge from the bud come from the peduncle. This principle (*li*) can never be ignored. Thus, to the section on painting the flowers is added this part on painting the buds and peduncles.

Principles of painting the leaves

There are also a great variety of leaf forms in chrysanthemum painting: pointed, rounded, long, short, broad, narrow, luxuriant, and sparse. The Five Paths and the Four Spaces (*wu ch'i ssŭ ch'üeh*)[6] are very difficult to draw. The leaves should not appear identical, with the effect of being stamped out flat and stiff. The positions of the leaves should be carefully considered: whether they are facing upward, turned back, curled, or folded. The face of a leaf is called *chêng* (upright, face); the back, *fan* (turned over); facing up but partly folded, *chê* (diminished, folded); turned upward and over, *chüan* (curled).[7] After one knows how to render these four aspects, one must

6. An analogy to the Five Points and the Four Directions: the fifth point, the Center, points upward; the four spaces refer to the spaces between the four indications of direction.

7. These terms, significantly numbering four (cf. the Four Directions and the number of materialization of the One), have associated ideas: *chêng,* describing the face of the leaf, also has the connotation "upright" and, by analogy, the center of a target—hence it is a way of speaking of the fixed center or the *Tao; fan* is used in Taoist works to describe the characteristic action of "returning" to the *Tao; chê* describes another aspect of returning, more specifically "diminishing" or putting to rest (folding) worldly desires and ambitions. An important meaning of *chüan* (scroll, to roll) is indicated by the part of the character that depicts a hand picking or selecting, thus choosing and discriminating. These are minimum deductions, based on the characters themselves, and give an idea of the layer of deeper meaning apart from the technique of representing positions of leaves; there were probably many other associated ideas.

still know how to arrange them and also how to draw the veins of the leaves. Then the leaves will not all be alike, and the results will have variety.

The leaves immediately beneath the heads of the flowers should be rich and large, their color deep and luxuriant, for the strength of the whole plant is concentrated there. Young leaves on a stem should be pliant and delicate, their color light and clear. The leaves that are fading at the base of the plant should be yellow, their color indicating that they are beginning to wither. The color of the face of the leaves should be dark; of the back, light. So, we end the discussion.

Principles of painting the main stem

Flowers should cover the leaves and the leaves, in turn, should cover the stem. The main stem and base should first be sketched in with charcoal, then the flowers and leaves are placed, after which the painting begins. Only after the main stem has been finished can the flowers and leaves be added. This is done so that the flowers and leaves facing in various directions may be made to hide the main stem (at certain points). If the sketching in with charcoal is omitted, it will not be possible to establish the directions of the stalks and leaves. If, after establishing the position of the main stem, flowers and leaves are not properly added, they will incline this way and that, but all on one plane instead of around the stem. The main stem should be strong, the auxiliary stalks young and tender. The base of the stem should be old. The main stem should be supple yet should not look like a climbing plant, strong yet not like a lance; it should curve but not hang over. The chrysanthemum, as the flower "in the wind" and "with its face to the sun," holds its stem upright though not rigidly straight; sometimes it is "laden with dew" or it "braves the frost." The structural integration (*shih*) of flower, bud, stalks, base, and stem must be properly rendered; the charm of the flower will then be completely realized. The chrysanthemum may belong to a minor category of subject matter but (the painting of) it is not easily explained.

Rules of painting the chrysanthemum phrased for memorizing [8]

The chrysanthemum season is mid autumn. It is the flower that "braves the frost." To capture its quality, brush style (*shih*) [9] must be imbued with dignity. Its color is that of the Center, that most

8. As in the three preceding books, these sections of four-character phrases for memorizing cannot be rendered with the uniform brevity of the original.

9. Structure created and integrated by the brush.

honorable of colors, gold.[10] Spring flowers are supple and captivating, but how can they be compared with the chrysanthemum? Transferred to a painting, it wafts a fragrance that lingers.

Rules of painting the flowers phrased for memorizing

These are the rules of painting the flowers of the chrysanthemum. Petals are pointed or rounded. Flowers face upward or to one side. Their positions are in front or in back. Those inclined are only half visible. Those straight are in full view. Those about to open spit forth pistils and stamens. Those tightly closed are like a handful of stars. The flowers multiply according to the number of peduncles and stalks, and spring from the stems. Do they not?

Rules of painting stems phrased for memorizing

When a cluster of flowers has been painted, a stem may be added below it. Space should be left on stems where leaves may be added. Stems bend, are straight, are tall, are short. An upright stem should not be too straight. A bending stem should not hang. The structure and integration (*shih*) of bending or straight stems determine the air of the flowers and leaves.

Rules of painting leaves phrased for memorizing

These are the rules of painting the leaves. They should grow from the stem. The Five Paths and the Four Spaces, the face and back of the leaves, should be clearly indicated. Leaves support the flowers. The flowers then have a setting. Where leaves are few, fill in the spaces with stalks; where leaves are thick, add flowers. With flowers and leaves happily disposed, the whole plant will issue properly from its base.

Rules of painting the (main stem and) base phrased for memorizing

These are the rules of painting the main stem and base. At the top the stem should branch out. The form and style (*shih*) should have the effect of age and venerability. The idea (*i*) should be

10. The Center as the Sun.

of noble solitude. The stem should be straight, though not like that of the artemisia. While it has a certain loose grace, it should not resemble a jungle growth. Around the base, grasses should be added that partly conceal the main stem. A rivulet of water and some stones will enhance the total effect.

Faults to be avoided in painting the chrysanthemum phrased for memorizing

Brush should be pure and noble, and one should be careful to avoid too few leaves with too many flowers, vigorous stalks on a weak main stem, flowers not properly attached to stems, petals without peduncles, a clumsy brush, dead color, a confused conception and thus an obstruction (of mind and brush, heart and hand). To be aware of these faults is a step toward knowing what to avoid.

CHRYSANTHEMUM

Examples of painting the flowers of the chrysanthemum

Flowers with flat heads and long petals

Two flowers, one bending, one looking up.

Side view.

Back view.

Two flowers, screening each other from the light.

Buds opening.

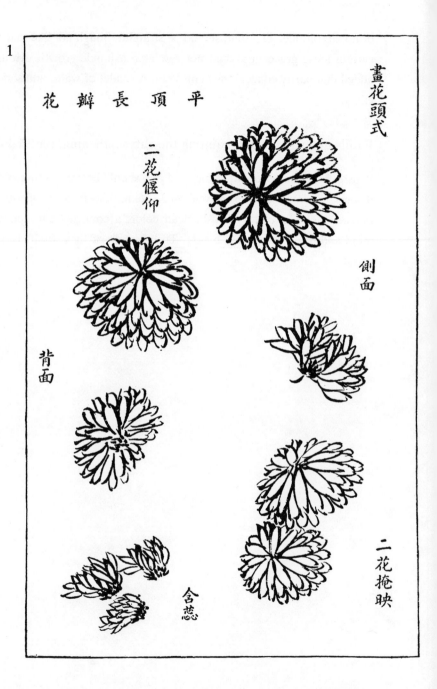

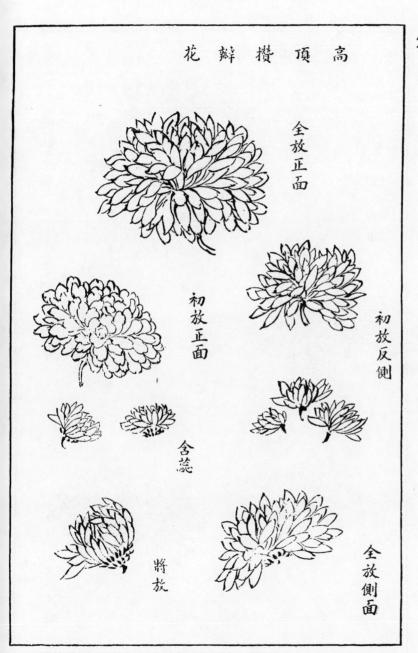

花瓣攢頂高

2 Flowers with high rounded heads
formed by clustered petals

全放正面

Face of a fully opened flower.

初放正面

Face of a newly opened flower.

初放反側

Back and side views of a newly opened flower.

含蕊

Buds opening.

將放

(Bud) about to open.

全放側面

Side view of a fully opened flower.

CHRYSANTHEMUM

Flowers with heads formed by clustered
pointed petals

Face of an opened flower, bending over.

Side view of a flower in full bloom.

Newly opened flower.

About to open.

Flower in full bloom, facing upward.

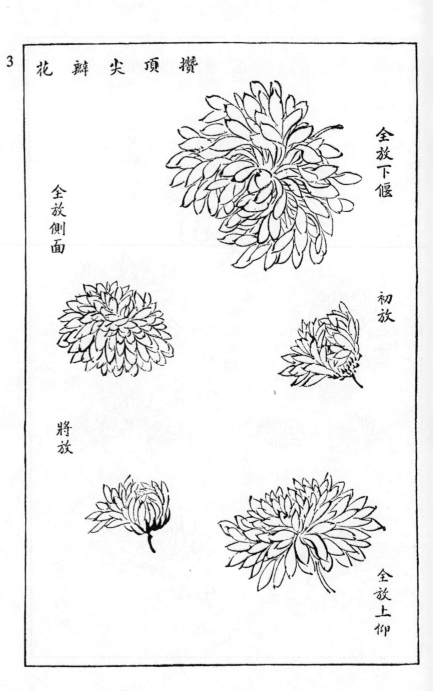

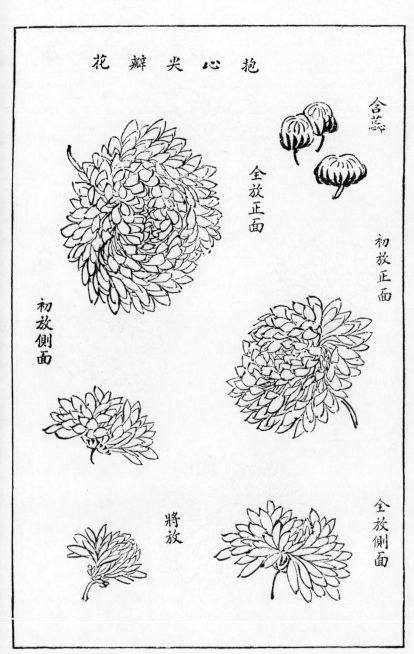

4 Flowers with pointed petals enveloping the heart

Face of a newly opened flower.

Buds opening.

Side view of a newly opened flower.

Face of a fully opened flower.

About to open.

Side view of a fully opened flower.

Flowers with heads formed by layers of small petals

5

Face of a flower in full bloom.

Back view of a flower in full bloom.

Side view of a newly opened flower.

Face of a newly opened flower.

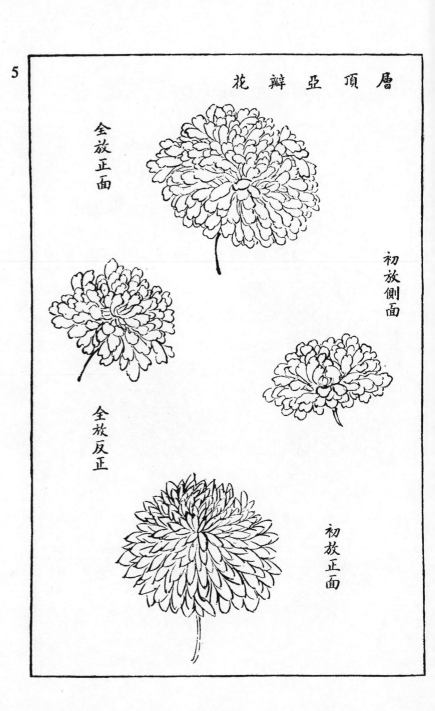

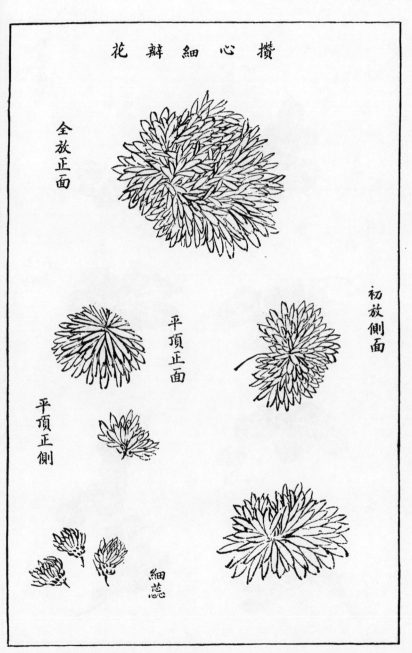

6 Flowers with delicate petals clustered
around the heart

Face of a fully opened flower.

Face of a flower with flat top.

Side views of a newly opened flower.[1]

Side view of a flower with flat top facing upward.

Left:

Delicate buds.

1. The explanation applies to the flowers center right and
bottom right.

CHRYSANTHEMUM

Examples of leaves in ink [1]

Back of leaves, facing upward.

Face of hanging leaves.

Back of curling leaves.

Face of leaves, pointing upward.

Face of curling leaves.

Face of a folded leaf.

Back of folded leaf.

Face of (folded) leaf facing upward.

1. As with the leaves of the orchid and bamboo, variation in ink tones was unfortunately lost in the lithographic reproduction of the Shanghai edition and the reprints based on that edition.

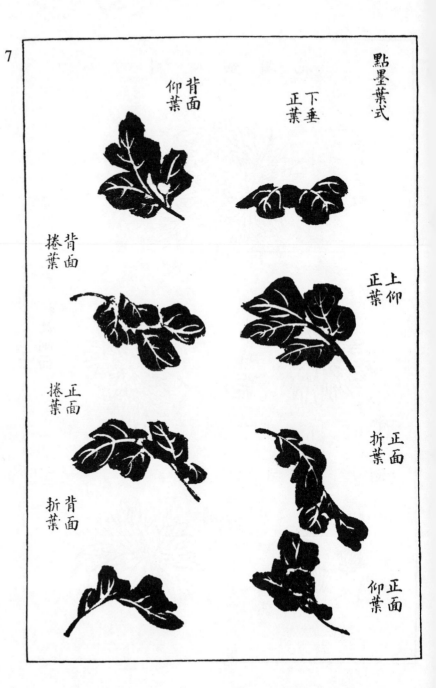

8

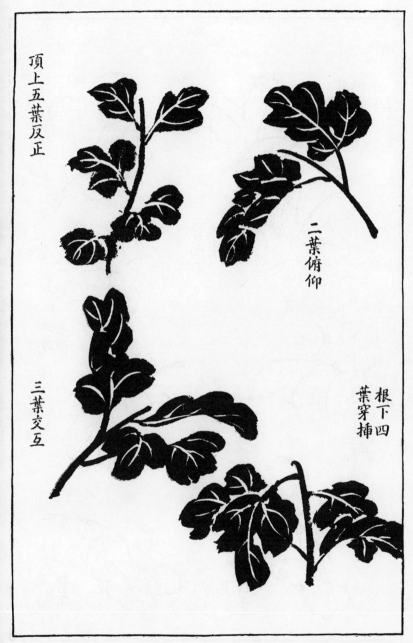

頂上五葉反正

二葉俯仰

三葉交互

根下四葉穿插

Face and back of five leaves near the top of a plant.

Two leaves, one bending and one facing upward.

Group of three leaves.

Four intersecting leaves near the base of a plant.

Examples of leaves in outline (*kou lê*)

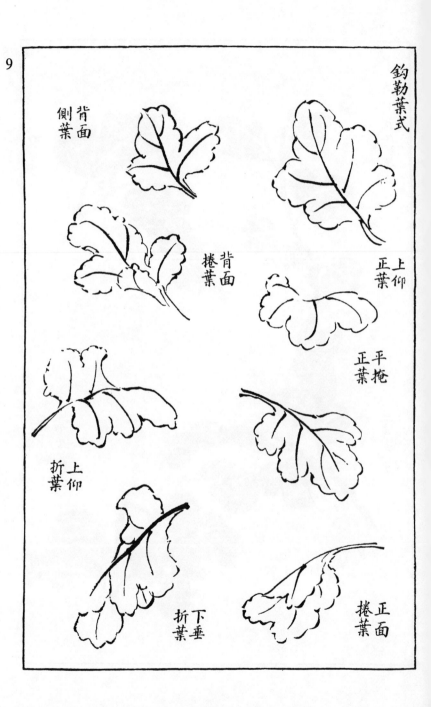

Back of a leaf, pointing to one side.

Face of a leaf, pointing upward.

Back of a curled leaf.

Face of a half-concealed leaf.

Folded leaf, facing upward.

(Face of a hanging leaf.) [1]

Folded leaf, hanging down.

Face of a curled leaf.

1. As in original edition, for third leaf from top on right.

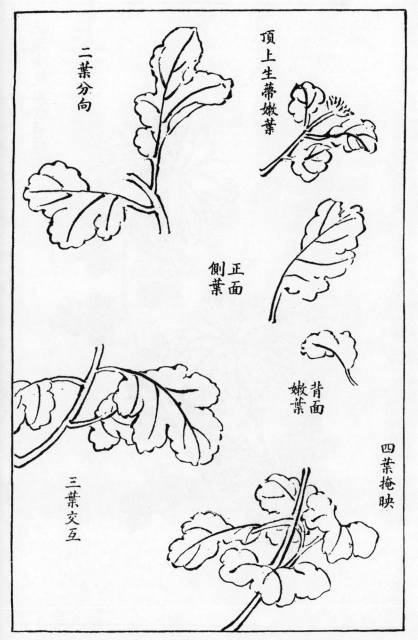

二葉分向

頂上生蔕嫩葉

正面側葉

背面嫩葉

三葉交互

四葉掩映

Two leaves on either side of a stem.

Peduncle and young leaves at the top of a stem.

Face of a leaf pointing to one side.

Back of a young leaf.

Group of three leaves.

Four leaves shielding each other.

CHRYSANTHEMUM

Examples of flowers growing on stems
with leaves on which the veins are indicated

11

Two stems with flowers in full bloom.

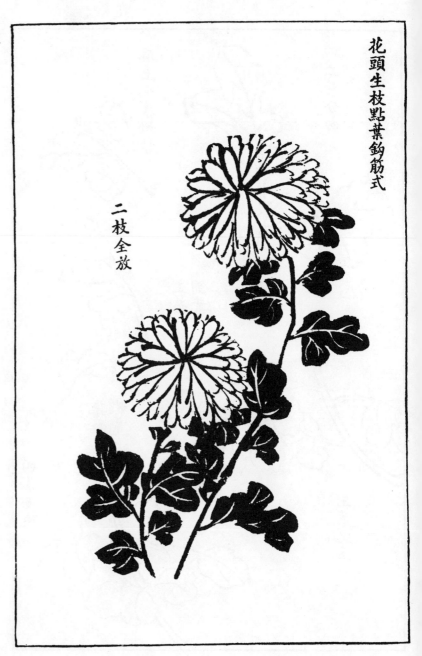

花頭生枝點葉鈎筋式

二枝全放

12

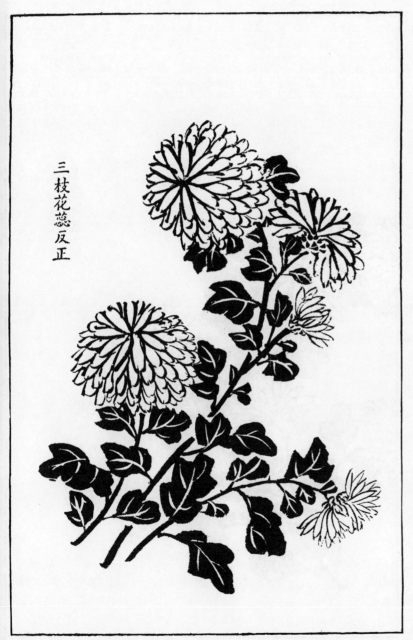

三枝花蕊反正

Three stems of flowers and buds, front view and turned.

13

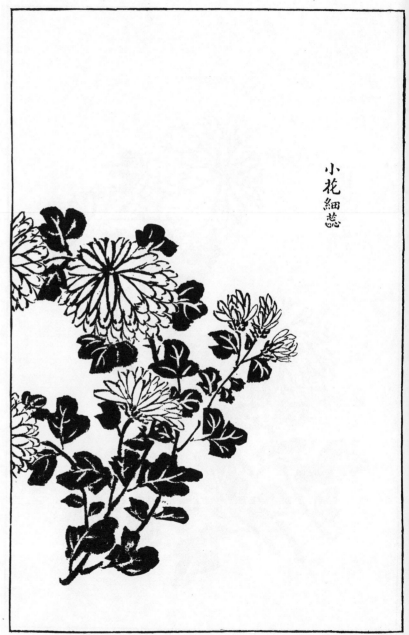

Small flowers with delicate buds.

14

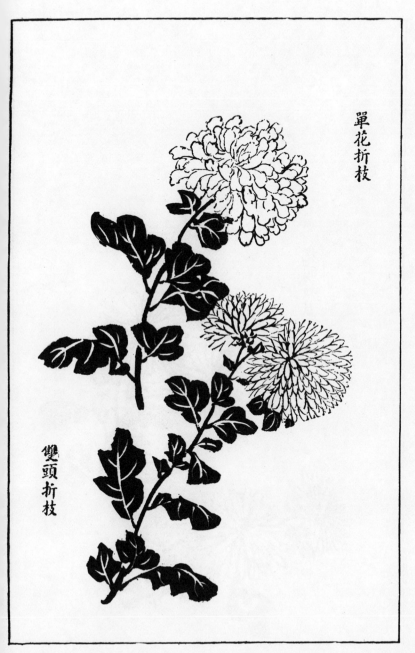

單花折枝

A single flower on a cut stem.

A pair of flowers on a cut stem.

雙頭折枝

15

Flowers on short stems.

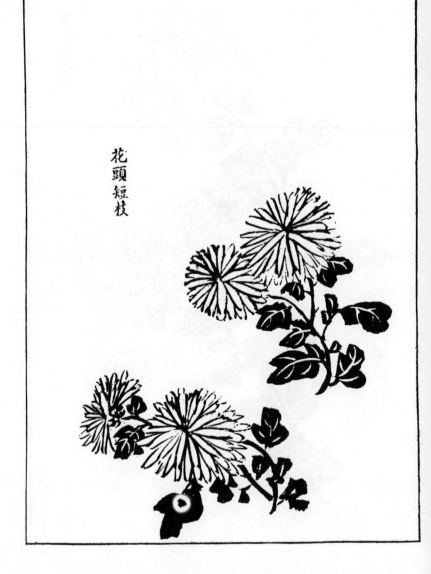

花頭短枝

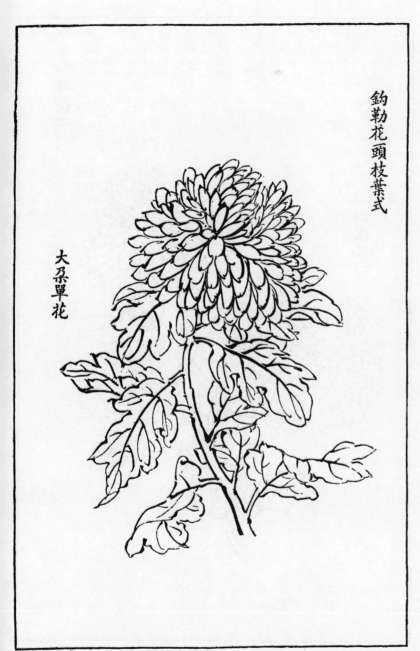

鈎勒花頭枝葉式

大朶單花

16 Examples of flowers, stems, and leaves in outline

A large single flower.

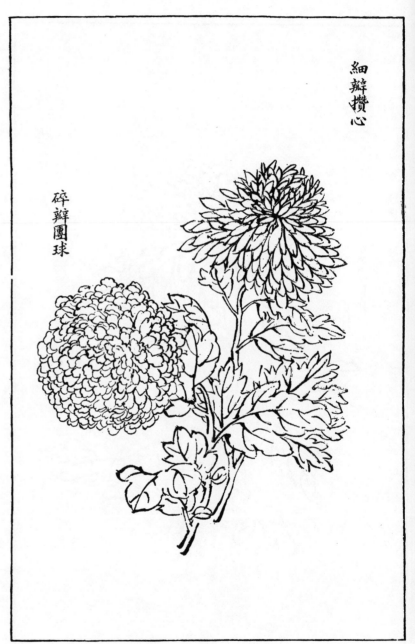

17

細
瓣
攢
心

碎
瓣
團
球

Delicate petals clustered around the heart of the flower.

Flower with short petals and a rounded form.

18

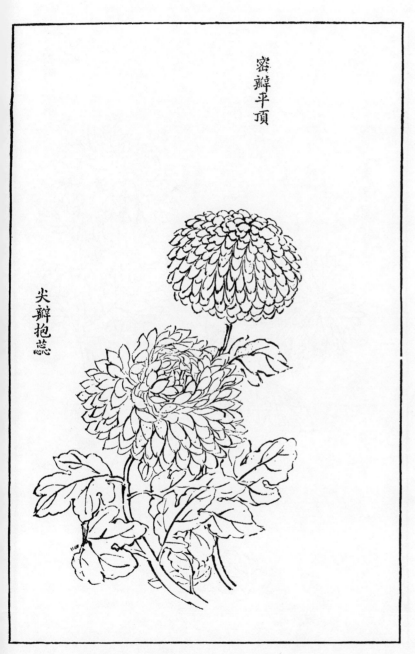

密瓣平頂

尖瓣抱蕊

Petals forming a compact and flat head.

Pointed petals enfolding pistil and stamens.

Head with pointed petals.

Head with long petals.

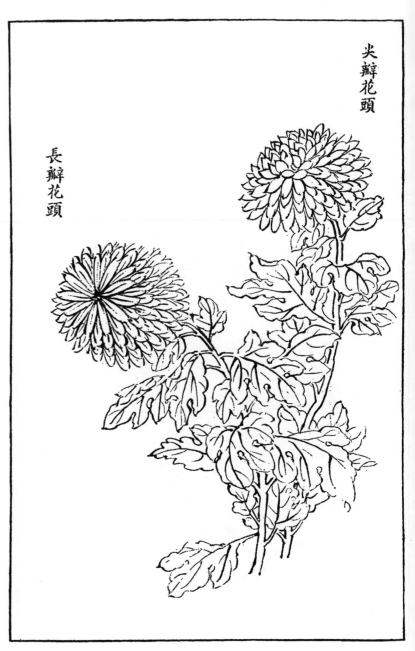

19

尖瓣花頭

長瓣花頭

20

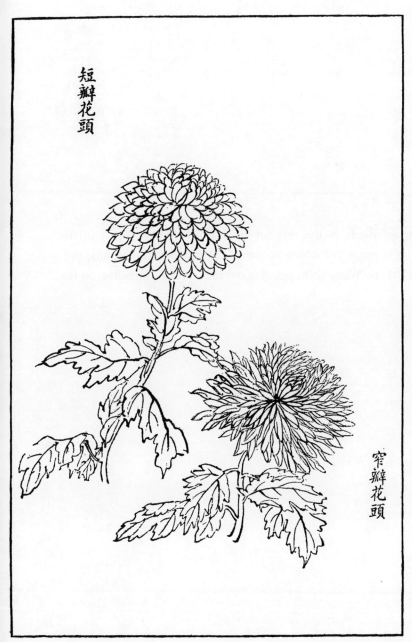

Head with rounded petals.

Head with narrow petals.

[A section of additional examples followed: in the original edition, 20 double pages; in the Shanghai edition, 72 additional single pages (of which 26 are of chrysanthemums alone), preceded by a brief comment, dated 1701, by Wang Shih, pointing out the scarcity of treatises on the chrysanthemum.]

PART III

Book of Grasses, Insects, and Flowering Plants

[A Book of Additional Examples]

Book of Feathers-and-Fur and Flowering Plants

[A Book of Additional Examples, also containing:]

Concluding Notes on the Preparation of Colors

[The 1701 edition contained, prefacing Part III, a testimonial by Wang Tse-hung, a friend of the Wang brothers.]

Book of Grasses, Insects,
and Flowering Plants

[In the 1701 edition, a preface was supplied by Wang Shih. It stresses the distinction between grasses or herbaceous plants (annuals) and plants with wood stems (perennials), and notes how the flowers of the former preceded those of the latter, and insects preceded birds.]

Ch'ing Tsai T'ang Discussion of the Fundamentals of Painting Flowering Plants, Grasses, and Insects [1]

General background of painting grasses and flowering plants [2]

ALL the plants in the world rival one another in their beauty and give pleasure to the hearts and eyes of men. They offer great variety. Generally speaking, the wood-stemmed plants may be described as having a noble elegance, the grasses a soft grace.

Grasses please heart and eye mightily. They are a subject of this book; in the illustrated examples, grasses and their flowers are dealt with first. Among them are the many varieties of the orchid and the chrysanthemum, with their subtle fragrance, which have already been discussed in separate books. Besides these, there are numerous other spring and autumn plants, including the magical blades of the *ling miao* [3] and the water grasses that grow on banks of rivers and streams. They are illustrated and discussed in these pages, together with insects that fly and hop.

Looking through the records of painting, one may see that each period had its masters. However, it was not until after the T'ang and Sung periods that noted painters of flowers differentiated between grasses and wood-stemmed plants. Those who were expert in painting flowers

1. The title-page order is "Grasses, Insects, and Flowering Plants"; the text heading, here, places "Flowering Plants" (which could also be "Flowers and Plants") first, apparently since that is the order in which they are discussed. This classification is, however, usually called *Grasses and Insects*. See Vol. 1, Pl. X, *Early Autumn*.

2. The distinction between grasses and wood-stemmed plants, briefly noted in this section, was a late development, probably of the Ming period.

3. The "divine sprout," either the *ling chih* (sacred fungus) or the *chih* (*Achillea sibirica*), stalks of which were used in divining.

and plants were also, on the whole, skilled in painting birds. How can one pick them out from the vast history of painting? Some details are set forth in the next book, on ligneous plants and birds. Here we are merely summarizing.

The great painters (of this category of subject matter) were Yü Hsi, Liang Kuang, Kuo Kan-hui, T'êng Ch'ang-yu, Shêng Yü, and Huang Ch'üan and his son (Huang Chü-ts'ai). Then we come to Hsü Hsi, Chao Ch'ang, I Yüan-chi, Wu Yüan-yü, and their followers. Each had his master and model. In the Yüan period, there were Ch'ien Shun-chu, Wang Yüan, and Ch'ên Chung-jên. In the Ming period, there were Lin Liang, Lü Chi, and Pien Wên-chin. Each was famous in his time. If one wishes to follow in their footsteps, the focus of attention should be on Hsü Hsi and Huang Ch'üan,[4] who were outstanding. Their styles were different, and a section is added here on the essential difference.

Discussion of the essential difference between Huang and Hsü

Huang Ch'üan's and Hsü Hsi's wonderful works offer a great deal to students of painting. Their styles have been handed down from generation to generation, just as, in calligraphy, the styles of Chung (Yu) and Wang (Hsi-chih) and, in literature, those of Han (Yü) and Liu (Tsung-yüan). Their fame has come down from ancient times. Each had his individual style.

Kuo Ssǔ wrote about the difference between Huang and Hsü. Huang Ch'üan's works were rich and elegant, Hsü Hsi's natural and unconventional. Both expressed their thoughts, what their ears and eyes observed, and what hand and heart had learned. But how can one really comprehend what was completely natural to each of them?

Huang Ch'üan and his son, Chü-ts'ai, were officials. At first (the elder Huang) was a *Tai Chao* (Painter in Attendance); later, he was promoted to *Fu Shih* (Assistant Commissioner); and finally, toward the end of his life, under the Sung dynasty, Ch'üan was elevated to the rank of *Kung Tsan* (Palace Aide). His son, Chü-ts'ai, also was a Painter in Attendance. Both served at the court. Consequently they painted what they saw in the Imperial Gardens, the rare flowers and strangely shaped rocks. Hsü Hsi was a scholar who lived in seclusion in Chiang-nan. His aims were lofty. Free, intelligent, and unrestrained, he usually took his subjects from river and lake, ex-

4. Both of the x century.

celling in painting flowers on a bank and wild flowers and grasses. The two painters were like the spring orchid and the autumn chrysanthemum. Each dared to be himself and both were renowned. The brush of each produced rare works of perfection; their brushwork may be taken as models. Though their styles were extraordinary and different, both were masters. Following (Huang) Ch'üan were his sons, Chü-ts'ai and Chü-pao. Following (Hsü) Hsi were his grandsons, Ch'ung-ssŭ and Ch'ung-chü. They carried on their family styles and gained places in the front ranks of painters past and present, not an easy achievement.

Four methods of painting flowering plants

In painting flowering plants, there are four methods. The first is outlining (*kou lê*) and filling in with color,[5] a method carried to perfection by Hsü Hsi. The majority of flower painters used to draw forms after placing them with touches of color, but Hsü Hsi was exceptional in that he first drew (wrote) in ink the stem, leaves, stamens, and calyx, then added color. His handling of form (*ku,* bone structure) and creation of atmosphere exemplified genius. In the second method, a style attributed to T'êng Ch'ang-yu (of the IX century), no outline is drawn, and color defines form. The idea (*i*) is transmitted through the laying out in color and, moreover, represents a living idea (*shêng i*). T'êng added cicadas and butterflies as adornment. After him, there was Hsü Ch'ung-ssŭ, who also did not draw an outline but painted directly in color. This method is called *mo ku hua* (no-bones painting). Liu Ch'ang used color lightly, in one stroke and in both dark and light tones.[6] In the third method, no color is used at all, the brush with ink being used to dot and to make washes. This method is attributed to Yin Chung-yung (of the T'ang period); he caught the true character and inner power (*tê*) of flowering plants. A slight variation of this method is dotting with ink and conveying an impression of the Five Colors. Later, Chung Yin successfully used only ink, making distinctions between what was in front and what was in back.[7] (In the Sung period) Ch'iu Ch'ing-yü painted grasses and insects in ink, indicating dark and light tones; he succeeded in transmitting a wonderfully true representation. In the fourth method, ink is used not as a

5. Style of landscape painting of Li Ssŭ-hsün (VIII century) and the Northern school. According to tradition, in the X century, Hsü Hsi established it as a method in flower painting, an innovation, since the general method was to place the flower with a blob of color and then with ink draw the details.

6. Method of ink painting applied to color.

7. Drawing and placing, handling of ink tones, and the rendering of the idea of the *Yin* and *Yang.*

wash but only in outlining, without color or shading, in the manner called *pai miao*. This method is attributed to Ch'ên Ch'ang (of the Sung period); he drew the stems and stalks of flowers in the *fei pai* (flying white) style.[8] The Buddhist monk Hsi Po and Chao Mêng-chien both used the *shuang kou* (double contour or outline) and *pai miao* methods.

General explanation of the composition and establishing the *shih*[9] of flowering plants

In painting flowering plants, the main thing is to establish their form and structural integration (*shih*). Although the stems and stalks may be entwined and twisted, from top to base their *ch'i* flows uninterrupted through the whole form. As to the *shih* of the flowers, although they may be numerous and mixed, facing in various directions and scattered, each is naturally expressive of the joy of flowers. Their essence or their law of being (*li*) is constant. As to the *shih* of the leaves, although they may be scattered, or dense, intertwined, and seemingly in disorder, they are never too few or too numerous, or actually in disorder, for all have their *li*.

In applying color, it should be handled according to appearance and form. Color washes (*hsüan jan*) should reveal the Vital Principle (*shên Ch'i,* the Divine *Ch'i* or Spirit) that governs their essence (*li*) and structural integration (*shih*).

Further details may be added, such as bees, wasps, butterflies, and other insects hovering around to gather the fragrance of the flowers. They climb along stems and alight on leaves. Accomplishing this effect depends on how true the form is rendered according to the structural integration of the plant. Whether the insects are half-hidden or exposed to view, each should be drawn according to its nature. They should never be superfluous ornaments. Thus may complete structural integration be achieved.

Among the leaves, distinction should be made between those rendered in dark tones and those in light; they should seem to screen and protect the flowers from the glare. The flowers should be placed in various positions and should be joined naturally to their stems. The (lesser)

8. Dry brush in a sweeping stroke, so that some of the paper or silk shows in the brushstroke.

9. For *shih,* see Appendix; also above, p. 366 n. In traditional Chinese thought, *shih* (to maintain strength) was used, for instance, by the Legalists in a political and social sense: a ruler through his *shih* (power) controlled and ordered the people and the kingdom, hence the structural integration of the state. The Taoists used *shih* as the "all-pervading power" of the *Tao,* and it is mainly in this sense that it is used in the Manual, which contains many Taoist ideas and terms applied to painting. *Shih* stands for both a technical integration and an underlying harmony of thought and ideas, dependent on observation, skill, and the cultural and moral development of the painter.

stems are straight or inclined, and, to be natural, should be properly joined to the main stem.

If, in the composition of a picture, the conception (*i*) is not reached through thought (*ssŭ*), the whole effect will be blocked, like an old Buddhist priest trying to patch a garment with a hand trembling with age. How can one possibly express the divine and the wonderful in this way? That is why the *shih* is a prized element in a painting. It pertains to the spirit (*ch'i*) that should pervade the whole picture. Examination of details should yield further evidence of the divine (*shên*) and the soul or essence (*li*) of things. In this way, an expert hand reveals itself. There are, however, many ways to obtain the *shih* in a painting, and all are elusive. One must seek them among the methods of the ancients; and if they can not be found there, they must be sought in the natural (*chên,* true) forms (*hsing*) of the plants. In seeking the true forms of plants, they should be observed under various circumstances, in wind, in dew, in rain, and in the sun. The variety of aspects will become clear according to the degree of attentive observation.

Method of painting stems

Generally, in the painting of flowering plants, whether the style is in fine, delicate brushstrokes or the free-sketch (*hsieh i*) manner, the moment at which the brush is poised to begin is like that in a game of chess, when a whole plan of action (*shih*) should be in one's mind before the first move. The life movement engendered by the spirit (*ch'i*) should animate the whole picture. Only in this way will it avoid being stiff and lifeless. In establishing the structure (*shih*) of plants, it is necessary first to distinguish between plants with wood stems and those classed with the grasses. Ligneous plants are like old men, while grasses are delicate and graceful. However, in painting grasses and rendering their tender grace, their *shih* should be established through the three positions of pointing upward, hanging down, and leaning horizontally; in each of these three positions (*shih*) there are additional forms of branches forked, crossing, shooting out, bent, and broken off. Among the stems branching off are some high and some low, some in front and some in back; any form like *i* should be avoided. In the crossing of stems it should be clearly indicated which are in front and which in back, which are thick and which delicate; any form resembling *shih* should be avoided. When stems incline to one side, it should be clearly indicated which point up and which point down, which extend horizontally and which vertically; one will then avoid coiled

之 forms like *chih*. There are three more things to avoid: when stems point upward, there should be a reason, and care should be taken not to make them appear stiff in their straightness; when stems bend, they should have life movement (*shêng tung*) and not appear to be exhausted; when stems are extended horizontally, they should cross each other but not seem to prop each other up. This, then, is the way to paint the stems. Flower and stems resemble a man with four limbs and a head: even though the countenance is beautiful, if the four limbs are weak or incomplete, how can the man be whole? [10]

Method of painting flowers

Whatever the species, large or small, it is necessary to indicate whether flowers are in full bloom, half open, placed high or low, facing front or back. Even when massed together, flowers are not identical. They should not be upright without that graceful air lent by their suppleness. They should not bend without the pleasing effect that perfect balance gives. They should not be side by side without the charm in their variety that arises from their being together. They should not be joined without the design that is the result of their being placed strategically as part of the composition. They should be facing upward or inclined naturally; and, as they turn toward each other, some intimation of feeling should be conveyed in their gaze. While there is variation in their positions and poses, there is clearly also a harmony.

Besides color, light and dark tones should be apparent, not only in a group of flowers but in one flower and even in one petal. Color and tones should be deep at the heart and light at the edges. Thus it should be when the flower is rendered according to its mode of being.[11] In a flower not yet open, the petals at the center are of deeper tones of color; when the flower is fully opened, they are light. When some of the flowers on a stem are past full bloom, their color is faded, while the color of others in full bloom on the same plant is fresh, and those not yet opened are of a dark tint. Flowers should not all be in the same tones of one color; there should be variation presented by a judicious use of light tones; accentuation of dark tones by lighter ones will give results beautiful to the eye.

10. The integration of the composition of the plant is strengthened by applying the analogy of integration of character and personality in man and, by implication, the Wholeness and unifying power of the One (Heaven, Spirit, *Tao*) on Earth and among all things here (Four).

11. *Fa,* as "mode of being," in its use as law (*dharma*).

The yellow used for flowers should be light and clear. For white flowers, use the prepared white and touch up the outline with a light green. If white is not used for outlining, use a light green, and the whiteness of the flower will stand out. Thus, white can be used variously, in layers, in outline, in touching up. If the painting is on paper, there is a method of dotting in white on a color wash, or color may be mixed with a little white directly on the paper. All these methods may be used, but each should be used appropriately. Painting in color without outlining is the method called *mo ku hua* (no-bones painting). There is also the method of painting only in ink, in which color is suggested by various tones of ink without the use of actual color; this method is rich in possibilities. The literati of former times delighted in this method, and in many instances excelled in it. The success of this method rests entirely in the divine quality (*shên*) of the brush.

Method of painting leaves

When one has learned to establish the structural integration (*shih*) of the main stem and stalks of a plant and the drawing of the flowers on the stems, one should then proceed to add the leaves. How can one be indifferent or careless about the *shih* of the leaves? The naturalness of the flower on its stem depends on its *shih,* and the whole movement and pattern of that *shih* depends on the *shih* of the leaves. The elegant tones of red framed by the various greens are like a lady and her entourage; when she wishes to move, her attendants are the first to rise.

It is by the manner in which leaves are drawn and painted that flowers can be shown in various conditions and moods. Flowers are like swallows, graceful and light, and appear as though they were about to fly. According to the way leaves are drawn and painted, the plant will be shown either dew-laden or bending in the wind. This is done by rendering the various positions of leaves: *fan yeh* (turned-over leaf), *chê yeh* (folded leaf), and *yen yeh* (half-concealed leaf). When all the leaves are facing upward and one of them is turned over, that is *fan yeh*. When all the leaves are flat and one is folded, with part of its back showing, that is *chê yeh*. When most of the leaves can be seen whole and one is half concealed by the others, that is *yen yeh*. There are many types of leaves, large, small, long, short, dentated. In painting the leaves of plants with many small and delicate leaves, such as climbing plants (*t'êng*) and grasses, the use of *fan yeh* lends variety. For plants with long leaves, such as the *lan* (orchid, iris, etc.) and the day lily, *chê*

yeh may be used. For plants whose leaves are dentated, such as the peony and the chrysanthemum, *yen yeh* is effective.

If ink is the medium, the face of leaves should be dark, their backs light. If color is used, the face should be a dark green and the backs a light green. For the back of the leaf of the lotus or water lily, a green mixed with white should be used. Only the leaf of the begonia is red on its back. What has been said about the *shih* of leaves in wind or dew-laden may be applied generally to all herbaceous plants whose flowers blossom in the spring and fade in the autumn.

Method of painting the peduncle

The stems of both ligneous and herbaceous plants have peduncles that support the buds, the buds being wrapped by the calyx. The peduncles may not be identical, but each supports and envelops a bud containing all the petals.

In plants with large flowers, such as the peony and the hibiscus, the peduncle holds the bud within it. The hibiscus bud is green, the receptacle part a gray-green. The peony bud is green inside and red outside. In general, when flowers are seen full face, their centers are visible and the peduncle is hidden. When the back is seen, the flowers will show the peduncle and not the center. With the side view, they show half the peduncle and half the center. The receptacle of the begonia is joined directly to the stem without a peduncle. In the magnolia and the day lily the petals are joined at the base in the peduncle.

When there are many petals, there also are many sepals; when there are five petals, there are five sepals. Some flowers have a receptacle and no peduncle, and others have a peduncle but no receptacle. And there are flowers that have both. Here we are speaking generally of the base called the peduncle; various kinds are illustrated later in the examples. The true (*chên*) flower must be perceived to be able to render its natural color and form.

Method of painting the heart

The flowers of herbaceous plants have a peduncle, and in this they are different from the ligneous plants. In the peony and the hibiscus, the heart is deep at the base of the petals. In the lotus and

water lily, the heart is pale with yellow stamens. The magnolia, the red lily, the day lily, and the tuberose have six petals and also six stamens tipped with anthers; from the base of the flower rises the pistil, which has no anther. Among the many kinds of chrysanthemum are some with centers visible, others with centers hidden; their shapes, color, and tones and the number of blossoms on a stem vary a great deal. The begonia has a large and rounded center. The receptacle of the orchid is light red; that of the marsh orchid is pale green. The heart of the marsh orchid is white sprinkled with red. It is important to place and paint correctly the heart of a flower among its delicate petals. The hearts and countenances of flowers are unlike those of human beings.

Summary of rules of painting flowering plants phrased for memorizing [12]

Rules of painting flowers are as follows: Each has its particular form; above are flowers and leaves, below the stem and stalks; all should be appropriate. The *shih* should be clearly understood. Flowers should carry themselves lightly. They are of various colors. They should be drawn with liveliness, accurate color, in appropriate circumstances, placed properly, and with buds added. Leaves, at intervals on the stems, have great variety; they join perpendicularly and horizontally, sometimes thickly but not seemingly in disorder, sometimes sparsely but not seemingly fragmentary. To render the form of the plant and its true divine nature, one should carefully examine and study it. The transmitting of its very essence depends on the hand and supreme brushwork. Really, it is impossible to put this into words, for the secret originates in the heart and from there must rise.

General background of painting insects among herbaceous plants

Poets of ancient times alluded to birds, animals, grasses, and plants, and also insects, down to the smallest and most humble; moreover, they made them symbolize ideas. When insects are noticed by poets, how can they be neglected in painting? In examining works of the T'ang and Sung periods, it may be seen that many painters excelled in flower painting and also in paintings of birds,

12. As in Part II of the Manual, the sections summarizing rules in these last two books are phrased for memorizing in four and five characters, and can not be translated as concisely as in the original.

animals, and insects. The origin of this category of painting is difficult to place, but there were many expert painters in this line. In the State of Ch'ên there were Kuo Yüan-fang, Li Yen-chih, and the Buddhist monk Chü-ning, who were known for their works in this class. There also were Ch'iu Ch'ing-yü, Hsü Hsi, Chao Ch'ang, Kuo Shou-ch'ang, Han Yu, Ni T'ao, K'ung Ch'ü-fei, Ts'êng Ta-ch'ên, Chao Wên-shu, the Buddhist monk Chüeh Hsin, and Li Han-ch'ing, of the Chin period. In the Ming period, there were Sun Lung, Wang Kan, Lu Yüan-hou, Han Fang, and Chu Hsien. All were masters of flower and insect painting.

Besides earth-insect paintings, there were paintings of bees, wasps, and butterflies. Each period had painters who specialized in these subjects. During the T'ang period, T'êng Wang-ying excelled in painting butterflies. T'êng Ch'ang-yu, Hsü Ch'ung-ssŭ, Ch'iu Yu-liang, and Hsieh Pang-hsien were expert in painting bees, wasps, and butterflies. Liu Yung-nien specialized in painting insects and fish. Yüan-I, Chao K'ê-hsiung, Chao Shu-no, and Yang Hui were great painters of fish; their fish seemed to swim, to rise to the surface, to gape and draw breath. Painted among duckweed and water grasses, they were as enjoyable to look upon as paintings of insects, bees, and butterflies accenting spring and autumn flowers. Consequently, more will be added later on this subject.

Methods of painting insects among herbaceous plants

When painting insects that live among herbaceous plants, attention should be given to rendering their appearance when flying, fluttering, chirping, or hopping. Flying, the wings of an insect are unfurled; returning to rest, folded again. Those that chirp vibrate parts of their forewings against their haunches, making the sharp sounds that are their song. Those that hop straighten their bodies, poised, as it were, on tiptoe, giving an impression of lively skipping. Bees, wasps, and butterflies have a pair of large wings and a pair of small. Insects that live among grasses have six pairs of long and short legs.

Butterflies are of many sizes and colors, the most common being the black, white, and yellow ones. Their forms and colors are actually so varied that it would be impossible to enumerate them all. The ones marked with black have large wings and trailing tails like queues. Butterflies painted among spring flowers have pliant wings; the lower part of the body is enlarged because they are about to lay their eggs. Those painted among autumn flowers have strong wings and

lean bodies, lengthened at the tail because they are growing old. They have eyes, mouths, and antennae. When they fly, (a tube-like part of) their mouths is coiled; alighting, (this part of) the mouth extends to penetrate the flower and draw its nectar.[13]

Insects around herbaceous plants are of various sizes, large and small, long and short; their colors change with the seasons. When the plants are in full leaf, their color is completely green, and when they begin to shed their leaves, their green gradually turns to yellow. While insects are ornamental touches to paintings of plants, they should nevertheless be added according to seasons and under the proper conditions.

Rules of painting insects among herbaceous plants phrased for memorizing

Methods of painting insects are different from those of painting birds and animals, for in painting insects the method used is *tien jan* (dot and tint), and for birds and animals, *kou lê* (outlining). In his time, T'êng Chang-yu was supreme in knowledge of these methods; he painted flowers in color and cicadas and butterflies in ink; Ch'iu Ch'ing-yü also painted flowers in color and insects in ink; in using the *tien jan* method, both achieved variation of tones, and in rendering form they succeeded in transmitting the true forms. The ancients had their models among the masters who painted insects. There were Chao Ch'ang and Kuo Shou-ch'ang, whose flying and hopping insects had real *shih*. Forms are obtained by the finest strokes, and the divine quality (*shên*) must be perceived before the first stroke of the brush. How, otherwise, did T'êng Wang-ying become famous for his paintings of butterflies?

Rules of painting butterflies phrased for memorizing

In painting most things (*wu*), the head is the first part drawn. But in painting butterflies the wings are done first, for they are the most important part of the butterfly. It is there the *shên* (divine quality) is to be found.

When flying, only half the body is visible. At rest, the whole body may be seen.

On the head of the butterfly are two antennae; in between them is the mouth. When it is

13. "The mouth parts of moths and butterflies are especially adapted for sucking nectar from flowers. If the head of a butterfly be examined, there will be found a long sucking tube, which when not in use is coiled on the lower side of the head between two forward-projecting appendages." (Comstock, *A Manual of the Study of Insects*, p. 192.)

drawing nectar, (the tube-like part of) its mouth is extended; when it is flying, its head is drawn in. Flying in the morning, its wings are straight up, opposite each other; resting at night, its wings are folded. It flutters among the flowers, and where there are flowers there also should be butterflies adding their decorativeness to the colors of the flowers, like a beautiful lady accompanied by her two maids.

Rules of painting the praying mantis phrased for memorizing

Although the praying mantis is a small creature, it should nevertheless be drawn and painted with its own kind of majesty. Painted at the moment it is about to seize its prey, it should have its own aspect, which is similar to that of a tiger. The look (*shih*) of its two eyes shows it will devour the object. Its nature is greedy and gluttonous. Such a ferocious insect may be included in paintings, much as war songs may be played on instruments of peace, like the lute and zither.

Rules of painting various kinds of insects phrased for memorizing

In ancient times, some painted the tiger and snow goose, making them look like dogs and ducks. Nowadays, in examining paintings of birds and insects, forms and concepts (*i*) seem happily blended and complete. The *shih* of those creatures that walk reveals movement, of those that fly shows they are soaring, of those that fight suggests they are attacking. Those that chirp seem to be vibrating their bodies, those that hop and jump are stretching their haunches, and those that are merely looking seem to observe everything. As (the Sung poet) Mei (Yao-ch'ên) Shêng-yu wrote in an inscription on a painting of insects by Chü-ning: "Here one perceives that to create the wonderful and mysterious forms of nature one may not alter the smallest detail contrary to nature's pattern."

Rules of painting fish phrased for memorizing

Fish must be painted swimming and darting with vitality. They should appear startled by a shadow, or they should be floating idly, opening and closing their mouths. As they float on the

surface, dive, or glide among the water grass, the clear waters envelope them or ripple off them. Deep in one's heart, one envies them their pleasure. As with human beings, they should have an *i* (idea, meaning). If one fails to render this aspect of their divine quality (*shên*) and merely copies their appearance, even painted in a stream or mountain torrent, the fish will look as dead as on a platter.

Examples of first steps in painting
flowers of herbaceous plants [1]

Flowers with four and five petals

Poppy (*Yü mei jên hua,* beautiful-people-of-Yü
flower).[2]

Garden balsam (*chin fêng hua,* golden-phoenix
flower).[3]

Begonia (*ch'iu hai t'ang,* autumn *hai t'ang*).[4]

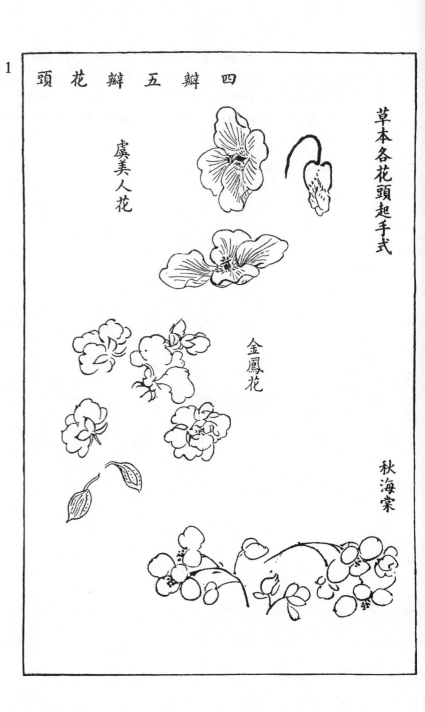

1. The examples of flowers in the original edition and
those in later editions vary in a few instances, and one or
two are shown in different positions. The majority of ex-
amples are, however, the same.
2. *Papaver rhoeas.*
3. *Impatiens balsamina.*
4. *Begonia evansiana.*

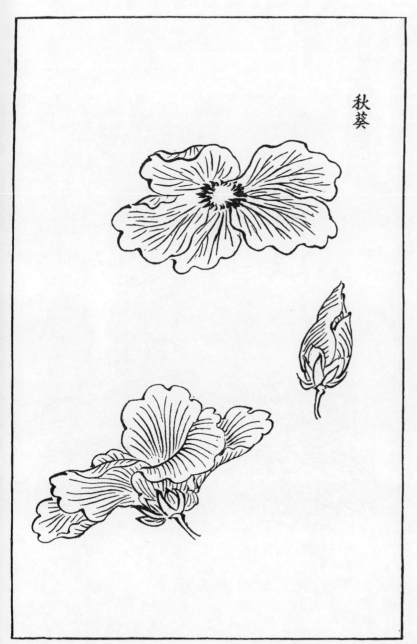

秋葵

2

Mallow (*ch'iu k'uei,* autumn hibiscus). [1]

1. *Hibiscus abelmoschus.*

481

3

(More examples of the mallow.)

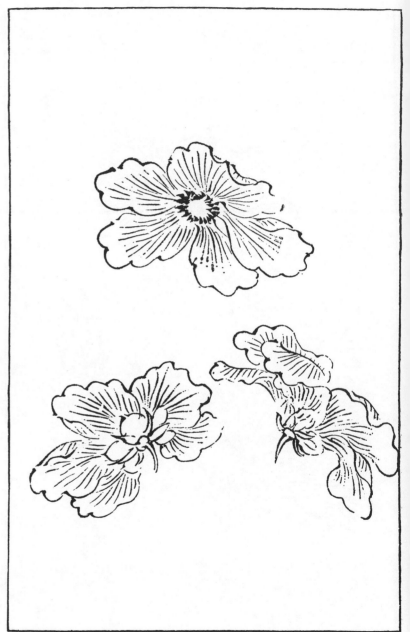

4

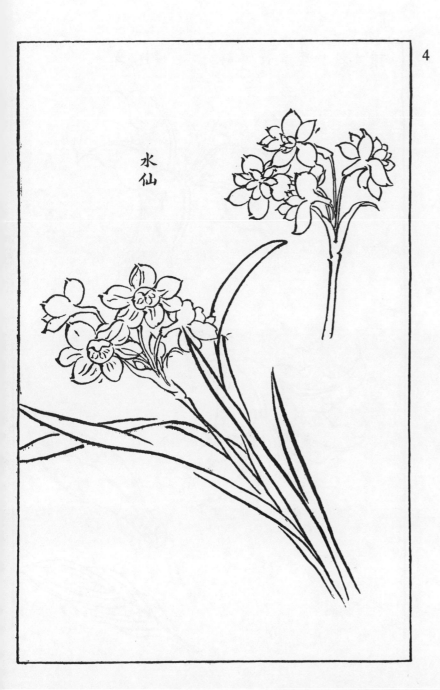

水仙

Narcissus (*shui hsien,* immortals of the water).

Flowers with long peduncles and five
and six petals

White lily (*pai ho,* all white).

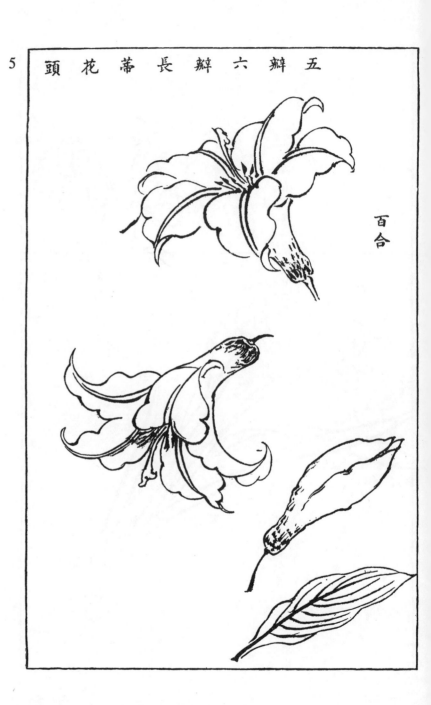

5

百
合

484

6

玉簪

Tuberose (*yü tsan*, jade hairpin).[1]

山丹

Red or Japanese lily (*shan tan*, mountain red).[2]

1. *Polianthus tuberosa.*
2. *Lilium tenuifolium.*

Day lily (*hsüan hua,* flower of maternity).[1]

Pink (*chien lo,* snipped gauze).[2]

1. *Hemerocallis graminea.* Sometimes also called *i nan hsüan* (must-have-a-son lily).
2. *Dianthus barbatus.* The literal translation of the Chinese name *chien lo,* "snipped gauze" or "thin silk," quite fortuitously offers a description of the tailor's term "pinking," cutting the edge of a piece of cloth in an indented pattern.

頭花大辦多亞缺

芍藥

8 Large flowers with many and dentate petals

Peony (*shao yao*, herbal spoon flower).[1]

1. *Paeonia albiflora*, the roots of which are used medicinally.

9

Hollyhock (*Shu k'uei*, mallow of Shu).[1]

1. *Althaea rosea*. Example of peony at top belongs with preceding page.

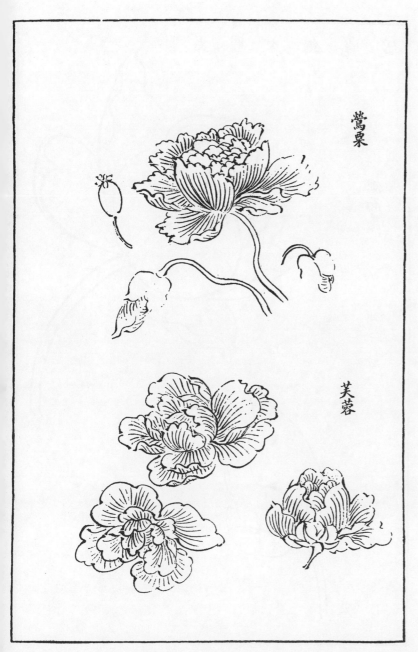

10

鶯粟

Poppy (*ying su*, seed for the oriole).[1]

芙蓉

Hibiscus (*fu yung*, fairyland flower).[2]

1. *Oriolus chinensis.*
2. *Hibiscus mutabilis.*

Lotus or water lily with large round petals and pointed tips

11 花蓮瓣大圓尖

側面菡

Side view of a lotus bud opening.

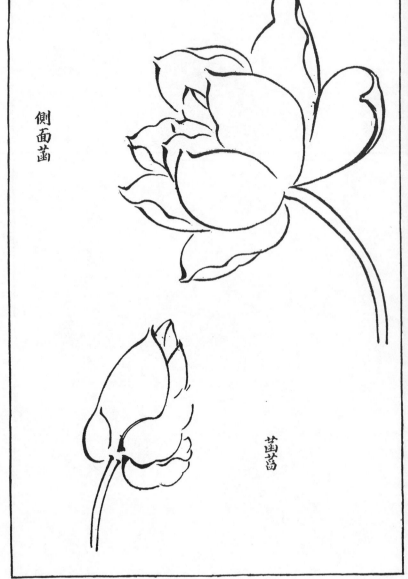

A lotus bud.

菡萏

490

12

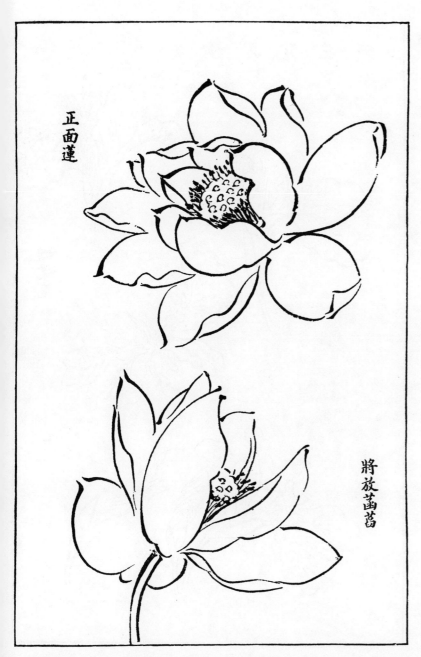

正面蓮

Full face of a lotus.

將放菡萏

Lotus bud almost fully opened.

Forms of various kinds of flowers

13

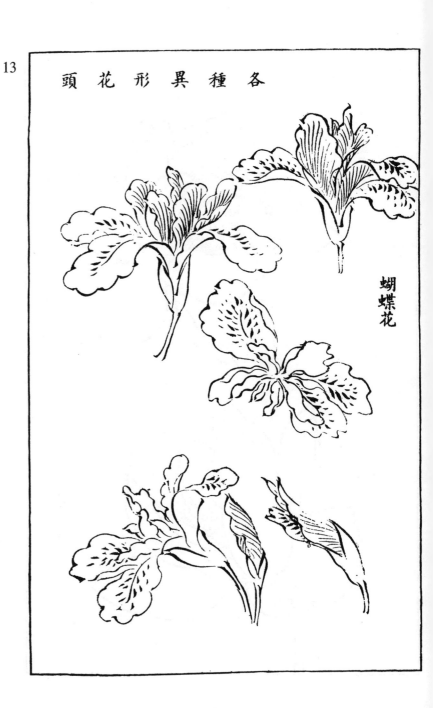

Iris (*hu tieh hua*, butterfly flower).

14

Hydrangea (*hsiu ch'iu hua*, embroidered-ball flower), of the ligneous class.

Convolvulus (*ch'ien niu hua*, leading-an-ox flower).[1]

Sweet william (*lo yang hua*, white Loyang peony).[2]

1. *Ipomoea hederacea.*
2. A species of the *Dianthus.*

Wisteria (*tzŭ t'êng hua*, purple climber), of the ligneous class.

Monkshood (*sêng hsieh chü*, Buddhist-slipper aster).[1]

Marigold (*chin chan hua*, golden-cup flower).

Bleeding heart (*yü êrh mou tan*, fish's-son variety of the *mou tan*).[2]

Red azalea (*tu chüan hua*, little-cuckoo flower).[3]

1. *Aconitum fischeri.*
2. *Mou tan*, name commonly used for the peony and camellia, but the example suggests that here is meant the bleeding heart (*Dicentra spectabilis*), the form of which in Chinese eyes resembles a fish with a smaller fish issuing from its mouth.
3. *Rhododendron indicum.*

草本各花葉起手式

各種尖葉

山丹

百合

16 Examples of first steps in painting
leaves of herbaceous plants

Examples of tapering leaves

Red lily (*shan tan*).

White lily (*pai ho*).

17

雞冠

金鳳

Coxcomb lily (*chi kuan*).[1]

Garden balsam (*chin fêng*).

1. *Celosia cristata.*

各種團葉

秋海棠

蜀葵

玉簪花

18 Examples of round leaves in groups

Begonia (*ch'iu hai t'ang*).

Hollyhock (*Shu k'uei*).

Tuberose (*yü tsan hua*).

Examples of pronged leaves

Mallow (*ch'iu k'uei*).

Monkshood (*sêng hsieh chü*).

20

芙蓉

Hibiscus (*fu yung*).

Examples of long leaves

Leaves of the day lily (*hsüan hua*).

Iris (*hu tieh hua*).

22

水
仙

Narcissus (*shui hsien*).

Examples of dentate leaves

Peony (*shao yao*).

23 葉亞種各

芍藥

24

Poppy (*ying su*).

Poppy (*yü mei jên*).

25

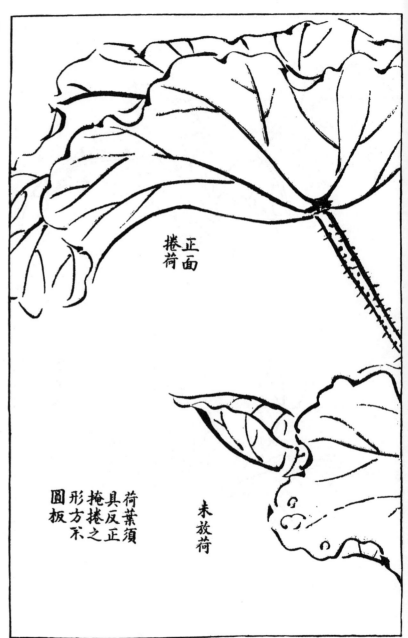

Lotus leaf curling over face of leaf.

Lotus leaf not yet opened.

The forms of lotus leaves should be varied: turned over (*fan*), facing up (*chêng*), half-covered (*yen*), and curled (*chüan*). They should never be round or flat like a board.

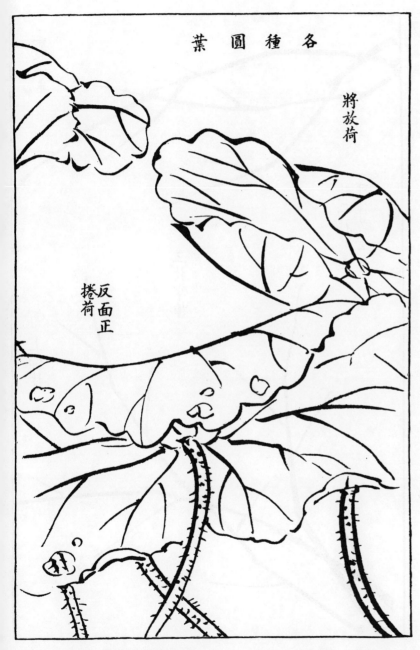

Examples of circular leaves

Lotus leaf unfolding.

Lotus leaf turned back, showing the back.

Three horizontal and crossed stems.

These two extended stems may be used for the *fu yung* hibiscus.

Three-forked stem pointing upward.

Upright stems at the top of a plant.

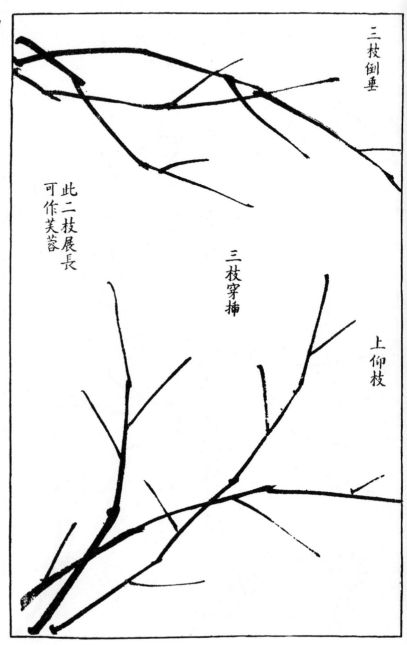

27

三枝倒垂

此二枝展長可作芙蓉

三枝穿插

上仰枝

28 Examples of first steps in painting the stems of herbaceous plants

Two crossed stems.

A stem bending over.

These three stems are suitable for groups of flowers on a single stalk, from which lesser stems with leaves branch off.

507

Base of stems of the peony.

29

芍藥根枝

三枝交加
此枝展長可
作蜀葵秋葵
鶯粟枝

Three crossed stems: these long stems may be used for the hollyhock (*shu k'uei*), the mallow (*ch'iu k'uei*), and the poppy (*ying su*).

30

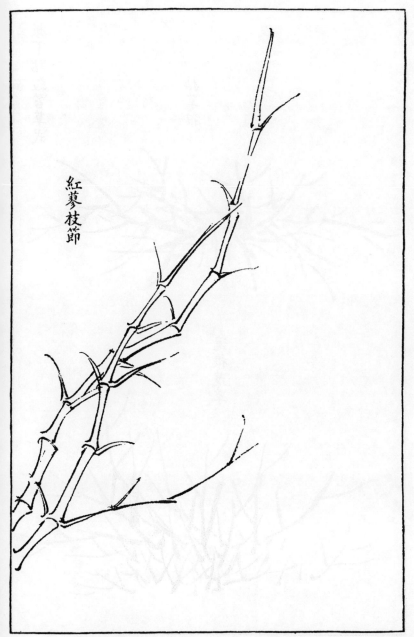

Jointed stems of the polygonum (*hung liao*, red smartweed).[1]

1. *Polygonum orientale.*

Examples of dotting various mosses
and grasses at the base of plants

31

根下點綴苔草式

枯草根

Moss and weeds at the base of a plant.

遮根茂草

Flourishing grasses covering the base of a plant.

四時為妙
衰冬枯合乎花之
分別春嫩夏茂秋
根下點綴小草須

霜後衰草

初生嫩草

爬根細草

32 Distinction should be made in dotting the grasses around the base of plants in spring, when they are delicate, or in summer, when they flourish, or in autumn, when they are a little drawn, or in winter, when they are withered. When they are represented in the same stages of development as the flowers of the four seasons, they will be lovely.

Grasses after frost.

First shoots of young grass.

Delicate grasses at the base of a plant.

511

Moss and grass in tapering brushstrokes.

Moss and grass in round brushstrokes.

Moss and grass laden with dew.

Shepherd's-purse (*yeh chi*) at the base of a plant.

Shepherd's-purse and dandelions (*p'u kung*) are two grasses that can endure snow and frost and so are suitable to paint at the base of the chrysanthemum, the plum tree, and the orchid.

34

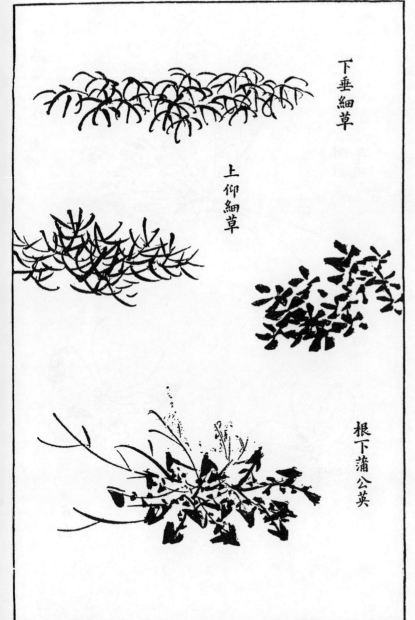

下垂細草

上仰細草

根下蒲公英

Curled blades of delicate grass.

Upright blades of delicate grass.

(Moss dotted in groups of three and five brush-strokes.) [1]

Dandelions at the base of a plant.

1. As in original edition.

Examples of insects for paintings of grasses and herbaceous plants: I. Butterflies with yellow and red wings and black markings (*chieh tieh*)

35

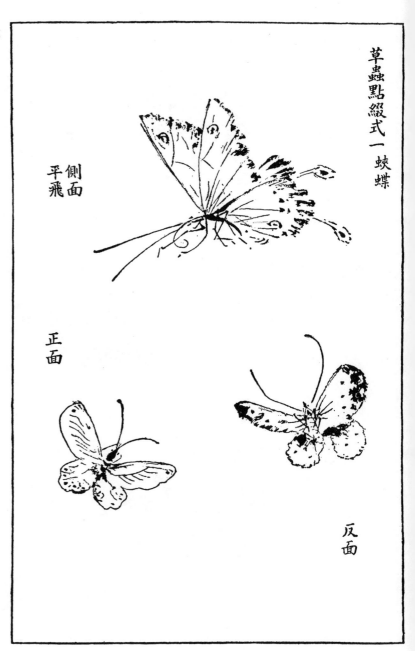

Side view, flying horizontally.

Seen full view from above.

Seen from below.

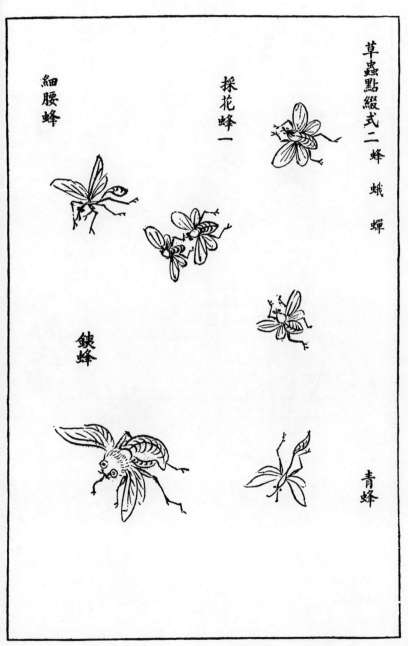

草蟲點綴式二 蜂 蛾 蟬

細腰蜂

採花蜂一

鋏蜂

青蜂

36 Examples of insects for paintings of grasses and herbaceous plants: II. Bees, wasps, moths, and cicadas

Bee drawing nectar.

Wasp with narrow waist.

Black-headed wasp (*t'ieh fêng*).

Green fly (*ch'ing fêng*).

Pair of moths.

Fluttering moth.

Cicada, head down, grasping a stem.

Cicada, head up, weighing down a stem.

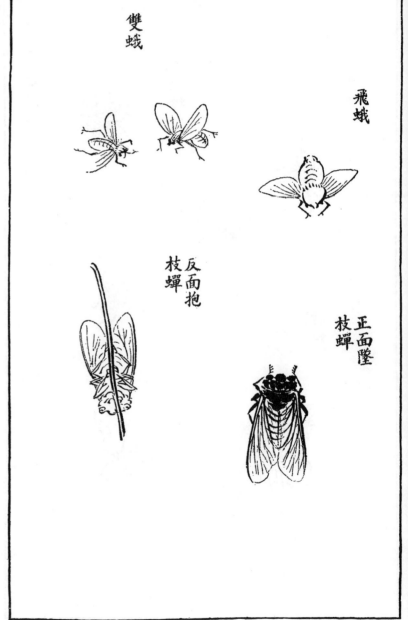

37

雙蛾

飛蛾

反面抱
枝蟬

正面墜
枝蟬

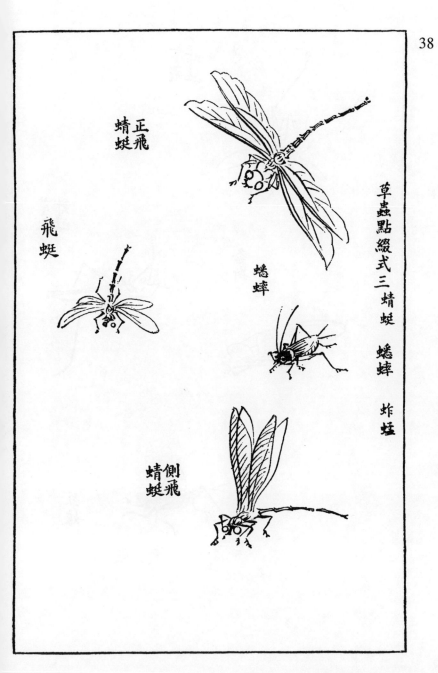

正飛
蜻蜓

飛
蜓

草蟲點綴式三蜻蜓　蟋蟀　蚱蜢

蟋蟀

側飛
蜻蜓

38　Examples of insects for paintings of grasses and herbaceous plants: III. Dragonflies, crickets, and grasshoppers

Dragonfly in flight, seen from above.

Dragonfly in flight.

Cricket.

Dragonfly in flight, seen from the side.

Grasshopper alighting.

Grasshopper on grass.

Locust.

Female locust.

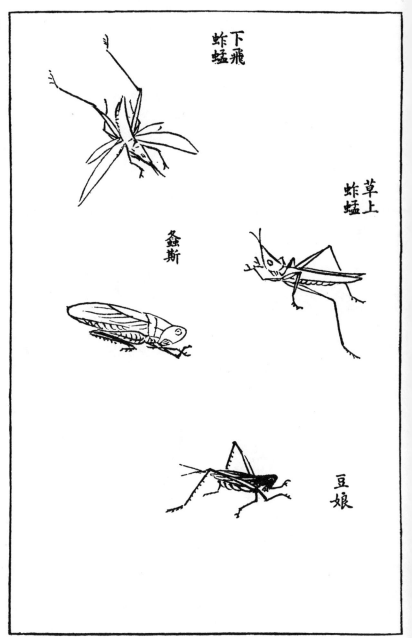

39

蚱飛
蜢下

草上
蚱蜢

螽斯

豆娘

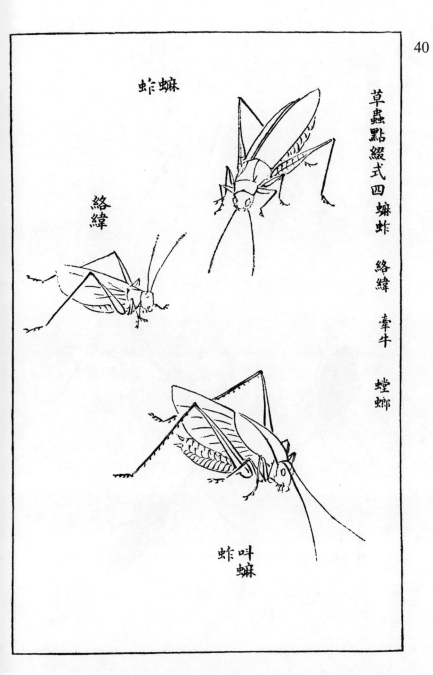

蚱蜢

絡緯

草蟲點綴式四 蟋蚱 絡緯 牽牛 螳螂

蚱叫蜢

40 Examples of insects for paintings of grasses and herbaceous plants: IV. Large green grasshoppers, crickets, beetles, and the praying mantis

Grasshopper.

Cricket.

Singing grasshopper.

519

Praying mantis seizing an insect.

Beetle crawling downward.

Praying mantis.

Beetle.

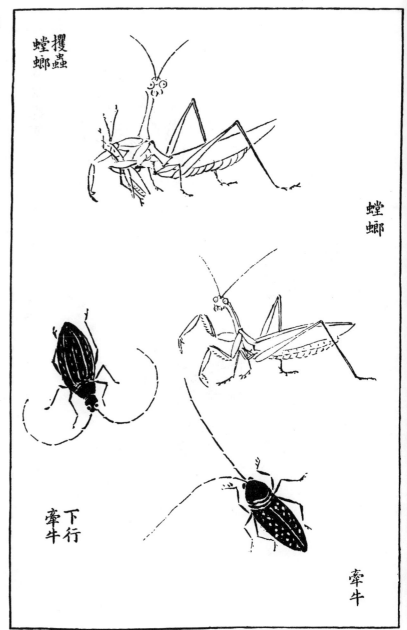

[In the Shanghai edition, the tenth book contains an additional section of 40 single pages of examples, here omitted.]

[The eleventh book (here omitted) of the original edition contains still further examples of grasses and insects, on 40 double pages. In the eleventh and thirteenth books of the Shanghai edition, over 100 pages of additional examples were offered for *Grasses and Insects* and *Feathers-and-Fur*.]

Book of Feathers-and-Fur
and Flowering Plants

[In the 1701 edition, a preface was supplied by Wang Shih. It deals with the 46 flower painters listed in the Imperial Sung catalogue and the many birds, animals, flowers, and plants mentioned in the *Shih* (Odes).]

Ch'ing Tsai T'ang Discussion of the Fundamentals of Painting Flowering Plants and Feathers-and-Fur[1]

General background of painting plants with wood stems

THE introduction to the *Hsüan Ho Hua P'u*[2] described plants as possessing in essence the Five Elements and the Breath (*Ch'i*) of Heaven and Earth (i.e., nature); in the alternating action of the *Yin* and *Yang* (the Two *Ch'i*), the process of exhalation brings plants to full flower and that of inhalation causes them to fade.[3] Among all the numerous varieties of grasses and plants, it is impossible to distinguish and name all of those with wood stems. Nevertheless, their forms and colors adorn all of civilization, though that may not have been nature's prime intent. Are they not evidence of the harmonizing power of the *Ch'i?* Poets frequently mentioned them, and they are the subjects also of painting.

For the display of delicate stems and small flowers, grasses and herbaceous plants have the advantage; but if the entire form is to be shown, trees and wood-stemmed plants are the supreme examples. Nature has given the peony its elegance, the begonia its fascination, the plum its pu-

1. As in the preceding book, the title-page and the text heading are slightly different; the classification, however, is usually called "Birds and Flowers," as in the following pages. *Ling mao* (feathers and fur) refers literally to birds and animals, though it is often used only for birds, as here, in the sense of "feathers and down." Here, "flowering plants" means ligneous or wood-stemmed plants, including trees, shrubs, and bushes.

2. *Hsüan Ho Palace Catalogue of Paintings:* the record of the collection of the Sung Emperor Hui Tsung, published in the early XII century.

3. The complementary action of the *Yang* (exhalation of the *Ch'i*) and the *Yin* (inhalation) was described as accounting for the cycle of the seasons. Also, spring-summer was *yang,* autumn-winter, *yin.*

rity, and the apricot its abundant blossoms. The flowers of the peach tree grow in thick clusters, while those of the plum are single and unadorned. The camellia is lovelier than the red lily. The fragrance of the cassia rises from its golden seeds. The poplar, willow, and *wu t'ung*[4] are esteemed for their purity and dignity. The stately pine and ancient cypress represent maturity and steadfastness. In paintings, these trees and plants express man's highest concepts, evoking the very essence of the divine spirit (*shên*).

To consider the works of those who specialized in painting flowers and birds, in the T'ang period, there were Hsieh Chi, Pien Luan, Chih Jan-kuang, Yü Hsi, Tiao Kuang, Chou Kuang, Kuo Ch'ien-hui, and (Kuo) Ch'ien-yu. All were renowned for their paintings of flowers and birds. In the period of the Five Dynasties, T'êng Ch'ang-yu, Chung Yin, and Huang Ch'üan and his sons continued the tradition. (T'êng) Chang-yu, with heart and hand in accord, had no need of a teacher. Chung Yin took as his models the Kuo brothers. Huang Ch'üan excelled in combining the methods of various masters of the past; in painting flowers he followed (T'êng) Chang-yu, in bird painting Tiao Kuang; in painting dragons, cranes, trees, and rocks he likewise followed masters of the past. His sons Chü-pao and Chü-ts'ai carried on the family style and for this were celebrated in their period. The methods used by these painters were handed down from ancient times; they have been tested and are dependable. For this reason, from Sung times, the methods and style of the Huang family set a standard.

In the Sung period, Hsü Hsi appeared and, singlehanded, changed the old methods. He has therefore been described as unique, without rival before or after. Some have classed him with Huang Ch'üan and Chao Ch'ang, but he alone achieved the divine (*shên*) and the wonderful (*miao*). He bequeathed these gifts to his grandsons Ch'ung-ssü and Ch'ung-chü, who faithfully carried on his methods; truly, they followed in the steps of their grandfather.

Chao Ch'ang's manner of applying color was supreme. He not only achieved form (*hsing*) but, through color, he succeeded in transmitting the divine quality (*shên*).

It has been claimed that Hsü Hsi, Huang Ch'üan, and Chao Ch'ang were equals. Ch'üan's painting, however, had *shên* but not *miao*, and Ch'ang's had *miao* but not *shên*.[5] After I Yüan-chi had achieved a place in the top ranks of painting, he happened to see some works of Ch'ang

4. *Sterculia platanifolia.* See below, p. 117.
5. The art critics enjoyed the centuries-old argument over the relative merits of these masters of flower and bird painting. These typical phrases about *shên* and *miao* were borrowed from discussions that became routine and somewhat meaningless.

and commented: "From generation to generation there has been no lack of talent, but it is necessary to shed old practices and try to surpass the ancients. That is the only way to perfection!"

Ch'iu Ch'ung-yü at first took Chao Ch'ang as his teacher, but in his later years he followed Hsü Hsi. Ts'ui Po, Ts'ui Ch'ueh, Ai Hsüan, Ting K'uang, Ko Shou-ch'ang, and Wu Yüan-yü all were summoned to the Imperial Academy of Painting and were well known in their times. Ai Hsüan was considered equal to Hsü (Hsi) and Chao (Ch'ang). Ting K'uang was not in a class with Huang (Ch'üan) and Hsü (Hsi). At first, Ko Shou-ch'ang's forms lacked the essential, but by dint of hard study he improved them. Wu Yüan-yü took Ts'ui Po as his model and eventually achieved a style of his own. Through his example, the painters of the Imperial Academy cast off old habits and gradually adopted freer methods. In expressing themselves (i.e., writing) from the heart, they purified in one stroke the old methods and thereby strengthened the tradition. Such was the influence of (Wu) Yüan-yü!

Mi (Fei) Yüan-chang, seeing the flower and bird paintings of Liu Ch'ang, held that he was equal to Chao Ch'ang. When Lo Shih-hsüan began to paint, he followed the methods of Ai Hsüan; but later he became aware of his master's limitations and, breaking away, eventually surpassed his predecessors. His paintings of flowers and birds were living ideas (*shêng i*) that made (Ai) Hsüan seem like a man lost in the underworld. Wang Hsiao followed the style of Kuo Ch'ienhui, though he did not seem to achieve it. T'ang Hsi-ya and his grandson, Chung-tsu, not only were masters of form (*hsieh hsing*, write form) in their pictures but also managed to transmit the nature of their subjects. Liu Yung-nien and Li Chêng-ch'ên both painted with great style. Li Chung-hsüan's flowers and birds, though decorative, lacked style and originality.

During the Southern Sung period, there were not only sweeping territorial changes and domestic upheavals, but changes also in painting methods and styles. There was Ch'ên K'o-chiu, who followed in the style of Hsü Hsi, and Ch'ên Shan, who followed in the style of I Yüan-chi. Their manner of applying color was light and clear, surpassing that of Lin (Ch'un) and Wu (Yüan-yü). Lin Ch'un and Li Ti each had their masters; in turn, Han Yu and Chang Chung followed Lin Ch'un, Ho Hao followed Li Ti. Liu Hsing-tsu followed Han Yu. And Chao Po-chü and (Chao) Po-su carried on the methods and style of their family. Wu Yüan-kuang, Tso Yu-shan, Ma Kung-hsien, Li An-chung, Li Ts'ung-hsün, Wang Hui, Wu Ping, Ma Yüan, Mao Sung, Mao I, Li Ying, P'êng Kao, Hsü Shih-ch'ang, Wang An-tao, Sung Pi-yün, Fêng Hsing-tsu, Lu Tsung-kuei,

Hsü Tao-kuang, Hsieh Shêng, Tan Pang-hsien, Chang Chi, Chu Chao-tsung, and Wang Yu-tuan all were famed for their flower and bird paintings. Whether they had masters whose names may not have been recorded or whether they worked independently, their paintings conformed to the ways of the ancients and represented the flowering of a whole epoch. P'ang Chu and Hsü Yung, of the Chin dynasty, and Ch'ien Shun-chü, Wang Yüan and Ch'ên Chung-jên, of the Yüan period, were all considered masters. And each had their chosen masters. Ch'ien Shun-chü took Chao Ch'ang as his master. Ch'ên Mêng-hsien followed Ch'ien Shun-chü. Wang Yüan followed Huang Ch'üan and Ch'ên Chung-jên. Tzǔ-ang (Chao Mêng-fu), lamenting the passing of Huang Ch'üan, declared that Wang Yüan was his reincarnation. How could he, therefore, have missed the true method? Shêng Mou, Ch'ên Chung-mei (jên?), and Li Po-ying studied the work of Lou Kuan; they were able to modify his methods, and they surpassed him in results. Ch'ên Lin and Liu Kuan-tao worked in the tradition and succeeded in combining many good traits of the masters. Chao Mêng-fu, Shih Sung, Mêng Yü-jun, and Wu T'ing-hui also were masters. Yao Yen-ch'ing, although he worked diligently, was not able to avoid certain practices of his times. Chao Hsüeh-yen had experience and skill in applying color. Wang Chung-yüan applied ink richly. Pien Lu and Pien Wu, considered among the prominent painters, were skillful in handling ink in a playful manner. Lin Liang and Lü Chi, together with Pien Wên-chin, of the Ming dynasty, were all renowned. Yin Hung's place is between Pien and Lü. Ch'ên Ching-mên followed the style of Hsü Hsi and Chao Ch'ang. Huang Chên achieved the brush quality of Huang Ch'üan. T'an Chih-i achieved the *miao* class of Hsü (Hsi) and Huang (Ch'üan). Yin Tzǔ-ch'êng may be placed after (Tan) Chih-i. Fan Hsien, Chang Ch'i, Wu Shih-kuan, and P'an Hsüan all were masters. P'an was particularly successful in painting plants in the wind or dew-laden.

Chou Chih-mien, Ch'ên Shun, Lu Ch'ih, Wang Wên, Chang Kang, Hsü Wei, Liu Jo-tsai, Chang Ling, Wei Chih-huang, and (Wei) Chih-k'o all excelled in ink painting of plants. It is said that, among those who painted in ink, after Ch'ên Ch'i-nan none compared with Ch'ên Shun and Lu Ch'ih. Ch'ên was of the *miao* class but lacked trueness (*chên*). Lu Ch'ih had *chên* but not *miao*. Only Chou Chih-mien had both qualities. All these worked in the manner of the literati (*wên jên*), eschewing color and using ink alone to express the divine (*shên*); they were outstanding in their times.

Those who are learning to paint and are looking for models among the masters should choose

to follow Huang (Ch'üan) and Hsü (Hsi). Let them study their works to be influenced by their gifts, and then seek among the other masters points that will help in rendering a breath of the divine (*shên*). In this way, they will be free of the commonplace and the undisciplined, and they may progress according to the *Tao*.

Method of painting branches and stems

The branches and main stems of ligneous plants are different from those of herbaceous plants. Grasses are supple and lovely, whereas wood-stemmed plants are old and rugged. There are differences, too, wrought by the changes of the four seasons.

Among spring plants, plum, apricot, peach, and pear all differ in structure; moreover, the branches and stems of each vary. The old trunk of the plum tree should be gnarled, with lean branches and twigs. Thus the *shih* [6] of the plum tree exhibits both strength and tortuousness. The branches of the peach tree should be straight, upward pointing, and sturdy. The branches of the apricot tree should be rounded, sleek, and curving. The characteristics of these three trees present a basic pattern from which one may learn the structure of others. The roots and joints of the pine and cypress should be twisted and gnarled. The trunk, main stems, and stalks of *t'ung* trees and bamboos should give an effect of height and of purity. If one draws a branch bent, curved, or jagged, one should place it where there is space or where the foliage is rather sparse, pointing upward, downward, or horizontally. Each position should be studied for the *shih* of the particular branch. In drawing or painting a branch, the brush should be held obliquely, and the stroke should start with the tip; it should not be held vertically. In painting fruit, their *shih* requires that they hang from the branch, that being their nature.

Method of painting flowers

The flowers of most trees and ligneous plants have five petals: for instance, plum, apricot, peach, pear, and camellia. But the flowers of plum, apricot, peach, and pear are different in color and in the shape of their petals. The flowers of the tree peony, that perfect blossom, are naturally differ-

6. Structural integration. See above, p. 366 n ; p. 470 n ; and Appendix.

ent from all the others; the petals of the many kinds of peony have a great variety of forms. The red peony has long petals and a center like a rounded knot or button. The lavender peony has short and rounded petals, and its center is flat. The pomegranate, camellia, plum, and peach trees have blossoms with numerous petals. The flowers of the magnolia open like the lotus. The flower of the hydrangea is similar to a cluster of plum blossoms. Among the ramblers are the cinnamon rose (*ch'iang wei*) and the pink and the red rose (*mei kuei*). When in bud, the white rose (*fên t'uan*), the pale yellow moon rose (*yüeh chi*), the white or yellow climber (*t'u mi*), and the banksia rose (*mu hsiang*) all resemble each other; when their flowers open, they are different in color. The petals of the *yen p'u* vine are like those of the white jasmine, though of a different size. The red cassia resembles the flower of the mountain alum (*shan fan*) tree of Honan, but one blooms in the spring and the other in the autumn. In the flowers of the quince (*hsi fu*) and tamarisk (*ch'iu ssŭ*), of the wild plum family, the calyx must be clearly defined from the base of the flower. Among the various kinds of plum blossoms, one should indicate the difference in petal forms and centers—for instance, between those of the green-calyx plum (*lu ngo*) and the wax or winter plum (*la mei*).

These various blossoms open in the course of the seasons. Everyone can see them and, with a little attention, get to know the various forms and colors. Various regional species, herbs, and sprouts may occasionally be included in paintings, but space does not permit discussion of the details of their forms and appearance.

Method of painting leaves

Leaves of herbaceous plants are young and supple, those of ligneous plants are old and thick. This is a fixed principle. There are, however, some trees, such as peach, pear, wild plum, and apricot, whose leaves sprout in the spring at the same time as their blossoms; and, although these are ligneous, their leaves are young and supple. Leaves that grow in autumn and winter should be painted in deep, dark tones. Because grasses and the leaves of herbaceous plants are young and supple, a few should be drawn turned over. The leaves of the cassia, orange, and camellia can endure frost and snow without wilting and wind and dew without being shaken. Their leaves, though dark and rich in color, should still be rendered with variations of tone; the distinction should be clearly made between the characteristic light and dark tones of their faces and

backs. The folded or turned-over leaf should be dark green on its face, light green on its back. After painting the leaves, one adds their veins, of thickness or thinness depending on the form of the leaf and of tones in accordance with those of the rest of the leaf.

Having discussed the tones of green for leaves, we should now proceed to the use of red for leaves, keeping in mind the difference between those that are young and fresh and those that are fading. Leaves sprouting in spring often have tips of red. In autumn, when leaves begin to fall they first turn red. For young leaves not yet in full foliage, rouge red (*yen chih*) should be used. For leaves that are about to drop, umber (*chê shih*) should be used. I have observed, in examining old paintings of flowers and fruit, that the ancients had a way of painting a few withered leaves that insects had fed on, among the dark green tones of the other leaves. By such touches they adorned their works. One should know how to do this.

Method of painting the calyx

The blossoms of plum, apricot, peach, pear, and wild plum trees are five-petaled. The calyxes are of the same number, with sepals shaped like the petals. Blossoms with pointed or tapering petals usually have calyxes so formed; and similarly those with rounded petals.

The calyx of the blossom of the sturdy thorn tree (*kêng, Hemiptelea davidi*) is connected with the thorns. From the calyx of the tamarisk blossom hang fine red threads. The calyx of the camellia is composed of several layers like fish scales. The calyx of the pomegranate is long with many sepals.

The color of the plum-blossom calyx changes, as the flower does, from green to red. The calyx of the peach blossom is both red and green, that of the apricot both red and black. The calyx of the wild plum flower is a dark red. Each blossom is turned at a particular angle, some showing their stamens, some their calyxes. The calyxes of the *yü lan* and *mu pi* magnolias in bud are green and reddish brown. The cinnamon rose has a long green calyx, red at the tip. Here, then, are various calyxes that one should be able to identify.

Method of painting the heart and stamens

The calyxes of the blossoms of trees and ligneous plants are rooted in the hearts of the flowers; when, for instance, the blossoms of plum and apricot are seen full face, the calyx is not visible but

the heart is the source both of the flower inside and of the calyx outside. It is the real (*shih,* substantial, living) core of the flower. At the center point are also the five small dots where the stamens issue; their ends are tipped with yellow anthers. The stamens of plum, apricot, and wild plum blossoms are not all alike: those of the plum are thin, while those of the apricot and the peach, flowering in different seasons, are luxuriant. Moreover, the stamens of the white plum are few and thin, while the red plum stamens are numerous and luxuriant, though not like the apricot's. Blossoms vary, and they may be identified by their hearts.

Method of painting the bark of trunks and stems

Like their blossoms, the stems or trunks of ligneous plants are different from those of herbaceous plants. In painting the bark of the peach and *t'ung* trees, the brushstrokes for modeling (*ts'un*) should be drawn horizontally. For the pine and juniper the *ts'un* should be drawn like the scales of a fish. The bark of the cypress should be knotty, that of the plum tree should look old. The bark of the apricot should be a reddish purple. The stems of the cinnamon rose should be smooth and shining, those of the pomegranate lean and dry, and those of the camellia green and sleek. The bark of the wax or winter plum, like the ordinary plum, should have an old look. If, in painting the roots and trunks, the proper *ts'un* are used in drawing the bark, the forms of trees and ligneous plants will then be perfect.

Rules of painting the branches phrased for memorizing [7]

To paint branches, one must think and reflect about them. Flowers and leaves grow from branches, and together they enhance each other. As a man has limbs and a body, so the whole of a tree, from branches to roots, is one. The branches of trees and ligneous plants should be rugged, unlike those of the herbaceous plants. The principles concerning their bark, color, and forms that have been discussed should be memorized. Hence they are here phrased for that purpose.

7. The rules summarized for memorizing in this book are all in five-character phrases. As in the preceding books, these phrases have not been translated so briefly or uniformly.

Rules of painting flowers phrased for memorizing

Flowers grow from calyxes and branches and dominate them. If the flowers are not successfully painted, branches and leaves properly done can not remedy the results. First, flowers should display their grace, and then branches and leaves may add their charm. The colors of flowers should be light and elegant, bringing out their natural beauty. They should seem about to speak. By such results are men's hearts stirred. And that is the reason the reputations of Hsü (Hsi) and Huang (Ch'üan) will endure.

Rules of painting leaves phrased for memorizing

Where there are flowers, there also certainly are leaves. Leaves should be painted appropriately, shielding part of the trunk or main stem, adding graceful movement among the flowers, and swaying in the wind and under the weight of dew. When flowers and leaves are properly placed and the range of tones clearly indicated, the painting of the plant as a whole will be saved from monotony. There are, moreover, the changes of the four seasons; in spring and summer leaves are abundant, in autumn and winter they endure the frost and the snow. The plum tree alone, at the time of flowering, is bare of leaves.

Rules of painting stamens and calyxes phrased for memorizing

In painting flowers, one should show their complete forms, the calyx outside, the stamens inside. The stamens issue from the calyx and touch it both outside and in. The fragrance hidden in the heart rises. From the calyx, too, the fruit will grow. Depending on how the flower is drawn, from front or back, either its heart or its calyx will be visible. By the nature of things, the heart of the flower is surrounded by petals and the calyx is attached to the branch. Flowers have these features as men have whiskers and eyebrows.

General background of bird painting

In the Six Styles of Poetry, poets frequently alluded to birds, animals, grasses, and trees. In the exposition of the four seasons in the *Yüeh Ling* (Monthly Regulations, Book IV, *Li Chi* or *Book*

of Rites), it is recorded when birds sing or are silent and when plants flourish or fade. When flowers and plants are associated with birds and animals in the *Shih* (Book of Poetry, or *The Odes*) and the *Li Chi*, naturally they should also be associated in painting. The background of flower painting has already been outlined in the book on herbaceous plants, preceding the sections on insects and butterflies. In the present book, on ligneous plants, there is a section on birds. The flowers and birds in the great works of the T'ang and Sung periods were superb. How can one add anything further of importance to the record? As to birds, there are many kinds. The cranes of Hsüeh (Chi) and the sparrow hawks of Kuo (Ch'ien-yu or Ch'ien-hui) were renowned in ancient times. Was there no one after them who specialized in bird painting? (Certainly there were!) After Hsüeh Chi there were Fêng Chao-chêng, K'uai Lien, Ch'êng Ning, and T'ao Ch'êng, who all excelled in painting cranes. After Kuo Ch'ien-hui and (Kuo) Ch'ien-yu there were Chiang Chiao, Chung Yin, Li Yu, and Li Tê-mao, who all excelled in painting eagles and hawks. Pien Luan excelled in painting peacocks; Wang Ning, parrots; Li Tuan and Niu Chien, pigeons; and Ch'ên Hêng, magpies. Ai Hsüan, Fu Wên-yung, and Fêng Chün-tao excelled in painting quail; Fan Chêng-fu and Chao Hsiao-ying, pied wagtails; Hsia I, waterfowl; Huang Ch'üan, chickens and mandarin ducks; Huang Chü-ts'ai, pigeons and partridges; Wu Yüan-yü, swallows and yellow orioles; the Buddhist monk Hui-ch'ung, seagulls and egrets; Ch'üeh Shêng, crows and rooks; Yü Hsi and Shih Ch'ing, ringed pheasants. Ts'ui Ch'ueh, Ch'ên Chih-kung, Chang Ching, Hu Ch'i, Chao Yüeh-chih, Chao Shih-lui, and the Buddhist monk Fa-ch'ang excelled in painting wild geese. Mei Hsing-ssŭ excelled in painting fighting cocks; Li Ch'a, Chang Yü, Mu Hsien-chih, and Yang Ch'i, chickens; Shih Tao-shih, Ts'ui Po, T'êng Ch'ang-yu, and Ts'ao Fang, geese; Kao Ch'ou, ducks sleeping and wild geese swimming; Lu Tsung-kuei, chickens, chicks, and ducks; Huang T'ang-kai, wild birds generally; Ch'iang Ying, Ch'ên Tzŭ-jan, and Chou Huang, waterfowl; and Wang Hsiao, birds singing and calling. These were the masters of various periods of the past. Some excelled at painting certain kinds of birds among flowers; some, still better, were able to paint all kinds.

Mountain birds and water birds vary according to their habitat, and their feathers change in texture and color in the course of the seasons. The forms of their beaks, wings, tails, and claws vary according to whether they are flying, singing, resting, eating, or drinking. These positions are illustrated later in pictures, and should be learned also by observing the birds.

Steps in painting birds

In painting birds, begin with the long stroke for the upper part of the beak and then complete that part of the beak. Next comes the long stroke for the lower part of the beak, and then complete that part. To dot in the eye, place it near the point at which the beak opens. The head is drawn next, and then the back, from the neck down along the wings. Proceed with the breast, then the curve of the stomach, and then the tail. Finally, add the strokes for the legs and claws. The shape of most birds resembles an egg; we will mention this again later.

Rules of painting birds phrased for memorizing [8]

In painting birds, begin with the beak. Eyes are placed above the upper part of the beak. Before completing the eye, draw the head. Then draw the feathers around the lower part of the face and around the top of the shoulder, using large and small half-circle strokes and long and short tapering strokes. Draw in carefully the tips of the wings. Step by step, draw in the tail and the feathers down along the spine and under the tail. Breast and stomach should be placed ahead of the legs. Last, add the legs, for the feet either grasp a branch or are spread out.

Complete rules of bird painting phrased for memorizing: the form and structure of head, tail, wings, feet; the dotting of eye; the positions of flying, singing, drinking, pecking

One should know well the whole form of the bird. Birds are born from eggs. And their forms resemble eggs, with head, tail, wings, and feet added. Flying, their power (*shih*) is in their wings. When the wings are spread, they are raised and light. When the head is lifted, the beak is open, as when a bird sings on a branch. When a bird is perched on a branch, the position of the feet is firm and secure, in no way uncertain. On the point of flying, the tail quivers. And with the quivering of the tail, the bird takes off. One should catch the quality (*shih*) of flight in the outspread wings; one should catch the hopping from branch to branch, the bird never for one moment still. All this describes the forms of birds in various positions.

 There is much in the manner in which the eyes are drawn that may help to give an effect of

8. Illustrated below, pp. 564–65, 572.

aliveness (*shên*). When drinking, the bird is as though it were descending in its flight; eating, it seems about to begin a dispute; angry, it seems about to fight; joyful, it seems about to break into song. When two birds are perched together or flying around each other, they should seem to be turning their heads to look at each other. As in a portrait, the whole work depends on how the eyes are drawn. There should be method in placing and drawing the eyes. Then the whole form will be true (*chên*). Each detail has its reason (*li*). And that is the only way to produce lasting results.

Rules of painting sleeping birds phrased for memorizing

In general, one knows how birds look flying, singing, drinking, and pecking. But one may not know how they look asleep. A bird asleep on a branch has the eyes closed, the eyelids firmly folded. Unlike any animal, birds tuck their beaks under their wings and their feet into the down on their stomachs. Observing birds asleep brings to mind the saying, "When chickens sleep they perch high, when ducks sleep they lower their beaks and tuck them under their wings. Birds that perch to sleep bend and draw in their legs." Although only the habits of chickens and ducks are mentioned, the remark applies to all kinds of birds. One should know about this in painting; for good results it is essential.

Rules of painting the beaks and tails of two kinds of birds phrased for memorizing

In painting birds, one should note two general classes, mountain birds and water birds. Mountain birds necessarily have long tails; in flight their wings are very light. Water birds have short tails; swimming, they bob their heads into the water. One should know these characteristics in order to render their forms.

Birds with long tails should be drawn with short beaks; they sing beautifully and fly high. Those with short tails should be drawn with long beaks, thus they are able to catch fish and shrimps under water. Cranes and egrets have long legs. Seagulls and wild ducks have short legs. Although they belong in the category of water birds, their legs are characteristic and should be clearly defined.

Mountain birds live among trees and in the woods. Their plumage is of the Five Colors. The *luan* phoenix, the *fêng* phoenix, and the cock pheasant are resplendent in reds and greens. Water birds are constantly bathing in clear water, and therefore their bodies are always clean and glistening. Wild ducks and wild geese have blue and green plumage, seagulls and egrets have white. The color of the mandarin duck differs according to its sex: the female has feathers of the Five Colors, the coloring of the male resembles that of the wild duck. The kingfisher is brilliant as though ornamented, its feathers green and blue with touches of violet. Its beak and claws are a shade of cinnabar. It is the most beautiful of the water birds.

1 Examples of first steps in painting flowers of ligneous plants with pointed, tapering, large, and small petals

Flowers with five petals

Peach blossoms.

Apricot blossoms.

Pear blossoms.

Golden-thread peach (*chin ssŭ*).[1]

1. *Hypericum ascyrion.*

白者為玉蘭
紫者為辛夷

3

When these flowers are white, it is the *yü lan* magnolia; when purplish, the *hsin i* magnolia.[1]

1. *Yü lan, Magnolia conspicua; hsin i* may be another name for the *mu pi* (*Magnolia kobis*), mentioned in the opening discussion.

Flowers with eight and nine large petals

Camellia.

5

栀子

Gardenia.

6

White jasmine.

Gardenia.

(Flowers with numerous petals) [1]

7

海棠

Wild plum (*hai t'ang*). [2]

(*Pi t'ao*, double-petaled peach.) [3]

1. Heading as in original edition.
2. *Pyrus spectabilis.*
3. As in original edition.

Many-petaled deep-red peach.

(Many-petaled pomegranate blossom.) [1]

1. As in original edition.

9

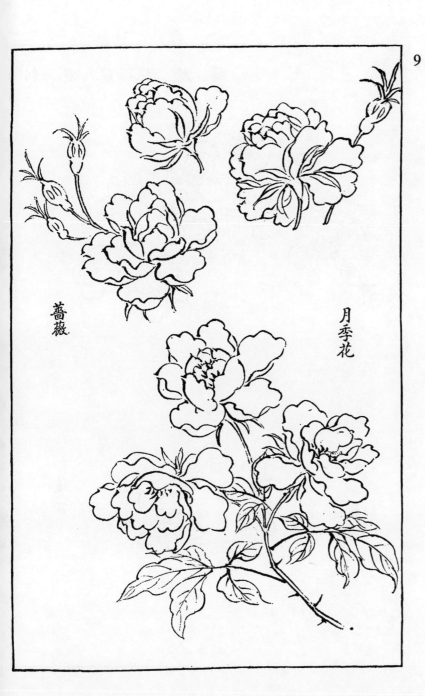

薔薇.

月季花

Cinnamon rose.

Pale-yellow moon rose.

Flowers of thorny and climbing plants

10

(Wild rose.) [1]

Pass-over-the-clouds (*ling hsiao*).[2]

1. As in original edition.
2. Begonia?

548

11 Large flower of the peony

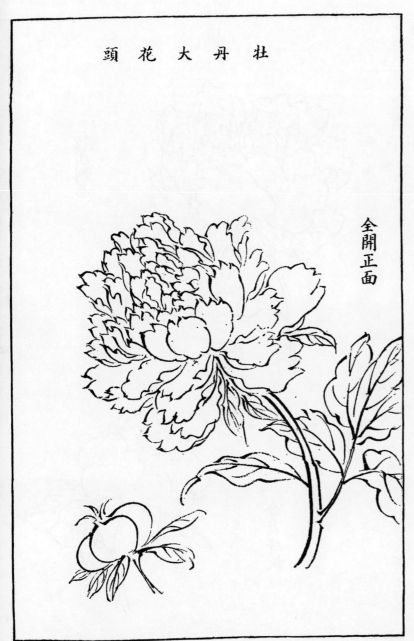

牡丹大花頭

全開正面

In full flower, front view.

(More views of the peony)

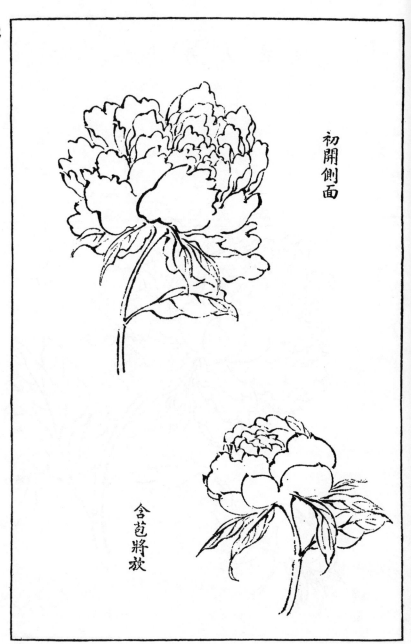

Beginning to open, side view.

初開側面

Bud about to open.

含苞將放

葉長　葉尖

木本各花葉起手式

海棠

13　Examples of first steps in painting the leaves of ligneous plants

Pointed and long leaves

Wild plum.

(Pomegranate.) [1]

1. As in original edition.

Leaves of the peach tree.

Leaves of the apricot tree.

Leaves of the plum tree.

When the plum tree flowers, it is bare of leaves; when the apricot tree flowers, its leaves are still at the stage of just sprouting. This point is added for the sake of authenticity (*shih*, realness, solidity).

桃葉

杏葉

梅葉

之用以為綴實嫩芽時備此花開時葉只無葉杏開梅開花時

15

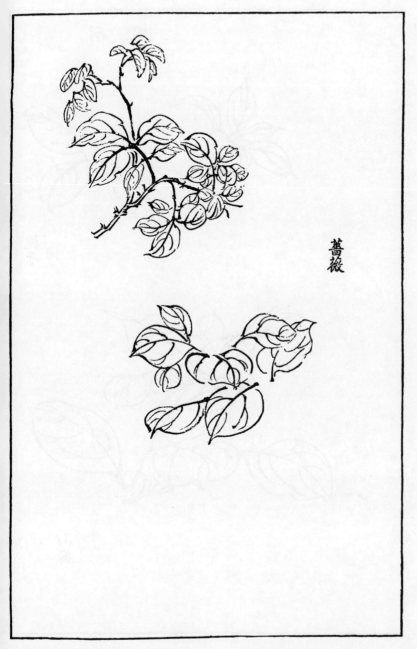

薔薇

Cinnamon rose.[1]

1. Being a plant with thorns, this example should follow p. 555, below, as in the original edition.

553

Thick leaves that withstand winter [1]

16

Gardenia.

Camellia.

1. Half of heading on this page, half on facing page.

17

Cassia leaves.

(Orange leaves.) [1]

(Plants with thorns and) furry leaves [1]

18

Pale-yellow moon rose.

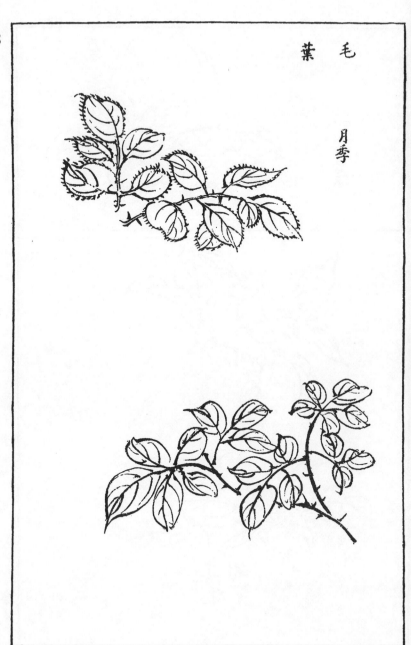

(Red rose.) [2]

1. Full heading, as in original edition.
2. As in original edition, by the lower example.

19 (Peony) leaves in various positions [1]

End of a stem.

Leaves below a flower.

1. Full heading as in original edition. There, too, the examples of peony leaves are on two pages; only the one that was on the right appears here. The other, missing here, showed "young leaves" and "leaves at the base of a plant."

Examples of first steps in painting
branches of ligneous plants

Addition of supple intercrossing branches

These branches are suitable for the fine branches
of the pomegranate and the crape myrtle.

老枝交加
此枝展長可
作桃橘枝幹

莉枝
此枝宜於薔薇
月季根下

21

Additional old branches intercrossing

Extended, these branches may be used for the peach and orange trees.

Branches with thorns

These branches are suitable for the cinnamon rose and the pale-yellow moon rose.

A hanging and bent branch

This kind of branch is suitable for the old branches of the peach, pear, wild plum, and camellia.

23

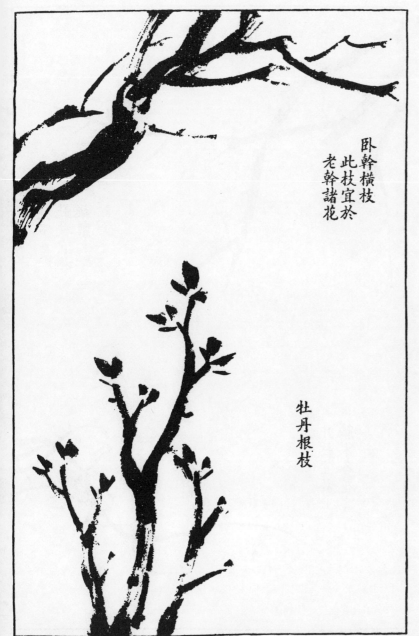

卧幹橫枝
此枝宜於
老幹諸花

牡丹根枝

Inclined trunk with horizontal branches

These branches are suitable for trees with old trunks which blossom.

Branches of the peony plant.

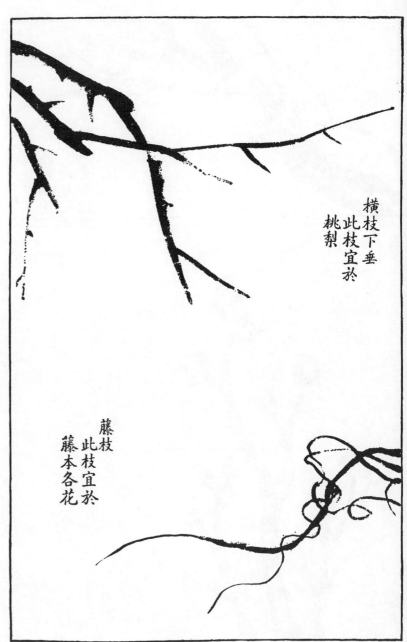

Horizontal branch hanging down

These branches are suitable for those of the peach and pear trees.

Climbing plant on a branch

This kind of branch is suitable for climbing (*t'êng*) plants.

25

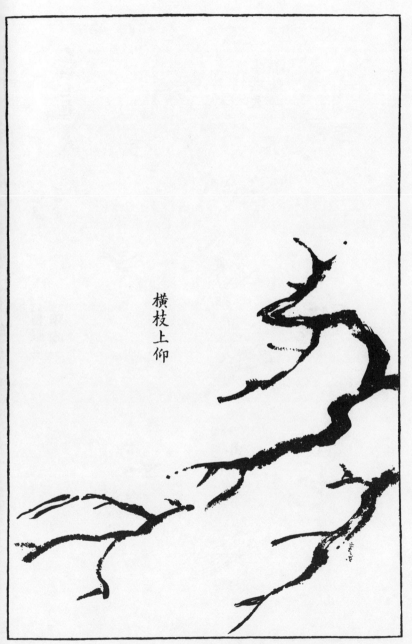

橫枝上仰

Horizontal branch facing upward

Examples of first steps in painting birds

26

Downward, starting at right:

(In painting birds begin with the beak.) [1]

The eye is placed above the upper part of the beak.

Before completing the eye, draw in the head.

(Draw in the feathers around lower part of face and top of shoulders.)

Use large and small half-circle brushstrokes.

Use long and short tapering strokes.

Draw in carefully the tips of the wings.

1. First and fourth legends as in original edition.

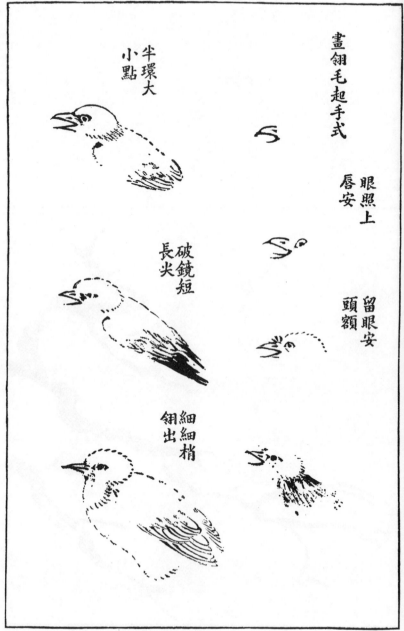

27

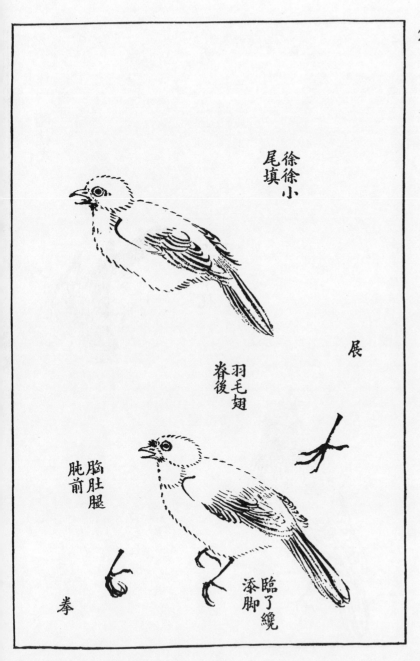

Step by step, draw in the tail.

And the feathers and down along the spine and under the tail.

Breast and stomach should be placed ahead of the legs.

Lastly, add the legs.

(The feet either grasp a branch or are spread out.) [1]

(Claw) spread out.

(Claw grasped like) a fist.

1. An explanatory note included in original edition.

Examples of birds on branches

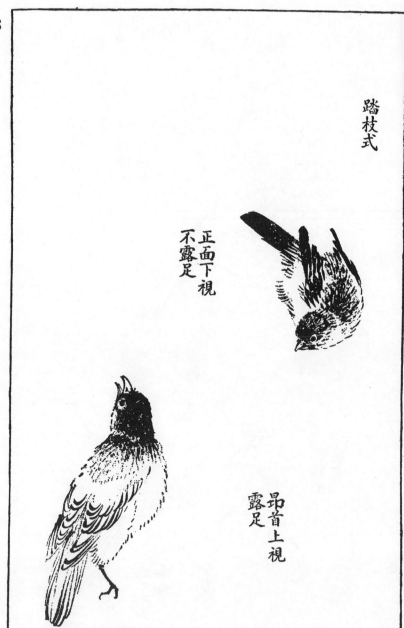

28

Front view of bird looking down; its feet are not visible.

With head raised, looking upward; a foot is visible.

29

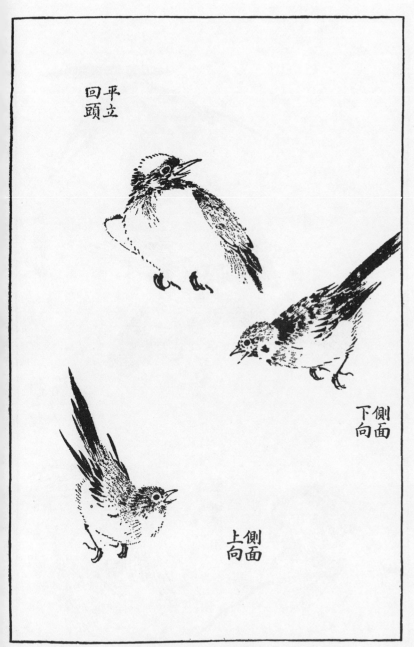

Bird perched, turning its head.

Side view, facing downward.

Side view, facing upward.

Examples of birds flying or perched

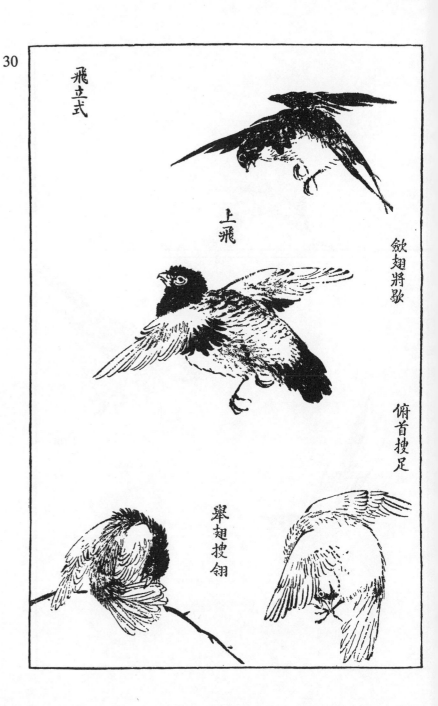

Drawing in its wings, about to come to rest.

Flying upward.

With wing raised, investigating its feathers.

Head down, looking at its feet.

31 Examples of birds together

A pair of white-headed birds "growing old together."

Flying downward.

32

Swallows perched together.

Resting together.

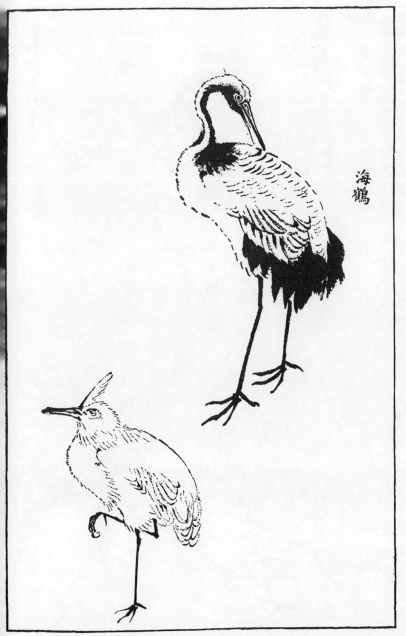

33

海鶴

Crane.

(Egret.) [1]

1. From the original edition.

Examples of first steps in painting birds
in fine brushstrokes

Right to left:

First draw the beak and then add the eye.

Draw the head.

Draw half the wing from top of shoulder and
spine.

Complete the wing.

Right to left:

Outspread claws.

Claw in walking along branch.

Claw closed like a fist.

Draw the stomach, add the tail and feet; the whole
form of the bird is complete on the branch.

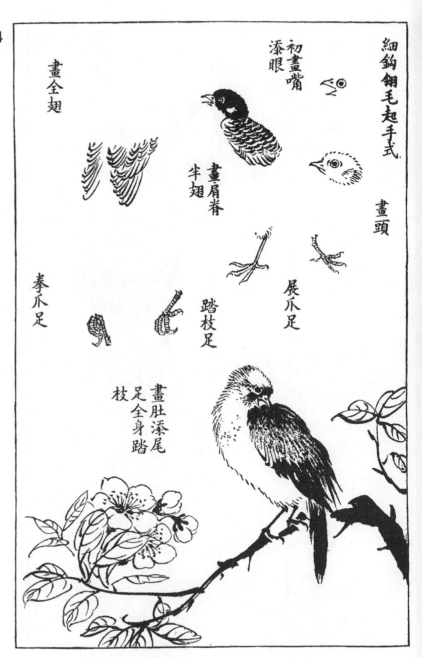

35 Examples of birds turned upside down and fighting while flying [1]

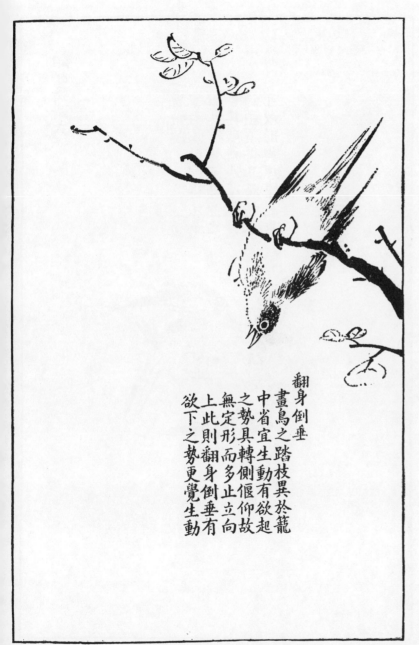

翻
身
倒
垂

畫
鳥
之
踏
枝
異
於
籠

之
勢
具
轉
側
偃
仰
故

中
省
宜
生
動
有
欲
起

無
定
形
而
多
止
立
向

上
此
則
翻
身
倒
垂
有

欲
下
之
勢
更
覺
生
動

Bird hanging upside down

A bird painted perched on a branch is different from one painted in a cage. It should have life movement (*shêng tung*), giving an impression of (its *shih*) being about to fly, turning to one side, bending over, or looking up; for its form is never rigidly set. Often, however, it may stop a moment and may perch, and may be seen front view. The example here shows a bird hanging upside down, about to fly down, giving an impression of change and further lively movement.

1. Heading from p. 574, below.

Two small birds fighting while flying

Painting two birds fighting in the air is difficult. The
effect (*shih*) should be of birds aroused, with wings
spread, heedless of what happens to their bodies.
Their manner of fighting while flying is to dart
swiftly at each other, pecking at throats. Such an
effect may be achieved only through the spirit
(*shên*); it is not to be found just in the form (*hsing*)
or the principle (*li*).

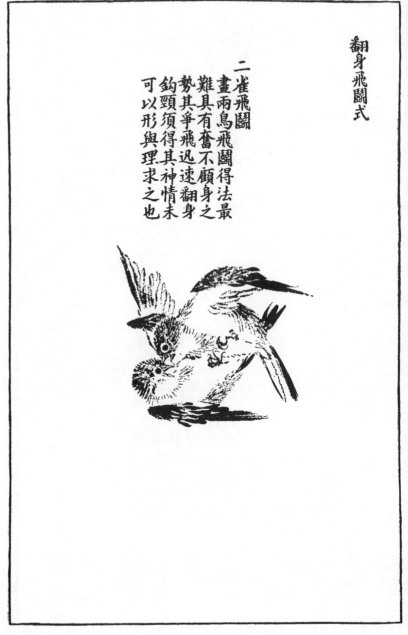

浴波式

鬥鳥與浴鳥較畫踏
枝者其情勢更要生
動鬥鳥翻身鈎勁須
奮不顧身浴鳥則浮
羽拂波須悠然自得
又各有不同處

浮羽
拂波

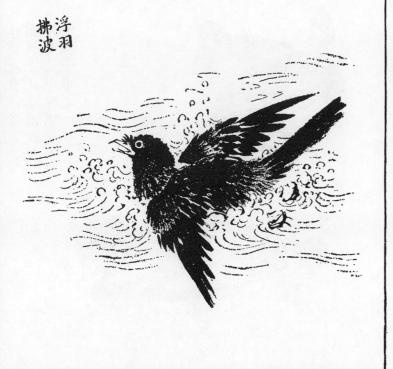

37　Example of bird bathing

Birds fighting and birds bathing should be rendered
with more vitality and movement than when they are
on a branch. Birds that are quarreling, turning them-
selves upside down, should be drawn fierce and un-
yielding, their wings spread, heedless of their bodies.
Birds bathing flutter their wings, shaking off the wa-
ter, and should seem perfectly happy. Each of these
two aspects has its particular characteristics.

Fluttering wings and shaking off the water.

575

Examples of water birds [1]

38

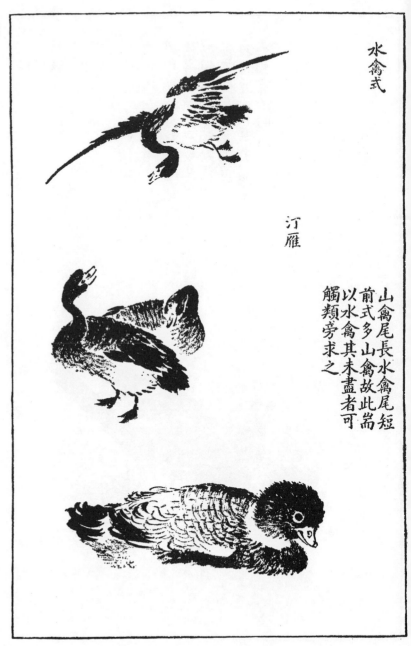

水禽式

汀雁

山禽尾長水禽尾短
前式多山禽故此篇
以水禽其未盡者可
觸類旁求之

Wild goose on a bank.

Mountain birds have long tails, water birds short
ones. Examples have already been given showing
mountain birds; therefore, here, a few examples of
water birds are included. Others may be drawn by
following these basic examples.

1. Original edition showed a bird on a bank with the
explanation, "Wings folded, waiting to bathe." The example
here appears only in the later (Shanghai) edition.

[In the Shanghai edition, the twelfth book contains 40 single pages of additional examples of birds and flowers, omitted here.]

[The thirteenth book (here mainly omitted) of the original edition contains 40 double pages of examples preceded by a note by the publisher, Shên Hsin-yu, again giving the names of those who had worked on the Manual and the fact that the work had taken twenty years. He himself added some notes on colors, which are translated following.]

Concluding Notes on the Preparation of Colors

METHODS of preparing colors have already been discussed in Part I, on landscape.[1] It may therefore be puzzling why these additional notes on colors are offered here, at the end of (Part III,) *Grasses and Insects* and *Birds and Flowers*. The preceding pages have given information about the history of painting and instruction in technique, demonstrated by numerous illustrations. For these concluding notes on colors to come after the instruction is in accord with the statement in the *Shu* (Book of History) that in carpentering one must first know how to saw and carve before decorating; hence, colors come after construction. Likewise, lines in the *Shih* (Book of Poetry) describe the pretty dimples of a smile and black pupils contrasting with the whites of beautiful eyes; the qualities of a lovely smile and eyes are inherent, and the coloring is an additional ornament. (As Confucius said in the *Analects*): "Applying colors comes after the groundwork." Thus, the classics can be quoted regarding the fundamental steps in painting.

Mineral blue (*shih ch'ing*)

To prepare mineral blue, select a piece of the kind called *mei hua p'ien* (plum petal), crush it in a bowl, and add a little water. Allow the mixture to dry in the sun. There will be three shades of

1. See above, pp. 34 ff. In many respects, this section repeats the notes on colors in the first book, but it refers mainly to flower painting, and so is translated here in full. In the Shanghai edition, these notes were placed after the opening discussion and before the examples in the *Book of Feathers-and-Fur*.

blue: the top layer, of light, clear blue, may be used in painting the faces of leaves; the middle layer, of a medium tone, may be used in painting blue flowers and in accentuating touches of blue on the heads and backs of birds; the bottom layer, very dark in tone, may be used on the wings and tails of birds and also for accents among leaves. Generally, in using blue in painting birds and petals, the accenting is done with indigo (*tien ch'ing* or *tien hua*). When the dark tones of mineral blue are used, touches should be added of rouge red (*yen chih*).

Mineral green (*shih lu*)

The method of preparing mineral green is the same as for mineral blue. And there also are three shades. The top layer, of a deep and dark tone, can be used only in touches in the background of leaves or grass. The middle layer, lighter in tone, may be used for backgrounds of leaves, for grasses, or for the face of leaves, when a touch of grass green (*ts'ao lu*) should also be added; this middle green may be used in painting the kingfisher, together with fine streaks of grass green. The bottom layer, lightest in tone, is best for the backs of leaves. In general, when mineral green is used, grass green should be used in outlining. When a dark tone of the green is used, the grass green should have more blue in it. And with a light tone of mineral green, grass green should have a touch of yellow in it.

Mineral blue and mineral green usually need to be dried. In powdered form they should be mixed with a little liquid glue, which should not be too thick or the pigment will be too heavy for the brush, nor too thin or the colors will fade. It is important to use just the right amount.

If grass green is used in painting on silk and the back of the picture is also to be painted, a light wash of mineral green should be used on the back. Grass green and dark tones of mineral green should be used in painting paper fans, since the backs can not be painted. The colors will then seem rich and deep. Washes should not be applied in one thick coat but in several light ones so that no traces of brushstrokes will show.

Just before mineral green is to be used, the glue should be removed by (setting the bowl in) boiling water, (which will make the glue rise to the surface). If the color is to be used again, fresh glue should be added. In this way the color will retain its brilliance.

Vermilion (*chu sha*)

The red to use in painting is *chu sha* vermilion. It does not change. *Yin chu* (deep vermilion) is likely to fade. In preparing *chu sha*, first grind it to fine powder, then mix with a little light glue. (When the mixture has settled,) the bottom layer of dark red and the top layer of orange should be removed. The middle layer, a fresh and bright tone, should be dried in the sun. With a little glue added, this color may be used in painting the camellia, pomegranate, and most other red flowers, the petals of which should be touched up with *yin chu*. The color of the bottom layer should be used only for backing the painting.

Deep vermilion (*yin chu*)

If the *chu sha* available is of poor quality, it is better to use *yin chu*. Grind it very fine and add water. The top and bottom layers should be removed and only the middle layer used, after adding a little glue.

Gold paste (*ni chin*)

Dab a finger moistened with a little glue on gold leaf and put the leaf flake by flake in a saucer. Mix it with a little glue and make a smooth paste. Add a little boiling water to dilute the mixture and also to make the glue rise to the surface. Dry over a low fire. When the gold is to be used, add a little glue. For the most brilliant effects, it should be used with *chu sha* vermilion and mineral blue. Used in fine strokes in painting the plumage of the phoenix and pheasants, it will heighten the shining effect of the blue-green and red feathers. It may also be used in painting fruit and in drawing the veins of blue or green leaves. After using the gold, the glue should be removed (from the gold left in the saucer) in the same way as with blue or green.

Cock yellow (*hsiung huang*)

Select a transparent piece. Grind it and mix with water and glue as in the preparation of mineral blue and green. With a little glue added, this color may be used in painting golden flowers, but (it

should be noted that) the tones will later change. Rattan yellow (*t'êng huang*) serves equally well; touched up with *chu sha* or *yin chu* vermilion, it will give the same effect of golden yellow.

Preparing white (*fu fên*)

Use the white called *hui ch'ien ting fên* (white lead), from Hangchou. Grind it fine and mix with a little glue. Add a little water and pour the mixture in a saucer. Let it sit for a while, then pour into another saucer, leaving the residue at the bottom, which may be discarded. Warm the liquid over a low fire. A dark coating of the lead will form on the surface. This should be skimmed off with a piece of paper. Add more glue, again grind, and then dry over the low fire. When used in painting, the white should be mixed with a little hot water. It may be used in painting white flowers or may be mixed with colors. Usually, when white is used, a light coating of it should also be applied on the back of the painting.

Method of steaming the white: Make a hole in a piece of bean curd and in it put a piece of white lead. Steam in a pan. The lead will be absorbed by the bean curd and the white is ready to be ground and used.

Method of applying coats of white: White should be used lightly and should not run into the black of the outlines. Additional coats of white may be applied, but each should be very light. If the first coat is thick and others are added, the black outline may be overlapped. When the outline has then to be retouched, the effect of the whole picture is spoiled. In general, white should be used with care, for in time it will darken.

Method of touching up with white: In painting white flowers, such as the lotus or the water lily, the tips of their petals should be touched up with white. This accentuates their forms and the arrangement of the stamens. The petals of most white flowers may be touched up in this manner.

Method of tracing with white: Flowers such as the water lily and the hibiscus have veins in their petals. These may be traced with white, over which color is then applied. Each petal of the chrysanthemum has a long vein, which can be drawn in white and then tinted. In dotting the stamens of flowers, first sketch in the form of their ring, then draw the stamens in white and accent the tips with yellow.

Method of dotting with white: In painting flowers in the manner called *hsieh shêng* (write

life; catching the essence and movement of life), outlining is not used. Colors are handled freely, mixed with a little white. It is therefore essential to have the conception clearly in one's mind. This manner is different from the outline style (*kou lê*). Stems and leaves are all drawn and painted in color. This is sometimes called the "no-bones" style.

When white and rattan yellow are mixed for painting stamens, the tone should not be too deep. Only a small proportion of glue should be added. The outside stamens should curve outward and the inner ones curve inward toward the heart.

Method of backing a painting with white: On the back of pictures of flowers painted in colors mixed with white, a coat of white will enhance the results. If the colors used are clear and light, pure white should be applied on the back of the painting. If the colors are dark or in a low key, the white on the back should be tinted with tones of these colors. If a light green is used in painting the backs of leaves, a similar tone should be used on the back of the painting, although mineral green should never be used for this purpose.

Rouge red (*yen chih*)

Choose the best quality available. Soak it in boiling water to extract the essence of the color. Remove the dregs. Dry in the sun. On rainy days the red may be dried near a fire, though care should be taken that it does not dry out. Rouge red with white contributes to the painting of flowers. The purity of white pertains to the nature of flowers, and the freshness of red to their very spirit. Applying these colors in painting flowers is like tinting the cheeks of lovely women. Their beauty is not, however, in the amount of rouge on their cheeks; that is why, in painting, red should be used lightly and in light coats to obtain a perfect effect.

Soot black (*yen mei*)

Soot black is used only in painting human hair, animal fur, and feathers. Soot may be gathered from a small bowl placed for a little while over an oil lamp. This soot of lampblack may then be mixed with a little glue; if too much glue is used, the black will be too shiny and will show traces of

brushstrokes. This black may be used in bird and insect painting to touch up the feathers of the thrush and the blackbird, the wings of the crane, and the wings of butterflies. It may also be used in drawing tail and wing feathers. These accents of soot black are distinctively mat, while with ink the effect is glossy.

Indigo (*tien hua*)

Among all the blues, greens, golds, and reds, indigo receives less attention than the other colors. Yet it is the basis of many blues and greens, and it has a wonderful brilliance. It is probably the most difficult color to prepare. Other colors may be prepared in a day, but indigo requires several days. Other colors may be prepared in any season, but for indigo a summer's day is best since it should be dried in the sun. Unless it is urgently needed, indigo should not be dried by a fire as it may easily be burned.

In paintings of flowers, people generally notice only the red and white of the flowers. The leaves are, however, equally important, and if their colors are not just right, the effect of the flowers can be spoiled. Indigo adds immeasurably to greens, which, in turn, enhance the reds and pinks. They complement each other. The manner of preparing indigo has already been explained in Part I of this work, and there is no need to repeat the details.

Rattan yellow (*t'êng huang*)

The kind called *pi kuan huang* (brushtube yellow) is the best. There are two kinds, the dark and the light. The dark is heavy, the light pure. When mixed with other colors, the light is preferable. In preparation, this yellow should be soaked in water and kept away from fire or heat, or it will become grainy. This color may be used in painting light yellow flowers. For darker petals, add to the yellow a little umber (*chê shih*) or rouge red (*yen chih*).

Indigo and rattan yellow will produce three kinds of green:

Shên lu (deep green)—seven parts of indigo and three parts of rattan yellow; for painting leaves of the camellia, the cassia, and the orange; use indigo to accent the outlines.

Nêng lu (intense green)—equal parts of indigo and rattan yellow; for painting all kinds of dark leaves; outline in mineral green.

Nun lu (fresh green)—three parts of indigo to seven parts of rattan yellow; for painting young leaves of plants with wood stems, leaves and stems of herbaceous plants, and the backs of leaves whose faces have been painted with mineral green; outline in a green of medium tone.

Rattan yellow should be used pure for the tender shoots of new leaves, with outlines in red; and the painting should be backed by a wash of green mixed with white.

Umber (*chê shih*)

Choose pieces that are brilliant in tone. In an earthenware dish, crush into fine powder and add water. The white layer rising to the surface and the dregs should be removed. The middle layer should then be mixed with a little glue and dried by the fire. This color is used in painting old branches, dried leaves, and the buds of the magnolia. It may be mixed with other colors.

Mixed with ink, it turns to the color of iron, which is used in painting trunks and roots. Mixed with rouge red and ink, it turns to a dark reddish brown, which is used in painting the calyxes of the wild plum and apricot. Mixed with rattan yellow, it turns to the color of sandalwood, which is used in painting the petals of the chrysanthemum. Mixed with green, it turns to a dark green, which is used in painting the calyxes of the winter plum and the hibiscus, and also in the drawing of young branches of plants with wood stems and of old branches of herbaceous plants. Mixed with *chu sha* vermilion, it turns to a dark red, which is used in painting the petals of the chrysanthemum.

Mixing colors

The various greens have already been described in the notes on indigo and rattan yellow; in discussing umber, other combinations of colors have been dealt with. There are still others.

Red with indigo produces lotus green (*lien ch'ing*); with a little white added, the pale green of the points where lotus roots join (*ngou ho*). Ink with intense green produces oily green (*yu lu*). Umber with a pale green produces gray-green (*ts'ang lu,* old green). Vermilion (*chu sha*) with rattan yellow produces a burnt orange. Umber with pink produces flesh red (*ju hung*); with *chu sha* added, this makes a deep pink (*yin chu*). Rouge red and vermilion produce the highest

degree of red (*yin hung*). Rattan yellow with vermilion produces a golden yellow. The combinations are innumerable, and others that do not pertain to bird and flower painting need not be mentioned.

Use of ink

Ink is, of course, indispensable in flower painting. In some works in color, the leaves are painted in ink. In others, ink is used to outline and dot. Ink tones are brought out entirely by the light and dark shades of ink alone. Tones of ink for flowers should be different from tones for leaves. In flower painting, a touch of rattan yellow with the ink enhances the effect, as though colors had been used.

Applying alum on silk

The silk should be stretched on three sides of a frame, along the top and the two sides. The bottom is fixed by bamboo pegs. String intertwined among these pegs and others around the frame helps to tighten the frame and stretch the silk evenly.

Glue should be prepared, and alum ground to fine powder. In winter the proportions should be ten *ch'ien*[3] of glue to three *ch'ien* of alum; in summer, seven *ch'ien* of glue to three *ch'ien* of alum. The glue should be put into boiling water in a clean pan, the alum powder dissolved in cold water in a porcelain bowl. When the glue has cooled, the alum and water are blended with it. Add a little boiling water.

The framed silk should be leaned against the wall and the solution applied smoothly with a flat brush. After the coat is dry, repeat. Three coats are necessary. For the last two coats, the glue should be diluted with a little hot water, because a cold solution sets too quickly. In winter, it may be necessary to keep the glue warm over a low fire. To test the thickness of the glue, flick or tap the silk; if the sound has a dull quality, the glue is all right.

3. 1 *ch'ien* = 1/10 Chinese ounce (*liang* = a bit more than an ounce avoirdupois).

Applying alum on colors

If strong colors are used in painting on silk, such as mineral blue, mineral green, and *chu sha* vermilion, one should be careful they do not lose brilliance on being applied. An extra coat of the alum solution should be applied to the silk before it is removed from the frame. To test the amount of alum, taste the solution; if it is very sour, then there is enough alum. In applying the alum solution, the flat brush should pass over the surface lightly and smoothly. Hesitation will leave marks. The back of the silk should also be given a coat of alum if color is applied.

These different ways of using colors are among the secrets of painting. No effort has been spared in searching them out for the benefit of those who are learning to paint, and they should be carefully studied.

Notes written by Shên Hsin-yu, tzŭ Yin-po, of Hsi-ling.

Summary of the Chieh Tzŭ Yüan Hua Chuan

THE FOLLOWING detailed summary of contents is substituted for the tables of contents which, in the Chinese editions, were printed at the beginning of each book. The additional prefaces, comments, testimonials, and sets of examples omitted in this translation of the Manual are indicated below in brackets. The term "original edition" refers collectively to the K'ang Hsi editions (Part I, 1679; Parts II and III, 1701) and the Ch'ien Lung edition (1782). "Shanghai edition" refers to the 1887–88 edition printed in Shanghai. For a discussion of editions of the *Chieh Tzŭ Yüan Hua Chuan*, see the Introduction.

Men of quality

Great masters

Important changes

A general list of the brushstrokes used for modeling (*ts'un*)

Explanation of terms

Use of the brush

Use of ink

Brushwork and color washes (*hsüan jan*)

Placing the sky and earth

Guarding against evil influences

Avoiding the banal

NOTES ON THE PREPARATION OF COLORS
(AND OTHER MATERIALS OF PAINTING)

Approach to color

Mineral blue (*shih ch'ing*)

Mineral green (*shih lu*)

Vermilion (*chu sha*)

Deep vermilion (*yin chu*)

Coral red (*san hu mo*)

Cock yellow (*hsiung huang*)

Mineral yellow (*shih huang*)

Liquid gold (*ju chin*)

Preparing white (*fu fên*)

Preparing red (*t'iao chih*)

Rattan yellow (*t'êng huang*)

Indigo (*tien hua*)

Grass or vegetation green (*ts'ao lu*)

Umber (*chê shih*)

Yellow ocher (*chê huang*)

Old red (*lao hung*)

SUMMARY OF THE CHIEH TZŬ YÜAN HUA CHUAN

OUTLINING LEAVES FOR COLORING

17 Methods of outlining leaves

18–19 Methods of outlining and coloring leaves

PAINTING VINES

20 Method of painting a vine growing on a tree / Method of painting a vine growing on a cliff

TREES BARE OF FOLIAGE

21 Fan K'uan's style of painting trees

22 Kuo Hsi's style of painting trees

23 Wang Wei's style of painting trees

24 Ma Yüan's style of painting trees

25 Hsiao Chao's style of painting dead trees

26 Yen Chung-mu's style of painting trees in the wind

27 Ts'ao Yün-hsi's style of painting trees / K'o Chiu-ssŭ's style of painting trees

TREES IN LEAF

28 Ni Yün-lin's style of painting trees / Li T'ang's style of painting trees

29 Wu (Chên) Chung-Kuei's style of painting trees, which was copied by Shên (Hao) Shih-t'ien

30 Huang (Kung-wang) Tzŭ-chiu's style of painting trees

31 Another example of Huang Tzŭ-chiu's style of painting trees

32 (Wu Chên) Mei-hua Tao-jên's style of painting trees

COMBINING VARIOUS KINDS OF TREES

33 General methods of combining various kinds of trees

34 Shêng (Mou) Tzŭ-chao's style of combining various trees

35 Liu Sung-nien's style of combining various trees

36 Ni Yü's style of combining various trees

37 Kuo Hsi's style of combining various trees

38 Li T'ang's style of painting trees growing on a steep cliff

39 Style of Ching Hao and Kuan T'ung in combining trees

40 Hsia Kuei's style of combining various trees; used also by Li Ch'êng

Book 5 [An additional book of Part I contained further examples with inscriptions copied from works of various painters. They are 10 double pages, 10 album paintings, 10 folding fan paintings, and 12 additional double pages. The Shanghai edition contained 68 pages.] *

* For explanation of material in brackets, see headnote of this summary.

PART II

[Section of 16 additional pages of examples in both the original edition and the Shanghai edition. Individual pages different. Introduced by Wang Shih, with concluding remarks by Wang Nieh.]

[Section of additional examples with an introduction by Wang Shih: original edition—24 double pages; Shanghai edition—28 single pages.]

Book 8 Book of the Plum *page* 397

[A Testimonial for the *Book of the Plum* and the *Book of the Chrysanthemum*]

CH'ING TSAI T'ANG DISCUSSION
OF THE FUNDAMENTALS OF PLUM PAINTING

 General background of plum painting

 Summary of Yang Pu-chih's rules of painting the plum

 T'ang Shu-ya's rules of painting the plum

 Hua-kuang Ch'ang-lao's precepts on plum painting

 Principles of establishing the composition of the plum tree

 Explanation of the symbolism of plum painting

 One calyx

 Two trunks

 Three sepals

 Four directions of the main branches

 Five petals

 Six branches

 Seven stamens

 Eight types of crossings of branches

 Nine transformations

 Ten kinds of plum tree

 Summary of plum painting phrased for memorizing by chanting

 Principles of painting the trunk and main branches of the plum tree phrased for memorizing

 The four elegances of the plum tree phrased for memorizing

 Essentials of plum painting phrased for memorizing

 The Thirty-Six Faults in plum painting phrased for memorizing

 1–2 Examples of first steps in painting the plum tree

[Section of additional examples: original edition—20 double pages; Shanghai edition—25 single pages, preceded by remarks by Shên Hsin-yu and Wang Shih, with concluding remarks by Wang Chih, *tzǔ* Yün-an.]

PART III

Methods of painting insects among herbaceous plants

Rules of painting insects among herbaceous plants phrased for memorizing

Rules of painting butterflies phrased for memorizing

Rules of painting the praying mantis phrased for memorizing

Rules of painting various kinds of insects phrased for memorizing

Rules of painting fish phrased for memorizing

1–4 Examples of first steps in painting flowers of herbaceous plants/Flowers with four and five petals

5–7 Flowers with long peduncles and five and six petals

8–10 Large flowers with many and dentate petals

11–12 Lotus or water lily with large round petals and pointed tips

13–15 Forms of various kinds of flowers

16–17 Examples of first steps in painting leaves of herbaceous plants/Examples of tapering leaves

18 Examples of round leaves in groups

19–20 Examples of pronged leaves

21–22 Examples of long leaves

23–24 Examples of dentate leaves

25–26 Examples of circular leaves

27–30 Examples of first steps in painting the stems of herbaceous plants

31–34 Examples of dotting various mosses and grasses at the base of plants

EXAMPLES OF INSECTS FOR PAINTINGS
OF GRASSES AND HERBACEOUS PLANTS

35 Butterflies with yellow and red wings and black markings (*chieh tieh*)

36–37 Bees, wasps, moths, and cicadas

38–39 Dragonflies, crickets, and grasshoppers

40–41 Large green grasshoppers, crickets, beetles, and the praying mantis

[In the Shanghai edition, 40 single pages of additional examples.]

Book 11 [Original edition—40 double pages of additional examples. In the Shanghai edition, Books 11 and 13 contained over 100 additional examples of the subjects in Part III.]

Book 12 Book of Feathers-and-Fur and Flowering Plants *page* 523

[Preface by Wang Shih to the *Book of Feathers-and-Fur and Flowering Plants*]
CH'ING TSAI T'ANG DISCUSSION OF THE FUNDAMENTALS OF PAINTING
FLOWERING PLANTS AND FEATHERS-AND-FUR

Vermilion (*chu sha*)

Deep vermilion (*yin chu*)

Gold paste (*ni chin*)

Cock yellow (*hsiung huang*)

Preparing white (*fu fên*)

Rouge red (*yen chih*)

Soot black (*yen mei*)

Indigo (*tien hua*)

Rattan yellow (*t'êng huang*)

Umber (*chê shih*)

Mixing colors

Use of ink

Applying alum on silk

Applying alum on colors

ANALYSIS OF BASIC TERMS

The pictographs of Chinese writing often illustrate their meaning more vividly than an explanation. Particularly, the terms of Chinese painting become more meaningful when the old forms of the pictographs are examined. They are among the earliest known Chinese writing; they are simpler than the characters used today and show more clearly the components of a word.

A number of key terms are analyzed here. In some cases the modern forms are followed by the older forms; in others the components are placed after the pictograph, and where the modern forms are shown, they precede the older forms. A few characters associated with the concept of *Tao* (apart from other senses in which they are used) are included after the *tao* character. The contents of the appendix are as follows:

4. *ssŭ* (thought)
5. *i* (idea, meaning)
6. *i* (fit, proper)
7. *tzŭ jan* (naturalness)
8. *chên* (true, genuine)

VII. Other terms of painting
1. *ching* (seasonal aspect)
2. *pi* (brush)
3. *mo* (ink)
4. *hua* (to draw, to paint)
5. *hsieh* (to write, to draw and paint)

I. The character *tao*

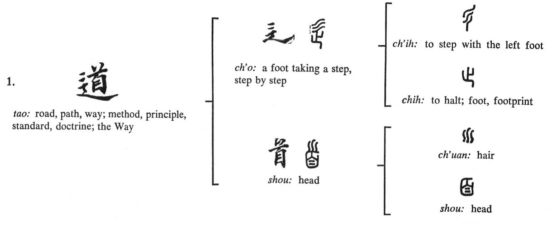

1.

tao: road, path, way; method, principle, standard, doctrine; the Way

ch'o: a foot taking a step, step by step

shou: head

ch'ih: to step with the left foot

chih: to halt; foot, footprint

ch'uan: hair

shou: head

1*a.*

"deer's head," from an inscription *c.* 1000 B.C.

II. Synonyms and terms descriptive of *Tao*

1.

jih: sun, day; symbolically, the Sun, *Yang,* Heaven, *Tao*

2.

chung: center, middle; "center of the four quarters"; the Mean, the Center, *Tao*

3.

chi: ridgepole, the extreme, utmost; the *T'ai Chi,* Great Ridgepole or Axis of the Universe and of the Wheel of Life, the Absolute, *Tao*

mu: wood, tree; roots and branches of the whole tree

chi: man depicted between two lines representing Heaven and Earth, striving through words (mouth) and deeds (hand) to live according to the concepts associated with the *T'ai Chi*

4.

hui: to return to or from; a turn or revolution

5.

hsüan: to revolve; a complete and continuous revolving between the line representing Heaven and that of Earth

6.

fan: to turn over; a drawing of the motion of the right hand turning something over

III. Basic terms of painting borrowed from Chinese thought

1.　理

li: principle; reason, essence, inner law, fitness of things

玉

yü: jade (a symbol of purity and the vitality of life)

里

li: lane, thoroughfare; markings, veins; the veins in a piece of jade, thus the very essence of its purity and vitality

2.　禮

li: rituals, ceremony, and conduct be-fitting an occasion; the sense of fitness

示

shih: signs or omens in the heavens; the will of Heaven discernible in the movement of the sun, moon, and stars hung in the heavens (the two lines at top)

豊

li: sacrificial vessel (the green sprigs or branches in the vessel symbolized plenty and other benefits, i.e., hoped-for results)

3.　仁

jên: Goodness; "the virtue that must unite men" (Wieger, p. 73)

人

jên: man

二

êrh: two (representing relationship)

4. 陽

yang: clear, light, hot; dryness, fire, red, day; upper, outer, front, open; South; south of a mountain and north of a river; male or positive element, force, and principle, Sun, spring-summer, Heaven, Spirit

fu: mound; hill, mountain

yang: sun, light; the sun radiating heat and light

tan: dawn; sun above the horizon

wu, a phonetic used sometimes as a negative and a prohibition, also in the sense of motion of jerking, flapping, waving, or, as here, radiating

5. 陰

yin: shady, dark, cold; moistness, water, black, night; lower, inner, back, closed; North; south of a river and north of a mountain; female or negative element, force, and principle, Moon, autumn-winter, Earth, Matter

fu: mound; hill, mountain

yin: cloudy, shaded, dark; a coiled cloud; the moment when clouds cast shadows

chin: now, the moment

yün: cloud

6.

The eight trigrams around the *Yin-Yang* emblem (the *T'ai Chi*)

IV. The First Canon: *ch'i yün shêng tung*

1.

ch'i: vapor, breath; air, manner, influence, weather; *Ch'i*—Breath of Heaven, Spirit, Vital Force, the vivifying principle

ch'i: vapor, breath

mi: rice, grain; a picture of grains and the four cardinal points, therefore sustenance in every sense throughout the universe

1a.

an ancient form of *ch'i;* the two parts, depicting "sun" and "fire," form a double symbol of power and life; the bird form may have been intentional, to suggest the association of a bird with the sky-air element and the spirit

jih: sun (see II, 1)

huo: fire

2.

yün: to turn, revolve; a circuit

ch'o: step by step (see *tao* character, I, 1)

chün: a legion, army with chariots

pao: figure bending to enfold an object; by extension, to wrap, to enclose; bundle, group

chê: chariot, carriage; hence, to roll, revolve

axle

wheels

body of chariot

3. 韻

yün: rhythm, harmony

yin: utterance (of a sound or word)

員

yüan: official; border; roundness ("round like a cowrie shell")

4. 生動

shêng tung: life-movement or producing movement of life

生

shêng: to grow, to bear, to produce; to live; life (picture of a plant sprouting)

動

tung: to move, stir, arouse; to set into action or motion by strength of one kind or another

重 重

chung: heavy, weighty; important

力 力

li: sinew, strength

全

t'ing (picture of a man standing on earth, in his place)

東

tung: east; important (picture of the sun rising on the horizon, just below tree top and above its roots; used here as the phonetic, though contributing to the meaning)

V. The Second Canon: *ku fa*

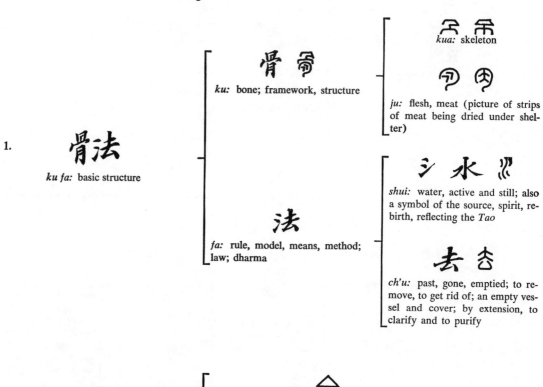

1. 骨法

ku fa: basic structure

ku: bone; framework, structure

fa: rule, model, means, method; law; dharma

kua: skeleton

ju: flesh, meat (picture of strips of meat being dried under shelter)

shui: water, active and still; also a symbol of the source, spirit, rebirth, reflecting the *Tao*

ch'u: past, gone, emptied; to remove, to get rid of; an empty vessel and cover; by extension, to clarify and to purify

1a. 企

another form of *fa*

chi: union, harmony

chêng: to arrive and stop; the limit; by extension, straight, correct, upright, moral

1*b.*

fa: dharma, law: (used exclusively for Buddhist terms, although Kuo Jo-hsü purposely put it in the Second Canon. The parts of this character, as shown here, were probably based on Buddhist symbolism: water as a spiritual, creative, and purifying element from a source outside the world (i.e., the house or hut); within, two characters, the soaring, long-tailed bird and the "empty" (pure) vessel (right half of *fa*), further symbolize a process of purification. The bird might originally have been a drawing of the legendary phoenix, an important and popular emblem of the Sun)

fa: see above, V, 1

广 广

yen: roof of a shed or hut; a cover

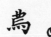

contraction of *niao* (a long-tailed bird)

VI. Other basic terms borrowed from Chinese thought

1.

shih: to maintain strength; power, authority; structural integration, style, effect

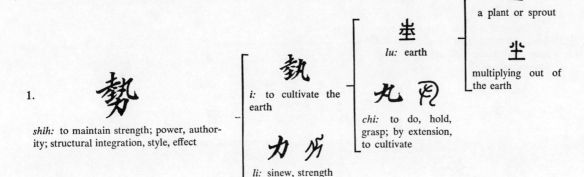

i: to cultivate the earth

li: sinew, strength

chi: to do, hold, grasp; by extension, to cultivate

lu: earth

a plant or sprout

multiplying out of the earth

2. or

shih: solid, substantial; actual, authentic, real, true, living quality (picture of a string of cowrie shells, an ancient form of money, under one's roof, therefore representing material wealth and, symbolically, richness in other ways; the second form of the character represented "to be" under one's roof, *shih* (to be) depicting "to walk guided by the sun," or to live according to the ideas associated with the Sun, *Yang,* the positive and active principle of life)

mien: hut, roof

kuan: to string, to tie together

pei: cowrie

3.

hsin: heart, heart-mind

4.

ssǔ: thought; to think (that which rises from the heart-mind up through the brain and head, here represented by drawing of a skull)

yen: to speak; words, speech

yin: sounds or words uttered (issuing from the mouth)

5.

i: idea, meaning, conception; the intention from the heart-mind uttered in words

hsin: heart-mind (see above, 3)

6. 宜宜

i: fit, right, proper, harmonious; a frequently used term with the special meaning, as illustrated by its parts, of "arranging things in order in the house"

7. 自然

tzŭ jan: certainly; of course; naturalness, spontaneity; self-existent

tzŭ: nose, beginning; self; personally, characteristically; certainly

jan: yes; certainly (the early origin of this character may be seen in its parts representing the sacrifice of the flesh of a dog, in ancient times an offering of filial piety and thus a gesture of utmost affirmation)

ju: pieces of meat

ch'üan: dog

huo: fire

8. 真 眞

chên: genuine, true, real; hence, spiritual, divine, and according to nature (the composition of the character denotes that what ten or many eyes have gauged and found straight and true was set up as a standard; or that what had been perceived as complete and perfect (ten) was established as true—what the Taoists called "perfectly true")

shih: ten

mu: eyes

wu: base, pedestal, platform

VII. Other terms of painting

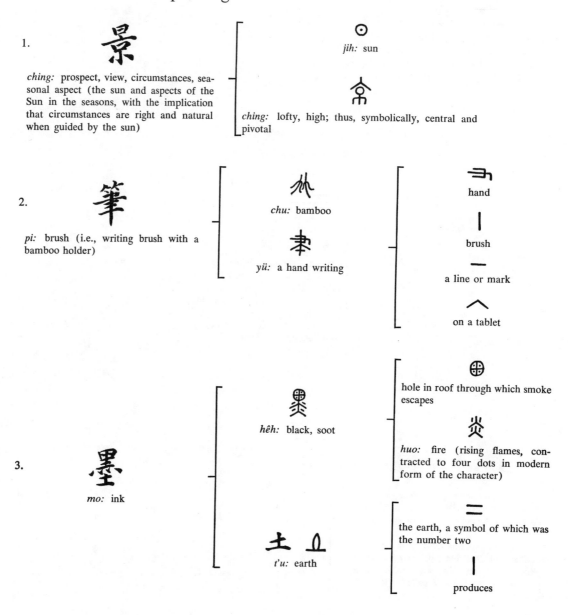

1.

ching: prospect, view, circumstances, seasonal aspect (the sun and aspects of the Sun in the seasons, with the implication that circumstances are right and natural when guided by the sun)

jih: sun

ching: lofty, high; thus, symbolically, central and pivotal

2.

pi: brush (i.e., writing brush with a bamboo holder)

chu: bamboo

yü: a hand writing

hand

brush

a line or mark

on a tablet

3.

mo: ink

hêh: black, soot

t'u: earth

hole in roof through which smoke escapes

huo: fire (rising flames, contracted to four dots in modern form of the character)

the earth, a symbol of which was the number two

produces

4.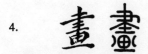

hua: to draw, to paint (see *pi,* "brush," above, for the upper part of the character, depicting a hand tracing with a brush, to which is added below a picture of a subject in a given, framed space)

mien: hut, house; roof

5. 寫

hsieh: to write; also to draw and to paint

yeh: magpie (it has been suggested that neatness and trimness were associated with the magpie; the origin of the idea is, however, lost; the character has the meaning of setting things in order in one's house; hence, also, to set ideas in order in writing and painting)

Index

The index lists the masters of painting and calligraphy cited with the examples of brushwork in the Manual, giving the *ming* (personal name) and in some cases also the *tzŭ* (courtesy name) and the *hao* (literary name). The page references indicate also where these names are evoked, enlivening the tradition, elsewhere in the text, in the discussions of the fundamentals of painting.